MARIA LONGWORTH STORER

MARIA LONGWORTH STORER

FROM MUSIC AND ART TO POPES AND PRESIDENTS

CONSTANCE J. MOORE
NANCY M. BROERMANN

About the University of Cincinnati Press

The University of Cincinnati Press is committed to publishing rigorous, peer-reviewed, leading scholarship accessibly to stimulate dialog among the academy, public intellectuals and lay practitioners. The Press endeavors to erase disciplinary boundaries in order to cast fresh light on common problems in our global community. Building on the university's long-standing tradition of social responsibility to the citizens of Cincinnati, state of Ohio, and the world, the press publishes books on topics that expose and resolve disparities at every level of society and have local, national and global impact.

The University of Cincinnati Press, Cincinnati 45221
Copyright © 2019

ucincinnatipress.uc.edu
Published in 2019

ISBN 978-1-947602-33-5 (hardback)
ISBN 978-1-947602-36-6 (e-book, PDF)
ISBN 978-1-947602-35-9 (e-book, EPUB)

Library of Congress Cataloging-in-Publication data

Names: Moore, Constance J., 1950-, author. | Broermann, Nancy M., 1950- author.
Title: Maria Longworth Storer : from music and art to popes and presidents / Constance J. Moore and Nancy M. Broermann.
Description: First Edition. | Cincinnati : University of Cincinnati Press, [2019] | Includes bibliographical references and index.
Identifiers: LCCN 2018029045 (print) | LCCN 2018042103 (ebook) | ISBN 9781947602366 (Ebook, PDF) | ISBN 9781947602373 (Ebook, EPUB) | ISBN 9781947602335 | ISBN 9781947602335 (hardback : alk. paper) | ISBN 9781947602342 (paperback : alk. paper) | ISBN 9781947602366 (e-book:PDF) | ISBN 9781947602373q (e-book :EPUB)
Subjects: LCSH: Storer, Maria Longworth, 1849-1932. | Women philanthropists—United States—Biography. | Catholic converts—United States—Biography. | Socialites—United States—Biography. | Diplomats' spouses—United States—Biography. | Women potters—United States—Biography. | Cincinnati (Ohio)—Social life and customs. | Cincinnati (Ohio)—Biography. | LCGFT: Biographies.
Classification: LCC E748.S884 (ebook) | LCC E748.S884 M66 2019 (print) | DDC 738.092 [B]—dc23 LC record available at https://lccn.loc.gov/2018029045

Designed and typeset for University of Cincinnati Press
 by Alisa Strauss
Typeset in: Avenir, Baskerville 120 Pro, Cocotte, and Copasetic
Printed in the United States of America

Second Printing

To Bill and Steve, our husbands, who went on this incredible journey with us. You supported us with humor, insight, and love.

To Bill and Sue, our husbands, who went on the
incredible journey with us. You supported us with
humor, insight, and love.

TABLE OF CONTENTS

ILLUSTRATIONS

ACKNOWLEDGEMENTS

IT WAS FORTUNATE that the authors got together to write this book about Maria Longworth (Nichols) Storer. One from El Paso contacted the other in Cincinnati. Over a series of conversations and many emails, a friendship developed, and an invitation to visit Cincinnati was extended in 2013. This began a series of trips to the Queen City as well as visits to Washington, DC, and France, seeking information from archives, museums, libraries, healthcare institutions, cemeteries, and a golf course.

Maria Longworth Storer was a prolific letter writer who sent hundreds of letters during her lifetime. Part of the fun of researching her life was the pleasure of contacting over thirty different sites and archives in the United States, England, and the Netherlands. Without the interest and passion of the archivists, historians, librarians, researchers, and other professionals, this book would not have been written. We identify them as follows:

Baltimore: Alan Mason Chesney Medical Archives, Johns Hopkins Medical Institutions, Marjorie Winslow Kehoe. Archdiocese of Baltimore Archives, Dr. Tricia Pyne. Associated Archives at Saint Mary's Seminary and University, Alison M. Foley.

Boston: Archdiocese of Boston Archives, Robert Johnson-Lally. Harvard University Archives, Virginia Hunt. Historic New England, Stephanie Krauss. Houghton Library, Harvard University, Susan Halpert. Isabella Stewart Garner Museum, Shana McKenna. Massachusetts Historical Society, Sabina Beauchard.

Cambridge, Massachusetts: Longfellow House–Washington's Headquarters National Historic Site, Christine Wirth.

Chicago: Archdiocese of Chicago's Joseph Cardinal Bernardin Archives and Records Center, Meg Hall.

Cincinnati: Archdiocese of Cincinnati Archives, Sarah Patterson. Church of the Advent, Rick Boydston. Cincinnati Art Galleries, Randy Sandler. Cincinnati Art Museum & the Mary R. Schiff Library/Archives, Geoffrey Edwards, Rob Deslongchamps, Anita Ellis, Galina Lewandowicz. Cincinnati Arts Association, Society for the Preservation of Music Hall, Ramona Toussaint. Cincinnati Catholic Women's Association, Janet Buening, Pat Evans. Cincinnati Children's Hospital Medical Center, Cher Stokes, Michelle Wirth. Cincinnati County Club, Pat O'Callaghan. Cincinnati historians, J. Richard Homlar, Betty Ann Smiddy, Thomas White. Cincinnati Museum Center, James Damico, Christine Schmid Engels, Janice Forte, Scott Gampher, Anne Shepherd. Cincinnati Parks Board Library & Archives, Vicki Newell. Cincinnati Symphony Orchestra, Meghan Berneking. Humler & Nolan, Riley Humler. Jacob Rader Marcus Center of the American Jewish Archives, Dana Herman. Lloyd Library & Museum. Public Library of Cincinnati/Hamilton County, Diane Mallstrom. Rookwood Pottery Company, Rick Wiley. Saint Ursula Academy, Lelia Keefe Kramer, Jill Cahill, Margie Matthews, Chris Potter-Wroblewski. Spring Grove Cemetery, Angela Ryan. Taft Museum of Art, Tamera Muente. University of Cincinnati, Christine Celsor, Kevin Grace. University of Cincinnati Press, Sarah Muncy, Elizabeth Scarpelli. Ursuline Sisters of Cincinnati Archives, Anne Gutzwiller, Janet Hirst, Kit and Jack Overbeck, Elaine Semancik. Ursulines of Cincinnati, Sister Mary Jerome Buchert, Sister Margaret Mary Efkeman.

College Park, Maryland: National Archives at College Park, Amy Reytar.

Dickinson, North Dakota: Theodore Roosevelt Center at Dickinson State University, Sharon Kilzer.

El Paso, Texas: El Paso Public Library Main Branch, Bonnie Coles.

Fremont, Ohio: Rutherford B. Hayes Presidential Center, Becky Hill, Nan Card.

Garrison, New York: Friars of the Atonement Archives/Record Center, Barbara Martire.

Leuven, Belgium: KADOC Documentation and Research Center on Religion Culture and Society.

New York City: Archdiocese of New York, the Rev. Michael P. Morris. Manuscripts and Archives Division, New York Public Library, William Stingone.

Oyster Bay, New York: Sagamore Hill National Historic Site, Elizabeth DeMaria, Susan Sarna.

South Bend, Indiana: Archives of the University of Notre Dame, Peter Lysy.

Princeton, New Jersey: Princeton University Library, AnnaLee Pauls.

Richmond, Virginia: Catholic Diocese of Richmond, Edie Jeter.

Saranac Lake, New York: Adirondack Health, Mary Daniels. Historic Saranac Lake, Amy Catania. Saranac Lake Free Public Library, Michele Tucker.

St. Paul: Archdiocese of Saint Paul and Minneapolis, Theresa A. Hartnett. Minnesota Historical Society, Erin Schultz.

York, England: Borthwick Institute for Archives, University of York, Lydia Dean.

Washington, DC: Library of Congress, Crystal Miles. Society of the Cincinnati, Anderson House, Ellen Clark, Emily Schultz Parsons.

We must offer exceptional thanks for Anita Ellis, Jean Preston, Anne Shepherd, Betty Ann Smiddy, and Brian Yothers for their thoughtful critique of the manuscript. They also provided invaluable counsel along the way.

We are particularly indebted to Jean François de Chambrun, now deceased, his widow, Nicole, and Jacques de Chambrun. They generously shared their family history and allowed us to use photos in the book.

Special thanks to Dave Bossart, who designed a map showing the location of Maria's Grandin Road mansion, which was torn down when the Cincinnati Country Club acquired the property. An outline

of the nineteenth-century mansion is highlighted on today's ninth and tenth fairways of the golf course.

We very much appreciate our translators Frida Atwood, Jane Evans, Jean-Yves Ferry, Camille LeBlanc, and Lut Smets, who meticulously translated Latin, Italian, German, and French letters that we collected. Their insight went beyond the words on the page. All helped us to understand the context of the letters, which was very helpful. We are forever indebted to Jean-Yves Ferry who contacted several people in Marvejols and helped us understand the impact of World War I on the town.

We wish to acknowledge our debt to a remarkable circle of biographers and historians whose studies of Theodore Roosevelt, Archbishop John Ireland, the American Catholic Church, and World War I provided the context that we needed throughout.

We are particularly appreciative of our families and close friends who asked questions and encouraged us to continue with the work when we felt discouraged. Lastly, we are grateful to have found Maria who was such a fabulous person about whom to write.

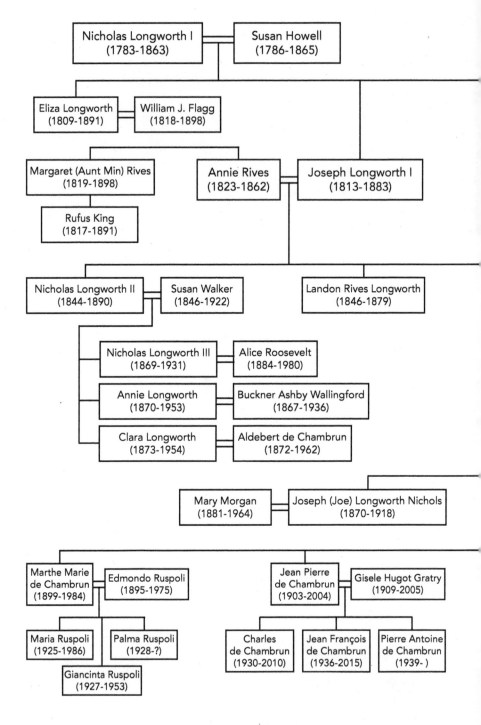

MARIA LONGWORTH STORER
FAMILY TREE

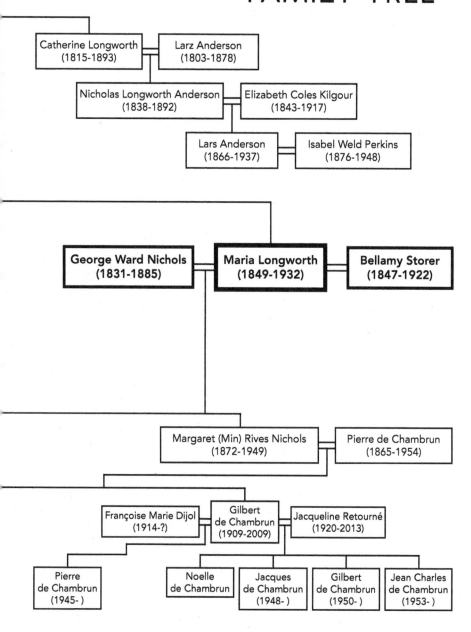

Catherine Longworth (1815-1893) — Larz Anderson (1803-1878)

Nicholas Longworth Anderson (1838-1892) — Elizabeth Coles Kilgour (1843-1917)

Lars Anderson (1866-1937) — Isabel Weld Perkins (1876-1948)

George Ward Nichols (1831-1885) — **Maria Longworth (1849-1932)** — **Bellamy Storer (1847-1922)**

Margaret (Min) Rives Nichols (1872-1949) — Pierre de Chambrun (1865-1954)

Françoise Marie Dijol (1914-?) — Gilbert de Chambrun (1909-2009) — Jacqueline Retourné (1920-2013)

Pierre de Chambrun (1945-)

Noelle de Chambrun

Jacques de Chambrun (1948-)

Gilbert de Chambrun (1950-)

Jean Charles de Chambrun (1953-)

CAST OF CHARACTERS

Adams, Henry: historian, novelist, political writer, autobiographer, editor; Maria's Washington, DC, society friend and fellow writers' patron

Anderson, Larz: diplomat and Maria's cousin (1866-1937)

Benedict XV: Catholic pope (1914-1922) who appointed Bellamy Storer as the administrator of the Bureau of Inquiry to find out information about missing soldiers, presumed to be prisoners of war

Benson, Robert Hugh: Catholic convert priest, writer, poet, novelist, essayist; Maria's travel companion and correspondent on Catholic Church–related matters

Bliss, Eugene F.: writer, editor, teacher, president of Cincinnati Historical Society; Maria's house sitter and thirty-year correspondent

Boehle, Rose Angela: Ursuline sister, first biographer of Maria

Cameron, Elizabeth: Senator J. Donald Cameron's wife and Maria's Washington, DC, society friend who sided with President Roosevelt during the 1906 scandal

Cerretti, Bonaventura: Vatican diplomat, intermediary for Lord Halifax's Anglican–Catholic Church reunification efforts; Maria's adviser

Chambrun, Aldebert de: general, diplomat, and Maria's niece Clara Longworth de Chambrun's husband

Chambrun, Gilbert de: French war hero, politician, and Maria's grandson

Chambrun, Jacques de: French businessman and Maria's great-grandson

Chambrun, Jean François de: French businessman, family historian, horticulturist, and Maria's great-grandson

Chambrun, Jean Pierre de: French researcher, artist, philanthropist, and Maria's grandson

Chambrun, Pierre de: French lawyer, diplomat, politician, and Maria's son-in-law

Chambrun Ruspoli, Marthe de: French writer and Maria's granddaughter

Coleman, Fidelis: Ursuline sister, superior of the Ursulines at Saint Ursula Academy, who contracted with Maria and Bellamy Storer to build their apartment at the school

Cox, George: Cincinnati's political boss, supporter (and later enemy) of Bellamy Storer

Crawford, Francis Marion: Catholic novelist, playwright; Maria's friend who is likely to have introduced Maria to Boston society matron Isabella Stewart Gardner

Dexter, Julius: lawyer, Cincinnati civic booster, lifelong friend of the Longworth and Nichols families

Duveneck, Frank: American painter whom Maria employed at the Art School of Cincinnati

Elder, William: Cincinnati archbishop who asked for Maria's assistance with charitable projects

Farley, John: cardinal of the New York Archdiocese, one of the largest and wealthiest American archdioceses; Maria's friend and correspondent on Catholic Church–related politics and World War I philanthropies

Flora, John W.: sued Maria and the other heirs of the first Nicholas Longworth estate, claiming he was an illegitimate descendent of one of Maria's aunts; the court ruled against him

Foraker, Joseph: Ohio Republican politician, opposing attorney in the Flora lawsuit and political enemy of Bellamy Storer

Force, Manning: Civil War veteran, lawyer, judge; Maria's Cincinnati friend and political supporter of Bellamy Storer

Freaner, Baptista: Ursuline sister, superior of the Ursulines at Saint Ursula Academy; Maria's friend and confidant when the Storers lived in the apartment at the school and later when they relocated to Europe

Gardner, Isabella Stewart: philanthropist; art collector; the Storers' Boston society friend and thirty-year correspondent

Gasquet, Francis: historian, Benedictine monk, cardinal; Maria's friend referred to as one of her "dear cardinals"

Gest, Joseph H.: assistant director and then director, Cincinnati Art Museum; vice president, and later director of the Rookwood Pottery Company; Maria's forty-year correspondent about art

Gibbons, James: cardinal of Baltimore, Maryland, second cardinal in the American Catholic Church; the Storers' correspondent and religious and political consultant

Goodwin, Parke: antislavery editor, journalist, author; George Ward Nichols's friend

Goshorn, Alfred: local and international event organizer; first director, Cincinnati Art Museum; friend of the Longworth and Nichols families

Goyau, Georges: prolific biographer, historian, essayist; Maria's correspondent and supporter of Archbishop John Ireland

Harrison, Benjamin: Republican president (1889–1893); Congressman Bellamy Storer served during his presidency

Hay, John: secretary of state for Presidents William McKinley and Theodore Roosevelt who supervised Bellamy Storer's diplomatic work; Maria's Washington, DC, society friend and correspondent

Hayes, Rutherford B.: Republican president (1877–1881); political patron of Bellamy Storer through the intervention of Manning Force

Hollister, Howard: lawyer, judge, senator; Maria's Cincinnati society friend and correspondent

Holmes, Daniel: one of Maria's friends, a wealthy, elite Cincinnatian

Hudson, Daniel: editor of *Ave Maria*; Maria's correspondent

Ingalls, Melville E.: lawyer, philanthropist, railroad president, president of the Cincinnati Art Museum; Maria's correspondent on art matters

Ireland, John: archbishop of St. Paul, Minnesota, leader of Americanist faction of Catholic Church; the Storers' close friend until 1906 when his proposed selection for cardinal was the focus of the scandal involving President Roosevelt, the Storers, and the Vatican

Keane, John: first rector of Catholic University, archbishop of Dubuque, Iowa, leader of Americanist faction of Catholic Church; the Storers' lifelong friend, despite the 1906 scandal

Leo XIII: Catholic pope (1878–1903); first of three popes with whom the Storers had private audiences

Lesley, Shane: diplomat, author, editor of the *Dublin Review*, which published Maria's article about President Roosevelt and Archbishop Ireland's relationship

Lodge, Henry Cabot: historian, senator; Bellamy Storer's Washington, DC, friend who sided with President Roosevelt after the 1906 scandal

Longfellow, Alice Mary: daughter of poet Henry Wadsworth Longfellow, philanthropist; lifelong friend of Bellamy and Maria Storer

Longworth, Joseph: lawyer, philanthropist, art patron, booster of Cincinnati; Maria's father

Longworth, Landon: artist, physician; Maria's brother

Longworth, Nicholas I: lawyer, land speculator, art patron, horticulturist; Maria's grandfather

Longworth, Nicholas II: lawyer, judge, writer, inventor, linguist; Maria's brother

Longworth, Nicholas III: musician, congressman, Speaker of the House; Maria's nephew

Longworth de Chambrun, Clara: novelist, memoirist, Shakespeare expert; Maria's niece

Maxwell, Lawrence: lawyer, solicitor general under President Grover Cleveland; the Storers' lifelong friend

McKinley, William: Republican president (1897–1901) who appointed Bellamy as minister to Belgium in 1897 and to Spain in 1899; did not censure Maria's diplomatic efforts involving the Vatican

McLaughlin, M[ary]. Louise: ceramicist, author, president of the Cincinnati Pottery Club, and Maria's chief pottery competitor

McLean Hazen Dewey, Mildred: Maria's childhood friend

Merry del Val, Rafael: Pope Pius X's secretary of state

Meyer, Adolf: psychiatrist, founding director of the Henry Phipps Psychiatric Clinic, Johns Hopkins Hospital; physician who cared for Joseph Longworth Nichols and Bellamy Storer

Moeller, Henry: Cincinnati archbishop who supported Maria's women's group, the Cincinnati Catholic Women's Association

Morgan Nichols, Mary: Joseph Longworth Nichols's wife and Maria's daughter-in-law

Newton, Clara Chipman: ceramicist, woodcarver, oil painter, art teacher; Maria's friend and Rookwood Pottery Company employee during the early 1880s

Nichols, George Ward: artist, art dealer, soldier, journalist, novelist, musician, school administrator; Maria's first husband

Nichols, Joseph Longworth (called "Joe"): philanthropist, physician, researcher; Maria's son

Nichols, Maria Longworth: Maria's name during her first marriage to George Ward Nichols (1868–1885)

Nichols, William W.: George Ward Nichols's brother, who disliked Bellamy Storer for marrying his former sister-in-law and wrote to President McKinley asking that Bellamy not be appointed to a government position

Nichols de Chambrun, Margaret (called "Min"): nurse, physical therapist, philanthropist; Maria's daughter

O'Connell, Denis: bishop of Richmond, Virginia, college administrator, leader of Americanist faction of Catholic Church; the Storers' acquaintance

O'Connell, William: social conservative cardinal of Boston, and Storers' spiritual adviser and correspondent

O'Gorman, Thomas: bishop of Sioux Falls, South Dakota, leader of Americanist faction of Catholic Church; the Storers' acquaintance

Perkins, James: Maria's cousin, and a preacher and antislavery advocate

Pius X: Catholic pope (1903–1914) who met with the Storers about the ill-fated selection of Archbishop Ireland for cardinal

Rampolla, Mario: Vatican diplomat, Pope Leo XIII's secretary of state

Reuter, Dominic: American Franciscan, who succeeded Bellamy Storer as the administrator of the Vatican Bureau of Information, which attempted to find missing soldiers during World War I

Rives King, Margaret: philanthropist, author, family historian; Maria's aunt

Roelker, Annie: Cincinnati treasurer, and later president of the Cincinnati Woman's Exchange; Maria's Cincinnati friend and correspondent

Roelker Wulsin, Katharine: Cincinnati society friend of the Longworth, Nichols, and Taft families; Maria's lifelong correspondent

Roosevelt, Theodore: Republican president (1901–1909) and close friend (later enemy) of Bellamy and Maria Storer; fired Bellamy from his ambassadorial position due to Maria's indiscreet negotiations with the Vatican

Root, Elihu: lawyer, secretary of war, and later secretary of state for President Theodore Roosevelt; first-line supervisor of Bellamy Storer who asked for his resignation

Shahan, Thomas: rector of Catholic University; Maria's acquaintance who refused to support her World War I peace initiative

Stoddard, Charles: college professor, author, friend, and correspondent of the Storers; Maria gave him an annual stipend when he was unable to work

Storer, Bellamy: lawyer, politician, diplomat, philanthropist; Maria's second husband

Taft, William Howard: Republican president (1909–1913), chief justice of the Supreme Court (1921–1930); lifelong friend of the Storers who consulted with Maria about Philippines negotiations with the Vatican

Taylor, W[illiam]. W[atts].: cotton broker, manager, later director and then owner of the Rookwood Pottery Company; Maria's lifelong friend

Thomas, Theodore: violinist, orchestra conductor who created the Cincinnati May Festival with George and Maria Longworth Nichols (Storer)

Trudeau, Edward: founder of the Adirondack Cottage Sanatorium at Saranac Lake, New York; hired Joseph Longworth Nichols as a tuberculosis researcher

Tyrrell, George: Catholic theologian, writer, and Maria's acquaintance, who discussed Catholic Church politics in terms of his excommunication

Walker Longworth, Susan: Cincinnati society matron and Maria's sister-in-law

Ward, Wilfrid: English Catholic essayist, biographer, editor of the *Dublin Review*, which published Maria's poetry, an essay, as well as two articles of Pierre de Chambrun, her son-in-law

Welch, William: dean of the Johns Hopkins School of Medicine; Joseph Longworth Nichols's mentor

Wood, Charles, Viscount Halifax (Lord Halifax): lay leader of the English Church Union; Maria's host and correspondent on Anglican–Catholic Church reunification

Wood, Leonard: army general officer, army chief of staff, military governor of Cuba; Maria corresponded with him briefly after the Spanish-American War

Wulsin, Lucien: businessman, lawyer for Longworth family estate; Maria's lifelong friend, confidant, and correspondent

MARIA LONGWORTH STORER

DECEMBER 1905—EGYPT

"**D**ON'T ANSWER NOW; he is out of his head! He could not write to you like that if he were in his right senses," Ambassador Bellamy Storer advised his beloved "Ia."[1] The tall, good-looking man worried about his wife's reaction to President Theodore Roosevelt's harsh letter of December 1905.

His advice fell on deaf ears. The short, determined gray-haired woman was highly insulted by what the president had written. He complained about her inflammatory behavior, her meddling in American-Vatican affairs, and her offer to act as an official representative of the U.S. government to the papacy. Roosevelt ordered her to stop interfering in affairs of state. He directed her to write him promising that she would change her behavior. Failure to do so would cause her husband's recall from his post as ambassador to Austria-Hungary.[2]

The Storers had thought for months that their rapport with the president, an old friend and political ally, had improved. He had chided them several times before, after their visits to the Vatican had caused disturbances in American newspapers. However, each time, after the vigorous man calmed down, their friendship continued, nearly as before.

Regardless, the diplomatic couple had mixed feelings about Bellamy's post as ambassador to Austria-Hungary. They liked Vienna's intellectual atmosphere, museums, musical events, and plays. They even somewhat enjoyed the exacting rules of the stuffy court. Yet, Maria wrote William Howard Taft on December 28, 1905, they were "tired of ten years...in exile."[3] They disliked the frivolous nature of diplomatic life with its expensive social events, which were not reimbursed by the government. For example, they were strongly encouraged to hold a public Thanksgiving reception for American expatriates at their own expense.

The criticism from Washington about their interference in religious politics and the president's lack of warmth, especially toward Bellamy, caused them to believe that his career in the diplomatic service would not advance. So, the independence and freedom of private life tempted them both.[4]

Neither Bellamy nor his wife responded to the president's first letters, nor later to his second note, dated February 26, 1906. Roosevelt summarily recalled the diplomat on March 6, 1906, when the Storers were vacationing in Egypt.[5] The president, in hopes of handling the matter quietly, failed to follow the normal procedure of sending a letter of recall to the Austria-Hungary government. But if he hoped to play down the decision, the opposite occurred. In the history of American diplomacy up to this time, no diplomat had ever been removed in so precipitous a manner.[6] Newspaper reporters noticed the unusual nature of the dismissal, and speculated on the reason.

Why was Bellamy removed from office while on vacation? Was there a problem between the governments? The situation that Roosevelt desired to deal with discreetly blew up into a complex and convoluted international incident that involved several popes, secretaries of state, presidents, cardinals, and envoys. Diplomatic censure and ecclesiastical intrigue of all sorts ensued. It may be difficult for us today to understand how humiliating the sudden recall was for

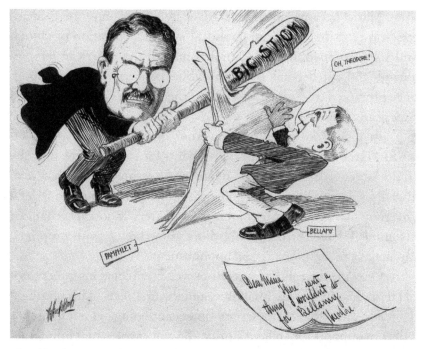

Fig. Prologue 1 Cartoon showing President Roosevelt clobbering Bellamy Storer with his big stick. *Courtesy of Sagamore Hill National Historic Site, National Park Service, Oyster Bay, NY.*

the Storers, when a cabinet official can be fired via social media, but at the time, it was a scandal.

The central reason for Roosevelt's displeasure was Maria's determined maneuvering on behalf of Archbishop John Ireland of St. Paul, Minnesota, the foremost leader of the progressive part of the American Roman Catholic Church, to be appointed a cardinal. Both the Storers and their close friend, President Roosevelt, highly admired and valued the archbishop. This brilliant, ambitious, eloquent priest fashioned himself as a reformer, and met Roosevelt when both were lecturing about the evils of alcohol.[7] Maria and Bellamy were introduced to him after the archbishop gave a spellbinding sermon from the pulpit. The couple was impressed with his optimistic vision for the American Catholic Church.[8]

Maria became an ardent advocate of his innovative ideas, which prized the American "political system, separation of church and state, compatibility of Catholicism with the American temperament, and intellectual freedom."[9] She believed the archbishop, once promoted to cardinal, could lead the Church's assimilation into American culture.

In 1899 Roosevelt, then governor of New York, wrote a letter to Maria saying he supported Ireland for cardinal and that she could "show it [his letter] to anyone you see fit."[10] Later that year, after President William McKinley cautioned him about the federal government's position on church-state matters, Roosevelt changed his mind. He then wrote her, "I don't know how I, with propriety, can make a request for such an appointment."[11]

Over the next six years, as Roosevelt completed his gubernatorial term, his vice presidential time, and the first years of his presidential tenure, he wrote Maria several times cautioning her not to use his letters of support for Ireland's promotion or involve him in internal affairs of her Church in any way. Yet, face-to-face, Roosevelt still told her that he wanted Ireland to achieve a higher position within the Church hierarchy. In 1903–1904 Roosevelt asked Bellamy to speak to the pope about Ireland's advancement and yet, at the same Roosevelt emphatically denied that he ever asked anyone *officially* to influence the pope. Maria later called the president "a liar and coward" for not admitting his involvement.[12] She was deeply offended by Roosevelt's giving in to political pressure and abandoning what she felt were his obligations to friendship.

Who was this woman? Maria was a Cincinnatian first and foremost. The Queen City was home to her family and the source of the Longworth wealth. She was a philanthropist who supported the establishment of a music festival, a music school, the first pediatric hospital, and the first kindergarten in her hometown. She also was

a talented artist who painted in oils, worked in clay to form decorative pottery, and tapped beautiful pictures on thin pieces of copper. She was an accomplished pianist who played solos and accompanied other musicians at concerts. She established a successful international business, the Rookwood Pottery Company, in an era when women were expected to be domestically focused rather than entrepreneurial. She helped put Cincinnati on the map as a center of art.

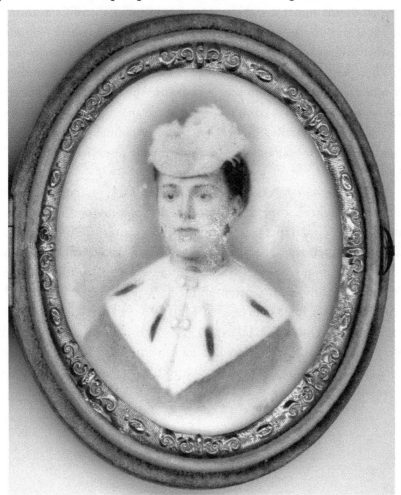

Fig. Prologue 2 Portrait of Maria Longworth by an unknown artist. *Mary R. Schiff Library and Archives. Cincinnati Art Museum, Cincinnati, Ohio.*

Supporting her second husband Bellamy's political and diplomatic careers, Maria put aside her business and most of her philanthropic activities. On the national stage, she became a social hostess of some repute with close friendships with Presidents McKinley, Roosevelt, and Taft. On the international stage, she influenced American diplomatic policy after the Spanish-American War.

Most biographical accounts only speak about Maria the artist. This study demonstrates she was so much more: a prolific author, a political pundit, an energetic philanthropist, a cherished wife and mother. She inspired and persuaded with the power of her money and her pen. Maria did not involve herself with suffrage movement or other feminist reform initiatives because she believed that she did not need the vote to accomplish what she wanted. At the age of seventy, she explained that "we women have…an influence and a sphere of action in the moral and spiritual world which is most important."[13] And so she did.

The sources for this volume consist of primary as well as secondary sources, especially personal correspondence, contemporary books, newspapers, magazine articles, and autobiographical accounts. Interviews with Maria's grandson and great-grandsons provide personal context.[14] Because other excellent aesthetic histories have already been written about her artistic work,[15] this study provides only a brief overview of Maria's world-famous decorative art business. Our book takes a closer look at Maria Longworth Storer's very full life beyond her role in founding one of the premier art potteries of the United States. She herself would approve redressing the balance.

WEALTHIEST UNMARRIED LADY IN THE COUNTRY

THE STORY OF Maria Longworth Nichols Storer does not begin when she was born, on March 20, 1849, but almost fifty years earlier with the arrival of her grandfather, Nicholas Longworth, in Cincinnati. The basis of her position in society was his acquisition of property and wealth. His rags-to-riches story demonstrated to his descendants how hard work and business expertise could create financial success.

In 1803 Nicholas Longworth came to a small frontier village named Cincinnati, on the Ohio River, with few possessions. "His material wealth consisted of the contents of a battered leather trunk and a small green lawyer's bag, and a few coins."[1] The short young man with a long nose and brown eyes dusted off his rumpled clothes and peered at the few log cabins by the river. He always looked intently at people when he talked.

Nicholas sought training with the famous jurist Judge Jacob Burnet, who was "one of the leading attorneys in Cincinnati." Both he and the jurist had lived in Newark, New Jersey, and he may have been drawn to Cincinnati because of the older man's reputation. In 1804 Nicholas was admitted to the bar and began representing clients.[2]

Nicholas was a shrewd lawyer who won many cases. His contemporary biographies laud how he "brandishes logic's battle axe full in the face of law and facts."[3] Payment for Nicholas's first case was thirty-three acres of what was termed useless land. He happily accepted the property because he correctly theorized it would increase in value. This property, which is no longer owned by the family, is in the heart of downtown Cincinnati, and is worth billions today.[4]

Nicholas continued this practice of land speculation and became the largest landowner in the city. In 1816 he bragged, "I have thus far in life been endeavoring to make a fortune. I have exceeded my utmost wishes."[5] It is believed he was one of the wealthiest men in the United States at that time.[6]

As much as Nicholas enjoyed being a real estate mogul, he was also an enthusiastic horticulturalist, who wanted to make wine. In 1823 he tried unsuccessfully to work with various European vines. Then, he planted a cutting of an American grape called the Catawba. He enthused, "I give the Catawba the preference over all other grapes." Yet "it took years of unmerited care...widespread investigations, and the expenditure of large sums of money" to prove the efficacy of this wine. In 1845 he discovered the formula for Catawba champagne, more by "accident rather than design." The sparkling drink would become his most popular wine.[7]

Nicholas advertised his products in popular magazines, promoting Cincinnati and his vineyards as vacation destinations. The vintner had two places where tourists sampled his wine, one in the city and the other in the country overlooking the river.[8] In trade journals such as the *Cultivator* and the *Western Horticulture Review*, the expert wine producer wrote letters and answered questions posed by other growers and novice horticulturalists.[9] His correspondence helped to market his wine products and create product recognition. Largely due to his influence, Cincinnati became the "[biggest] and most productive wine region in the nation for three decades around the Civil War."[10]

Due to his wealth, Nicholas became a member of the elite or patrician class, and therefore, according to ideas about public service and good citizenship at that time, was expected to assist the less fortunate. Nicholas opened up a vacant house that he owned to create a makeshift hospital for desperately ill travelers who needed medical help. He fed the poor and indigent by giving them free bread. Without moral judgment, he helped an alcoholic who was chided for his illness, and a group of Mormons who were vilified for the practice of polygamy. He also built a four-story building above his wine cellar where laborers could stay even if they could not pay rent.[11]

Nicholas's most well-known and greatest cultural impact, though, was in the arts. In *Cincinnati in 1841: Its Early Annals and Future Prospects*, Nicholas's patronage was detailed as "six sculptors, a cameo-cutter, five miniature artists, and twenty-one portrait and landscape painters."[12] He bought their paintings, funded their travel and study, and introduced them to other influential patrons. Nicholas also helped a woman author publish her poetry and a novice editor create a newspaper. Many of these artists and journalists became his friends for life and were eternally grateful for his assistance.[13]

On Christmas Eve 1807, Nicholas married Susan (Howell) Connor. Their only boy was Maria's father, Joseph, who was born in 1813.[14]

Joseph Longworth has often been overlooked by historians. He had neither the dynamism of his father nor the celebrity status of his daughter, Maria. Joseph's son, Nicholas (called Judge Nicholas) the noted jurist and sportsman, and his grandson, Nicholas, who served many years in Congress (called Representative Longworth or Speaker Longworth) also overshadowed him. Yet, Joseph has his place in Cincinnati's pantheon of important citizens for his philanthropy in art, music, and civic projects.

The patrician was a "modest, thoroughly cultured man" who possessed a wonderful memory and "was full of wit and fun...His massive leonine head, perfectly chiseled mouth and hazel-brown

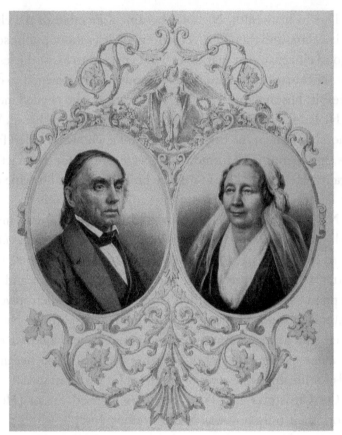

Fig. 1.1 Nicholas and Susan Longworth, 1857. Reproduced from the *Memorial of the Golden Wedding of Nicholas and Susan Longworth Cele-brated at Cincinnati on Christmas Eve, 1857.* Original color lithograph by Hunckel and Son, Baltimore. *Collection of the Public Library of Cincinnati and Hamilton County.*

eyes…matched his sanguine complexion." He was reputed to read voraciously and to be able to recite page after page of poetry from memory.[15] On one occasion, when the poet William Cullen Bryant visited Cincinnati, "a dinner [was given] to which Longworth was invited. Being well known as a reciter of verses, Mr. Longworth was called upon and what did he do but [to] recite 'The Waterfowl,' one of the first poems Mr. Bryant ever wrote." The author was thrilled, and he listened with tears glistening in his eyes.[16]

Joseph's courtship of his wife, Annie Rives, was described in her sister Margaret Rives King's rose-colored memoir entitled *A Memento of Ancestor and Ancestral Homes*. She remembered that they met on a boat going to Cincinnati. The sisters invited "two very agreeable, entertaining gentlemen to join us…My sister and I had our guitars with us, and both played well, and lent our voices in duets to the instrument…So we started, as merry a set as ever left the shore, and drifted lazily through six beautiful autumn days."[17]

Joseph fell in love with Annie during those halcyon fall days. He married her in May 1841, at a solemn service held at Cincinnati's Saint Paul's Episcopal Church. Annie brought love, music, and laughter into Joseph's life.[18] Although there was a difference of ten years, this was not a problem for them. Joseph brought his wife home to live at his father's huge mansion in Cincinnati called Belmont.[19]

Fig. 1.2 Joseph Longworth, c. 1884, oil on canvas, by Thomas Satter-white Noble, 1835–1907. *Cincinnati Art Museum. Gift of Nicholas Long-worth, 1885.1.*

Fig. 1.3 Portrait of Annie Rives Longworth. *Chatfield Photograph Album, SC 108, p. 80 (B-91-072). Cincinnati Museum Center.*

As early as 1847, both knew they desired their own home in the suburbs. They wanted to raise their children, Nicholas (born in 1844), Landon (born in 1846), and Maria (born in 1849) far away from the city's "unhealthy odors from the distilleries, slaughter houses and the tallow chancelleries."[20]

Joseph named his new estate Rookwood after the crows that perched in the trees. Annie selected a promontory on the property for the mansion where the views of the river were fabulous. Joseph poured all his love of beauty into his home and grounds. With tremendous care, he landscaped more than one hundred acres of fields surrounding the home.[21]

Annie simply loved her home. She even wanted to be buried on the property rather than at Spring Grove Cemetery with the other members of the Longworth family. Maria's niece Clara Longworth (later de Chambrun) remembered, "Our grandmother...made a spot under the beech trees where she chose to be buried." Her husband and their son, Landon, were also entombed there.[22]

Joseph and Annie's beautiful home was a destination for friends and artists, including the landscape painter Worthington Whittredge. Annie possessed that "quality...of drawing to her a host of friends...[like] a magnetic pole." Her parties were noted for the sparkling company, games, dancing, and other joyful activities.[23] The English novelist William Makepeace Thackeray described the warmth and friendliness of the family during his visit: "I never saw a spot where even the landscape seems to wear such a cordial smile of welcome."[24] Her daughter, Maria, inherited that skill.

In 1863, with the physical impairment and later death of his father, Joseph took charge of the Longworth properties. He ensured rent was collected and taxes were paid. Joseph actively converted unproductive lands to income-producing properties.[25]

Joseph handled his philanthropic activities differently from his father. He did not meet directly with destitute individuals, as his father had. Rather, he worked through various civic, religious,

and social organizations to help raise the educational and cultural standards of his city.[26] In 1881, Joseph Longworth became "the animating spirit of the [Cincinnati Art] Museum" as a generous benefactor. He served on the initial board of trustees and functioned as the museum association's first president.[27] He endowed the Art School of Cincinnati with a gift of $371,000.[28] Longworth extended his philanthropic efforts by creating a musical legacy. He and other local philanthropists underwrote the Philharmonic Orchestra, the Cincinnati College of Music, the

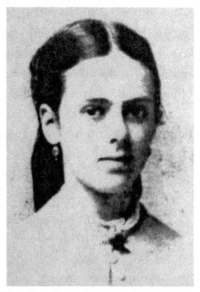

Fig. 1.4 Portrait of Maria Longworth. *Cartes de Visite Collection, S, SC 59. Cincinnati Museum Center.*

Cincinnati May Festival, and the Cincinnati Music Hall. He also helped to fund one of the largest organs in the world.[29] His greatest philanthropic impact, but the one least written about, was the sale or leasing of property to the city. "Joseph practically made a free gift" of 174.77 acres for Eden Park to the city.[30]

Nicholas and Joseph's legacy for Maria was a large fortune, belief in hard work, a love of learning and the arts, and a sense of responsibility for the less fortunate. From her father, Maria absorbed how to form a business, hire experts, and use creative advertisements to promote it. From both parents, she learned the joy and pleasure in sharing her home with friends and family, and to create, and promote, art.

Maria's birth, on March 20, 1849,[31] was a very special event for Joseph and Annie Longworth. She was their only girl and their last child. They reared Maria in an atmosphere of privilege. Private tutors, governesses, and elite schools educated her; a governess, Caroline Godell, instructed her in the French language.[32]

Margaret Rives King, their aunt, provided an elegant description of Maria and her two brothers with their mother:

> "A lovely custom was that of having tea on the lawn, on bright, dry summer evenings. A pretty picture it was, the beautiful mother, arrayed as she always was, in the purest white or heavenly blue, with her bright lovely children around her…The beautiful mother tranquilly interesting herself with her pencil, of which she never tired; drinking in the music of cheery little voices."[33]

Annie was a joyous, artistic woman who probably encouraged Maria to develop her creative side. She may have taught her daughter the rudiments of drawing and other artistic skills. Moreover, Annie's love of music may have influenced her daughter. She accompanied herself and other singers on the harp and guitar. Could these musical interests have influenced Maria to become a highly accomplished pianist who collaborated with choral groups and soloed before hundreds of concert attendees?

Maria was a highly spirited, active adult, so it is likely she was an animated, lively child. In all probability, she dissipated energy by playing games in a "thicket" of bushes on the family's property or indoors by sewing decorative needlework in vivid colors or reading enthralling literature by Scott or Dickens. A little theater built on the estate was possibly used to act out make-believe theatricals, or to model political tableaus or mime complicated charades. There was also "a bowling alley behind the stage" where she could set up pins and bowl to her heart's content.[34]

It is likely that Maria's childhood playmates included her brothers, Longworth relatives, and other children of her class. One such playmate, Jim Perkins from the Owl's Nest estate, was the son

of a very close friend of her mother. Maria remembered playing with him: "Jim was my most intimate friend, fourteen months older than I. He was five and I four when I first remember playing 'prisoner's base' on our front lawn at Rookwood."[35]

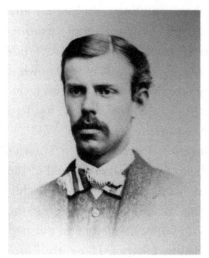

Fig. 1.5 Nicholas Longworth, age twenty-two, from *The Harvard College Class of 1866 Class Album.* Maria's oldest brother, he became a judge and a renowned photographer. *HUD 266.04. Harvard University Archives.*

Fig. 1.6 Landon Longworth, age twenty-one, from *The Harvard College Class of 1867 Class Album.* He became an artist and physician. *HUD 267.04. Harvard University Archives.*

Maria and her brothers, Nicholas and Landon, shared many of the same creative talents. Like their mother, the siblings became expertly talented artists.[36] Like their father, they were voracious, retentive readers. As adults, Nicholas translated Greek classics into English and wrote legal briefs and books of fiction;[37] Landon wrote and lectured at the Cincinnati Medical School;[38] Maria translated German song lyrics and French short stories into English; she also wrote several poems, articles, books, and pamphlets.[39] All were adept with their hands and highly mechanically oriented. Nicholas designed a kayak-like, decked canoe; Landon earned a patent for the

"construction of an electric lantern"; and Maria held a patent for the "chromatic ornamentation of pots."[40]

When Maria was nine she traveled with her family to Europe on a leisurely two-year tour.[41] The expedition provided her father and mother with opportunities to purchase paintings, sculptures, and objects d'art for the family's home. Armed with a letter of introduction from Ralph Waldo Emerson to the poet Thomas Carlyle,[42] they desired to meet famous literary people of the day. It is not known if Maria's parents met Carlyle, but the fact they sought such an introduction to the well-known poet indicated their interests in modern literature, in addition to their desire to tour and buy art.

The Longworths planned educational excursions to libraries and museums for the youngsters; their children were tutored in the history of the places they stayed. One can only imagine how the children responded to the operas in Vienna, the fashions of Paris, and the health spas of Baden-Baden. It is wholly conceivable that they visited Rome and saw the frescoes of the Sistine Chapel. Her early European experiences impressed Maria. Later in life, after returning there many times, her excitement about visiting Spain for the first time in 1899 was apparent. She wrote, "I shall be greatly interested…in the churches, the galleries, the palaces—everything that is artistically beautiful and I am very curious about the people and the language."[43]

Religion was an important part of Maria's life. She remembered, "I was brought up and confirmed in the Episcopal Church, and we belonged to the 'High Church' school."[44] However, when she was eighteen years old, Maria and her family changed their memberships from Saint Paul's "High" Episcopal Church to the Church of the Advent, a "Low Church."[45]

At this time, there was a feud between the High Church and Low Church sects. It was "a fierce struggle for the identity of the Episcopal Church." The High Church "emphasized the authority of the episcopal office and stressed the supernatural elements in Christianity"; whereas the Low Church stressed "the rational approach to

Christianity and gave attention more to morality than to religion."[46] Maria and her family listened to both sides and decided they preferred the less structured atmosphere of the Walnut Hills church. They also may have liked attending a church that was closer to their home.

Searching for religious truth became the central focus of Maria's life. Imaginably, her quest began when she examined her beliefs as to which parish she wanted to be a member.

In the 1860s the Longworth family was saddened by the death of Maria's mother in 1862,[47] and the chaos brought about by the Civil War. While some other Cincinnati businesses expanded operations as a result of the war, the Longworths' labor-intensive wine production suffered from a lack of workers. However, the loss of revenue from the winery did not negatively impact their wealth. They remained the "largest landowners in the city." The real estate holdings would prove a firm financial base for future generations as well.[48]

Women's participation in the war was generally limited to the home front. Some women raised money, cooked, sewed, knitted, farmed, nursed, or spied in support of the military action. They managed their property in the absence of their husbands and sons. One creative housekeeper even put her horse in the basement so as not to be found by Confederate troops.[49] The war expanded many women's ideas of what they could do with their lives.[50]

Yet wealthy young women like Maria were generally sheltered from the impact of the war. They remained cloistered in their mansions, far away from the trouble engulfing regular citizens. Their involvement was limited to ladylike contributions. Her friend, Mildred McLean (later Hazen Dewey) remembered how young girls were asked to join in "making flags for various purposes....All the girls had thimbles and thread and needles, and made ready [to complete the sewing]."[51]

Maria studied at a local, privately funded girls' institution, the Elizabeth Haven Appleton School, which educated "more than four hundred girls...who...[became] the leading women of Cincinnati."[52]

The curriculum for "Miss Appleton's Girls" emphasized literature, with very little or no training in math and science. The coursework included ornamental and domestic skills such as sewing, dancing, watercolor, and oil painting. With the heavy emphasis on creative skills, Maria was encouraged to develop her artistic talents.

While attending the school, Maria met Clara Chipman Newton who became a lifelong friend.[53] Wealthy girls socialized with their friends when not in school. One lady reminisced, "The young girls visited for the afternoon, taking their knitting and staying to tea. There were a few parties, the singing-school, picnics, sleigh-rides, and the sewing society."[54] Daughters from the patrician class were cautioned not to use makeup. Mildred McLean gossiped how a lady "burdened with many care and much poverty...had [h]er cheeks... painted and her eyes and brow blacked....She has now alas[,] all the mannerism of beauty and belle-hood, but none of its traces." McLean felt her saving grace was that "she was evidentially beautiful in [her husband's] eyes."[55]

After the 1866 school term, Maria, at age seventeen, transitioned from the schoolroom to the adult world. She was a striking young woman with a heart-shaped face and large, flashing eyes. She was a talented pianist, a budding artist, and a proficient linguist who had traveled to Europe. Maria had worked diligently, and was considered highly "accomplished."[56]

Maria was frank and outspoken, with a subtle sense of humor that betrayed her cosmopolitan background. She peppered her conversation with French or German phrases to add humor when making a point. She loved to flirt and joke with others.[57] When a newspaper announced that she was "the wealthiest unmarried lady in the country,"[58] it was another reason for potential suitors to want to court her. Maria had several beaus. Bellamy Storer and William Watts Taylor were two who showed interest.[59]

During a time when the upper class had a heightened concern for propriety, Maria held distinctive and unconventional views.

To demonstrate this point, she joked about the rigid rules that required rich eligible women to be properly chaperoned at all times. She wrote to an unmarried friend, "You will only be unprotected from Boston to Woods Hall a period of two hours and fifteen minutes[!]" She then joked that the young lady could "throw yourself on the protection of the conductor [if there is] a transgression of the rules of hospitality[!]"[60]

Maria poked fun at the rigid rules of deportment. The whole idea of these rules was to introduce the debutante to a "proper" young gentleman who would be a suitable spouse. She, however, flouted convention and decided to marry outside her class.

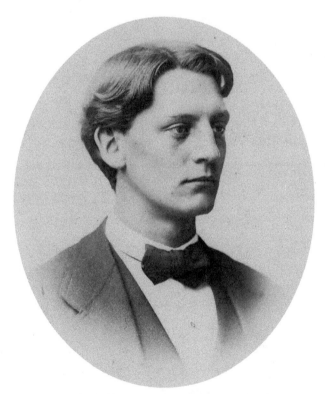

Fig. 1.7 Bellamy Storer, age twenty, was Landon's college classmate. *HUP Storer, Bellamy (1B) Harvard University Archives.*

SEASON OF HOPE, OF DESIRE, OF PROMISE

[A] young girl...looks up into his face with undisguised delight. That look means nothing else than love, and he answers it with a smile....Never had she appeared more beautiful to her lover than now....Her dark hair relieved against the pure skin, blooming with the freshness of the morning....It was a tremulous, broken cry of ecstatic joy which came from her lips....[S]he ran to his open arms and nestled in his heart.[1]

—*The Sanctuary,* 1865

GEORGE WARD NICHOLS wrote this romantic passage reflecting his beliefs about the ideal woman. It sounded as if he were describing Maria, although they probably had not met. So, who was the man who captured her heart?

George was born on June 21, 1831, at Mount Desert Island, Maine. He was the sixth of eight children of John Nichols and Esther Todd Nichols. Most of his celebratory biographies boasted that his father, and both grandfathers, "belong[ed] to...[a] daring race of sea captains from Maine...[who] lived in perpetual contest with the seas."[2] His family moved from Maine to Boston, where he grew up. It is not known where he attended school. Yet as a young

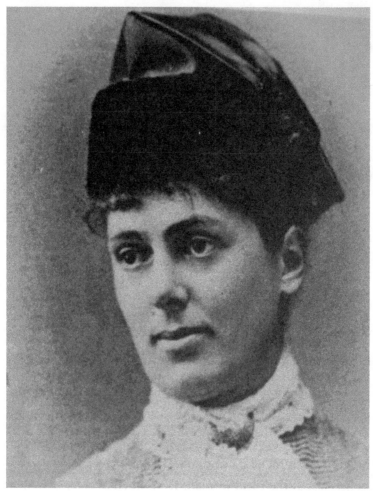

Fig. 2.1 Maria Longworth Nichols, c. 1868–1885. *Cincinnati Art Galleries.*

man, he spoke both German and French, wrote with an engaging, colorful style, played piano expertly, and painted near-photo-quality landscapes.[3] In his twenties, he was a man of average height with brown hair and a mustache. His distinctive face had a broad mouth with a straight nose.

Before marrying into the wealthy Longworth family, Nichols had a difficult life, often moving around and trying his hand at

different jobs. The first professional reference to him appeared in the 1853 Boston *Directory* where he was referred to as an engraver.[4] Engravings were extremely popular as illustrations in magazines and as affordable decorations in many middle-class homes. While doing this work, Nichols became familiar with the business side of art as a commodity to be bought and sold.

In 1855 Nichols traveled to the Kansas Territory in support of the free-state (antislavery) movement. He remained there less than a year because he could not find a job and chose not to farm or ranch.[5] From

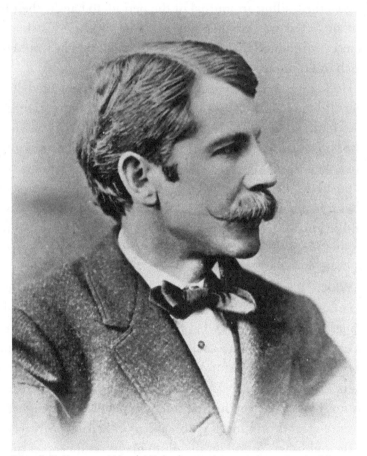

Fig. 2.2 George Ward Nichols. *Archives & Rare Books Library, University of Cincinnati.*

there he moved to New York City to be a part of the hustle and bustle of the busiest art center in the United States.[6] In 1859 Nichols opened a commercial art gallery, T. W. Parker and Co., on Broadway.[7]

Nichols became a shrewd, resourceful gallery owner who kept his business in the news by exhibiting artists' paintings and selling their lithographs. When hired as an art critic for the *New York Evening Post*, he secretly advertised his shop in anonymous articles positively reviewing his latest exhibitions. He changed the name of his gallery to the Crayon Art Gallery because he "had made arrangements with *The Crayon*, the leading art journal of the period, to handle their business affairs." This was another smart way to advertise his shop. He was successful enough that, in 1861, rumor had it that he would open a branch in London.[8]

He was in the English capital when rebel artillery fired on Fort Sumter and the bloodiest war in American history burst forth. Soon after he returned home, George volunteered for military service. In the short succession of three years, he served in three staff jobs in Virginia, New York, Wisconsin, Georgia, and South Carolina. In all these positions, he demonstrated an ability to handle innumerable tasks with ingenuity. He successfully completed missions as diverse as handling mail, recruiting soldiers, procuring Thanksgiving dinner, processing forms, and carrying important dispatches from one command to the next.[9]

When he participated in Major General William Tecumseh Sherman's March to the Sea from Atlanta to Savannah, Nichols kept a detailed log of each day's happenings. His personal reflections about the daily events were shaped into a compelling war memoir, *The Story of the Great March*. After he sent the manuscript to Harper and Brothers, they immediately decided to publish his book. It became an instant best seller. The first edition was delivered in August and the twenty-second printing less the five months later in November 1865. The publisher "found it difficult to manufacture copies quickly enough to meet the demand."[10] Why was it so successful?

The timing was perfect: the war was recently won and the country was looking for heroes. Many northerners lionized General Sherman after reading the flattering history. The memoir also influenced other writers. For example, the publication served as a resource for Herman Melville's *Battle-Pieces and Aspects of War* (1866).[11] Yet it was also controversial. *The North American Review,* asserted sarcastically that it really was Nichols's march to the sea, "for little space is devoted to Sherman."[12] The book continues to arouse visceral responses today when Sherman's campaign is discussed.[13]

The popularity of his writing changed George's life. He became a celebrity. After resigning his commission in the army in late 1865 he immediately went on the lecture circuit throughout the northern states giving speech after patriotic speech to enthusiastic audiences.[14]

About this time George was introduced to Maria. How did they meet? Different versions of their meeting have been suggested. One newspaper proposed they met at Cape May, New Jersey, when they were vacationing at the same resort.[15] Another intimated that General Sherman introduced the best-selling author to the young heiress.[16] Yet oral tradition has passed down that Maria's father hired George to catalogue his art treasures, and they met while George worked at Rookwood estate. No one really knows the circumstances of their meeting, but they met and became enamored with each other.

Eighteen-year-old Maria did not care that George was twice her age and not from the same social class. She was simply attracted to this talented, articulate, handsome veteran. George, in turn, was immensely drawn to this prominent and artistically inclined young woman. She was exceptionally well-read, cultured, and highly intelligent.

When they married on May 26, 1868, the Longworths kept it a simple affair. There was only a brief statement in the newspaper that Maria and George's wedding was presided over by the Rev. Frances Lobdell at the Church of the Advent.[17]

It was curious that the wedding was not a big event on the social calendar in Cincinnati. Later, a newspaper would speculate

Fig. 2.3 Maria Longworth and George Ward Nichols's wedding certificate. *Marquis and Marquise Jean François and Nicole de Chambrun Collection.*

that the family disapproved of the marriage. George was neither "young enough nor practical enough for her."[18] However, his father-in-law built a palace for the young couple on his estate, so the older gentleman must have somewhat approved.

As Maria and George settled into married life, their home was completed on the west side of Rookwood. The two-story stately manor was "an enchanted palace" "constructed of blue limestone, with free stone trimmings." On the first floor there was an entrance hall followed by a reception hall that contained a floor-to-ceiling "brick and stone fireplace....Jeweled lamps and quaint incense burners from old temples [hung] from the ceiling with many colored lights."[19] Additionally on the first level were the grand music and dining rooms. Woodcarver Henry Fry and his assistants worked on site for several years fashioning the black walnut woodwork. As described by George, "Under the touch of his chisel gr[e]w drooping ferns, pend[a]nt wreath[s] of leaves and flowers,...climbing vines of j[as]-mine and ivy, feathery grasses, graceful and elaborate arabesques."[20]

Charles Wyllys Elliott illuminated this one-of-a-kind home in 1876, by including an engraving of the Nicholses' dining room in *The*

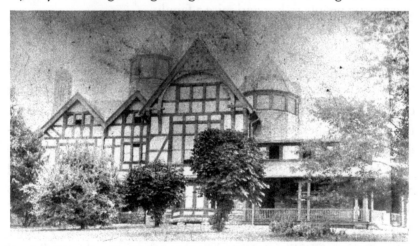

Fig. 2.4 Storer House, Walnut Hills, also known as the Nichols Mansion, was Joseph Longworth's gift to Maria Longworth. *Chatfield Photograph Album, SC 108, p. 101 (B-91-059). Cincinnati Museum Center.*

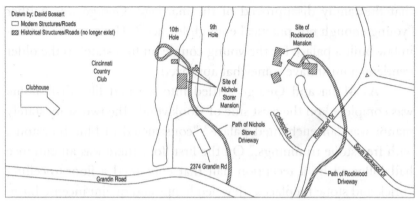

Fig. 2.5 Map of the Nichols Storer and Rookwood mansions. Outlines of the Nichols Storer mansion (left) is highlighted on the current Cincinnati Country Club Golf Course and the Rookwood mansion (right) is superimposed on an existing housing area. *Courtesy of David Bossart.*

Book of American Interiors. The etching was one of twenty-two outstanding rooms in wealthy Americans' homes presented in this book. The Nicholses' home held the distinction of being the only one selected from this part of the country.[21] It seemed to be a wonderful place for two artistic people to live and raise a family.

Maria was the manager of the palatial home. Training servants was a continuous challenge as the years went on. Although she never cleaned the drawing room grate or polished furniture, she directed housemaids to perform these duties properly. She was an excellent cook herself,[22] but that was not her role. Instead, she created menus for the chef, who purchased the food and prepared the dishes for the family's meals. Maria took pride in having delicious food for her guests.[23]

Her correspondence suggests that Maria maintained fun-filled relationships with a group of friends and family. She "belonged to the small set where...[the lady] shone as a 'bright particular star.'" The group included Bellamy Storer, Daniel Holmes, James Perkins, Julius Dexter, "'William [Watts] Taylor,...Lawrence Maxwell, and 'Will' Taft." She socialized with Annie Roelker, and her sister-in-law,

Susan Walker Longworth. With these people, she visited the city, made day excursions, or attended lectures.[24]

Maria also participated in public life and gave money to Manning Force's political campaigns and advised her friend, "It may not be worth much (my opinion) as coming from one who is not even a voter....The best policy is the course that you pursue simply because it is right. Please excuse this outburst of a somewhat incoherent eloquence."[25] There is a certain playfulness in these letters that sets them apart from others of the era. Maria was not a sheltered, housebound, and house-defined woman, as her mother and most middle-class and upper-class women were. Her memos were filled with little jokes and sketches or political cartoons. One sketch, believed drawn around election time, made fun of the "Solid South and the Northern Democracy." She supported the renegade Liberal Republicans' belief that the South should become an active force in politics. Maria had an opinion and she always expressed it.[26]

As much as Maria loved to visit Europe in her second marriage, it is surprising that she and her first husband never traveled across the Atlantic. In March 1870, they journeyed with her father, brother, and three Anderson cousins down the Mississippi to New Orleans, and went by train to Florida where they stayed six weeks.[27] It must have been very beautiful and highly romantic, since she probably became pregnant with her son, Joseph Longworth Nichols, during this time.

Based on George's experiences on the steamboat and "wintering" in Florida, he wrote two articles for *Harper's New Monthly Magazine*, entitled "Down the Mississippi," and "Six Weeks in Florida." His gift for description was apparent as he presented in detail the state-of-the-art steamboat, saying that it bore "us safely over the turbid waters of the great river....The two big smoke stacks [were] nostrils of this monstrous moving, living thing, that sen[t] forth vast clouds of smoke, which...spread forth and cover the heavens." In Florida, his words were as lyrical:

"In a row boat we wandered along the shore, past forests whose somber depths were veiled to us by vast screens of drooping moss, or, pushing our little craft over and through the wide spread beds of water lilies, we entered within the precincts of this solemn Hades."[28]

At the end of the year, George and Maria were happy and proud with the birth of their son, Joseph, or "Joe." Their daughter Margaret or "Min" was born nearly two years later.[29]

Maria, more so than George, was responsible for the education of their children. She hired several tutors and governesses for them. French language skills were considered essential for the upper class. A tutor was hired to teach this language to the young children so they spoke the language as naturally as English. Both were taught at home until they were old enough to attend private schools. As a teenager Joe was educated at White and Sykes, a private school in Walnut Hills. A few years later, Min attended Blanche Mathieu's school for girls in Eden Park.[30]

In the early 1870s, "Rare evenings... [were] ... [in the Nicholses'] well-proportioned music room." Maria designed beautiful place cards, mailed engraved invitations, and created musical programs for their guests.[31] German chamber music dominated the nights. Several talented amateurs and professional musicians performed with their hosts at these private concerts. The amateur performers practiced and prepared to meet the standards set by the professionals. Both Nicholses

Fig. 2.6 Watercolor illustrated program by Maria. *Margaret Rives King Scrapbook. Cincinnati Museum Center History Library and Archives.*

performed. Neither were mere dilettantes. Maria was quite gifted on the keyboard. She often accompanied singers and stringed instrumentalists. George played piano expertly and had a good singing voice.[32] Maria and George set the tone for elite society by the display of wealth, artistry, and culture.

George loved to sing in public and joined a local choral group called the Harmonic Society, which gave several concerts each year in the city. Among its members were other prominent men who were colleagues of the same civic and social groups as George. For example, lawyers Julius Dexter and Bellamy Storer sang with the group. In January 1872, George was elected president of the organization. Under his leadership the Harmonic Society expanded, and was no longer in debt.[33]

George and Maria regularly attended concerts, operas, and religious services that "made for a rich musical environment."[34] Both were impressed with Theodore Thomas, who brought his traveling orchestra to Cincinnati in 1869. The conductor and ensemble played classical music in twenty-one cities at more than two hundred concerts each year.[35]

The Nichols invited the orchestra leader to their home to discuss establishing a local choral concert series.[36] Maria

Fig. 2.7 Program of a masquerade held at the Nicholses' home, illustrated by Maria. *Margaret Rives King Scrapbook. Cincinnati Museum Center History Library and Archives.*

remembered, "When I was twenty-one, I proposed the foundation of our Cincinnati [May] Festivals to Theodore Thomas who organized and led the musical performances for so many years."[37] The festival she proposed was a series of formal music presentations, held over a period of days using a large-scale orchestra and choral concerts.[38]

The orchestra leader was very much taken by the elegant, petite, dark-eyed beauty. He remembered that "a young married lady...laid before me a plan for a large Musical Festival. She proposed that I should be the conductor of it, saying that if I would be responsible for the artistic side, she would find the men who would take charge of the business details." He stated further, "I soon found out that this lady was not only very talented herself in many ways, but that her taste was not amateurish in anything, and I readily consented to undertake the work she wished me to do."[39]

In truth, Thomas agreed to the proposition only if a guarantee of $50,000 was raised.[40] Maria turned to her husband and his civic-minded friends to bankroll the festival. George assumed the role of president of the group that took care of the financial and administrative part of the festival. They met at Bellamy Storer's law office, in September 1872, with the projected performance dates to be the first week of May the following year. By October 29, they wrote Thomas informing him the guarantee fund contained the amount requested.[41]

George was heavily involved in the details. He created a group of standing committees and organized tasks for each. Through these committees, he supervised a group of dedicated volunteers who worked many hours to make the event a success. Since he was president of the Harmonic Society, he leveraged the members' participation in the event. Other choral groups were convinced to join too. He hired rehearsal staff, negotiated contracts with the soloists, and dealt with other issues.[42] Maria was also actively involved. She designed and "sketched some of the programs" with Thomas.[43]

Before the event occurred, Thomas complained about Nichols. He chided George for not communicating properly with an intended

soloist. Thomas stated, "You seem to be under the impression that you have done well so far for the Musical Festival, I think otherwise."[44]

Yet, once the event began, it was a flawless series of performances. Concert attendees experienced a brilliant program of choral, operatic, and symphonic classical music. Patrons who were thirsty imbibed beer on the floor below the orchestra. They became so noisy that Thomas ordered the establishment closed while the music played. The guest soloists received ovation after ovation for their performances. Theodore Thomas and George Ward Nichols were also lionized for their efforts. Many complements were extended to the city by visitors. The performance gave "the cause of music and our city due credit and honor," a proud journalist chortled.[45]

Bellamy Storer remembered how the executive group strained to meet the overwhelming response of the public. "The committee... was scarcely prepared to handle the crowds. ...[They] swarmed to the doors in such numbers that the ticket sellers were unable to handle them. The Executive Committee then shouted for people to come right up to the doors with their money and pay the entrance fee."[46]

In 1875 the second May choral program was heralded as triumphantly as the first festival. The *Cincinnati Enquirer* bragged, "Cincinnati deserves more than a passing mention...of the spread of musical culture throughout the land."[47] Maria, too, was involved in this festival. She wrote her friend Mrs. Manning Force that "my time [has] be[en] occupied with the Festival Chorus," probably helping by entertaining the musicians at her home and assisting out-of-town guests with their tickets.[48]

The Longworth family loved these events. Maria's niece, Clara Longworth de Chambrun, remembered,

> "What marvelous occasions these were! The influx of out-of-town guests, the return of many a native to share once more the old delight, social amusement, civic, and patriotic satisfaction, the crescendo of enthusiasm from concert to concert throughout the whole week, combined to create an atmosphere unique in America."[49]

Maria also kept busy in other ways. She became enamored with china painting, which was "a mania with ladies of Cincinnati."[50] She and a friend, Mrs. L. B. Harrison,[51] were introduced to and became fascinated with the process. Karl Langenbeck, a neighbor, had received bottles "of china-painting colors" that he shared with them in 1873.[52]

Maria was intrigued by this art. The complex integration of shapes, textures, colors, and patterns required great precision and vision to produce something of beauty. She lost herself in the process, dealing with the beautiful colors and challenging herself to make each piece unique. A friend recalled, "She always painted with an absolute absorption, that made her oblivious to her surroundings. This power of concentration added to her love of the art [and] explains the rapidity with which her work was accomplished."[53]

Word spread about the art form among the well-to-do ladies who were artistically inclined, including Clara Chipman Newton, M. Lousie McLaughlin, and Jane (Porter Hart) Dodd.[54] They attended a china painting class under the auspices of Ben Pittman of the Practical Art Department of the Charles McMicken School of Design. They received only minimal exposure to principles and components of china decorating. Mostly, they experimented and taught themselves.[55]

Maria fared a little better. She worked with Gustav Hartwig, who advertised himself as the "only practical operating china painter and decorator in the city."[56] She fired her creations in his little commercial oven at his store on Sixth Street. She remembered, "This kind of kiln is heated only to the point of vitrifying the overglaze colors without melting the hard glaze of the ware upon which they painted."[57]

In anticipation of the national centenary in 1876, Maria joined a group of women who formed the Women's Centennial Executive Committee of Cincinnati in October 1874. The purpose was to create a women's exhibit for the Philadelphia Centennial, which was the first world's fair held in the United States.[58] They believed it was

especially important to provide an attractive and highly artistic display to demonstrate the sophisticated artistic talent in Cincinnati.[59]

The group raised funds for the women's exhibit by hosting two tea parties where they sold food and pottery.[60] "Because they sold so well at [the first event], the fledgling china painters decided to paint teacups sporting patriotic decorations for auction at the [second party.]"[61] M. Louise McLaughlin's sale of cups and saucers earned the largest sum and nearly doubled that of Maria Longworth Nichols, whose sales were the second biggest. As a result, the Cincinnati Committee contributed $5,000 toward the construction of the Woman's Pavilion.[62]

The president of the Women's Centennial Executive Committee of the Women's Pavilion, Mrs. Elizabeth Duane Gillespie, visited the city and complimented the work, stating, "I found many beautiful specimens done by the ladies."[63] The petite dynamo became fast friends with Maria, both sharing a love of art and music.

"The Cincinnati Exhibit at the Centennial attracted much attention as its features of wood carving and china painting were novel and in advance of the women's work shown by other cities." The students in the Cincinnati University, School of Design created new tableware specifically for the exposition. The ladies "painted porcelain trays, cups, saucers and plates, sculpture, and carved wood."[64]

With her husband, Maria toured the exposition's various exhibits. It took more than a week to examine everything carefully. She was particularly excited about the Japanese display that "had the largest and the finest [pottery] exhibit in the collection. Their art and their manufactures retain a certain piquant individuality."[65] She saw "bronzes inlaid with gold and silver...which were so elaborate... [that she must have] fancied skill and patience could go no further."[66] The imaginative decorations, their use of color, and their distinctive design appealed to Maria. From this experience Maria dreamed of owning a pottery where she would employ artisans from Japan.

Because of Maria's growing interest in decorative arts, she and George worked together on a large reference book called *Pottery: How It Is Made, Its Shapes and Decoration*. He researched and wrote the volume. Inspired by Japanese art from the Centennial exhibition, she provided etchings for the publication. Her unusual drawings were bizarre, yet delightful and charming illustrations that made one smile.[67] "The book gave her a sense of how pottery was made."[68] She was mesmerized about the process.

The 1878 Cincinnati May Festival was the high point of both Nicholses' involvement with the concert series. George and his committees were responsible for the flawless execution of the musical events.[69] Thomas's musical direction was an inspiration.

The performances were the first events staged in the new Cincinnati Music Hall, which was the "largest and most commodious public hall in the country...[that seated] 5,000" people, with enough room for a large orchestra and a large chorus.[70] It could be converted to a large display room, when the chairs were removed for conventions, art exhibits, and public meetings.[71] The excellent acoustics were due to the "light golden" wood paneling that gave the larg-

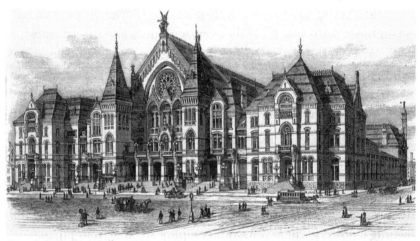

Fig. 2.8 Music Hall, 1878. *Collection of the Public Library of Cincinnati and Hamilton County.*

est stage in the United States an almost golden glow.[72] The great hall also contained a Hook and Hastings organ, which was "sixty feet high, had 6,287 pipes, and cost $32,000." It was one of the largest organs in the United States, and took an entire year to build. It was George's idea to purchase the instrument, and he helped to fund it.[73] He wrote and collaborated with Maria on a pamphlet detailing how the musical instrument was built and decorated, entitled *The Cincinnati Organ*. Maria is believed to have illustrated the booklet with whimsical drawings.[74]

The next musical milestone was the creation of the Cincinnati College of Music.[75] George was named president and Theodore Thomas was hired as the music director. The school incorporated in August 1878 and opened its doors less than two months later. Both the faculty and students were busy with classes and public performances. They gave twelve chamber, orchestra, and organ concerts. Additionally, they filled Music Hall twice weekly with glorious organ music.[76]

The Longworth family thought highly of the school and its music director.[77] Maria's nephew, Nicholas Longworth (later a congressional representative and Speaker of the House) described how he trained under Theodore Thomas. The conductor was "the real pioneer of first-rate music, from whom I bought my first fiddle, and who was my guide."[78]

George Ward Nichols and Theodore Thomas, however, did not have a happy working relationship. Both were born promoters with determination and self-confidence, who were dictatorial and expected their decisions not to be questioned. There were bound to be problems between them. In one letter, George lectured Theodore Thomas to "eat moderately, drink temperately, walk briskly, sleep soundly, come back cheerfully." Thomas must have felt condescended to.[79]

Almost from the beginning, there was newspaper gossip about their conflict.[80] All the excuses and denials from the school during

the first couple of years gave way to the truth in 1880.[81] Thomas was very unhappy. He presented two sets of ultimatums to the board of directors. The major conflicts were differing views over admission criteria and the school's mission. Thomas demanded "exclusive direction of the school in all its departments. Everyone connected with the school must be under [his] control." Such sweeping announcements were not well received. When these demands were not met, he resigned.[82] George also resigned. The board accepted Theodore Thomas's appeal to leave, but turned down George Ward Nichols's request. "In the final analysis the Board stood by one of its own."[83]

One local newspaper complained, "The affair...attracted the attention of the entire country, and in it the good name and pride of...[the] city...were involved."[84] Every newspaper of substance in the country seemed to have weighed in. One suggested that Thomas's "persistence and the pettiness of his annoyances were like the buzzing and sting of a horsefly, you can't remember each particular sting, but all together they cause a painful irritation."[85]

This scandal affected the Cincinnati May Festival's organization too. Within a few days of news of Thomas leaving, the festival chorus staged a demonstration and demanded George's resignation from the Board of Directors. He handed in his notice, and it was accepted.[86] Maria had translated a libretto for a new German opera *Der Thurm zu Babel (The Tower of Babel)* that was not performed, possibly for political reasons.[87]

Friends took sides. George's supporters backed him and the school. Thomas's fans championed the music festival. Maria never talked or wrote about her husband's various trials and tribulations with Thomas. The fact that she remained friends and entertained the conductor after her husband's death suggested she was not very sympathetic to George's position.[88]

One wondered if George might have been angry that she did not support him publicly. He wrote to a close friend, "You will be glad to know I am very hard at work—working all the time, never

resting....It is my great relief my escape from my own thoughts." He added, "My happiness is in my dear children, who are growing all sweet and gentle ways."[89] Maria was not mentioned. His intrusive thoughts could have been about the school or about his marriage.

Maria's high-spirited behavior may have upset him. She loved to flirt with single men from her social set. To a close friend, she wrote, "I went to Annie Norton's wedding—escorted by a friend and wearing the leopard skin [coat] and my gorgeous new hat so you can imagine how fierce I looked....I had a very good time." However, Maria never allowed these flirtations to go beyond socially prescribed behavior, as demonstrated in another part of the Wulsin letter. She wrote that she teased Julius Dexter "unmercifully." He "goes east tonight—and I would have gone too if Sue," her sister-in-law, "could have been

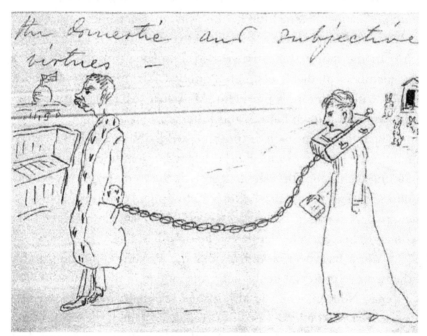

Fig. 2.9 "So intent upon displaying the matrimonial yoke," November 11, 1881. Maria's drawing depicted her brother leading his enslaved wife. *Katharine E. R. Wulsin Correspondence, 1914–1918.* Cincinnati Museum Center.

41

persuaded to accompany us. But she is so intent upon displaying the matrimonial yoke." Maria likened Susan's marriage to enslavement. She drew a cartoon of her brother marching her sister-in-law chained and yoked, much like a master parading a slave.[90]

If Maria felt enslaved or repressed by her marriage, she sought ways to distract her attention. In 1879, she visited a pottery for the first time and decided to rent a room from Frederick Dallas at his Hamilton Road factory. Her goal was to "experiment in pottery." She stated, "I never spent happier days of work,…when I drove many times to the pottery on Hamilton Road with my small yellow Indian pony."[91]

At the factory, away from everything else, she gained a better understanding of steps to make decorative art pottery, and perhaps, the work helped relieve some of the tension in her home life. Maria once said, "Every woman has within her what might be called the mud pie instinct."[92] She built her knowledge of ceramics with a sense of fun, and became an acknowledged expert.

In the fall of the same year Mr. Dallas also rented space to the members of the Cincinnati Pottery Club. Maria developed a rivalry with the group's president, M. Louise McLaughlin. Louise, a brown-eyed, brown-haired, and lithe figure of a woman, who was somewhat of a celebrity in the pottery world. She successfully "experiment[ed]…[and] reproduce[ed] the Haviland 'Limoges' underglaze painting technique" that she had seen at the Centennial. Many decorators learned the method after watching her.[93] Various Cincinnati newspapers heralded Louise's discovery because it was unusual for a woman to become a leader in that field.[94]

Maria had been asked to join the Pottery Club along with other women potters, but she never responded to the request. "Clara Chipman Newton, who was also a good friend of Nichols, informed Louise that Mrs. Nichols had not received the invitation and chose to view it as a personal slight. Another invitation was issued, but Nichols refused in a conscious decision not to mend the rift."[95]

Continuing to define herself, beginning in 1879, Maria displayed several pieces of beautifully hand-painted ceramics at the Cincinnati Industrial Exposition, an exhibition created to showcase products of local businesses.[96] In 1880, the up-and-coming artist sold her wares for "a handsome sum" in jewelry stores, such as Tiffany's in New York City.[97] What's more, Maria continued the public display of her hand-painted ceramics at three receptions of the Women's Art Museum Association, and at the 1880 Cincinnati Industrial Exposition.[98]

The following year, Maria opened her own pottery. She wanted total control of the "entire process," of selecting "the clay mixture, the colors, [and] the glazes." Maria recalled, "When I was twenty-nine [years old] I founded my Rookwood Pottery [Company] named for my father's country place." Her father had offered her an old schoolhouse he had recently purchased and the financial means to renovate it.[99]

The site of her factory was a dirty place where trains and street cars noisily went by. It was "a ramshackle old building in the lower

Fig. 2.10 Rookwood Pottery, 1880–1890. *Courtesy of Nancy Broermann.*

43

part of the city" down by the river.[100] She spent $20,000 for equipment and supplies, buying second-hand machines, potters' wheels, and clay processors. Her first kiln was operational by November 1880.[101]

Maria described herself as "devoid of any practical business sense or executive ability"[102] so it was quite daring to start the business. Lacking entrepreneurial experience, Maria hired key experts throughout her factory. Her uncanny ability to employ the right people helped to make her enterprise a success.

In August 1880, Clara Chipman Newton, her pretty, brown-haired classmate, received a letter from a friend who wrote, "'Have you heard that Ia has started a pottery which she has named Rookwood after her old house? I wonder whether anything will come of it?'" Clara continued, "I too wondered whether anything would come of it, little dreaming that in another year's time…[I would be] helping to make the experiment a success."[103]

Maria hired Clara as her secretary to help with the business correspondence. Clara had training as a potter so she was knowledgeable of the equipment, the chemicals, and the process. Edward Cranch, an attorney and artist, was to be employed as the business manager. However, a reversal occurred: Newton became the manager while Cranch became an artisan.[104] Albert R. Valentien, a landscape painter and illustrator, was the first decorator engaged. "Clay workers, throwers, turners, mold makers, kiln men, and firemen [were also hired.]"[105]

The Rookwood Pottery Company's founding was not without controversy. Thomas Wheatley had patented the underglazing technique that McLaughlin claimed she created.[106] He warned both her and Maria not to use "his" process. Stories filled the newspapers about a conflict among the potters. Maria insisted that he was not the first individual to discover the method. In fact, it was Louise. Wheatley threatened to sue her. Maria laughingly responded, "He might as well get a patent out on wood carving.…I don't care [what] he does, I shall build my pottery."[107] Maria argued that the process had been created many years before, and then rediscovered by

McLaughlin. She would use the same contention in 1893 when the ownership of the process was in question again.[108]

While Maria's world was expanding and she was realizing her artistic goals, George's world was contracting as he dealt with the aftermath of the Thomas's resignation and fought a life-threatening illness. About this time, George was diagnosed with tuberculosis. Although physicians encouraged him to slow down and rest when he had a fever or felt tired, the determined college president looked upon the chronic condition as an obstacle for him to overcome. George added a new department at the school to train students for the opera. He approached conductor Max Maretzek with an offer of a position. "The veteran musician accept[ed;]...the new chair is designed...for educating aspirants in operatic art."[109]

Nichols organized yet another successful music festival. In February 1881, the first opera festival was well received. The *Cincinnati Enquirer* hailed the musical extravaganza with an over-the-top comment, somehow reporting it was "the grandest social event in the history of the world." To be sure, the performances were a high point of Cincinnati's music season that year with 7,000 in attendance on the opening night. Nichols was highly praised for this accomplishment.[110]

Clara Longworth de Chambrun recalled, "With the famous opera festivals, music came alive." "'Uncle George,' holds the distinguished place in my early memory of having opened the doors 'behind the scenes' during the opera festival and getting us all indiscriminately kissed by the stars of the period." Another person marveled at the "bewildering confusion...of elegant carriages...[the building] illuminated by the newly-invented electric light" for the concert's series.[111]

Despite the success of the opera festival, Nichols and Maretzek did not coexist well as a management team. In less than two years

Maretzek resigned from the school, stating that his problem was the dictatorial leadership of Nichols. Again, newspapers reported the latest scandal involving Nichols. The *Cincinnati Enquirer* said that Maretzek "acted like a child," while the *St. Louis Post-Dispatch* opined that the musician "has been forced to fold up his fiddle and baton and beat a retreat."[112] For the remainder of his life, Nichols worked long hours at the school. As the dominant power, he ran it without other major problems.

Historians have opined that he had a negative effect overall on the musical environment in Cincinnati. One stated, "The hostilities which existed seriously hampered Cincinnati's cultural growth for at least the next twenty years."[113] Another suggested, "The city's music cohesion lay shattered."[114] On the other hand, Cincinnati made a name for itself as a music center, through his assistance. The school prospered despite all the drama and conflicts, and became a fiscally sound, scholarly institution under his management.[115]

For Maria, all the problems at the school and the constant criticism of George in the newspapers must have been difficult. He worked all the time, so when she saw him, he was tired and coughing. Her refuge from this situation continued to be the dirty factory on the river's edge. She was rarely at home during the day. Clara Longworth de Chambrun wrote that Joe and Min were "oftener at 'Rookwood' than at [their] home....Aunt Ia...seldom came home at lunch."[116]

At the Rookwood Pottery Company, Maria and the other potters tested and retested ideas to create distinctive ceramics. They trialed clays and the glazing, experimented with different forms or colors, and varied the texture and the decorations. "The drawing of the kiln brought ...[her and other artists] together....[They] each knew what was in the kiln. If it were an experiment that was being tried, [they] were anxious to know the result."[117]

Maria injected into her art a sense of whimsy. This quirkiness in her work was reminiscent of "the grotesque aspects of Japanese art....
[Vases were made] like sculpture entwined with a supernatural array

of crawling elements."[118] Her pottery was so lifelike that one observer noted that she was "tempted to reach forth her hand"[119] to pet a bird.

Maria observed that the attention paid her as a female entrepreneur was free and "gratuitous." Clara Chipman Newton wrote about the voyeuristic interest, "The story...found its way from papers to magazines without the least effort upon the part of Mrs. [Nichols]." Locals and visitors to the Queen City were curious about the society lady who was competing in the business world of men. Proud Cincinnatians hosting conventions made sure the attendees had time to tour the establishment.[120]

Many famous visitors were enchanted with the decorative pottery. The English poet and playwright Oscar Wilde was among the guests to visit. Wilde came to America on a lecture tour to share his views about "art for art sake."[121] His reputation for acting like an opinionated cad preceded him. Clara Chipman Newton had the onerous task of taking Wilde on a tour of Rookwood Pottery, in Maria's absence. Wilde's appearance rather shocked the somewhat conservative manager. He wore "a calla lily green overcoat and a shrimp pink necktie."[122] The guest offered some positive and some negative comments about the pottery he was shown. "The Irish Apostle of the Vague" said some vases were "too branchy."[123] Wilde met his match in the person of the Rookwood Pottery Company's superintendent, Joseph Bailey. He countered the showman's criticisms with "cold practical facts."[124] Later, Wilde had a late luncheon at the Nicholses' gray stone mansion with Maria, a few friends, and the press.[125] The next evening when Wilde lectured, he took the opportunity to criticize the factory's products. He said the creations were not as good as what he had seen in Dayton. Maria, who was in the audience, laughed and took what he said in good part.[126]

Despite all the publicity, the business required infusions of money to meet payroll, buy chemicals, and operate its kilns. Specifically, in 1882, Joseph Longworth bailed out the organization with $1,000.[127] Several money-making strategies were employed to increase

the firm's revenue. Maria founded a pottery school and rented space to the Pottery Club. She established a downtown Rookwood shop, and hired a salesman.[128] The company fashioned designs inspired by current events, popular songs, and Japanese ceramics in hopes of attracting customers.[129]

The company advertised in the local, national, and English newspapers. The decorative pottery was loaned as a promotional item to art dealers, for exhibitions at several local and national events, and museums. The Rookwood Pottery Company competed for and received a gold medal from the 1881 Cincinnati Exposition. The advertising and recognition from the award demonstrated the pottery's artistic merit, and hopefully, sales potential.[130]

Unfortunately, the tactics were not enough to increase revenue. To help turn around the company in 1883, Maria brought in W. W. Taylor to replace Clara Chipman Newton as manager.[131] The genial man with goatee and twinkling eyes would prove to be a master at business organization and public relations.[132]

Several changes in fact were made almost immediately. Taylor instituted a record of shape designs and sales. He asked potters to sign the bottom of their ceramics to help track pottery transactions. He discontinued the non-art tableware, closed the school, and terminated the salesman. Later he moved the Pottery Club out. He continued the practice of sending the decorative pottery to international expositions in both the United States and Europe. He also cultivated important writers and news reporters to generate positive publicity.[133]

In 1885, Maria could look back on the first five years of her business. She had been actively involved both financially and artistically in the organization to keep it afloat. However, with Taylor managing the day-to-day business, she must have hoped that he would take more responsibility off her shoulders, and turn things around financially.

Another way in which Maria distracted herself from her personal problems was through her philanthropic work. When she

reached out to other people in need, her efforts were generous, broad-ranging, and personal.[134] She began, with her husband, by providing financial support for the first Cincinnati May Festival in the early 1870s. The festival continues to this day as an internationally known event. She continued and reinforced the Longworth legacy of charitable and philanthropic activities in Cincinnati.[135] Like her father and grandfather, she wanted "to help [people]…without distinction of race, color, wealth or rank."[136] Maria was an active member of the Society for the Prevention of Cruelty to Children and Animals, the Associated Charities, the Free Kindergarten Association, and the Unity Club. These organizations aided destitute men, women, and children. She and other ladies organized fundraising events or contributed their own money to help meet the organizations' goals.[137]

Maria started the first pediatric hospital in Cincinnati, the Home for Sick Children, which delivered free hospitalization services for indigent children. The institution provided care "for thirty patients, up to age twelve. They were kept until they were cured."[138] The facility in many ways was a forerunner of today's Cincinnati Children's Hospital Medical Center. There was a no discrimination based on gender, color, religion, or class. The staff worked with the police and social agencies to identify vulnerable children. In a time before the concern about patient rights, the hospital had a policy to avoid publicity. The staff maintained vital statistics, and used the latest equipment, such as the telephone. And it was the first hospital in the city to train nurses.[139]

"The absence of a governing body divide[d] responsibility between [Maria and Dr. Frederick Forchheimer,] the head of the medical staff."[140] This meant that Maria handled both administrative concerns and financial aspects of the organization. In modern terms, she served as both the chief operations officer and the chief financial officer for the facility. Not a mere figurehead, Maria was very involved in the day-to-day operation of the facility. There was evidence she worried that the children received adequate amounts of milk so she "sent three

gallons of milk a day" for one year.[141] Because of this important work it is not surprising that later in her life she financially supported hospitals in the United States and France during World War I and the 1920s.

In addition, Maria patronized young musicians and decorative artists. She changed their lives by creating opportunities for concerts, exhibitions, and training classes. She also bought their work or underwrote their living expenses. For cellist Adolf Hartdegen, she paid his salary at the music school, designed programs for his performances, and created concert events for him to gain recognition and to earn extra money.[142] She financed the training in Paris for two and one-half years for the gifted artist Artus Van Briggle, who later founded his own pottery.[143]

Solving complex civic and humanitarian problems around Cincinnati required perspective, grit, and leadership from women such as Maria. Charitable work provided her a variety of public service experiences that would become useful in her support of her second husband's political career.

In December 1883, Joseph Longworth died. He bequeathed money and property to his children, his only surviving sister, and various Cincinnati organizations, but presented not a penny to his son-in-law, George. The family home where the college president, Maria, and their children lived for nearly fifteen years was not deeded to him. All buildings, artwork, and tangible assets connected to their home became Maria's property.[144] Joseph's thoughts about George were very clear.

Six months after her father's death, Maria began building a second house on what was now her property.[145] When it was completed the following year, the house stood at a right angle to the original home. The addition was connected by a walkway on the second floor.[146] George moved into the new part of the house to

isolate himself from the family because of his medical condition.[147] Although gossip in the newspapers said he lived there because the couple divorced, no records of a divorce decree have been found.[148]

Louise McLaughlin stated Maria "deserted" George at this very critical time when he was desperately ill.[149] Certainly, in the last two years of his life, George was generally not with his family. At one point, he was in New York for the summer while the rest of the family was in New Hampshire.[150] As he lay dying at home, his family was out of town. Only Julius Dexter, Dr. Bradford, and "grief-stricken" servants were in attendance when he passed away.[151]

Private funeral services for George took place at the mansion on Grandin Road. Public services were held at the school of music. Then, an honor guard escorted his casket for burial at Spring Grove Cemetery.[152] Again, in death, he was alone. He was laid to rest in a plot a half-mile from the Longworth family's graves.[153] This seems to be a strong statement about the family's lack of affection for him.

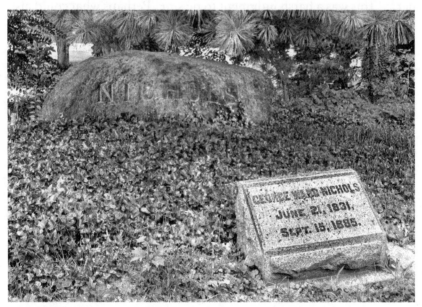

Fig 2.11 George Ward Nichols's headstone. Nichols was not interred in the Longworth plot. *Spring Grove Cemetery and Arboretum.*

Maria did not go into mourning as prescribed by Victorian conventions. She did not withdraw from society, wear black, or stop her involvement in any of her philanthropic activities.[154] Moreover, she waived her traditional duty to serve as the executor of George's will. She was not listed as next of kin. He only recorded the names of his children. This wealthy woman failed to contribute to her husband's scholarship fund. George's widow also never planned his memorial service, but she did attend.[155]

Long-time friend Bellamy Storer proposed to Maria. They announced their engagement four months after George's death. When they married on Maria's birthday, in March 1886, they did so six months after George left this earth.[156]

McLaughlin, acerbic as ever, wrote, "An effort to justify his wife's conduct toward him seemed to have been made which I don't believe was right. Mrs. Nichols was a spoiled child of fortune. She generally got what she desired as soon as it could be procured for her."[157] This was a harsh judgment to be sure. Perhaps what could also be concluded was that two passionate but very mismatched people produced music and art of tremendous lasting beauty.

In 1865, George wrote about a "young girl" who would look at "his face with undisguised delight."[158] He found her. Unfortunately, their romance faded. George must have been at first Maria's romantic daydream come true, but came to be her daydream gone wrong.

GOOD LOOKS, INTELLIGENCE, AND CHARACTER

THE *CINCINNATI EVENING NEWS* remarked the day before Maria Longworth Nichols married Bellamy Storer: "Since the death of Mr. Nichols, numerous rumors of every character have been floating about concerning the almost constant companionship of the widow and Mr. Storer. The engagement has been kept very quiet, and indeed, since the news has leaked out, strenuous endeavors have been made by both parties to keep it out of public print."[1] This was a juicy scandal. The famous owner of Rookwood Pottery, one of the wealthiest women in the country, was marrying a local lawyer less than six months after her first husband's death. Why would they both take such a risk? Was this another grand romance? Who was this man?

Bellamy Storer was born on August 28, 1847, in Cincinnati.[2] He was named for his father, who was a distinguished judge and a college professor. Judge Storer had served in the House of Representatives for one term and counted several presidents as friends.[3] It was almost foreordained that Bellamy would become a lawyer like his father. Not much is known about his childhood except he attended private school in Cincinnati. For college, he went east to study at Harvard University.[4]

At maturity, he was six feet, four inches with a boyish face, and wore gold-rimmed glasses when he worked. He played sports and loved the out of doors.[5] His physical beauty was so arresting that it was conjectured that he might be the model for Laurie, one of Louisa May Alcott's characters in *Little Women*. He had the "reputation of being the handsomest man in Southern Ohio."[6]

Maria's brother Landon, who attended Harvard with Bellamy, introduced them.[7] She liked Bellamy because he loved to laugh and flirt almost as much as she did.[8] For his part, Bellamy always wanted their relationship to go beyond flirting, but she only had eyes for George when they were younger. After graduation from Harvard in 1867, Bellamy returned to Cincinnati, and attended law school.[9]

During this time, Bellamy and other men from the upper class formed the Cincinnati Red Stockings, the forerunner of the professional baseball team the Cincinnati Reds.[10] Bellamy liked the team spirit and the feeling of group competition. When he was older, he favored individual sports such as tennis and golf.

With the completion of law school in 1869, and admission to the bar, Bellamy was appointed as the assistant United States attorney for the Southern District of

Fig. 3.1 Seated portrait of Bellamy Storer, age thirty-nine. *Chatfield Photograph Album, SC 108, p. 97 (B-91-071). Cincinnati Museum Center.*

Ohio. His commanding voice, eloquent speech, towering height, and handsome features greatly enhanced his ability to win the cases he prosecuted.

In 1872, he went into private practice with W. Austin Goodman, a fellow Red Stocking. His father, who had resigned his judgeship, also joined the firm, which primarily dealt with corporate law. They negotiated contracts, drafted legal documents, and represented their clients in court. The practice was quite successful.[11]

When his father died in 1875 Bellamy became responsible for his mother and his sisters. Bellamy liked the financial security he achieved for his family in private practice. Yet his passions lay elsewhere. He absolutely enjoyed the rough and tumble of Republican Party politics. Philosophically, he agreed with its vision of "material and moral progress." He exactly fit the nineteenth-century membership profile of a native-born, white Protestant voter. He liked that "the party represented the status quo."[12]

In 1875 Bellamy was selected as the local Republican Party nominee for Cincinnati's solicitor. He did not win,[13] but as a Republican party operative, he became more immersed in the workings of the political group. He served as a delegate to the state convention and as the president of the Republican Club in his district.[14] In 1876 he helped organize the Republican County Convention for Hamilton County.[15] In 1877 he ran again for city solicitor, and again lost.[16] Why did this happen to this persuasive, prudent, and thoughtful candidate? Judge Manning Force, a close friend of Bellamy's, thought that he was too "handsome," and "a favorite in society." "[For that reason,] he never got credit from businessmen for his real capacity."[17] Voters thought he lacked substance because he was a good-looking, single man.

Away from his law office, Bellamy had other interests. He joined several civic reform clubs, trying to help the less fortunate. He worked as a member of the Board of Officers of the Chamber of Commerce. He liked how various businesses joined together in

a mutual effort to increase commerce for the city and believed the organization could also exert influence on local government.[18]

Bellamy also kept busy as a member of some of the same social and cultural organizations to which George Ward Nichols and Julius Dexter belonged. Bellamy joined the Harmonic Club because he had a good singing voice. He found the teamwork and discipline of singing in a group to be deeply satisfying. He and Julius Dexter also attended the Harvard Club Annual Dinner to reminisce about old times in college.[19]

Maria invited Bellamy with her other friends on social outings. She was careful always to have another woman with her when men were included in her party.[20] Still, there was gossip. In response to a warning of a good friend, Maria angrily retorted, "I pass over in scorn to your allusion to the second letter of the alphabet and heap coals of fire on your head by the hope that you will someday find a friend in some remote degree possessed of some of the good looks, intelligence, and character of that maligned young man."[21] Whether the relationship was innocent as she implies, we cannot know.

After George's death, Maria sought Bellamy's legal advice to file for a patent for the "chromatic ornamentation of pots."[22] Her application was submitted in December 1885 by Bellamy. They

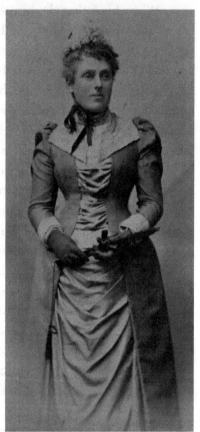

Fig. 3.2 Portrait of Maria (Longworth) Nichols Storer. *Chatfield Photograph Album, SC 108, p. 96 (B-91-060). Cincinnati Museum Center.*

enjoyed their time alone together gathering all the information required by the government.

Bellamy decided to court the new widow openly and seriously. He loved her exuberance; he valued her intelligence; he trusted her judgment. He also shared her lifestyle and enjoyment of traveling. He offered Maria none of the brilliance or artistic talent of her rigid, controlling first husband. In fact, he was a kindly, athletic lawyer with possible political ambitions. That's all. There was no drama, no public conflicts or need to prove himself, as George did. Instead, he was a gentle giant of a man with a heart of gold who enjoyed good food and wine.[23] He liked that she always was the center of attention. He never felt a need to compete with her.

Maria was attracted to him because he was relaxed, flexible, and indulgent. They were the same age from the same social set. There was no grand romance, but they felt comfortable with each other.

Bellamy attended her Christmas party on December 21 for her children, whom she lovingly called the "little people." Joe was fifteen and tall for his age. Min was quiet, not shy, but observant and thoughtful.[24] The house was beautifully decorated, but not so elaborately because their father had died three months earlier. Maria created a wonderful event with games, gifts, music, and laughter around their beautiful Christmas tree. Everyone enjoyed the festivities.[25]

In mid-January 1886, the newspapers reported that Maria and Bellamy were engaged. Friends congratulated both parties.[26] Notwithstanding this support, the announcement of their engagement was a breach of etiquette.

One newspaper said they planned to marry in January. Another said it would take place on Maria's birthday in March. A third suggested that they were to honeymoon in Egypt or Japan. Reporters dogged Bellamy and called Maria's home relentlessly trying to acquire any scrap of news. One lucky journalist unexpectedly ran into Bellamy at the Probate Court while he was applying for a marriage license.[27]

While Maria planned a small wedding, she continued to work at the Rookwood Pottery Company and to attend meetings of her charities.[28] Moreover, she invited and, possibly, paid for the oriental pottery expert Edward Sylvester Morse to lecture in Cincinnati about the culture of Japan. She also purchased 700 pieces of Japanese pottery from him. She hoped her decorators at the Rookwood Pottery Company and local art students could study and learn from the beautifully designed art pottery.[29]

Bellamy and Maria's wedding was a small, informal affair that took place in the bride's home, on her birthday, March 20, little over six months after George's death. They selected the Rev. George Thayer from the First Congregational (Unitarian) Church to marry them. Maria became acquainted with Thayer and his wife through her active involvement in the Unity Club,[30] a philanthropic group sponsored by this church. She may have attended his house of worship because she had become disenchanted with the Episcopal Church and likened it to a "lecture room which was interesting or dull according to the preacher."[31]

Both families were involved in the quiet ceremony. Maria's daughter, Min, and niece, Clara Longworth (later de Chambrun), served as her bridesmaids.[32] Bellamy's mother and sisters, Bessie and Fanny, brought flowers. Afterward, there was a light meal. The newlyweds left that evening for their two-week honeymoon.

To ease Bellamy's transition into the lives of her youngsters, Maria wrote "the children every day"[33] while they stayed in New York City. She described what the couple did so that the teenagers felt included. From the end of April until November, all four traveled throughout Europe.[34]

Maria's letters to her close friends and family were completely different from her written correspondence to them when she was wedded to George. In the early 1880s, she never mentioned her first husband, regardless of his major health issues or prolonged problems at the school of music. After her wedding to Bellamy, her

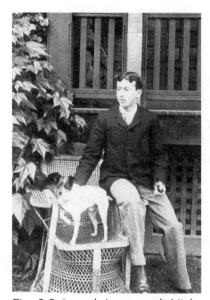

Fig. 3.3 Joseph Longworth Nichols. *Marquis and Marquise Jean François and Nicole de Chambrun Collection.*

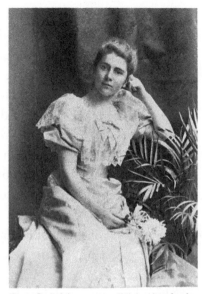

Fig. 3.4 Margaret Rives Nichols. *Marquis and Marquise Jean François and Nicole de Chambrun Collection.*

trivia-filled notes were full of descriptions of what they did as a couple and as a family.

Her second husband, lovingly called the "Old Man" or "Monsieur," and the children were front and center in these delightful "epistles," as she called her letters.[35] She described small, mundane things such as purchasing wine. She chuckled,

> "You should have seen the 'Monsieur' this afternoon tasting and purchasing wine....I was allowed to come in, my services as interpreter were required....I did my best and did it so well that we were [a]warded a slight discount and I with three beautiful rose buds from the garden. 'Monsieur' made up for the enforced vocal silence by looking appreciative."[36]

The Storers loved traveling in Europe. Both of them valued the art, the wine, the scenery, and the society. Upper and middle-class Americans like the Storers traveled to Europe for social prestige and intellectual stimulation. It was as if "going abroad allowed...

Americans to claim special and cultural standing as part of a traveling elite."[37] Maria took her children to Europe to expose them to other languages and cultures. Like Maria they learned French and German and gained knowledge about the history and art of European countries. The Storers continued the practice of traveling to Europe with Min and Joe until they both married.

Specifically, for the Storers, transatlantic travel also provided an escape from difficult situations they were faced with in the United States. Back home, they were not well received. General knowledge has it that when Bellamy escorted Maria to George's memorial service in March 1887, society was scandalized.[38] Perhaps it reminded those attending of the couple's failure to observe a period of mourning before marrying. Yet the newspapers reported positively on their treks to the east coast and Europe, and their local philanthropic, social, and business activities.[39]

For example, they met and entertained the author and editor Charles W. Stoddard. The Storers immediately liked the charming, short, bearded man. His lighthearted jokes and witty stories delighted his hosts. Every time he visited, the Storers' dining room was filled with laughter. Stoddard had the same nomad impulse that struck the Storers. He was excited to cruise on a yacht with the family down the Ohio River, exploring the shorelines and watching the sun play on the water.[40] He remained in their lives, as a charming but eccentric houseguest, until he died in 1909.

It was Stoddard who introduced Bellamy and Maria to one of his favorite friends, Mrs. Robert Louis Stevenson, the poet's wife. She had a wonderful time at their mansion and remembered her visit fondly: "The Storers live in a sort of enchanted palace and are very simple and gentle and kind."[41] Her husband wrote this poem in grateful praise, about her experience:

> Thank you for the whiskey, thank you for the ape:
> The first is number one, the second as jolly jape.
> By these romantic gifts, and all you did for my wife,

Dear Sir, Respected Madam,
You've made me, yours for life.[42]

Maria's charitable activities continued to support families and vulnerable children. She assisted Louise Taft, William Howard Taft's mother, in selecting teachers for the newly established free kindergartens in the city.[43] Her hospital was busy as ever, helping poor families with the best medical care at no cost.

Maria also actively supported the performing arts by her direct involvement with the Cincinnati May Festival. She served on a festival committee for the 1886 event.[44] The opera *Der Thurm zu Babel* (*The Tower of Babel*), which she had translated in 1878, was performed by the chorus.[45] Unfortunately, she missed the event because she was in Europe.

After their honeymoon and European trips, Bellamy returned to his law practice, often laboring six days a week.[46] Newspapers gossiped that he might be nominated to fill a position on the state supreme court in Cincinnati. This was only a rumor.[47]

Early in their marriage, the Storers became acquainted with Congressman (later governor and president) William McKinley.[48] The elegant, barrel-chested, blue-eyed politician was urbane and reticent. Bellamy "met him at a banquet in Cleveland. He had come back delighted by the personality of a man who impressed him as a...medieval knight."[49]

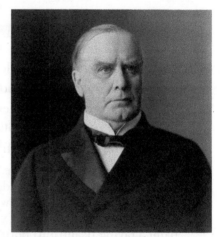

Fig. 3.5 William McKinley. *Library of Congress.*

Just like Bellamy, he was a highly principled lawyer. McKinley loved being invited to the Storers' Cincinnati mansion to be a guest in a happy, domestic home. Unfortunately, his daughters had died

and his wife was an invalid so "the visits gave him the companionship and the taste of home life for which he had long been starved."[50] They would remain friends until McKinley's death in 1901.

McKinley was a future ally of Marcus Hanna of the Cleveland faction of the Republican Party. Hanna wanted Republicans elected to national offices. He would find in McKinley the leadership qualities of a president. Bellamy's support for that branch of the party would dominate and affect his future political career.

The other branch of the party was created in Bellamy's back yard. The Cincinnati faction developed through the power base of city "Boss" George Cox and Governor Joseph Foraker. "Within the state Republican Party the rivalry between factions grew intense with Cox and Marcus Hanna regularly at odds over appointments, patronage, and which candidates to support for office."[51] The governor also had eyes for the presidency.

In 1887 Maria was spending less and less time at the Rookwood factory as she became excited about another art form and started painting with oils on canvas.[52] When she summered with Bellamy on Cape Cod, Maria's "epistle" was filled with gossip, plus descriptions of art lessons. Maria wrote to her friend Annie Roelker,

> "I am having a beautiful time. An elderly artist...gives me four lessons a week at his residence. It is delightful. He has seen so much and knows just what I lack—method....When I can add that to my madness you'll take the results....I will paint a raving beaut[iful] portrait of you."[53]

Maria believed the one-to-one guidance helped her achieve a greater level of artistic skill.

Maria took the Life Oil Class at the Art Academy of Cincinnati. She was a member of the first class to receive training in its new building adjacent to the Cincinnati Art Museum. She would

continue to take classes there until 1890. Maria had a strong interest in the school not only as a student but as an employer. No fewer than sixteen employees were hired from the school for the pottery and her father was a major contributor to the organization.[54] However, she disliked its leader.

Thomas S. Noble, president and principal of the Art Academy of Cincinnati, was the educator.[55] The tall man with an aquiline nose and hazel eyes was formal and "rigid in his approach to the teaching of art."[56] Noble explained, "We must let talent follow its own inclinations, but not allow it to proceed faster than is consistent with thoroughness....Occasionally I have a pupil who wants to soar, but after I held him back for a while he will thank me for teaching thoroughness."[57]

Maria loved to "soar" and paint what she wanted. She chaffed under Noble's painstaking direction. She rejected his insistence that students "draw [meticulously] from casts [of different anatomic parts]."[58] She believed live models were superior subjects. She also resented his inability to work consistently with the students. Administrative matters of the school often distracted him.[59] Moreover, George Ward Nichols had recommended Noble for the position when the school was created in 1869.[60] The two friends worked together on committees, and socialized at the same social clubs.[61] In the mid-1870s, he painted a charming portrait of George.

Another change took place that year in Maria's charity work. Although her hospital continued to be busy, she decided to close it in September 1887.[62] Maria's long vacations and travels to Europe left little time for her to manage the facility actively. The establishment of another children-centered hospital, the Protestant Episcopal Hospital (now called the Cincinnati Children's Hospital Medical Center) probably prompted the decision.[63]

However, Maria continued to provide for vulnerable children by organizing and funding a progressive day care center under the auspices of the Unity Club. For a nominal fee of five cents a day,

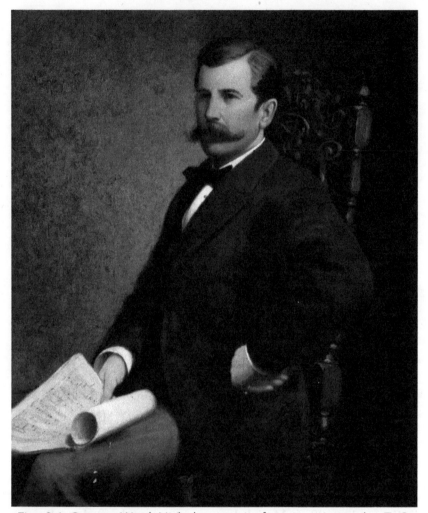

Fig. 3.6 George Ward Nichols portrait, from a painting by T. S. Noble. *Collection of the University of Cincinnati. Photo courtesy of the University of Cincinnati.*

working-class women and men (with no wives) could place their children under the care of a nurse at a well-equipped, homelike, immaculately clean facility. One person joked after visiting the establishment that there was "just enough infantile disorder to show the little ones enjoyed the utmost freedom."[64]

In the fall, Joe left home for the first time to attend Saint Paul's School, a private Episcopalian college preparatory school in the mountains of New Hampshire. The following year, he followed his uncles, grandfather, and now his new stepfather into college at Harvard.[65]

Socially, the Storers were quite busy in 1888. In January, Maria created an elaborate party for sixteen-year-old Min and eighteen-year-old Joe, who was back for the holidays. More than forty young friends from the neighborhood came despite the icy, poorly lit roads.[66]

At this time, Maria and Bellamy served as directors of the Society for the Prevention of Cruelty to Animals and Children. Their fundraising supported interventions by the police and concerned citizens. They handled reports of abused children under the age of sixteen years. The organization also responded to requests to remove "disabled animals from the street" and helped to finance a special horse ambulance for that purpose. In May 1890, Bellamy was elected the president of the state organization.[67]

Maria was still heavily involved in the Cincinnati May Festival. The chorus's first selection sung in English was the hymn "In Seiner Ordnung Schafft der Herr" ("In His Order, the Lord Creates"), which she translated from the German text. Coming up with the English words to fit the melody lines was tricky and time consuming. Maria enjoyed being immersed in the music, trying to select just the right word that was true to the original German, and would make sense to an American audience. In a moment of hyperbole, a newspaper reviewer stated the song was "the keynote of the festival in a reverential and solemn mood. The translation of the verbal part has been fittingly made by that queen of the management of high art in this city, Mrs. Maria Longworth Storer."[68] Maria must have cringed at the fawning description.

For the second year, Maria took classes at the art school. She still found it difficult to take art lessons from Noble and wanted the organization to terminate him and to hire someone else. She complained about his class to Alfred Goshorn, the director of the

art museum.[69] He did not change the instructor. In 1889, she complained again, and recommended hiring a new faculty member. She proposed a highly respected painter and teacher, Frank Duveneck, who was born just across the river in Covington, Kentucky.

The dark-haired, dark-eyed artist was the polar opposite of Noble. He nurtured fledging artists. "[He] was almost saintly in his devotion to them. A number of his former students commented upon his generous and sympathetic spirit."[70] Goshorn, again, did not act on her suggestion.[71]

In July, Joe joined the family and they stayed on the Massachusetts coast before taking a luxury steamer to Europe. They rode horses, swam in the ocean, and enjoyed the company of Cincinnatians who were summering there too.[72]

In Europe, Maria described in letters what the family did while they were in Germany. Min studied music, Joe drank beer, Bellamy perfected his German, and she painted. Maria gushed, "The ideal and artistic life is indeed going on and is more delightful than in my wildest imagination."[73]

The Storers' trip was cut short, in January 1889, because Bellamy's mother became seriously ill. Upon their return to Cincinnati, they found her close to death. When she died, Bellamy and his sisters mourned her passing. Bellamy then settled his mother's affairs and gave his share of the estate to his sisters.[74]

During their time at home, Maria asked Judge Manning Force to recommend Bellamy for a diplomatic post as ambassador to Rome. Maria wanted to experience the European lifestyle for longer periods of time. Bellamy would only consent if he found employment.[75]

With all pending business resolved, the Storers returned to Europe from April through September 1889. Maria, who worried about Bellamy's complaints of blurred vision and painful headaches, sought consultation with the world's preeminent ophthalmologist, Dr. Richard Liebreich in Königsberg. The noted physician diagnosed his "eye trouble—and treat[ed] him with glasses."[76] It was

an unusual treatment for someone in his early forties, since specta-
cles were generally ordered for the elderly.[77]

In June, Maria happily reported to the Rookwood Pottery
Company that at the Paris L'Exposition Universelle their beautiful
display created quite a sensation.[78] Maria was gratified that the pot-
tery received a prestigious gold medal. After receiving the honor,
there was such great demand for the decorative pottery that money
concerns for the company were a thing of the past.[79]

Maria's solicitation for a position for her husband was success-
ful. He was offered a diplomatic post in Greece. Incredibly, Bellamy
turned it down. Maria explained to Annie Roelker, "We have con-
cluded to take root—and decline Greece...we have fish to fry at home
so a telegram offering Greece...was no longer a temptation."[80]

"Fish to fry at home" could have alluded to her philanthropic,
business, and artistic commitments in her hometown. It also could
have intimated her desire to support her husband for public office.

For instance, Maria helped to establish the first class of the
Cincinnati Training School of Nursing, and turned her former
pediatric hospital on Elm Street into free accommodations for the
students.[81] Another possibility was Maria's decision to sell the Rook-
wood Pottery Company. For reasons known only to herself, Maria
decided she no longer wanted the responsibility of running the fac-
tory. She sold the business to W. W. Taylor, "reserving only the right
to have a studio there for her own use."[82] For the rest of her life, Maria
received press notices and questions from strangers about the organi-
zation. She became a "culture heroine of sorts known in households
throughout the nation."[83] Rookwood was to become the greatest
art pottery business in America, and a leader in world ceramics. It
helped to establish Cincinnati as a cultural center.

But she also might have meant her frustration with instruction
at the art school. "She held Noble in utter contempt. Maria fully
believed that the classes and the mode of teaching were a disservice
to the community not to mention her father's endowment and her

Pottery."[84] Maria decided to challenge the Board of the Cincinnati Museum Association governing body of the art school and the Cincinnati Art Museum. She had her old friend, L. B. Harrison, nominate her for a position on the board to gain some control over the school. But when it was determined there was not enough support, Harrison withdrew her name from consideration.[85]

The newspapers had a mixed reaction. One article was highly critical of her: "What could a woman know about managing an art school? What right had a female to mingle her voice in the deliberations of men over how not to make a school of design progressive?" Another article eloquently jabbed, "Mrs. Storer was a woman and a woman with ideas."[86]

She explained her actions a few days later in a letter to the editor of the *Cincinnati Commercial Gazette*: "There is supposed to be a class in oil painting, but as it is put under the instruction of Mr. Noble…it is impossible for him to be in enough places at once to give the time it requires, and the pupils grow disheartened and drop out one by one…I am deeply interested in all the students…It was only for this reason that I consented to have my name proposed at the late election."[87]

Maria did not give up. She decided to start her own school. She contracted Frank Duveneck to teach and administer the separate school for a salary of $3,600. The *Cincinnati Commercial Gazette* reported, "The school is the result of strained relations of long standing" between her and Noble.[88]

Forty years later, Maria recalled, "Mr. Storer and I…had gone to see [Frank] Duveneck in Boston and had engaged him as a teacher with a salary paid by us and the Museum gave him a room for his class."[89] "This was obviously a gesture of appeasement on the part of the Cincinnati Museum Association, not wanting to offend the powerful Longworth family, whose money and art collections greatly enhanced the academy and museum." It simply was not in the "best interest" of the school to be "held in disfavor with the formidable Maria Longworth Storer."[90]

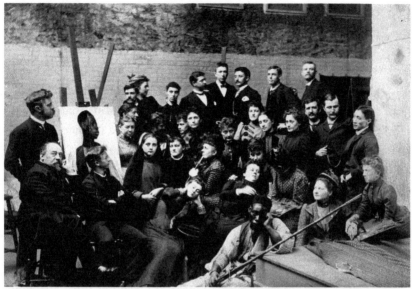

Fig. 3.7 Duveneck class at the Art School of Cincinnati, 1890–1891. Duveneck is standing on the far left. Maria is seated in the center, facing left, and wearing a polka-dotted dress and holding a paintbrush. *Mary R. Schiff Library and Archives. Cincinnati Art Museum, Cincinnati, Ohio*

Duveneck's class proved to be "a great success."[91] His reputation as a caring instructor and his use of liberal teaching methodologies attracted many students, including Maria and Min. To Maria's delight, the class was "integrated" with men and women, and drawings were made of live models.[92] Duveneck taught there for two years. "While [Maria] did not get a board appointment, she did get what she wanted. After the Duveneck classes, Rookwood's pottery decorations reached a new level of excellence and won the highest prizes at international fairs."[93]

Another art project came to fruition about this time. Sculptor Moses Ezekiel completed a magnificent marble bust of Bellamy in 1890. Later, the sculptor remembered, "My bust of Mr. Storer proved a great success. He was one of the finest specimens of a manly figure that I have ever seen, and his face was classically beautiful."[94]

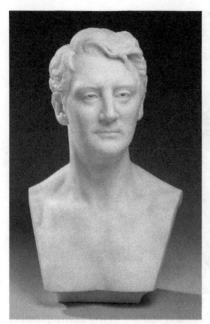

Fig. 3.8 Bellamy Storer, c. 1890, marble, by Moses J. Ezekiel, 1844–1917. *Cincinnati Art Museum. Anonymous Gift, X1963.1.*

During the summer of 1890, Maria, Bellamy, and Min traveled to Europe.[95] The family stayed at a Roman Catholic convent in Brittany, "where the chaplain... preached a sermon" that triggered a desire in Maria to have a broader spiritual experience.[96]

Maria represented a group of educated, high-minded Americans who were questioning their Protestant heritage and found the Catholic Church alluring. Like many of that group, she read the works of Cardinal John Newman, who had just died.[97] He was the lightning rod of the revival of Catholic ideas and practices within the Anglican Church in England called the Oxford Movement. Ultimately, he converted to Catholicism and led other intellectuals to the Church because of the clear apostolic succession from Saint Peter. Maria was impressed, but she needed more time, to think about what she wanted to do.

After returning from Europe, Bellamy announced his intention to run for a seat in the U.S. House of Representatives. Although he had been an unsuccessful candidate twice before for local office, Storer believed he would be successful in this race since he had both Maria's and "Boss" George Cox's support. How did he influence Cox to support him, even though Bellamy was known to be a McKinley loyalist?

It is likely that Maria's large donation of $27,000 to the local political operatives encouraged "Boss" George Cox to disregard

Bellamy's affiliation with the Cleveland faction. "Like other city bosses, he distributed favors and delivered the votes...demanding loyalty, favors, and money in return."[98] With Cox's influence and Maria's money, Bellamy was nominated by the Republican Convention on September 19.[99]

Both Storers campaigned vigorously for his election. First, they invited the party operatives to intimate dinners and planning sessions at the Storer mansion. Maria "arrang[ed] matters with this leader and that one, removing obstacle after obstacle."[100]

Bellamy kept busy speaking before different groups around the district. He argued persuasively how he could make a difference in their lives. Moreover, "Maria canvassed the district more thoroughly than any of the candidates and it was done in a quiet way."[101] She was driven in a plain carriage around the constituency, stopping to talk with individual voters on the street or in their homes. She asked people who had received a helping hand from her grandfather, the first Nicholas Longworth, to honor in his memory by voting for her husband. People were impressed how Maria immediately changed languages to German or French with older people, when she found out they had emigrated from Europe.[102]

Not everyone was happy to see her out and about. Some complained about her financial advantages: "The Democrats are trying to make capital out of the fact that [the candidate's] wife bathes in a $1,000 tub."[103] Maria was exhausted by the effort, and recalled later, "It has been a very hard fight. Why, we all had to work!" Ultimately, Bellamy's "unexpected victory" demonstrated that some of "the credit for the Republican victory certainly belongs to [her.]"[104]

On November 4, 1890, Bellamy became Representative-elect Bellamy Storer. Unlike today's Congress, which convenes on January 21 following a biannual election, Congress did not assemble until December of the following year.[105] This meant that Bellamy did not begin work until thirteen months later, and had quite a long time to prepare.

In December, Maria and Bellamy held Min's first debutante ball at the family's Grandin Road mansion. Maria received her guests in a "blue silk" gown, and "powdered hair decked with pink plumes"; Bellamy wore a "conventional suit"; Min was dressed in a "Martha Washington costume [of] flowered silk"; and Joe, home from Harvard for the holidays, impersonated Washington himself. "The dancers were mostly of the younger members of society, and the scene was one of the gayest revelry."[106] Everyone had a great time, but no young man seemed to catch Min's eye.

Just a few months earlier, on her eighteenth birthday, Min received, among other gifts from her mother, a buggy built in the city. It was a lightweight cart for the young lady to drive herself. This says so much about what Maria's hope for her daughter. She wanted the buggy to remind Min that an elite young woman need never be subordinated to what society dictates or to her husband's direction. If she drove herself, she could be in control of her life. One is reminded of the cart and yellow pony that Maria drove to and from the Dallas Pottery when she began loosening George's tight yoke around her neck. So fond of this conveyance was Min that she had it sent to the stables of her husband's château, in Marvejols, France, after her marriage.

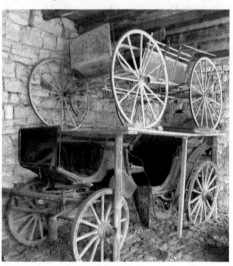

Fig. 3.9 The buggy on the platform was Margaret Nichols's eighteenth birthday gift in 1890. She liked it so much that she had it shipped from the United States when she moved to France in 1897. The Chambrun family buggy on the ground was built in France. *Jacques de Chambrun.*

When the Storers looked for a house to rent in the nation's capital, Maria complained to their friend Eugene F. Bliss, who was "housesitting" at their Grandin Road home, "All the furnished houses even of $4,000–$5,000 a year are dreary and stuffy and even smell[ed.]"[107] The following month, they finally rented a furnished house that they liked. The newspapers observed that all they needed to bring with them was a "dining room table."[108]

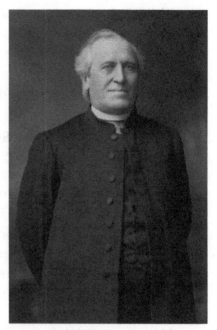

Fig. 3.10 Archbishop John Ireland. *Minnesota Historical Society.*

While in the nation's capital, Maria and Bellamy decided to attend religious services at a Catholic church because they found the beauty of artwork and the grandeur of the music to be awe-inspiring.[109] They attended Saint Augustine, which was a predominantly African American church. On the altar stood a tall lanky, powerfully built priest who had a "look" of "intellectual fire and spiritual grace."[110] He preached the "best sermon" they had ever heard.[111] The priest was Archbishop John Ireland, from the St. Paul, Minnesota, Archdiocese. From this point in time, he would play an important role in the lives of both Storers.[112]

Back home after house-hunting in Washington, Maria was busy creating a book with Eugene F. Bliss and her brother Nicholas's widow, Susan Longworth. They translated four French short stories for a small volume entitled *Tales of a Stormy Night*. These were sophisticated ghost stories that they hoped would thrill the

reader, as discussed in the following advertisement for the book: "The title of the book has been chosen in deference to the wide spread belief that stories of the marvelous and the supernatural should be read at night, and by preference on a rainy windy night."[113] They enjoyed the collaborative effort in creating the small volume. They also were excited that the work sold quickly and was reprinted for the third time later that year.[114]

From May to September 1891, the Storers and Min vacationed in Europe. Their guest was Mary Eva Keys, someone with whom Min could see the sights. This lady had traveled with her own family to Europe and loved Egyptian art.[115] While the young women visited museum after museum, Bellamy and Maria had fun scouring antique stores and art galleries for paintings and furniture to bring to Washington.[116] They also gathered Maria's favorite embroidered clothes that she had loaned to the Cincinnati Art Museum to take with them. She used the delicately colorful pieces as inspiration for her paintings.[117]

Maria inspected their rented house, hired a staff, bought linen, food, and other household essentials in preparation for their official move on November 19.[118] She hurriedly unpacked and planned a wonderful Thanksgiving dinner, because Joe would join them from college, and the family would be together in their new home.

The Washington social season began with this holiday,[119] and Maria ensured that the *Sunday Herald* included an announcement that they had taken the "Bain residence" on Massachusetts Avenue. Also, she advised that their plans were to entertain throughout the season, and that Min was a debutante.[120]

Bellamy's election to Congress meant that they would encounter a new city, meet new people, and have varied experiences. They couldn't wait.

GIGGLE, GABBLE, GOBBLE, AND GO

O N DECEMBER 7, 1891, Bellamy Storer came into the House chamber of the U.S. Congress for the first time. It certainly was not what he had expected. The room smelled of tobacco. Bellamy could barely see through the smoke across the floor to the desks on the other side. What also confronted him was utter filth and papers all over the room. Besides using cigarettes and cigars, "[Congressmen] chewed [tobacco.]…[They] often [were likely to] disregard [their] spittoon[s] and spit on the floor."[1] The unhygienic atmosphere of the august political chamber shocked Bellamy, who always dressed neatly and only smoked cigarettes.

Bellamy came to the House at a time when Republicans were not in power. They had been badly defeated in the 1890 mid-term elections.[2] The House had such a large Democratic majority that they did not need the Republicans to achieve a quorum.

While Bellamy was acclimating to the House, Maria was adapting to her role at the nation's capital. One newspaperman observed the best way to summarize Washington society was "giggle, gabble, gobble, and go."[3] The capital's social events generally involved witty, ironic talk, delightful food, and a lively atmosphere. Maria's dinners aptly fit this description.

In this society, position counted more than money. The president was the most important figure, but not necessarily the wealthiest. Thus, Maria's millions counted less than Bellamy's position. Her handsome, "big, bustling, and brainy" husband was a major asset at any of her banquets.[4] She slyly observed, "The Old Man, as you can imagine, create[s a furor] among the fairer sex."[5]

Congressional society calendars were jam-packed. One matron reported she attended "eighty-nine dinners, more than forty teas, and countless evening receptions and musicals."[6] Part of Maria's responsibility was to pay social calls, approximately 1,500–1,800 calls

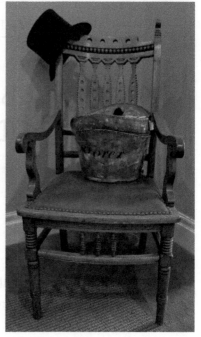

Fig. 4.1 Bellamy Storer's congressional chair, hat, and hatbox. *Ursulines of Cincinnati Archives.*

each winter. Four days a week she would call on wives of government officials from three to six o'clock. The other afternoon, Maria would be at home to receive callers herself.

Several of the Storers' first guests were friends from home. Charles Stoddard, who now served as the chairman of English Literature department at Catholic University in Washington, had lunch with them.[7] Judge Manning Force came to stay with them for a few days. Maria carefully planned several events for his enjoyment. One was a dinner where his Civil War buddies attended a lavish banquet at their home.[8]

Longtime acquaintance William Howard Taft and his wife, Nellie, who lived close by, came for dinner.[9] Taft had arrived the year before when President Benjamin Harrison appointed him solicitor

general to conduct litigation for the government. In a few months, March 1892, he would be returning to Cincinnati to work as a judge on the U.S. Court of Appeals for the Sixth Circuit District.[10] The tall gentleman, who later weighed over 300 pounds when he was president in 1908, was described in the late 1880s as "fine looking" and having a "fine physique." His kindness, "pleasant informality,"[11] level-headedness, and commonsense approach to life made him a wonderful confidant. He remained the Storers' valued friend and sounding board for the rest of their lives.

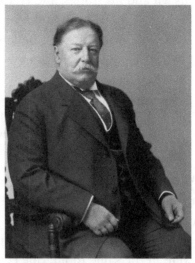

Fig. 4.2 William Howard Taft. *Library of Congress.*

It is most probably Taft who introduced Civil Service Commissioner Theodore Roosevelt to the Storers. Roosevelt was a man of tremendous enthusiasm, passion, and energy. A biographer elegantly explained, "Roosevelt's physicality...was the first thing everyone reacted to: an almost overwhelming discharge of energy, more thrilling than threatening. Men envied it; women and children basked in its glow."[12]

The Storers were no exception. The barrel-chested, charming Roosevelt amazed Bellamy with his diverse interests, the large num-

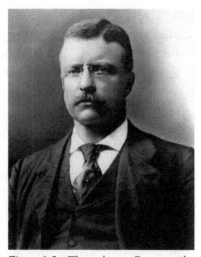

Fig. 4.3 Theodore Roosevelt. *Courtesy of Sagamore Hill National Historic Site, National Park Service, Oyster Bay, NY.*

77

ber of books he had read, and his highly retentive mind. Maria loved Roosevelt as the younger brother she never had. They both enjoyed his wit and his stories, and lavished affection on his family. The Storers and Roosevelt "met almost every day."[13] The charismatic, multifaceted man adored both Bellamy and Maria.

Alice Roosevelt Longworth many years later remembered Maria's generosity:

> When the measles ran through the nursery when we were children in Washington, Mrs. Storer used to send her carriage to take us for drives when we were convalescing. She was a great pottery expert, had started the Rookwood Pottery in Cincinnati, and herself used to make for me cups and saucers and jugs and decorate them with absurd fairies. The relation had been a close one with affection and admiration on both sides.[14]

Maria and Theodore competed for center stage whenever they were in the same room. She could laugh and poke fun at anything pompous in the news and entertain her guests with her well-informed opinions. She mesmerized listeners when she spoke about art and music, with such passion and understanding that they longed to see the artwork or listen to the music. Theodore disarmed everyone when he spoke with an unabashed, loud, squeaky voice. A torrent of words tumbled out about a kaleidoscope of topics. Both were brilliant, highly intelligent, ambitious individuals who energized guests at receptions, dinners, and other social events.

Maria and Bellamy also socialized with widower and writer Henry Adams; writer and diplomat John Hay and his wife, Clara; Senator Henry Cabot Lodge and his wife, Ann or "Nannie"; and Republican Senator J. Donald Cameron and his wife, Elizabeth or "Lizzie."[15] All the ladies of this group were well-read, intelligent, and sometimes challenging companions. Hay reportedly had an affair with gray-eyed Nannie and all the men, including Bellamy, wrote flirtatious letters to the tall, slim beauty Lizzie.[16] No one flirted with Maria, except her husband. Maria's distinction was her international

reputation as a business owner and artist. She attended many social events and patronized charities and artistic events with these ladies.[17]

Maria and Min were busily planning what dresses they were going to wear for the December debutante activities. Both knew that the city had many more single ladies than eligible men so they carefully discussed how to make the best impressions with their wardrobes. They also made time in their schedules for other interests. Min attended some college courses, while Maria visited art galleries and took in religious lectures.

Both women were intent upon learning more about the Roman Catholic Church after their exposure to Church theology and ceremonies the previous summer. Min attended a history class at Georgetown University, which was taught by the Vice-Regent Father Jerome Daugherty. She discovered that history taught from a religious perspective was quite different from the history classes she had as a child.[18] Maria listened to a lecture by Bishop John Keane, the first president of Catholic University. The thin, sloped-shouldered man with the rimless spectacles was selfless, honest, and charming. He spoke about Pope Leo XIII's recent encyclical, *Rerum Novarum* (*Rights and Duties of Capital and Labor*) that became the basis of the modern Church's position on social justice. Maria was so impressed with what she heard that she purchased the pope's encyclicals, and "read them with deep interest." She also attended a series of Keane's sermons during December. Upon her request, he sent her "some Catholic books, which she studied with great care and interest."[19]

It was a brave venture for two elite Protestant women to explore the ceremonies and beliefs of the Roman Catholic Church. Many people in the country believed that if Catholics were loyal to the pope, they could not be loyal to the United States.[20] That may seem far-fetched today because the pope has little secular power. Yet from the fourth through late nineteenth centuries, popes were civil rulers as well as religious leaders.[21]

After Christmas 1891, Bellamy traveled to Ohio's state capital, Columbus, to influence the selection of Ohio's senator. At this

time, the state legislatures appointed senators to Congress.[22] Former governor Foraker, from the Cincinnati faction, desperately wanted to return to elective office as Ohio's senator. But many believed John Sherman from the Cleveland faction of the Republican Party was the best qualified politician because he had served previously in both houses and held two cabinet positions.[23]

Bellamy supported Sherman rather than Foraker. He explained, "To elect Foraker in place of Sherman is to turn the Republican management over into the hands of men who would certainly run it into the ground."[24] Bellamy's candor disturbed Joseph Foraker, George Cox, and their cronies, especially when Sherman was indeed selected. Within a matter of days, there was a short statement in one of the Cincinnati newspapers that Storer might not be renominated in the fall.[25] Siding with the Cleveland faction had a negative impact on his career.

But that was in the future. In March 1892, the Storers attended a state dinner hosted by President and Mrs. Benjamin Harrison. A White House dinner request was considered as a "command to attend," taking precedence over any other invitations. Harrison was stiff, formal, and not comfortable with small talk. The first lady, Caroline ("Carrie"), helped the president with his social skills by talking gaily with their dinner companions. She had much in common with Maria because she also was an accomplished artist and china painter.[26]

For this event, the state dining room was decorated in "scarlet and green." Most likely, "the rooms and corridors [also we]re filled with flowers and palms." Guests for the formal event generally arrived twenty minutes before eight o'clock because "to be late was a social crime."[27]

Invitees were directed upstairs to remove their wraps. They returned to the first floor by a private staircase, which only the family and their guests used. There was a specific order for the seating of the guests, which was based on their position in Congress, or their rank

within the embassy system. Bellamy would not escort Maria into dinner. Another gentleman of equal rank would have that honor.

Once the guests were seated in the dining room, waiters served a delectable dinner on silver trays. At the close of each course, the plates were removed and plates for the next course were placed. These events included "eight to twelve courses" and generally lasted several hours.[28] Afterward, the ladies withdrew and the men smoked and then joined the ladies. By eleven o'clock, the guests retrieved their outer garments and awaited their carriages.

Mrs. Harrison probably showed Maria the recently refurnished library where the first lady had placed two stunning Rookwood vases on each side of the fireplace.[29] Maria had given her objets d'art the year before. The distinctive design on the decorative pottery showed "pitchers, plants, and leaves" cascading down "the terra-cotta glaze of the sides." For the next twenty years, Maria continued this practice of giving artwork that she had designed to each Republican first lady.[30]

By summer both Min and Maria converted to Catholicism. The faith offered consistent dogmas and doctrines that appealed to them. In a world confronted with Darwinism and scientific skepticism, it provided a certainty and sublime authority. Years later, when Maria wrote about her religious quest, she quoted a friend and fellow convert, the Rev. Robert Hugh Benson, who described conversion to be an "exchange of certitude for doubt, of faith for agnosticism, of substance for shadow."[31]

Maria thought her change of religion a personal matter, but she was one of several prominent intellectuals of her era who choose a faith that was very unpopular with the Protestant majority. Anti-Catholicism was arguably the most widespread prejudice in nineteenth-century America after racism. Maria was willing to lose some social status for the spiritual benefits of the Catholic Church. She knew it could adversely affect Bellamy's career, but she hoped not.[32]

There were two factions in the American Catholic Church at that time. From Bishop Keane, Maria learned more about her friend Archbishop Ireland. He was the leader of the Americanist or liberal clique who want to adapt or assimilate Catholics in American society.[33] They were a small, creative, and progressive bloc. The more conservative group's leader was Archbishop Michael Corrigan of New York. His faction, which attracted most of the hierarchy, preferred to "maintain the traditional integrity of the church."[34]

To advance his agenda, Ireland wanted more prominence and power within the Church and sought promotion to cardinal and the privilege of wearing the *galero* or "red hat."[35] As early as 1891, newspapers speculated that Ireland was being considered for that distinguished position.[36] While Ireland was in Rome, he heard from lay friends that President Harrison was asked to write a letter of recommendation to the Vatican in support of his selection. Harrison refused because he felt "embarrassed in volunteering advice in a church matter."[37]

The request for the Harrison letter was leaked to the press. It is not clear who did so. One of Ireland's friends, the Rev. Denis O'Connell, wrote from Rome, "The news of the Harrison letter did not come from this side."[38] The press followed the archbishop begging for information. Some created fictitious interviews when he refused to speak to them. Embarrassed, he stated, "For my own part, I feel that the fuss will keep the cardinalate away from me."[39] He did not know how accurate and prophetic this statement was.

Maria was quite taken with Americanists' beliefs and all the issues Ireland was fighting for. She heard Ireland's words and would live by them. He said that what "Catholics of the United States are called to do within the coming century is…to make America Catholic. These are days of action, days of warfare.…Into the arena, priest and layman! Seek out social evils and lead in movements that tend to rectify them!"[40]

She probably knew nothing of his maneuvering for cardinal at this point, except what she read in the secular press. Within a few

years, however, she would be deeply involved, along with his other friends, working to get him promoted to the higher Church office.

Although primarily based in Washington, Maria did not forget the Cincinnati Art School. In an undated twelve-page letter written to the art museum president Melville Ingalls, Maria painstakingly laid out her plan to change the teaching methodologies used by the educational organization. She talked about how other successful art schools in the United States and in Europe were organized and what she thought would work well in Cincinnati. Mostly, she wanted Noble removed. "I will cheerfully give a large donation to pension [Director] Thomas Noble....[A] variety of instructors is an immense advantage....It gives a liberal education and prevents mannerisms and imitation."[41] Maria was always dogged in her pursuit of what she believed, but her campaign ended in failure. Noble remained head of the art school until he retired in 1904.[42]

Maria and Bellamy attended the Cincinnati May Festival. From Bach oratorios to a Dvořák requiem the concert series offered a "delightful variety" for all music lovers.[43] They entertained Mrs. Elizabeth Duane Gillespie from Philadelphia.[44] She had met Maria while visiting Cincinnati as president of Women's Centennial Executive Committee of the Women's Pavilion for 1876 Philadelphia Centennial.[45] They became good friends and corresponded over the years. When an art exhibit or concert caught Maria's eye, she invited Gillespie to attend.

At a banquet at the Storers' mansion during the concert series, Mrs. Gillespie solemnly commented on the Cincinnati Music Festival as "leaving with an audience a memory which nothing can [change]."[46] The formidable lady greatly impressed Moses Ezekiel, who attended the same event. He recalled, "I met...Mrs. Gillespie, a very intelligent lady of Philadelphia." He concluded, "Mrs. Storer knew how to draw around her the best women and men."[47]

In June 1892, the family returned to Washington. While Bellamy worked, Maria and Min traveled to a cooler place in the Maryland Alleghenies.[48] They summered in Deer Park, Maryland, upon the advice of President Harrison who owned a summer home in the small, exclusive mountain hamlet. Bellamy could come and go with ease since the area was linked to the coast by a fast railroad line.[49] Ultimately, Maria was not happy with the weather. She found it not "dry" enough to meet their needs. With Bellamy's "rheumatic shoulder" a drier climate with mineral springs was what she preferred for her husband.[50]

Earlier in the year, Bellamy was quoted as saying, "I am a candidate for reelection. I like the work of a Congressman. It is very hard work, but it has many pleasant features."[51] Despite newspaper accounts sniping that other Cincinnati patricians might be selected, Bellamy was renominated by the party in August thanks to George Cox's influence.[52] When Governor McKinley stayed with the Storers in Cincinnati in September, he probably strategized with Bellamy about the major issues for the campaign. Bellamy spent the fall campaigning.[53]

It is strange that Maria was not involved, since she had been such an integral part of Bellamy's winning team in 1890. It is wholly conceivable that Maria feared her change in religious beliefs might cause Bellamy problems. When she converted, it was reported in the local and the national newspapers.[54] Maybe she thought anti-Catholic forces, or possibly, a Foraker crony sent this personal information to the newspapers? However, when political hacks made Maria's religion an issue in the campaign, Bellamy's Democratic opponent refused to support their diatribes.[55] In November, Bellamy overcame the acrimonious sniping and religious prejudice and was reelected.[56]

After the election Bellamy and Maria returned to Washington. The social season for Storers and Min changed. At the end of October, the first lady died.[57] With the White House in mourning, there were no social engagements with the presidential family. Then President Harrison lost the election to Democrat Grover Cleveland.

A Democrat in the White House meant no dinner and reception invitations for Republicans.

Things looked even bleaker for the Republicans than in 1890. For the first time since the Civil War, the White House and both houses of the Congress were in the hands of the Democrats. However, the Fifty-Third Congress's minority party did not make the majority party's work any easier. The two opposing parties created an atmosphere that was "inharmonious, quarrelsome, and factional."[58]

After the House went into holiday recess on December 22,[59] the family returned to Cincinnati. Since their Grandin Road house was closed, the Storers asked if they, Joe, and Min could stay with her aunt Margaret Rives King, in her large home on Third Street. She was happy for the companionship.

Joe was now in his last semester at Harvard. He believed that his undergraduate education provided the best "scientific training" for his career aspiration of becoming a doctor. The following year, Joe applied to Johns Hopkins University School of Medicine.[60] He became a member of the inaugural class, which leaned heavily on the clinical application of science and research. Maria must have been happy to have her "boy" closer to her in Baltimore. He could visit on the weekends when they were in Washington.

Min, ever watchful and ever thoughtful, had gotten into the social whirl in Washington and Cincinnati. She had met many eligible men, but none of them caught her eye.

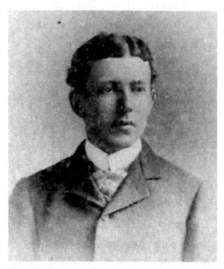

Fig. 4.4 Joseph Longworth Nichols, at college, from *The Harvard Portfolio of 1893*. HUD 293.04.2. *Harvard University Archives*.

In January 1893, the Storers and Min came back to Washington. This year would prove challenging to American society. The country suffered a national economic crisis created by the collapse of the Philadelphia and Reading Railroad and the National Cordage Company. The stock market was frightened; stock values plunged; investment firms called in loans; and overextended investors were ruined. "Fifteen thousand businesses...[b]anks, railroads, and steel mills...were bankrupted."[61] The results of business failures were high unemployment and declining prices for agricultural products.

Bellamy and other politicians did little, if anything, about the economic crisis. There was more concern with bureaucratic operating rules than the disastrous financial issues confronting the nation. "Votes on nonprocedural questions...accounted for a rather small proportion of all house votes....Agricultural matters,...[and] votes for public work to help the unemployed" did not dominate their considerations.[62]

Governor McKinley was "financially wrecked by the failure of a banking firm." Several wealthy friends, including the Storers, offered to help him. Their contribution was $10,000. A total of "5,000 donations" helped him recover completely.[63]

The Storers had a somewhat different social season than in the past. Because of the strong Democratic presence in the capital, there were no state dinners and fewer receptions for Republicans like themselves to attend. Yet with Maria's conversion to Catholicism, they received invitations to events associated with her Church. For instance, both she and Bellamy attended a party in honor of Francis Marion Crawford, who "was the author of some forty novels and one play, 'Francesca da Rimini,' and his publications commanded a larger sale than those of any contemporary writer of fiction in England or in the United States." It is likely the Storers met several Boston elites because of his introduction, including his social activist aunt Julia Ward Howe, and art patron Isabella Stewart Gardner.[64]

Although the Storers were not attending state dinners, their friends, the Roosevelts, were often asked to the White House for the special events. When the younger couple "hesitated about going to President Cleveland's reception because of the expense, [Maria] not only sent Mrs. Roosevelt a dazzling new Paris dress—in which Edith looked a dream, but she sent her own carriage with two men on a box."[65] The Roosevelts had a wonderful time, and Maria enjoyed being a fairy godmother of sorts.

Bellamy also supported Roosevelt's writing. For the publication of the *Wilderness Hunter*, the congressman contributed a larger amount than required for the Boone and Crocket Club's subscription fee. Others were encouraged to follow his example. Thus, Roosevelt was "able to get out this volume."[66]

The Storers went to a tea for Archbishop Francesco Satolli, the first apostolic delegate to the United States. He was a papal representative with oversight of the Catholic hierarchy and laity.[67] It appeared that Maria and her family hobnobbed with the "elite class" of the Church leadership. Her access to the power brokers of her faith would persist throughout her life. When Maria had questions of faith, she usually asked the senior leaders, rather than her local priests.[68]

Maria's philanthropic efforts now focused on the Catholic Church. It became the most important mediating institution for projects she supported.[69] She was highly generous first locally, and nationally, and eventually internationally. For example, like McKinley, Archbishop Ireland had financial reverses resulting from the 1893 Panic, and asked her help. She gave him $10,000.[70] In Washington, Maria and a group of Catholic ladies financed a series of lectures under the auspices of Bishop Keane at the Catholic University.[71] She helped the archbishop and his archdiocese to remain solvent, and assisted the bishop in expanding the university's teaching into the community. Later, Maria also gave $10,000 to the Catholic University for operational improvements.[72]

During the spring the Storers decided to purchase a home in Washington located on the corner of Rhode Island and Seventeenth Street. Before they moved in, they renovated the mansion. "A new part...contains a new dining room, with the ceiling the height of two stories; a music room, and...a studio."[73]

Since the president had called Congress for a special session in August, the Storers moved up the dates of their traditional trip to Europe to late spring and early summer. Maria complained that after their trip they "shall probably go to some high and dry place not far from Washington for the opening of the session and appointments of committees[,] then if Congress keeps on, the Old Man will have to stay....If [President] Cleveland would only let things alone."[74]

After arriving in Italy, Maria was in a joyous mood. She loved when the immediate family went on vacation together. Joe had graduated from Harvard.[75] Min was even more beautiful than ever in her early twenties. Bellamy was his cheerful self. Maria gloried in Italy and Austria, saying, "Italy burst upon us in all the splendor of the spring—sunlight, roses beatified ruins—[the] sapphire Mediterranean[,] orange and lemon groves with both fruit and blossoms."[76]

Maria and Bellamy bought antiques, paintings, and other objets d'art for the Washington home, as Kate Swan McGuirk described:

> When asked recently what she had brought home from her last trip she answered promptly: 'Oh, nothing but a few articles of necessity; the financial depression is so great.' 'But what were they?' persisted the questioner. 'Nothing much,' Mrs. Storer hesitated, 'except a sedan chair and a sarcophagus.'...A visitor studying the design of its decoration asked the owner what connection she could establish between the cherubs treading [on] grapes and the original functions of the sarcophagus. 'He possibly met his end through over-consumption of the results,' replied Mrs. Storer.[77]

The family arrived back from their voyage in New York on August 7. Bellamy took a fast train to Washington so he could be present when the clerk called the roll the following day. The presi-

dent wanted Congress to deal with the financial crisis by repealing certain tariffs that had reduced American revenues. Fearful British investors sold off American securities.[78]

Although the country was in the throes of the worst depression of the nineteenth century in the summer of 1893, Bellamy saw fit to travel with Maria along the New England coast, seeing relatives and meeting new friends. Bellamy did not have a good record of attendance for roll call votes. During his four years in Congress, he "missed 453 of 677 roll call votes," or 67 percent of the time, he did not vote.[79] It is not known if his lack of attendance was an issue for his constituents.

The Storers visited their friend Isabella Stewart Gardner at her Green Hill home in Brookline, Massachusetts.[80] Maria was immediately drawn to her because they had similar interests and outlooks of life. They shared a love for art and music. Both had "a startling frankness" that was refreshing to some, or irritating to others.[81] They were energetic and loved to travel. Isabella found solace in the Episcopal Church. Maria found inner peace in the Catholic Church. They corresponded and visited each other until Isabella's death in 1924.

At the same time, the Woman's Columbian Association was formed to gather artwork created by local artists for the Cincinnati Room at the 1893 Chicago World's Fair. They were selecting the best "paintings, sculpture, ceramics, wood carving, art needlework, and books" for the display. The group asked Maria to lend one of her paintings that she had completed the previous year. Besides her painting, Maria also loaned several decorative pottery pieces that she designed. She was unable to participate in any of the fundraising activities at home, but she donated $100 to help pay expenses of the display.[82]

When M. Louise McLaughlin went to Chicago to see the Cincinnati Room, she read the catalogue for the exhibit and was upset that there was no mention of her discovery of the underglaze technique. Clara Chipman Newton, who wrote the exhibit pamphlet, told her that the brochure had originally stated that McLaughlin

was the originator of the process. However, Rookwood's W. W. Taylor had requested that the information be removed. He believed that Maria had developed the technique.[83]

When McLaughlin returned home, she wrote to Taylor stating that the "process of underglaze decoration first introduced by me, was the foundation principle of the process...now used by Rookwood." He replied that Maria "did not admit that Rookwood was indebted to you." Undeterred by his rebuff, she wrote a superficially polite, angry letter to Maria saying, "I feel...that any true history of the introduction of this pottery in Cincinnati must give me credit for having furnished the idea upon which the industry has been founded."[84]

Maria countered, "I laughed at the idea that the method was anything new or original....Your reputation can rest so well upon what you yourself have done that it is not necessary that you... should seek it outside of things which you have had absolutely no connection." The following day Louise retorted by saying, "I am not disposed to admit the justice of your objection." Maria sarcastically responded, "There is not the slightest doubt that you painted pottery before me—so did the Egyptians....[If] you had never painted[,] Rockwood Pottery would have been the same." One more time McLaughlin answered, "You have stated your opinion, I have stated mine, and there we must agree to differ."[85] Maria was not bothered by the anguish felt by Louise.

In November 1893, the Storers were back in Washington for the next session of Congress. They moved into their new home during the early months of 1894, excited to have the renovation completed. At a cost of $32,000, the results were spectacular: as one newspaper complemented, "Each room had its own collection." She asked Henry J. Gest, the Cincinnati Art Museum's assistant director, to send back her 700-piece Morse pottery collection and several Japanese articles of needlework that she had loaned the museum and art academy. She had an art studio where she could display and be inspired by the unique designs of the pieces.[86]

They entertained Theodore and Edith Roosevelt at dinners many times over the social season.[87] Maria described the one dinner:

"In those old days, our house on Rhode Island Avenue was another home for [the Roosevelts]. Once, when Mrs. Roosevelt was absent, 'Theodore' gave there a large dinner-party of men where he was the host and my husband was a guest. I was allowed to peep at it from behind the curtain in the gallery; here my meal was served. The dinner was a great success."[88]

Roosevelt wrote his sister about his Washington friends, "We are on terms of informal intimacy in houses like the Cabot [Lodges,] the Storers[,]…and Henry Adams. It is pleasant to meet people from whom one really gets something; people from all over the Union, with different pasts and varying interests."[89] The Cincinnatians also introduced Roosevelt to Catholic Church leaders, such as their good friend Bishop Keane. Roosevelt noted to his sister, "Another evening we dined with the Storers, to meet…ecclesiastics, among others Bishop Keane whom I like, and with whom I had a long and very plainspoken argument over public schools."[90]

The Storers exposed Roosevelt to the anguish of religious prejudice. During the 1892 election, he saw how certain anti-Catholics targeted Bellamy. He could see how tormented Maria was, and Bellamy's bluff attitude to "soldier on." Yet Roosevelt knew the congressman was angry underneath and concerned for his wife's upset.

Theodore and Edith Roosevelt complimented the Storers by asking Bellamy to be one of the godfathers for their child Archibald ("Archie").[91] Roosevelt explained to Maria, "You know very well that there are but few people in the world who are as dear to us as you and Bellamy are."[92]

Outside of politics and social obligations, Maria also kept busy with her artwork. She had a small kiln nine inches by six inches in her Washington studio.[93] When she was in Cincinnati, she updated her skills at the Rookwood Pottery Company. At the factory, she met Yosakichi Asano, a Japanese metalworker who joined the staff

to "fabricate and apply...metal mounts" to the pottery. Under his influence, Maria began experimenting with metal in her work.[94] At this point there is no evidence of her oil painting projects.

In June, Bellamy served as the temporary chairman of the Ohio Republican Convention. Governor McKinley escorted Maria into the auditorium where he spoke, and they listened enthusiastically. His address set the tone of the convention. The Republicans wanted to be back in power at the national level. Bellamy held the audience in the palm of his hand when he said,

> "And not in contrition, but in self-confidence, not in shame, but in triumph, [we] will march back into the control of the nation's well-being that mighty army of Republicanism.... And as ever at the head will march Ohio, always the leader, ready and able to take up the burden and the responsibility of leadership."[95]

The Storers went on to Washington, where Bellamy worked for a few weeks. While Bellamy attended to business, Maria, Min, and Joe packed to go with him to Hot Springs, Virginia. At the thermal springs, Bellamy "[took] hot water and a massage for his rheumatic shoulder, and arm which trouble[d] him much." Maria, as usual, reveled in the scenery, "We...drove over one of the most beautiful roads I have ever seen. The clear trout stream ran through one of the valleys and bushes covered with blooming rhododendrons."[96]

Joining the family was a German aristocrat, Baron K. von Nostitz Wallwitz, who was visiting this area for the first time.[97] He was one of the eligible men whose eyes followed Min when she danced. At the spa, the baron saw her every day, as Maria explained to Eugene F. Bliss, "Young von Nostitz...has come down here for a couple of days to see us and is making sheep-eyes at [Min]. Joe is here, and they are riding and driving all the time, but poor Joseph finds it a trifle dull chaperoning the Loon [Min] who gives him no peace."[98] The Storers must have approved of the baron because they invited him to be their guest in the fall in Cincinnati.[99]

After the visit to Hot Springs, the Storers traveled to New England to visit family and friends. Bellamy campaigned for his friend Congressman Thomas Reed, in Maine. While he was away from Cincinnati, Bellamy employed two clerks to manage his political interests. Unfortunately for him, neither clerk had the inside information that George Cox planned to dump him and nominate someone else as the Republican Party candidate for Congress in 1894.[100] The *Cincinnati Enquirer* suggested, "It behooves Congressman Bellamy Storer to visit his district." The newspaper stirred the pot more a few days later with another story that reported, "Mr. Storer has kind of lost caste with party leaders here."[101]

The political intrigue made national news. A reporter in Boston tracked Bellamy down at a hotel and asked him about what happened. Bellamy replied, "I was on my way west ten days ago, but Mrs. Storer, who was with me, was taken suddenly ill when we arrived in Boston and we were compelled to remain here....All I know is that the convention nominated someone else."[102]

Newspapers delighted in discussing what happened when Storer was "decapitated" or suffered a "coup de gráce." Some reporters speculated about the reasons. They wrote article after article that Storer consistently supported the McKinley-Sherman faction over the Cox-Foraker clique. Others suggested that the anti-Catholics targeted the congressman. One journalist speculated that Maria refused to accept Mrs. Cox socially, and her rudeness caused Cox to throw his support elsewhere.[103]

For all Bellamy's support of the Cleveland Republicans, where was Governor McKinley when he heard about the political maneuver? Bellamy said he was "sitting supinely with his hands folded."[104] He lashed out in print at the boss-run Cincinnati faction: "I knew I might not be re-nominated....The machine, owned by one man, had power to defeat me....Was not one man alone who was 'turned down,' but every Republican."[105] Bellamy illuminated a problem that others in U.S. cities had, where bosses coerced voters to support their candidates.

Roosevelt wrote to Henry Cabot Lodge about the high jinx, "Storer was defeated for the re-nomination." A few days later, in another memo he added, "I have seen Storer since coming back. He takes his defeat well. Of course, he minds it much. He is just as sweet and good as ever."[106]

Bellamy's mood lightened somewhat when he wrote Eugene F. Bliss and asked him to come to Washington on Thanksgiving, and he provided a snapshot of the family:

> "Thanksgiving is five days off and a turkey stuffed with chestnuts will be served. No attack at the house either is anticipated from either infuriated Forchheimerites or indignant McKinleyites....Joe...assists [medically] at the football game of today....The Madam has a new piano, which sounds grandly. The Loon [Min] is well as usual."[107]

The couple also attended with Charles Stoddard a double bill theater performance at the New National Theater. The professor was a bohemian of sorts who added a pinch of vinegar to their lively Washington dinners. They also enjoyed helping him furnish his bungalow. Maria gave the educator a pair of antique chairs for his somewhat exotic front room.[108] Maria also created a short poem and a series of sketches for Stoddard's autograph album. The playful illustrations showed Stoddard diligently writing at his desk and Maria painting a piece of pottery. Additionally, she penned an affectionate verse: "My work is done is terra cotta / I'm nothing but a simple potter...Genius and wit these pages fill / The pen is mightier than the kiln / But one and all our hearts are soldered / To friendship for Charles Warren Stoddard."[109]

To complicate the family's holiday season, the newspapers reported a legal conflict between Storer and Foraker for the gossips to savor. Foraker represented John W. Flora in a lawsuit against the Longworth estate. Flora asserted he was the illegitimate heir of Maria's late aunt, Eliza L. Flagg, and demanded his fair share of the first Nicholas Longworth's estate.[110] The Flaggs' heirs, who included Maria, refused to pay so the suit went to court. Bellamy represented his wife's interests.

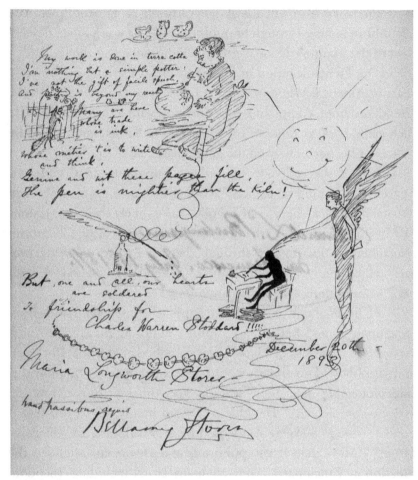

Fig. 4.5 Poem illustrated with ink sketches of Charles Warren Stoddard writing at his desk and Maria Longworth Storer painting pottery. *Charles Warren Stoddard Autograph Album, p. 106. The Huntington Library.*

During this difficult time, there was one bright spot in Washington. A new beau was courting Min. The German baron had stopped mooning about her. Now, a very tall, distinguished French nobleman with pale, delicate, expressive features and "a laughing pair of blue eyes" made himself known at the Storers' Rhode Island Avenue mansion.[III] Marquis Pierre de Chambrun was interested in Min.

Pierre was born in Paris of the politically prominent Pineton de Chambrun family. Through his mother's side, he was a direct descendant of the Marquis de Lafayette. His father served as the legal advisor to the French legation in Washington, so Pierre spent his early years in America. When he returned to France at about age ten, he attended school, completing his education with a degree in law. He then came back to America to work with his father, and eventually took over his position when the gentleman died.[112]

"Pierre succeeded to his father's popularity...and endeared himself to Washington society."[113] Some hostesses even overlooked his one drawback—he was a Catholic. It was likely they were jealous of Min for eliciting his affections. Clara Longworth de Chambrun remembered, "Pierre went through the usual stages of being progressively 'attentive,' 'devoted,' and by general degrees, 'in love' with her."[114] But nothing official was announced at this time.

As his final day in the House approached, several friends from Cincinnati invited Bellamy to a dinner honoring his congressional service. He responded, "I have always laughed at 'dinners' [for] men and said I hoped my friends would never offer me one—but now this [indecipherable] has come—it looks very different to me from the average complement." He added, "I need hardly say to you that if Foraker were to be present it would be very awkward and offensive to me."[115] More than 150 Republicans and Democrats attended the function at Cincinnati's Saint Nicholas Hotel including Theodore Roosevelt, who was "eloquently complimentary" about Bellamy's service.[116] He wrote his sister about the farewell events, "I attended a farewell dinner [for] Storer...I got back on Thursday and that night we went to *our* farewell dinner at the Storers."[117]

During the last few months, Maria systematically closed their Washington home. She maintained only a skeleton staff and sent most of their beloved art home to Cincinnati. She did not know if they would live in the nation's capital again.

When asked about their plans, she replied, "That is a very hard question to answer for we have no settled plans about our movements at all. We will go from here directly to Europe where we will remain for four months....Mr. Storer will devote his time at looking after his large property in town."[118]

Washington had been an important experience for Maria. She became a social hostess on the national stage. She met and established friendships among the Washington elite, Adams and Hay. She was a shining star of this small group, perhaps not flirted with like Lizzie Cameron, but respected for her artistic skills, energy, and intelligence.

The Storers made notable friends, such as the charismatic Roosevelt, the gentle Keane, and the fiery lightning rod Ireland. For Roosevelt, they were the "dear Storers" whom he looked upon as family. Keane and Ireland led the couple into the politically charged atmosphere of the American Catholic Church. Becoming a Catholic did not hurt Maria's reputation nor enhance it. However, that decision hurt her husband's reputation, and career. So, as in 1886, when they were first married and scandal was on the lips of gossips in Cincinnati, they steamed away on a luxury liner to Europe, away from prying eyes, to rest and reconsider their future.

EXILES

AFTER BELLAMY'S FAILURE to be renominated, the Storers felt exiled from the seat of power, Washington, DC. Yet their lives went on.[1] In the summer of 1895, Bellamy and Maria were excited when Eugene F. Bliss agreed to join them and their adult children on a trip to Europe. The group first sailed for Sicily. "The remainder of the time is occupied in traveling…through the outlying parts of the kingdom of Italy which was off the beaten track of travel."[2]

The Storers went to Rome for their first papal audience. Maria vividly described how a priest initially dismissed them because "private audiences are not granted to everyone." However, when he discovered that Bellamy had served in the U.S. Congress, he arranged a meeting. Although Bellamy was not a Catholic, Maria recounted, he "was interested in the church," and wanted to meet the pope.[3]

On the day of the audience Maria dressed carefully in a black lace dress with a beautiful lace mantilla covering her head. She was now a handsome forty-eight-year-old matron, whose hair was grayer than brown, with some small wrinkles around her dark eyes. Bellamy looked tall and distinguished in his formal attire, silk waistcoat, and black bowler. He thoughtfully gave her flowers to carry with her in the carriage to mark the important event.[4]

During the early afternoon, they entered "the Bronze Gates, the principal entrance" of the Vatican. They mounted a "flight of stone steps" and entered that portion of the palace occupied by the pope.[5] Then the couple was taken into a room and introduced to a man wearing a cream-colored vestment. He was Pope Leo XIII, a short, gray-haired man in his eighty-sixth year whom they both found endearing and disarming all at once. After his blessing, they left quietly and returned to their hotel. This was the first of seven private audiences that the couple would have with three pontiffs over the next twenty-five years.[6] From Rome the group journeyed to northern Italy.

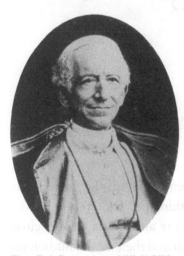

Fig. 5.1 Pope Leo XIII (1878–1903) was the first of three popes with whom Maria had private audiences. *Archdiocese of Cincinnati Archives.*

In Pallanza, Pierre de Chambrun joined the travelers. The lush landscape, the crisp air, and the loveliness of the Italian lake country worked its magic on the young couple. By the end of July it was official, Min was engaged to Pierre.[7] The trip at this point took on another purpose. According to Clara Longworth (later de Chambrun), Min "[went] through the ordeal of country-house visits and meeting the family....Family magnates...expressed their approval" for their wedding to take place in Cincinnati at the end of the year.[8] Maria and Min took time in Paris to find just the right dress and create a proper trousseau. The acquisition of clothes and linen for a society wedding could cost as much as $40,000.[9] It is doubtful that Maria spared any expense for her only daughter.

When the Storers returned to Cincinnati in late September, they took up their social life as if they had never left. Both attended many club meetings and parties given by their friends while prepar-

ing for the wedding.[10] Maria also loaned artwork to the Cincinnati Art Museum.[11] Bellamy became involved in local politics again. He was a favorite guest speaker on topics as diverse as taxation, improvement of the waterways, and Abraham Lincoln.[12]

Pierre married Min at a lavish wedding at Holy Angels Church. Maria had negotiated with Cincinnati Archbishop William Henry Elder to allow the event to occur during Advent.[13] Clara Longworth de Chambrun wrote, in a rather tongue-in-cheek statement, that Elizabeth Duane Gillespie "added a colonial touch" of American aristocracy, as a descendant of Benjamin Franklin. Likewise, Pierre's mother, the marquise, represented the French nobility as a descendant of Lafayette![14]

Min's gown was "a beautiful Paris creation of white satin with a high bodice and a full train....Bishop Keane officiated." At a reception for three hundred at the Storers' Grandin Road mansion, Min wore the Chambrun diamond crown. Maria's gift, "a magnificent necklace of pearls and a diamond pendant," was equally lavish.[15] After the festivities the couple left "on a short trip." They would have a happy marriage that endured two world wars.

Back in Washington after the honeymoon, Pierre and Min enjoyed the usual round of parties and receptions associated with Pierre's position at the French embassy.[16] However, they made plans to move permanently to France the following year.[17] The bishop from Mende, France, had contacted Pierre and asked him to run as a candidate for the Chamber of Deputies, representing the people of the surrounding communities of the *département* (district) of Lozère.[18] The prelate wanted a conservative Catholic to win the seat. Pierre's family had lived and owned an estate for generations near Marvejols so he knew many of the issues confronting the *département*. And Min, like her mother, would take an interest in her husband's political career.[19]

In February 1896, Bellamy represented the Chamber of Commerce at a meeting of the Board of Trade in Washington. From there he went to New York to visit Roosevelt, before coming home.[20] He wrote letters to Governor McKinley and other politicians about current issues involving the Republican Party that demonstrated his continued interest in national politics.[21]

The Storers' charitable efforts in Cincinnati, as in Washington, appeared to be guided by their Church. For instance, Archbishop Elder corresponded with both Storers about people who needed assistance.[22] It is believed they helped people who were destitute to find jobs. Maria and other members of Holy Angels Church in Cincinnati funded stained-glass windows for the house of worship.[23]

When the Unity Club asked Maria to present the history of the Rookwood Pottery Company at one of their meetings, she wrote an interesting speech, but apparently did not feel comfortable presenting it. So, she asked Bellamy, instead, to give the talk during their March meeting. The newspaper reporting about the presentation complimented Maria by observing, "Cincinnati is indebted for the creation" of Rookwood.[24]

In June 1896, after two years of litigation, the Flora case against the Longworth estate was finally resolved. Although Foraker valiantly argued that Flora was a legitimate heir to part of the Longworth estate, the court ruled against him. The decision read, in part, "In whatever aspect the case may be viewed, there is no merit in it."[25] Maria stated the case was the chief reason why Foraker became Bellamy's "personal enemy."[26]

William McKinley was nominated as the Republican presidential candidate in 1896, to the joy of Maria and Bellamy.[27] The Storers and Joe, who were summering in Westport, New York, asked the candidate and his wife, Ida, to join them for a short break in the

campaign. Maria craftily told her, "You could have your husband all to yourself for a while."[28] That was probably an appealing promise, but McKinley could not work it into his schedule.

The vacation did, however, produce several interesting yet divergent events. They met a parish priest, the Rev. Francis Xavier (F. X.) Lachance, who impressed Bellamy with his piety and love of the Catholic religion. The cleric counseled and convinced the former congressman to convert to Catholicism.

The Storers visited Sagamore Hill, Theodore Roosevelt's hill-top home, in Cove Neck on Long Island, New York, to call on him and his family. Maria recalled, "It was a great pleasure to see them all." Their host kept them laughing because "one never knew what he would say next." He and Maria rowed out on the calm, sheltered waters of the bay close to his home and discussed his future prospects. Roosevelt was "depressed," and believed his public life was over. Maria assured him that she and Bellamy would assist him in any way possible. He wanted to be named the assistant secretary of the navy. She agreed to talk to McKinley on his behalf.[29]

In the fall Storer and Roosevelt offered their rhetorical skills to the Speaker's Bureau of the Republican National Committee. As members of "an army of spellbinders," both eloquent orators crisscrossed the nation by rail, telling people why McKinley should be elected, and condemning his opponent, populist William Jennings Bryan. They campaigned together in New York City. After one of the Cincinnatian's rousing talks, the pair visited several Republican political headquarters, and praised the hard work of the New Yorkers for McKinley. A newspaper described Bellamy as "fearless as Roosevelt."[30]

On November 3, William McKinley was elected president and the Republicans were returned to the White House. Now the "time-honored approach of dangling favors and patronage" dominated the news. Bellamy's name was rumored to be in play for any number of positions.[31]

Roosevelt and Storer wrote multiple letters back and forth, planning, preparing, and deciding how to influence McKinley to select them for positions they wanted. The Storers went to Canton, Ohio, to visit the president-elect. Maria urged him to consider Roosevelt for assistant secretary of the navy. McKinley hesitated because of Roosevelt's "pugnacious" reputation, but he ultimately nominated the New Yorker.[32]

McKinley had considered Bellamy for a position in the State Department. Foraker, who had been elected to the Senate, fought against his confirmation.[33] The senator, however, did support his nomination for a diplomatic post, happy to see him out of the country. Newspapers were filled with gossip that Storer would be selected for a diplomatic post in France, Italy, or the Vatican.[34]

The administration received several letters opposing Bellamy's nomination for any position. All but one objected to him because of his religion.[35] The remaining protestor, tantalizingly, was George Ward Nichols's brother, William W. Nichols, who stated, "I respectfully refer you to a communication and protest to such appointment which I sent to Senator J. B. Foraker,...Senator Lodge and John L. Long." Unfortunately, there is no additional information in the Foraker, Lodge, or Long papers that explained his objections.[36]

McKinley did not listen to these protests, and ultimately nominated Bellamy for minister to Belgium. Bellamy accepted and was confirmed by the Senate on May 4.[37] The Storers had little more than six weeks to settle their affairs and say good-bye to their family and friends before boarding their ship. Maria contacted the Cincinnati Art School and the Cincinnati Art Museum. She loaned several pieces of Japanese clothing to the school, which she believed could be used to make a "beautiful study in color," and, "a vase for the case" in the museum.[38] Before leaving the city she visited with her aunt Margaret Rives King, who was frail and ill, and her good friend, Julius Dexter. It was the last time she saw them, for both would die the following year.[39]

The Storers packed several unusual items generally not seen in diplomats' homes, such as a small gas kiln, paints, chemicals, and different kinds of metals for Maria's studio. Why metal pieces? Maria invited Asano, with whom she worked at the Rookwood Pottery Company, to come to Brussels and work with her full time. He had mounted some of her most beautiful pieces of pottery. She brought him to "provide manual assistance with the process" of creating her metal artwork in her studio, plus he sometimes valeted for Bellamy.[40]

The Storers stopped in Washington before leaving the country. Since their mansion was rented, they entertained friends and politicians, such as Charles Stoddard and the Roosevelts, at the Shoreham Hotel where they were staying.[41] Just before leaving, Maria visited the White House and presented Mrs. McKinley with a "superb drinking cup of her design." Earlier she had presented McKinley with his portrait, which she had commissioned Fedor Encke to paint. The president and the first lady were both pleased with these gifts.[42]

The Storers, Min and Pierre de Chambrun, and Joe traveled to Europe together.[43] Joe was the only one returning in the fall. He had graduated from medical school "at the head of his class," and received a fellowship in pathology at Johns Hopkins.[44] He wanted to train as a bacteriologist. He would work for the brilliant, yet austere, William H. Welch, the first dean of the Johns Hopkins School of Medicine.

After spending time helping Min and Pierre get settled in France, Maria, Bellamy, and Joe went by train to Brussels and arrived on July 5, 1897. Maria wrote to a friend, "You would enjoy this place in every way. The park which opens out in front of our hotel windows is a lovely…place….We have a palatial suite of rooms, with a salon adorned with a portrait of [Belgian King] Leopold."[45]

The monarch had a terrible reputation as an adulterer and philanderer. Maria described how a lady "proceeded to entertain me with praise of the Belgian Queen and violent wrath, against her Majesty's spouse." She encouraged Maria not to "hesitate to '*brusquer*' [push around]" the ill-behaved king.[46]

On July 23, 1897, Bellamy presented his credentials to the king. He was ushered into a room where "officials took their positions at a distance, in a semi-circle, so that the conversation could be entirely confidential." Bellamy "made three bows," and presented the king his official papers on behalf of the president. He liked the ruler immediately, and the feeling was reciprocated.[47]

King Leopold was in the thirty-third year of his reign. The tall, lanky, white-bearded sexagenarian was considered "one of the shrewdest...monarchs [in Europe],"[48] who acquired colonial territories for himself and for his country. He had a mind for figures and was always looking for ways to expand the country's monetary interests. The great material progress of Belgium during his reign was attributed to him.[49] In 1902, Roosevelt wrote to Bellamy about the king, "What an extraordinary thing it has been, the way Belgium has played her part in the international development of [the Congo Free State in] Africa." Bellamy agreed. Opinions, however, would change drastically when the monarch's abusive policies toward the local population, today likened to a colonial genocide, came to light.[50]

The following month the Storers moved into the Palais d'Assche, a huge mansion they leased for their home and the legation.[51] Bellamy joked about their grand home, "We moved into our house last night. Slept amid old family portraits and heard old family ghosts until the Madame had candles lighted and with Coquette [her dog] had a conversational night....Our house faces the prettiest little square you ever saw and has a garden behind...that is pretty[,] and for Brussels[,] immense."[52] Maria was likewise captivated, and wrote to Eugene F. Bliss, "This house was built fifty years ago by Marquis de Assche, who said, 'I am going to build the finest house of the century to be lived in forever by my family.' But alas, his money slipped away and so did the old gentleman at last."[53]

Bellamy and Maria both loved the culture of the capital. They visited the art galleries and bookshops, and strolled through the lovely gardens and parks. Their main diversion, however, was play-

ing or watching tennis matches. Maria stated, "Our chief amusement now is to drive out to the tennis grounds where the Old Man plays and I look on, and have tea afterwards. Many of my friends go and it is pleasant."[54]

The Storers enjoyed living in a predominately Catholic country. The king and a large portion of the aristocracy practiced their religion. The Catholic party dominated politics. Religious instruction was part of the curriculum in state-supported schools.[55] This interconnection between religion and Belgian society was very appealing to Maria who always believed that religion should be the center of a person's life.[56]

Maria was fascinated by her duties as an ambassador's wife. Similar to her social round in Washington, she called on ladies in the diplomatic circle. "Favorite subjects among women were children and the rainy weather; aside from gossip there was talk of little else."[57] As a cosmopolitan woman, Maria was intrigued rather than irritated by the small points of etiquette that meant so much to the Europeans. For example, "An important guest should be seated on the sofa when calling and the maneuvering for the proper seat is sometimes as complicated as a Japanese tea ceremony."[58] One of her responsibilities was meeting Americans who resided in Belgium and holding receptions or dinners on certain U.S. holidays for them at the legation. The Storers entertained other diplomats, aristocrats, and visiting dignitaries, and patricians from the United States who were traveling in the country.[59]

By virtue of her intellectual and social brilliance, Maria attracted many people and their families to the legation. She always created an interesting social space around her, assembling an entourage of male political and religious mentors, and female aristocrats or elites. Her circle aided her forays into the political world. Maria considered the politician Auguste Beernaert, Belgium's former prime minister, to be "the greatest of the statesmen and Catholics."[60] She frequently spoke to him for advice and assistance.

Nuncio Aristide Rinaldini, the papal representative in Belgium, "c[alled] me often [to their receptions, even though] our unfortunate war with Spain...troubled him."[61] She counted aristocratic Belgian women as confidants and advisers. Comtesse Eugénie de Grunne, a cultured, wealthy woman, agreed with Maria that Archbishop Ireland should be promoted to cardinal.[62] The Comtesse de Flandre, who was the mother of the king's nephew, Crown Prince Albert, shared many common interests with her, as an artist and lover of nature.[63]

Maria wrote directly to McKinley generally seeking and giving diplomatic information. For example, in one note, she asked him if the fleet would be coming to Europe, and in another letter, she informed him that King Leopold might visit the United States.[64] It is unlikely that other diplomat's wives had such entrée with the president. As far as can be determined from the documents, McKinley did not object to her involvement. She relished her opportunity to be a part of the diplomatic world.[65]

She also wrote to Roosevelt and asked him to keep an eye on her son Joe. She hinted she would like the physician to live with the Roosevelts in Washington. Roosevelt responded, "Need I say, that we will be only too glad to do whatever we can do for Joe. Unfortunately, we can't have him stay with us in the winter, because there is a child in every cranny of the house, and he would have to room with your godson [Archie,] but we shall get him whenever he can come on Sundays."[66]

In February 1898, news was cabled to Belgium that an American battleship, the *Maine*, exploded in Havana harbor, killing 266 sailors. "Ostensibly on a friendly visit, the [vessel] had been sent to Cuba to protect the interests of Americans there after a rebellion against Spanish rule broke out in Havana in January."[67]

Americans immediately blamed Spain. War fever fueled anti-Spain tirades in the newspapers and on the floors of both houses of

Congress. The president held warmongers at bay by asking "the public to withhold judgment until the facts were established" by a "naval court of inquiry."[68] In Belgium, Bellamy received condolences from the king and other diplomats.[69]

Privately, Roosevelt did not believe that any evidence of Spanish involvement would be found; and publicly he called the situation an "accident." He penned in his diary that the president is "painfully trying for peace." Whatever the outcome, he concluded that "the Navy is in good shape."[70] On March 28, the navy report was made public, finding that the explosion resulted from a submarine mine.[71]

At the same time, the Storers were concerned with other matters. They had a private audience with the pope. Bishop Keane wrote to Archbishop Ireland that their "dear friends, Mr. and Mrs. Storer spent last week in Rome" talking about American "conditions, needs, and dangers," and about a promotion for Archbishop Ireland. Keane, who had coached the diplomatic couple, believed the conference "was satisfactory."[72]

It was an unofficial meeting; the pontiff received the Storers privately. If the U.S. secretary of state had been informed that the Storers discussed American "conditions and needs" with a leader of a foreign organization without prior departmental direction, it is likely their actions would be censored. They also lobbied on Ireland's behalf for his promotion to cardinal, which was certainly outside the scope of responsibilities of a diplomatic couple.

Later that month, when Maria came home to Cincinnati, she enjoyed being the center of attention at several social events.[73] Bellamy's diplomatic post seemed to increase her social prominence. Additionally, she brought "five pieces of pottery with bronze mounts and four pieces of bronze" for display at the Cincinnati Art Museum's Fifth Annual Exhibition of Works by American Artists that opened in May.[74] Maria's artwork was profoundly different from anything else that was shown. Her art inspired a modern expert who wrote, "Usually inspired by nature and sometimes even featuring elements

cast directly from natural objects, her works present motifs swirled together in animated, complicated scenes."[75]

By lending pieces to art expositions, she reminded the public of her work. Daily print journals ran stories and advertisements about her work after she moved to Europe, just as the media had for the last twenty years.[76] One newspaper even went so far as to say,

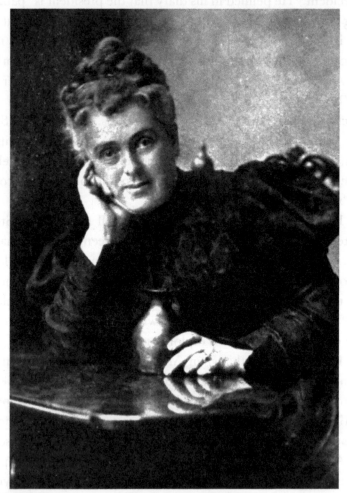

Fig. 5.2 Maria Longworth Storer, holding a piece of pottery. Reproduced from *Memoirs of Theodore Thomas by Rose Fay Thomas* (New York: Moffat, Yard, and Co., 1911).

"She is equally expert at the oven in making biscuits or molding clay novelties."[77] Hyperbole certainly, but again, it achieved the name recognition she desired and probably helped to sell her art. Sales of her decorative pieces, paperweights, and vases were brisk at high-end jewelry stores, such as the Loring Andrews Company in Cincinnati and Tiffany and Company in New York City. Her marketing must have been successful.[78]

Meanwhile, a newspaper reporter queried Bellamy about his reaction to the Cuba situation on March 19. He said, "I haven't much opinion to express upon our political affairs as I have been out of the country for some time.....I think our troubles with Spain will be adjusted without resorting to arms. In Belgium, President McKinley's conservative policy is commended. Much interest and sympathy was manifested over the *Maine's* catastrophe." His prediction proved to be incorrect.[79]

On March 27, the pope asked Archbishop Ireland, through his Secretary of State Cardinal Mariano Rampolla, to attempt a last-minute mediation.[80] Ireland had trepidations. As a special envoy for the pope, he knew that this undertaking could build or destroy his chance for appointment as cardinal.[81] He sought advice from Bellamy. They hatched a scheme to travel to Washington, meet with the president, and offer papal assistance. Bellamy contacted the State Department and the White House. A meeting was set for April 1 at the White House.[82]

In utter secrecy, the archbishop boarded a train bound for Cincinnati. A wire from Rome followed him there written in Latin, to maintain confidentiality, containing more guidance from Rampolla.[83] Then the Storers and the archbishop traveled to the nation's capital. Any curious reporters were told they were coming for "social entertainments."[84]

The meeting took place at the White House and included McKinley, Ireland, Storer, and Undersecretary of State William Day. Ireland summarized the conference in a cable to the papacy. His report gave the Church officials a very positive impression of papal

involvement. The "Vatican announced that Washington and Madrid had accepted papal mediation." McKinley was horrified and "immediately denied [the report]."[85] In the United States the announcement provoked latent anti-Catholic venom from Protestant pulpits and in print.[86] Many worried that Rome would try to take over the United States and demand total conversion to Catholicism. Hereafter, McKinley distanced himself from Ireland and would only deal with him through others.

With his negotiations made public, Ireland openly visited and discussed peace options with the assistant secretary of state, congressmen, and influential European diplomats.[87] Nearly every day Ireland sent optimistic cables to the Vatican and received guidance and information back from Rome.[88] Still, the response of the Spanish government, according to the U.S. minister to Spain Stewart Woodford, came from "the usual world-old Spanish delay and sinuosity."[89] In other words, their response was confusing and slow.

On April 14, Bellamy met with the president for the second time. He summarized the meeting for Ireland, describing how the "atmosphere last evening was heavy and dark." He said Congress wanted war.[90] On April 24, the Storers, Joe Nichols, Susan Longworth, and her two daughters, Nan and Clara, sailed for Europe.[91] The following day, war was declared.[92]

Roosevelt immediately resigned his position. "The president has asked him twice as a personal favor to stay in the Navy Department,"[93] but the New Yorker wanted to fight. He gathered an eclectic regiment of volunteers, including cowboys, boxers, Ivy Leaguers, hunters, frontiersmen, tradesmen, and friends to form the 1st Volunteer Cavalry Regiment, or the Rough Riders, to fight Spain in Cuba.[94]

Papal intervention between the United States and Spain was a political fiasco. The attempted negotiation caused McKinley to hold Ireland at arm's length. The pope also blamed Ireland for the mess. Maria noted two years later that Ireland "is still in great disfavor....

The chief grievance against him is still his 'failure' to prevent the declaration of war with Spain."[95]

The impact on Bellamy was also adverse. He played a pivotal role in international relationships of the United States by assisting the pope's efforts to maintain peace, but it created a perception of him as a "Catholic diplomat" not a talented "diplomat." This label would reduce his political opportunities in the future.

A week later the war began not in Cuba, but in the Philippines. Admiral George Dewey and the American navy destroyed the Spanish fleet in Manila Bay in just six hours.[96] Now the United States was involved in a war in both hemispheres.

Bellamy recorded rapturously the American navy's decisive victory to John Hay, ambassador to Great Britain, soon to become secretary of state: "Meet [the enemy] as soon as possible—fight as hard as possible and as much as possible[,] and let the immediate results take care of itself."[97]

Events in France temporarily distracted the family's attention from war talk. All were overjoyed to hear that Pierre was elected "by an immense majority" to a four-year term in the Chamber of Deputies. Clara Longworth de Chambrun remembered, "[Their] Country house called 'Carrière' served as a necessary base to electoral operations....After a political campaign which the wildness of the scene and the primitive ways of the mountaineers made exciting, Pierre was successfully chosen as deputy for the district." Maria wrote, "Pierre and the Loon [Min] are ecstatic over their victory."[98]

Maria was additionally distracted from the war by the domestic scene in the legation. She was happy to have her "boy" with her even if only visiting for a short time. She recorded that Joe "is having a delightful little vacation, but it unfortunately must end and he goes back on Saturday...for six months in the Laboratory. I hope to have him back at Christmas."[99]

Bellamy found the legation filled with chattering young people, barking dogs, and laughing matrons. The serious work of

communicating with Washington while the country was at war was interrupted so the Storers could escort his twenty-eight-year-old stepson to his ship at Le Havre, France. He complained to Eugene F. Bliss about "looking after" Joe who "resented it." He chose not to confront the doctor's pique because Maria was depressed over the news of the death of her Aunt Min. She also had become increasingly worried about Joe's safety when Bellamy mistakenly suggested that he cross the ocean in a "Spanish ship," and as he related to Bliss, "and as you know, there is no reasoning with her."[100]

Mrs. Longworth, Maria's sister-in-law, and the Storers took "a regular four week's cure" at a German spa. The newspapers reported that they went to Hamburg, which was "just now at its fashionable zenith." While the others went east, Clara journeyed south to France to visit Min and Pierre at Marvejols. She met her future husband Aldebert, who was Pierre's brother.[101] After their wedding in 1901, the Longworth cousins also became sisters-in-law.

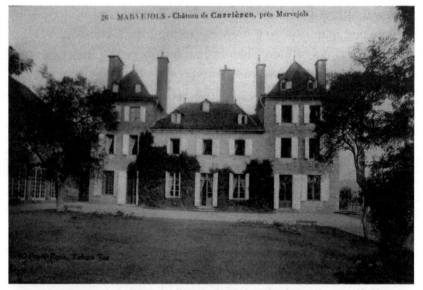

26 - MARVEJOLS - Château de Carrières, près Marvejols

Fig. 5.3 Château Carrière, country home of Margaret and Pierre de Chambrun. *Marquis and Marquise Jean François and Nicole de Chambrun Collection.*

In May, Bellamy received military intelligence of contraband operations taking place in supposedly neutral Belgium. A large "shipment of rifles" was sent by water from the port of Antwerp. Another load of weapons was sent by a circuitous route by rail to Spain. In June, Bellamy informed the Belgian government in vigorous terms of a potential blockade of ports unless their neutral position was maintained.[102] The diplomat did not take this issue any further because of the decisive news from the other side of the ocean.

On the island of Cuba, Roosevelt, the Rough Riders, and regular army military personnel trounced the Spanish forces. In July, Cuba surrendered, and in August, the Philippines capitulated.[103] The United States was a new force in world politics, which concerned many leaders in Europe.

In New York, Roosevelt was demobilized from the army. As the "man of the hour," the Republican Party looked upon him as a possible candidate for governor. When asked, he loved the idea. So, barely out of uniform, he toured the state in a flag-bedecked train spouting patriotic speeches to large, adoring crowds. In November, he won the election, and could hardly wait to exert executive power.[104]

At this critical moment in the history of international relations, Maria reached out in another direction. Her children were grown and no longer lived with them. There were only so many decorative art pieces she could make in her workshop. This witty, self-fashioning woman, perhaps, became bored and depressed. She wrote, "I can't get over a feeling of strangeness in a strange land, although it is all amusing and most of it agreeable....I feel here as though I were half way between the many who are gone and the few that are left."[105]

To deal with this sense of unreality, she decided to get busy. She read copiously. Reading the London *Times,* she became fascinated by a man called Lord Halifax, or Charles Linley Wood, 2nd Viscount Halifax. He was a thin, bearded man, who "possessed an enchanting personality." The aristocrat was an "outstanding, towering, aristocratic figure in Anglo-Catholicism," which empha-

sized the historic continuity of the Church of England with the Roman Catholic Church.[106] Halifax served as the lay leader of the English Church Union, an organization that worked toward reunification with Rome.

Maria wrote to him and found a lively, intelligent correspondent for the next thirty years, sometimes sending long dispatches of eight to ten pages, three times a week.[107] Initially, Maria wrote to him about Archbishop Ireland and the Americanist or liberal faction of the Catholic Church. Halifax was so impressed by her note that he sent it to the Archbishop of Canterbury and marked passages that fascinated him.[108]

Maria's vision was to win souls for the Catholic Church. Reconciliation with the English Anglican Church was certainly a great start. In her own inimitable way, Maria became a cottage industry, as she transcribed her correspondence and sent copies to several prominent Americans. Maria wrote to Bishop Keane that she thought both he and Archbishop Ireland should work with Halifax to aid the reunion movement. She and Bellamy would finance "all expenses of traveling, printing, halls for public speaking or anything else." She also approached several American Protestant church leaders to start the ball rolling. She sent Halifax copies of correspondence and articles that she thought were pertinent to him.[109] Letter writing was an advocacy tool, which she used to voice her opinions about specific issues. Notwithstanding, there is no evidence that any church leaders responded to her efforts.

In November, the Storers slipped away to visit Min and Pierre in Paris before Min had her first child. Maria marveled, "I never saw the Loon [Min] in a better frame of mind, and she is very well and strong; so that we are all looking forward impatiently to the new arrival." In late December they returned to await the birth of their first grandchild, Marthe Marie de Chambrun, who was born on January 7, 1899.[110]

In the United States Joe did quite well in his one-year fellowship. He published findings about his work with typhoid fever and the "pathology of superficial burns."[111] When he completed his fellowship, he joined the rest of the family in Europe, where the doctor "took post graduate work" at the University of Berlin.[112]

From America also came the news that *Harper's Weekly* had published Bellamy's highly patriotic poem about the superiority of American naval power, entitled "The Ocean Is Ours." He had sent a copy to Edith Roosevelt who thought highly of the verse and suggested it be published by the magazine. It reads in part:

> O'er the Pacific
> Come the roar of the ship guns—
> The English speaking ship guns—
> Singeing the beard of the Don at Manilla
> As Drake did at Cadiz three centuries gone.
> The Orient shakes at the thunder terr'fic,
> Drakes' message from Dewey: 'We sank their flotilla
> In spite of their fort! As you did, we've done!'
> The ocean is ours.
> The ocean is ours.[113]

Aggressive rhetoric of a cocksure American politicians was definitely in favor at this moment. The poem suggested that Bellamy was of the same mind with Roosevelt. Like many others, in the flush of victory, he rejoiced, not focusing on the problems of establishing an empire with nearly ten million people from Pacific and Caribbean Islands, where the Catholic Church was interwoven with the state.[114] On December 10, the Treaty of Paris was signed, ceding Cuba, Puerto Rico, and Guam to the United States and authorizing the purchase of the Philippines for $20 million.[115]

In Rome, there was trouble for the liberal faction of the American Catholic Church, led by Archbishop Ireland. Pope Leo XIII sent

an encyclical, called *Testem Benevolentiae*, to Cardinal James Gibbons of Baltimore, denouncing certain beliefs of Americanism. "In essence, Leo feared that some American Catholics were finding canonical and theological lessons for the Church where they should not be looking for them; [such as,] in the American cultural and political experience of democracy and individualism."[116] By censuring Americanism, the pope gave a clear message that the American liberals should be reined in.

After the catastrophe of Ireland's peace negotiations and the condemnation of Americanism by the papacy, the Storers did what they could to ameliorate Ireland's reputation with the Vatican. Bellamy asked McKinley to endorse Ireland for cardinal.[117] There was no response to this appeal in McKinley's papers. Next, a complex series of posts and telegrams from Bellamy to Theodore Roosevelt, who had been elected governor of New York, came into play. He inquired if Theodore would contact McKinley to support Ireland's elevation to cardinal.[118] Roosevelt carried out his mission, but McKinley did not act on the proposed action.[119]

Maria asked Halifax, Beernaert, and Roosevelt to write her notes in support of elevating Ireland to the cardinalate. She received correspondence from Roosevelt and Beernaert that she copied and sent to the Vatican Secretary of State Cardinal Rampolla.[120] In thanking Roosevelt, Maria wrote that the information "will go no further."[121] She failed to keep this promise.

On April 11, the Senate ratified the Paris Treaty, and at the same time announced that Bellamy was selected as the next minister to Spain.[122] Reestablishing diplomatic relations with a former enemy would be challenging and possibly dangerous. Maria seemed oblivious to these issues. She declared to Roosevelt that she was filled with excitement about seeing all the art galleries in Spain.[123]

Roosevelt responded with concern about the reality of the delicate, important work facing the Storers: "The fact that it may not be pleasant I count as nothing against the fact that you can do good

work." In a memo to Bellamy, he likewise stated, "You are being sent to Spain because it is a difficult post, and that is the very reason why it is worth your while to go....[It is] a position more important than any of our other diplomats hold."[124]

Before they left Brussels the Storers had two guests come to stay with them. Lizzie Cameron, the senator's wife, came for a short visit. Bellamy joked with her about how he had learned that "a minister should be more eyes, ears and less tongue." She attended a court ball with the Storers where she "was singled out by royalty."[125]

Archbishop Ireland also visited. He was in Europe because he had been asked to give an important speech about Jeanne d'Arc at Orléans, France, on the anniversary of her raising troops for the siege of the city that marked the turning point of the Hundred Years' War. The archbishop then spoke on several religious topics at churches and large assembly halls in Paris and Brussels.[126] Maria coordinated five banquets in his honor. The Storers hosted three official dinners at the American legation. King Leopold and Queen Marie-Henriette and Maria's close friend, the Comtesse de Flandre, honored him with formal banquets.[127] No doubt these events were part of Maria's campaign to rehabilitate Ireland's reputation. A few days later Ireland went to England where he spoke to noted English Catholic aristocrats and met with Lord Halifax.[128] Maria's influence, no doubt, facilitated the meeting.

The Storers continued to pester Roosevelt about Ireland's promotion. Roosevelt became a bit exasperated, writing, "It is very hard for me not to do anything you ask, but I simply cannot mix in this cardinal business when I know so little of the ground."[129] Nevertheless, he capitulated, and contacted the president once again. McKinley responded negatively to this appeal.[130] The president believed that the action would violate the separation of church and state.

The Storers packed up their home in Brussels and said goodbye to their friends. One of their last visits was with the Belgian queen who wanted to see their "little white dog."[131] The Storers,

servants, and Asano boarded a train for Spain, where new, challenging experiences awaited them.

During their two years in exile, they successfully represented the United States. They developed good relations with King Leopold and made friends in the diplomatic community. With coaching from Bishop Keane, they turned their private audience with Pope Leo into a quasi-diplomatic meeting where they talked about the American Catholic society and the political realities confronting it.

Bellamy's part in the unsuccessful negotiation between the American government and the Vatican demonstrated his political involvement with the Catholic Church and narrowed his career opportunities in the future. With the tacit approval of McKinley, Maria began to operate in the political sphere. Her focus on Ireland's promotion would never change and her communication strategy of sending multiple letters to powerful people would be used again and again.

THIS UNGRATEFUL COUNTRY

O N JUNE 16, 1899, Bellamy Storer presented his credentials to the ruler of Spain, the Queen Regent Maria Christina. It was a restrained, almost somber event. "There were no military honors. The throne room was not open." Bellamy met the queen regent "in the first antechamber, with her ladies in waiting." He then read a prepared speech, "couched in courteous terms, after which the Queen, without replying, conversed briefly" about other things. Less than forty-five minutes later, Bellamy returned to his hotel.[1]

Since 1886 the queen had ruled as regent for her son, who would come of age in 1902. She was a tall, thin woman, who never seemed to smile. William Collier, minister to Spain from 1905 to 1909, described her gloomy court in this manner: "Mirth was a stranger to the palace. Grand social functions were unknown. Madrid was…a very sad and forlorn sort of a place indeed."[2]

The monarch may have been grave and cheerless because she was a defeated ruler of a country hit hard by the loss of its colonies. She had to balance the budget and pay war debts. The queen asked the Spanish legislature, or Cortes, to raise taxes that could "be equitably divided among all classes."[3]

When Maria met her, the royal lady cried as she spoke about Spanish prisoners who had not been sent home by the Philippine insurgents.[4] This was the first issue that confronted Bellamy. After a series of negotiations, the ill and injured detainees were liberated by the end of the year. All the prisoners, 2,400 in total, were released by the summer of 1900. "Storer's ultimate success in obtaining their release...served as a means of establishing better relations between the United States and Spain."[5]

The Storers took a leave of absence after six weeks in the country and vacationed in Mont-Dore, France. Maria wrote, "The heat in July nearly killed me and my heart is rather weak."[6] Clara Longworth (de Chambrun), who visited that summer, offered another observation: "I think she feels pretty lonely and...[the flu] has left her quite depressed and worried about herself....I don't think she is really seriously ill....She is furious when every doctor she goes to tells her there is nothing wrong with [her], except...[from] overdoing the diet."[7]

From the French mountains the Storers, with Clara and her mother, Susan Longworth, traveled to Paris to visit Min and her family. Clara remembered, "It is a great pleasure for me to be with [Min]...and it

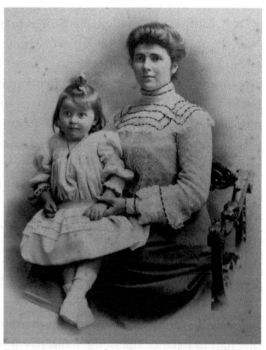

Fig. 6.1 Maria's daughter and granddaughter, Margaret de Chambrun and Marthe de Chambrun. *Marquis and Marquise Jean François and Nicole de Chambrun Collection.*

was splendid to see her so happy in her surroundings." Susan also observed that it was "nice to see such a perfect understanding as exists between [Min] and her husband."[8] This harmony proved to be the hallmark of their enduring marriage.

Returning to Madrid, Maria was pleased that they were settling in their "luxurious…mansion with a beautiful garden."[9] She was excited to have received new tapestries, which she had copied from Cardinal Richelieu's colorful wall hangings at the Louvre. It "makes one's room so fine as to put the rest to blush." On the mantle, in the same room, she was reminded of family and friends when she gazed upon a series of photos of her red-headed granddaughter, Marthe, and a "picture of Mrs. Theodore Roosevelt [as a child] clad only in a simple towel." Maria also liked the convenience of attending daily mass during the week in their little chapel "upstairs."[10]

Housekeeping at the legation was not so simple. "From a picturesque point of view," she stated, "Spain will be most interesting, but from the practical standpoint of a housekeeper, life is difficult!" She coped with "ineffectual servants, and intoxicated cooks." She hated to haggle over prices and worried that they were being cheated. "We found [cooks]—two in number, a man and a woman [who] stole more and cooked less."[11]

She started working in her studio once she had all the clay and metal she needed. As she wrote Eugene F. Bliss, "The bronze industry is getting started again at a brisk pace. It took a long time to find out what fire clay is in Spain and then to get it."[12] She and Asano also worked on a group of bronzes, which she would submit to the Paris Exposition Universelle the following year.

Maria found some pleasure "with quiet ways—in studying and reading."[13] Her correspondence revealed that she read books by English Catholic convert writers. Over the following years, correspondence from Robert Hugh Benson, George Tyrrell, and Wilfred Ward suggested her active solicitation of their ideas, and in

some cases, their friendship. For example, she perused books by and corresponded with the English Catholic convert and Jesuit priest George Tyrrell. He was "the most popular spiritual writer writing in English."[14] She examined his book, *External Religion,* which talked about common ground between Catholics and Protestants. She was so impressed with the clear language and thoughtful ideas that she recommended it to Lord Halifax.[15] Moreover, she asked for Tyrrell's feedback on essays she wrote and sent him religious books by Archbishop Ireland.[16] Their correspondence would continue until his death in 1909.

In contrast with her role in Belgium, Maria did not like her position as a minister's wife in Spain, where ministers were treated with less courtesy than ambassadors. She described one such event: "Yesterday at a reception[,]…ambassadors were taken into a special room and the ministers left in a row outside and last night a concert was given at the palace…the ambassadors were asked and the ministers left out!" She complained to Secretary of State Hay, "Legations are hardly recognized here socially."[17] Moreover, ambassadors' wives and ladies of the Spanish court were not required to call on her as a minister's wife.[18] Only three wives came to the legation on her "day at home" during the first six months of the assignment. She stated indignantly that it "would be almost better if we could have a good excuse to keep from appearing at court."[19] She also lamented, "[A] young and beautiful woman…who is fond of dancing and society would do infinitely better with the Spanish social world than an older more serious person.…With the Spaniards, the [diplomat's wife] is the more important" than the diplomat![20]

Nevertheless, Maria was happy when American friends and family visited. The former Cincinnati mayor Robert Bonner Bowler called on them when he came to Madrid. Joe, too, came from Berlin, but Maria recounted, "the poor child looks very thin and pale…so we hope to feed him up and fatten him during his vacation."[21]

From New York there was a superficial note from Roosevelt

who found time in his busy schedule as governor in Albany to give a speech in Cincinnati. He stayed with Taft, who was enjoying being a federal judge.[22] Senator Foraker introduced him to the crowd at Music Hall. Maria commented that he should be cautious:

> "I was glad...you abode with dear William Taft....That must have acted as an anecdote to the poisonous influence of that reptile Foraker....I can give sincere echo, even, to the 'reptile's' sentiment in introducing the governor of New York, though whether he meant what he said only time alone can show."[23]

Bellamy had high hopes that he could quickly complete the treaties that were needed so that a complete normalization of relations could occur between the United States and Spain. He began talks with the Foreign Office in November 1899, and received the Spanish government's first drafts for the proposed treaties in January 1900. Little did he know that the turbulence in Spanish politics, causing a change of governments, would slow the talks to a standstill. In the United States, the presidential election, and the assassination of McKinley in 1901 did the same. During his tenure in Spain, only one agreement, the Treaty of Amity, was signed.[24]

The diplomatic couple celebrated the Thanksgiving and Christmas holidays quietly. Maria wrote Eugene F. Bliss that "I find the winter delightful because in the crisp dryness I can walk without feeling tired."[25] Joe still was very thin; he was also coughing and feverish. He sought medical advice when his joints swelled. The doctor confirmed his fears that he had tuberculosis, with "inflammatory rheumatism." Joe's condition was so severe that the young man was ordered not to return to Berlin to resume his medical studies. Instead, he traveled to Biarritz, where he followed a strict regime of rest, good food, and "taking ice baths and riding horseback."[26]

In January 1900, President McKinley asked Taft to head a "commission to go to the Philippines and establish a civil government in the islands." Taft felt ill-prepared, but accepted the appointment with the encouragement of his family. The Storers were excited

to have their old friend involved in this work. Without prior direction from the State Department, both offered to assist him in every way possible.[27] They were concerned about how the complex church and state relationship of the former Spanish colony would change under the democratic beliefs of America.

The papacy sent Archbishop Placidus-Louis Chapelle from New Orleans, Louisiana, to be the apostolic delegate in the Philippines. His guidance from the pope was to secure the ecclesiastical property and maintain the safety of religious personnel. From the very first, Maria believed the archbishop's assignment was a mistake because he did not support the liberal wing of the Church and asked Taft to recommend Ireland as Chapelle's assistant. Taft informed her that he did not ask the president, "[because] in response to another request I had made of him [about Ireland], received an intimation that he preferred not to...make any request [of the Vatican]."[28] She also asked Roosevelt to help support this action. He did not act on her request. He responded, "It is utterly useless for me to do [that]."[29]

Maria wrote letter after letter dealing with legation issues and her concern about the situation in Philippines. On her own initiative, she contacted Cuba's Governor-General Leonard Wood, a man she had never met, but who was Roosevelt's friend, about his policy toward the Catholic Church. Wood responded, "Like Governor Roosevelt, I am a Protestant, but have realized that our purpose in Cuba should be to benefit the people and not to in any way interfere with their beliefs."[30]

Maria was impressed by Wood's attitude toward the Church. She translated and sent his letter, along with sections from Roosevelt's and Taft's correspondence, to the Vatican.[31] She explained to Roosevelt, "I have shown the power of the Governor [Roosevelt] of our greatest state, the Governor General [Wood] of our new Atlantic Colony and the President [Taft] of the [2nd Philippines] Commission to organize the Pacific conquest—all three unite in friendship and approval [of] liberal American Catholicism."[32] This is one of

several examples of Maria informing Roosevelt that she had shared part of his letters with the Vatican.

Ireland told her that Secretary of State Rampolla was pleased to receive the information.[33] Maria was acting as a diplomat in this situation, without being asked by the State Department to officially represent the American government.

Maria became more and more involved with the work of the legation. In an undated memo to her friend Eugene F. Bliss, Maria complained about how she stepped in to help her husband with his workload: "My eyes have been in a state and the Old Man's right arm has been practically useless....[For] weeks I read papers and wrote dispatches for him until my eyes can do no more." Bellamy quipped, "No, I do not write. The Madame does most of that. I mediate, smoke mildly, [and] read Spanish newspapers."[34]

Reading the papers was not always relaxing. The Spanish papers informed the public of every perceived insult in the American news. One such incident occurred when the Spanish minister to America was mistakenly invited to a celebration of the victory in Manila. Bellamy quickly explained to the Spanish government that event organizers were not affiliated with the American government and mistakenly invited the Spanish minister. The American press interpreted his fast action as an abject apology and demeaning to the country.[35] He hated being scrutinized on both sides of the Atlantic.

In March 1900, Susan Longworth and daughter Clara visited Madrid to the delight of the Storers. The matrons haunted fabric shops to acquire "lovely brocade" and "tapestry." They also walked in the parks, visited art galleries, and attended concerts. There was, of course, talk about Clara's wedding to Aldebert de Chambrun in Cincinnati the following year.[36] Bellamy took a sixty-day leave of absence. "Treaty negotiations were not impeded, as Storer corresponded with both the [State] Department and the Spanish government during this time."[37] They summered at Villers-sur-Mer on the French coast where they stayed at a villa. The Storers were joined by

Joe and the Longworth women until the ladies departed to return to America. Maria was pleased that her son had gained fifteen pounds. She told Eugene F. Bliss, "The whole medical [community] would now consider [tuberculosis] curable [when diagnosed] in the beginning so we are hopeful of his complete cure in time."[38]

At this same time, across the Pacific Ocean, Taft took leadership of the Philippine Commission upon his arrival in September 1900. He noted the Catholic Church held both religious and civil authority in the islands. The Church built schools, maintained hospitals, and provided other social services for the population. Several religious orders, operated by Spanish friars, owned vast tracks of land, buildings, and other real property.[39]

Many of the friars had left the area when fighting began and were viewed with much mistrust by many of the indigenous population.[40] There were many reports that friars were "incompetent or depraved." They allegedly "interfere with the execution of the laws… [or] openly violated them."[41] Taft stated,

> "The truth is that the Friars ceased to be religious ministers altogether and became political bosses losing sight of the beneficent purpose of their organizations. They unfrocked themselves in maintaining their political control of this beautiful country."[42]

He had the additional problem of a poor working relationship with the papal representative, Archbishop Chapelle.[43]

After receiving this information from Taft and with his knowledge, Maria communicated with the Vatican. She encouraged Rampolla to take "Chapelle out of his present position," and to replace him with someone from Ireland's liberal faction, Bishop Thomas O'Gorman.[44] Maria, again not Bellamy, was negotiating with a foreign power as if she held the diplomatic post.

Earlier in the year Maria submitted several pieces for exhibit at the Paris Exposition Universelle. She joked, "I was given a gold medal for my 'hidiosities.'" She was gratified when she heard the judges "greatly appreciated" her work. After the fair, she sent the Cincinnati

Art Museum the display "so that people at home might see it."[45]

When her artwork reached the United States, it was held up in New York until duty on foreign artwork was paid. Maria was incensed that she was being charged and stated emphatically, "I am an American, and my husband is the diplomatic representative of the United States in Madrid. I have done the work at the United States Legation, which is according to international law considered United States ground." She contacted the Treasury Department requesting an exception to policy. It was unknown whether her argument worked, but it is known that the museum did receive the crates containing her bronzes.[46]

When McKinley was nominated for his second term he selected Roosevelt as his vice-presidential running mate.[47] The Storers had no doubt the pair would be elected. They offered their Washington mansion at a reduced rental fee to the Roosevelt family of eight. Theodore and Edith were tickled. He wrote, "Edith and I were touched by your note and your absolutely characteristic offer. We shall try not to entertain too much!"[48]

Across the ocean, the Storers went to Rome for a private audience with the pope. The couple took the initiative to "push along" the papacy's knowledge of Taft's negotia-

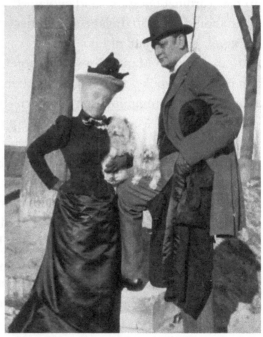

Fig. 6.2 Mr. and Mrs. Bellamy Storer. Chatfield Photograph Album, SC 108, p. 107 (B-91-069). *Cincinnati Museum Center.*

tions in the Philippines.[49] The Storers also solicited the promotion of Archbishop Ireland. Maria asserted that McKinley directed them to see the pope about the archbishop's promotion.[50] However, there is no correspondence in the McKinley presidential papers to substantiate this claim.

Maria arrived in Madrid with Bellamy on October 20, 1900, after six months' absence. She immediately became sick with acute laryngitis and went to bed.[51] It was utterly depressing for her to be ill whenever she was in the Spanish capital.

On November 6, McKinley and Roosevelt were elected. She sent "congratulations to the vice president, vice presidentess [Edith], and the vice-presidential Bunnies [children]." She then requested that Bellamy be considered for the French diplomatic position, if the current ambassador could be found another job. She again brought up the "cardinal question" and explained yet again why the government should support Ireland's candidacy.[52] The vice president did not agree with her and did not act.

In a note to Maria, Roosevelt wrote that "two members of the administration spoke" to him about "extracts" from his letters talking about Ireland's promotion that had been shown and gossiped about as "coming from" Maria.[53] The new vice president acted as if he did not know she had quoted his letter, even though he had given her permission and was aware the copies had been sent to the Vatican. Maria responded, "I do not know that I have been indiscreet about any of your letters, surely not with intention."[54] However, Maria had been warned; she knew his deep concern, but she continued to use his words to push her agenda about Ireland.[55]

In the Philippines Taft was frustrated by the stalled negotiations and aggravated with Chapelle's maneuvers. "Chapelle sent off angry cablegrams to the secretary of war…[and to the] president[,]… insisting that the friars be restored to their parishes, by military force if necessary."[56] Taft did not appreciate the prelate going around him to his bosses. Yet Taft chose to do the same thing. Instead of dealing

directly with Chapelle, he communicated indirectly through Maria to the Vatican.[57]

Back in Spain in December 1900, Bellamy received permission to relocate the legation to San Sebastian because of Maria's health. She had been continuously ill since their return from Rome. In total, she only lived three and one-half months in the Spanish capital that year.[58]

In January 1901, Maria begged Secretary Hay for a change of assignment because it was a "question of life or death for me." She added, "Bellamy will have to resign on my account if he does not get a transfer." The following day she wrote Vice President Roosevelt in the same manner. She complained, "I have aged ten years since I came to this ungrateful country!"[59]

The Storers returned to Madrid for a royal wedding in February, and found a city torn apart with riots. "Radical Republicans, socialists, and others in opposition to the government joined forces and caused such disorder" that martial law was imposed. In this critical situation, newspapers were censored and people were prohibited from congregating in groups.[60] Bellamy said, "My carriage containing myself and Mrs. Storer was hissed once. We laughed and spoke the name of our country in Spanish, and received a laugh in return."[61] The couple continued about the business of their diplomatic life. For instance, they held two dinners at their home during this chaotic time.[62] In March 1901, a new Spanish government was formed. Change in government meant Bellamy must work with a new minister of state. Thus, "treaty negotiations are deferred."[63]

Another celebration of a different kind was held in Washington on March 4. McKinley and Roosevelt were inaugurated as president and vice president, respectively. Roosevelt noted to Bellamy, "Everything went off as nicely as possible."[64]

After attending the wedding and other diplomatic duties, the Storers moved back to the French coast. Maria explained in a note to Ireland, "I am trying to recover here from my third attack of ill-

ness in Madrid....Three days of the delightful sea air have already revived me."[65] Bellamy was twelve hours by train from the capital so he commuted back and forth for the next few months.[66] She also established a workshop and renewed the "bronze industry" with the assistance of Asano.[67]

Again, Maria meddled in the political sphere of her husband. She next provided Taft's and Roosevelt's letters as background information for a long memorandum to the Vatican. Newspaper editor

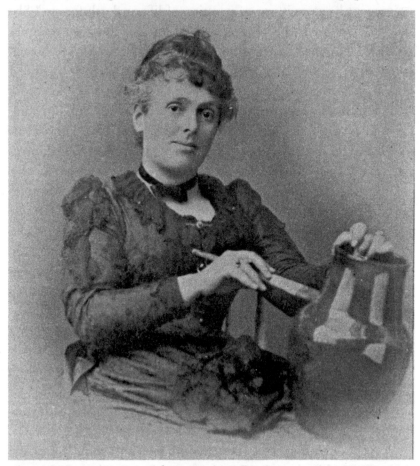

Fig. 6.3 Maria painting a decorative pot. Reproduced from *Blue Book of Cincinnati Society* by C.A.R. Devereaux, (Cincinnati, 1894). *Collection of the Public Library of Cincinnati and Hamilton County.*

and journalist Monsignor Eugene Boeglin sent a lengthy letter to Leo XIII advising him that "that Archbishop Chapelle was unsuitable as a negotiator and should be replaced by one more respected as a negotiator." In May, Taft informed Maria that Bishop Chapelle was recalled to the Vatican.[68] Maria believed that her intervention had been effective.

Bellamy wrote to Roosevelt that he needed a "long leave of absence in order to take Mrs. Storer into Switzerland. It has been seven or eight months since she has been thoroughly well; and at times has broken down in a way that alarmed and troubled me."[69] Maria felt so unwell that she left the country earlier than her husband. Bellamy took on the duties of packing and storing their household goods. From this time until the end of their assignment at Madrid, the Storers stayed in hotels, and did not rent a home.

However, despite all her complaints and worries, Maria painted a different picture to her close friends. She stated to Eugene F. Bliss, "We have reached a point of cheerful philosophy that we don't care what happens. We should be quite satisfied either to peg along between Madrid and Biarritz or to go elsewhere."[70] Yet when she corresponded with Hay or Roosevelt, she catastrophized their situation in hopes it would influence the government to assign them elsewhere.

An assassin shot President McKinley on September 6, 1901. Eight days later he lapsed into a coma and died of a gangrene infection.[71] Theodore Roosevelt took the oath of office on September 14 and became the youngest president in the nation's history.

Maria was unable to restrain herself longer than eight days before approaching the busy new president about Bellamy's prospects. She advised that Bellamy "is far more capable than ever to fill a place in the cabinet. *Please*, if you can give him either the navy or war."[72] Roosevelt responded with a warm, kindly post, "It is

unlikely now that I shall change any member of the present." He next explained his former boss Secretary of the Navy Long was not looking to leave and Secretary of War Elihu Root "was one of the ablest men he knew."[73]

Maria would not be deterred. If the answer was negative for the two cabinet positions, then she decided to ask for one of the two most prestigious diplomatic positions, Great Britain or France.[74] Roosevelt did nothing with her request. Roosevelt asked the couple, indirectly through Archbishop Ireland, to stop requesting a change of assignment "because Bellamy is safe in my hands." Ireland also passed along Roosevelt's sarcastic statement, "I must, I suppose, poison off one of our ambassadors to make room for Storer." This was strong language from their exasperated friend.[75]

In December 1901, Maria and Bellamy returned to Madrid after an absence since March. They moved into a hotel and set up a salon with some of their furniture and the beautiful tapestry that she proudly displayed in their Madrid home. She was happy not to have "the interminable cares of running a household and giving feasts to diplomats who return the courtesy every two years and the Spaniards who never ask you to cross their threshold…but who accept with alacrity to be dined and wined."[76]

In January 1902, Maria wrote to Joseph H. Gest that she was pleased he exhibited her bronzes at the Cincinnati Art Museum. He also displayed her artwork at the Pan-American Exposition and the Pennsylvania Academy of Fine Arts.[77] Her studio equipment was in storage since they lived in a hotel. With no work for Asano, he decided to return "to Japan ostensibly for a visit."[78] He disembarked from his steamer in Singapore and did not return. Detectives scoured the city, but had no luck finding him. He never reached Japan. Maria would never see the Japanese artisan again.[79]

Maria moved back to the French coast at the end of the month. During the Spanish tour of duty, she was out of the country 75 percent of the time.

In January, Roosevelt wrote Bellamy, "Will you ask Maria again if there is any letter of mine to her or a copy of any letter which, so far as she is aware, is in the hands of anyone else?"[80] This is the second letter of complaint that he had written about her use of his private correspondence. By writing to Bellamy rather than Maria, Roosevelt was telling the diplomat to get his house in order. Maria's behavior was affecting the relationship between Roosevelt and Bellamy.

Maria's response was defensive. She said, "I don't know who is trying to make trouble between you and me." She added, "I shall bring your letters on the subject of the Catholic Church in America when I go over in March." Roosevelt wrote back, "All I want you to do is to keep them yourself. Evidently some people in Rome have been talking."[81]

Bellamy asked and was given permission for a three-month leave of absence to return to the United States. The couple wanted to visit Washington to see if another position might be secured because, as Maria said, "We are so weary of Spain and so tired and homesick after four years' exile."[82]

Many in Washington knew why they came. Henry Adams gossiped about it with Lizzie Cameron: "Theodore is upsetting his whole diplomatic corps....Perhaps it will get Bellamy Storer [an] embassy."[83] So, with a change of assignment uppermost in their minds, Maria and Bellamy went to the White House to dine with the Roosevelts on March 19. They had not seen each other for such a long time. The Storers were grayer, and tired from their voyage. When they left for Belgium the three were equals. Now, President Roosevelt was Bellamy's boss.

Roosevelt was in his prime, a physically powerful, aggressively agitated man who dominated the room. Maria was shocked when the president "shouted aloud in the presence of the servants" at Secretary of War Elihu Root. She was very saddened to see Roosevelt was "very excitable and high strung."[84]

The president failed to give Bellamy any precise idea about his next assignment. Bellamy, at this point, wanted an embassy position, preferably in Berlin. From Roosevelt's perspective, Bellamy was well known in Europe for his close ties to the papacy. The president wanted to be certain Americans of German descent and the emperor would accept a Catholic diplomat. The president asked Maria, in what seemed to be beyond the scope of responsibilities of a diplomat's wife, to find out if the German American newspapers and the German emperor would support a Catholic ambassador in Berlin. Maria was up to the task. She immediately wrote to Count Alvensleben, the former German ambassador to Belgium, about securing an opinion from the emperor. She then contacted Taft and Ireland to help her canvass several German American newspapers.[85]

The Storers dined again with the president on March 23.[86] Roosevelt reported how the papacy had signaled its interest in dealing with an agent of the United States about the purchase of the friars' land in the Philippines. The president selected Taft, who now served as the governor general, to negotiate with the Vatican in person.[87] Taft, who was on leave of absence for medical reasons in Cincinnati, would go to Rome, meet with the pope, and then travel to the Philippines. When the Storers spoke with the Philippine governor general in Cincinnati, he told them he was sailing for Rome in May.[88]

In Cincinnati, the Storers were "simply happy to be home."[89] Small things had changed since they had last been home five years earlier. With their mansion rented, they stayed at a hotel.[90] The couple found time for philanthropic efforts to support the needs of the local Catholic Church. They presented the Sisters of the Good Shepherd with "fourteen acres of land on Tusculum Heights…[for a] girls' reformatory and a home for abandoned girls," and gave a ward in memory of her father to the Hospital for the Incurables of Saint Francis. They also paid the salary of a priest at Holy Angels, their Cincinnati parish.[91]

Then the pair headed west to Colorado Springs to see Joe. Possibly, Joe was invited to visit the mountain community by a former

Rookwood artisan, Artus Van Briggle, who shared the same medical condition. Van Briggle had left Cincinnati in search of clean mountain air in 1899 when he was diagnosed with tuberculosis. He established his own decorative pottery business, Van Briggle Pottery. "It is thought that [Maria] paid for his move and medical help in Colorado Springs. Records in Colorado Springs note that she underwrote his pottery there until his death from tuberculosis on July 4, 1904. All of this accords with her kindness and generosity, even though by funding the Van Briggle Pottery she was underwriting a viable competitor of Rookwood Pottery."[92] Bellamy gave the Glockner Sanitarium $2,000 in anticipation that Joe and Van Briggle would receive care at the organization.[93]

With Joe, the Storers returned to Cincinnati for the wedding of Maria's niece, Nan Longworth, and Buckner Wallingford.[94] While the Storers attended the wedding, Joe served as a member of the wedding party and enjoyed the company of his cousins. Bellamy became the life of the reception. He wrote,

> "It fell to me...to march in with Mrs. Davis Anderson and [toast everyone's] health before the fish was served. I was respectfully chided as committing an epicurean anachronism....All the ladies without exception were standing on the table[s] with their bouquets in rhythm."[95]

The Storers then immersed themselves in the Philippine business, again without the knowledge of the Department of State. They interviewed Archbishop Chapelle's proposed replacement, Monsignor Donato Sbarretti, who had arrived in the United States on his way to the Philippines. The monsignor had previously served as the pope's representative in Cuba and did not get on well with U.S. authorities. Maria wrote Taft that Sbarretti "would bring much annoyance to" him. Ireland had the same opinion and told the Vatican that the prelate should not go to the Philippines because of the Department of State's objections.[96]

She asked Taft to write her a letter stating this position and she would send it to the Vatican Secretary of State Rampolla since

"it worked perfectly and thoroughly in the matter of Archbishop Chapelle."[97] The Storers operated as free agents without the consent of the Department of State to interview a candidate for a religious post.

Maria wrote a letter advising Taft, an American official, how to sabotage this candidate. Both actions were beyond the scope of responsibilities of their positions. Taft was concerned about their meddling because he drafted the letter that Maria requested, but did not mail it to her. Instead, he sent the letter to Secretary of State Hay and asked if the secretary wanted him to forward it to her.[98] Hay's response is nowhere to be found in his or the Taft papers.

The fact that Hay did not censure the couple suggested his approval. Possibly, he judged it prudent not to do anything, considering Ireland had already contacted the Vatican about the problems with the prelate. If that was true, his gamble paid off. The Vatican reassigned Sbarretti for other duties.[99]

After Taft's Vatican visit, Ireland wrote Maria, "On the whole the Taft mission did rather well."[100] The papacy agreed to selling the lands. There was a spirit of collaboration, which had been lacking with Taft's earlier negotiations with Chapelle. In a gesture of good faith, the pope sent Archbishop Giovanni Guidi as the new apostolic delegate to the Philippines. He would prove to be a delightful person with whom Taft enjoyed a warm working relationship. Taft and Guidi hammered out the sale of the friars' land, a total of 410,000 acres, for $7.2 million.[101]

Despite the overall good feeling from Taft's meeting, Roosevelt was disturbed and lectured Taft in no uncertain terms, "I was completely taken aback by the violent attack made upon us by the Catholics....We found out that they had full information [in] Rome of your letters about Ireland for the cardinal's hat. I suppose Mrs. Storer sent them to Rome. Apparently, they were used to some effect to help beat the negotiations." Taft responded, "I regret especially that any letters which I had written before should have been the occasion...of increasing opposition to the object of our visit. I think that

it must be confessed that the opposition to Archbishop Ireland... added zeal to those who opposed our purpose."[102]

Taft took notice. This was the only time that he had to be chided by the president about gossip that pertained to Maria. Never again would he engage Maria in diplomatic efforts. It was not her fault that there was so much antagonism toward Archbishop Ireland, which caused the placid Taft to remark, "In some circles in Rome they use Archbishop Ireland to frighten children."[103] However, her alliance with the archbishop had complicated Taft's mission.

The Storers and Joe departed for Europe in June. Upon their arrival, Maria and Joe headed to Vevey, Switzerland, while Bellamy went to Spain and signed the Treaty of Amity on July 3, 1902. From Madrid, Bellamy joined Maria in the mountains while continuing to monitor the legation work from that distant place.[104] Maria, of course, was ecstatic about the hotel, food, and the people they met. In August, they were happily ensconced on the French coast. She called them "golfing maniacs," since they golfed sometimes twice a day.[105] She was so proud to say she even won a prize!

Joe returned to the United States to winter in Phoenix.[106] He enjoyed the dry climate and met other convalescents, who were also suffering from the same condition. One gentleman, Dr. Edward Livingston Trudeau, a tall, thin, ascetic-looking man, spoke to him about research at his laboratory at Saranac Lake, New York. When Trudeau found out that Joe had trained for a career in the lab, he invited him "to engage in research work connected with tuberculosis."[107]

Meanwhile, in France, the Storers were comfortably rooted on the seacoast, and waiting to hear where they might go. Maria noted, "We are absolutely in the dark still as to our future and it is a little awkward to be getting congratulations from zealous friends upon our appointment to Berlin."[108]

Back in the United States, Roosevelt was upset with the bad press he had received related to the "cardinal question." Several newspapers gossiped that he had officially approached Rome to give Ireland the red hat. Whether it involved Maria, he did not know, but he thought as much. In a letter written about that time, Roosevelt stated, "That years ago I might on some occasion have stated I should like to see Archbishop Ireland a Cardinal is possible,... but I doubt if I ever alluded to the subject to anyone since I have been President."[109]

This, of course, was only partially true. He had written and given Maria permission to use his letter in support of Ireland in 1899, when he was vice president. He knew there were letters she had quoted from his correspondence because she told him. The president was irritated that his words were taken out of context and out of time sequence to create public relations issues for him.

Despite the input of over twenty-five people,[110] Roosevelt had trouble making up his mind about where to send Bellamy. He was concerned that Maria's incessant and indiscreet, Catholic-focused activities might do irreparable harm to German and American relations. Austria-Hungary was a Catholic monarchy. He decided this posting was a better fit. Finally, on September 18, 1902, Roosevelt notified Hay to begin the appointment process for Senate approval to send Bellamy Storer to Austria-Hungary.[111]

After hearing the news Maria was relieved that everything was finally settled. She started planning to be an "Ambassadress" in the Austrian capital. To help revive her music skills, Maria bought a small piano.[112] As she wrote Roosevelt, "I have all my ambassadorial clothes....We are happy and contented."[113] When Bellamy presented his letter of recall to the king of Spain the second week of December, Maria did not accompany him. She was grateful that their assignment was finished. Bellamy put a positive spin on the ending: "I am glad to say Spain is again smiling, the people are happy, and the country is enjoying a fair degree of prosperity."[114]

Toward the end of the year, Roosevelt received a gift from Maria. It was his portrait that Fedor Encke painted, which he proudly hung in the White House State Dining Room.[115] Maria had asked the portraitist to depict him as the consummate military man in his Rough Rider uniform, tan, fit, and strong. She responded to Roosevelt's appreciative thank you, "It is delightful to hear that you are pleased with your portrait."[116] After his presidency, he placed it in the North Room at Sagamore Hill, where it can be viewed today.[117]

Maria became an ambassador's wife with enthusiasm. Belgium had proved to be a wonderful orientation where she watched aristocratic and elite women affect social and religious aspects of the Belgium society. She gained the perspective that religion was best when it is a part of, not separate from education and politics. She enjoyed the society and made life-long friends. In Spain, she had the opposite experience. Bellamy's job was more difficult and Spanish society did not seem to allow her entry. She hated the climate and removed herself from Madrid 75 percent of the time, generally residing on the French coast.

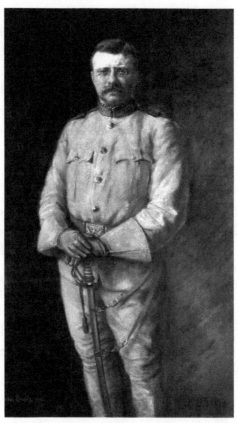

Fig. 6.4 Theodore Roosevelt portrait commissioned and presented as a gift by Maria, 1902. *Courtesy of Sagamore Hill National Historic Site, National Park Service, Oyster Bay, NY.*

With time on her hands she created her own signature metalwork, which won international recognition. She championed Archbishop Ireland's efforts for promotion. She reached out to Lord Halifax, hoping to assist Anglican reunion with the Catholic Church. Both men found her to be exceptionally honest and dogged in her support. As with her husband's promotion, she aggressively asked, cajoled, beseeched, and sometimes threatened to secure what she wanted.

Maria took it upon herself to send information and official papers from Taft to Rome, always including positive comments about Ireland's work and the regard held for him by American leaders. She wrote letters to both American and Vatican secretaries of state providing unsolicited, yet mostly accurate information, and highly biased advice. She impacted American policy by her actions and created a positive impression of Taft in the minds of the papacy leaders long before his semi-successful negotiations in Rome.

Under President McKinley, her foray into the public sphere was fostered, and possibly, ordered by him. When Roosevelt assumed the presidential role, things changed. He did not understand or accept her actions as anything other than meddling. He also was angered by gossip about his letters being quoted. Bellamy probably would have been appointed either to the French or German ambassadorial posts if she could have handled her enthusiasm for Ireland differently.

Despite all this, Roosevelt still valued and was grateful for her and Bellamy's friendship and wanted their experience in Austria-Hungary to go well for them. So on to Vienna they went.

AMBASSADRESS

WHEN THE STORERS arrived in Vienna by train on December 23, 1902, they checked into the very grand and exclusive Imperial Hotel and "began at once to look for a house."[1] Although Austria-Hungary was not their first choice, they were indeed pleased and heartened to leave Spain. Maria stated happily, "We love Vienna already. The cleanliness and cheerfulness and friendliness of everything and everyone is such a blessed relief after the desolateness and dreariness of Madrid."[2]

On January 3, 1903, Bellamy presented his credentials to Emperor Franz Joseph.[3] Maria described the experience:

> "Saturday afternoon [Bellamy] was received by the Emperor and he says it was the most magnificent spectacle he ever saw. The [Hofsberg] Palace was simply lined with personages in gorgeous uniforms." He was conducted "into the presence of a nice little gentleman-very 'grand seigneur' [great nobleman] in his manners and very friendly. He talked much about Spain and the Queen."[4]

Emperor Franz Joseph was seventy-three years old when he met Bellamy. He had reigned for fifty-five years over a layered polyglot of ethnicities in an empire that geographically was the second largest state in Europe, after the Russian Empire. The emperor had suffered several personal losses, including the assassination of his wife and the alleged suicide of his only son, the crown prince. Besides speaking about the Spanish situation, he peppered Bellamy with ques-

tions about America. Franz Joseph thought his empire was like the United States because both states were nationally heterogeneous.[5]

Later, they were invited to witness a solemn ceremony where the emperor commemorated Christ washing the feet of his disciples on Holy Thursday:

> "The Emperor in full-dress uniform of the field marshal performed this 'washing of feet'...[of] twelve old men and...women...from the municipal almshouses....The Emperor knelt before them, passed from one to the other and touched their bare right foot with a napkin dipped in water from a golden basin, while a priest read aloud the Gospel for the day."[6]

Maria was greatly impressed by the pageantry and symbolism of the religious event. The whole experience reinforced her belief that the ideal life was one where religion was integrated into everyday affairs.

All was not austere. British memoirist George Grenville Grenville-Moore observed, "In the winter there is a great number of balls given in Vienna. I do not think that in any capital in Europe there are so many balls given as in Vienna."[7] For example, Maria and Bellamy attended the Hof Ball, with more than two thousand people, on a cold, wintry evening. At the event, "the scene [wa]s magnificent, such a resplendency of diamonds and other precious stones and jeweled orders, such a richness and variety of coloring is rarely to be seen."[8]

Maria and Bellamy were not outshone. In photographs taken in honor of the event,

Fig. 7.1 Bellamy Storer. *Ursulines of Cincinnati Archives.*

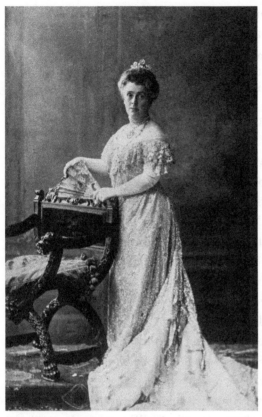

Fig. 7.2 Maria Longworth Storer, 1903.
Ursulines of Cincinnati Archives.

the fifty-three-year-old woman was presented in a dress of white satin, with a train that was nearly seven feet long. She dripped with diamonds from the tiara on top of her head, to the eight-stranded diamond choker at her neck, to the huge, but tasteful bracelet on one of her gloved arms.[9] Bellamy's photo also radiated elegance and tremendous social accomplishment. His "great stature and plain evening dress made him a striking figure."[10]

This was the event where Maria met the emperor and described him as "a dear old gentleman, very old looking— although he holds himself straight....He was dressed in a light...blue uniform coat— with bright red edges— and red trousers....He carried a military cap with an immense green plum[e]—I myself would for once like to see a monarch in robes and a crown for those I have beheld look too much like ordinary 'folk.'"[11]

Maria worried that "Bellamy will soon tire of a life which is simply to be made of society entertainments at our own private expense. It is a frightful waste of money for nothing....Vienna is the most expensive capital in Europe."[12] She was not the only one who

was concerned about non-reimbursable diplomatic expenses. For-mer Italian minister William Draper recollected,

> "An American representative cannot hold his own in the larger capitals—to say nothing of doing credit to his country in entertainment,—unless he is a wealthy man, willing to spend his substance for the prestige of his gov-ernment....My expenses in Rome were easily five times my salary [\$60,000]."[13]

When she could, Maria wrote to Lord Halifax about books and articles by contemporary Anglican or Catholic authors. Some-times they agreed about the value and merits of the documents, but more often they differed. Maria believed free intellectual inquiry was appropriately limited by the divinely established teaching authority of the Catholic Church. Halifax, on the other hand, relied on his own interpretation, not restricted by an official religious organiza-tion.[14] Yet, neither doubted the sincerity of the other. Over the years, their friendship deepened.

In March, Min gave birth to her second child, a boy, who was named Jean Pierre. The Storers were overjoyed for the young cou-ple.[15] That summer the Storers, again, took a long leave of absence and returned to the United States. Bellamy wrote to Bliss, "Joe,... [is going] to Colorado Springs where [he will]...take a house large enough to take us in." Maria also wrote Bliss that upon their arrival, "Joe met us at the station a week ago yesterday looking better than I have ever seen him—tougher and less fat than last year and with splendid color....He is considered cured." They made their stay a family affair with Bellamy's sister Bessie joining them for a visit. The family socialized with local luminaries and took in many sights, including Pikes Peak. "We have been busy doing nothing," Maria wrote gaily to Taft.[16]

With the probability of Joe living in Colorado Springs full time, Bellamy networked with the local bar association, and joined the Better Business Bureau.[17] It is likely that Maria visited the Van Briggle Pottery, where she was a director. Perhaps, stimulated by

seeing its beautiful products, she decided to resume her own art-work in America. For inspiration, she ordered several pieces from her award-winning bronze display to be shipped from the Cincinnati Art Museum so that they could be used to decorate their Colorado home, and later, be sent to Vienna.[18] All of these facts suggest that the Storers thought that Colorado Springs would be their second home in the United States because Joe would settle there. That did not happen.

In August, the family visited with Archbishop Ireland, who urged them, "Let me impress on you that you must spend some days in St. Paul before you again cross the Atlantic. Make your arrange-ments in view of this and give me timely notice. There will be much to talk over."[19] Ireland shared his happiness that Roosevelt had sent two official cablegrams on the death of Pope Leo XIII. He stated to Maria, "As regards of Catholic matters, he is becoming better and better each day."[20]

The Storers and Joe next journeyed to the remote community of Saranac Lake, a little village in the Adirondack Mountains of New York. Joe decided to visit the village because Dr. Edward Trudeau had offered him a job when they met in Phoenix the previous year. He was healthy and wanted to settle down. Although he had liked living in Colorado Springs and Phoenix, the thought of working in a research laboratory, which had always been his life's goal, was tempt-ing him to settle there.

Maria was not as taken with the scenic beauty of upstate New York as a possible home for "her boy." So she wrote to Dr. William H. Welch, whom Joe had studied with during his Johns Hopkins fellow-ship, and asked his opinion. The eminent physician replied,

> "I need not say that I have the highest opinion of Dr. Trudeau and of his management of cases of tuberculosis and I am glad that Dr. Nichols is to be with him. He will find a scientific spirit and opportunities for interesting lines of work there, and I am sure that Dr. Trudeau will be glad to have so skillful and well trained a worker with him."[21]

This letter changed Maria's mind about the community. Trudeau's research facility, Saranac Laboratory, was the best in the world. Experiments were conducted on animal subjects to develop a greater understanding the *mycobacterium tuberculosis*.[22] Also, it provided "diagnostic facilities to the patients outside the Trudeau Sanatorium."[23] Joe accepted the position and rented a home. Eventually, the village would become his permanent residence. He would later attribute his "good general health...to leading [an] outdoor life at Saranac Lake."[24]

From upstate New York, the Storers took the train to New York City. The couple visited Archbishop (later cardinal) John Farley, of the New York Archdiocese.[25] As the leader of the largest and wealthiest archdiocese in the nation, Farley was known to be a careful, middle-of-the road sort of leader, who did not side with the liberals or the conservative factions of the American hierarchy.[26] Maria would maintain an active correspondence and friendship with him that lasted until his death in 1918.

Bellamy traveled to the president's home on Long Island. He later stated about his meeting with Roosevelt, "Archbishop Ireland being the topic of conversation, the president said to me that if I went to Rome he would like to have me see the pope, and say to him in person that the archbishop was his friend, and that he would be pleased to hear that he had received the honor of promotion" to cardinal.[27] Roosevelt informed Archbishop Ireland about what he told Bellamy to do. The archbishop commented to the Storers, "The president...seemed rather proud of having done so."[28]

Publicly, however, Roosevelt sang a different tune. He was being hounded by gossip that he was involving himself in the Catholic Church's internal business. To an editor who asked the president about rumors of his support for Ireland's red hat, he replied, "No human being suggested to me anything about my recommending anybody for cardinal...at any time since I have been president."[29] Roosevelt was talking out of both sides of his mouth, which led to disastrous results, especially for the Storers.

Back in Austria, Maria plunged into many different tasks. She ensured that a copy of Taft's latest letter from the Philippines was sent to the new Vatican secretary of state, Raphael Merry del Val.[30] She also ordered twenty copies of Charles Stoddard's book, *Father Damien: The Martyr of Molokai*, to give to her Viennese friends.[31] Additionally, she set up her kiln and created art pieces for her next art exhibit, which was coming up soon in 1904.[32]

Maria also continued to lobby on Archbishop Ireland's behalf. She redrafted and sent the Reverend Boeglin's letter for the second time to the papacy. Although it had been sent originally to Leo XIII, she thought the new pontiff, Pius X, should read Roosevelt's words. As Maria explained to Ireland, she "sent that letter and a French translation of one of Theodore's letters."[33] Maria released his words again, despite two strongly worded admonitions from the president not to use his private correspondence.

On November 13, Ireland encouraged Maria and Bellamy to take Roosevelt's message to Rome quickly before the next selection committee of the College of Cardinals or consistory. He added, "Your position will warrant you to speak strongly. As things now are, your word will be decisive."[34] The Storers' plans were to travel after their Thanksgiving reception and stay only forty-eight hours in Rome. They wanted to meet with the pope and leave immediately to avoid any publicity.[35]

This was their first audience with Pope Pius X, whom Bellamy described as "a man shorter than middle size, with

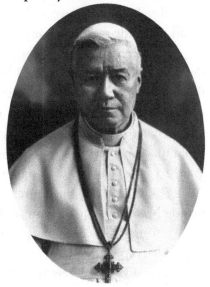

Fig. 7.3 Pope Pius X (1903–1914). *Archdiocese of Cincinnati Archives.*

snow white hair, and a kindly parochial face, [who] laughs readily." Bellamy presented the president's message, and Maria emphasized that Ireland's selection for cardinal was "for the good of the church." Pius X told her that the president's "wishes will be considered."[36]

Despite all the precautions the Storers took in Rome, newspapers immediately reported their audience with the pope. The *Hartford Journal Courier* simply reported the event, while the *New York Tribune* suggested it was about Ireland's promotion.[37] Protestant papers were livid. The New York *Christian Advocate*, a Methodist publication, denounced Bellamy for "running after popes and cardinals"[38] to obtain the red hat for Ireland.

The president immediately wrote to the diplomat, saying irately, "What has occurred shows clearly that it is hopeless for you to expect that people will appreciate the difference between what you, as an American Catholic, in your private capacity, say, and what you, as an American Ambassador, say." Bellamy's apology included his resignation from the diplomatic service. Roosevelt answered, "It is absolutely all right; we will treat the incident as closed. Nothing could persuade me to accept your resignation."[39]

But the incident was not "closed" for either party. Since Roosevelt's election in 1900 he had heard about incident after incident that alarmed him about the Storers' behavior. Because of the couple's very public zealousness for their religion, he had not sent Bellamy to Germany nor did he select the diplomat to serve in his cabinet. From this time forward, his correspondence to them would be more guarded and he would no longer deal patiently with their requests.

For their part, the Storers remained angry about the reprimand. Maria was quite livid and complained to Ireland that she was "retiring from diplomatic relations with the Vatican." Ireland responded, appealing to her vanity, "All that you and Bellamy write, is romance-like—intensely interesting,…[the] pope, [the] president, cardinals, ambassadors, publicists—all move before one's eyes— directed from Vienna, and each one closely to his part." In another

letter, he advised, "Do not go to Rome for Easter [g]ossip would be revived; and, our 'Executive' might be riled again."[40]

Maria next whined to Taft, "Today came a letter from Theodore...speaking quite unpleasantly about Bellamy's visit to Rome, and requesting...that Bellamy should in the future refrain from any 'interference on this subject!!!!'" Taft astutely replied, "I do not think that the president misunderstands the situation as you think he does....The cardinalate of Archbishop Ireland is so mixed up with Vatican politics that I find the atmosphere befogged in respect to it. I fear Archbishop Ireland suffers the fate of many who are honest and outspoken and who incur enmities for their candor."[41]

The Storers were happy that Taft now served in the cabinet as secretary of war. Roosevelt had offered him the position to replace Elihu Root, who was returning to private life.[42] She wrote to Merry del Val in an effort to encourage communication between him and Secretary Taft. After telling Taft about this, he, in turn, complained about her unsolicited efforts to the president, saying, "I have a letter from Mrs. Storer...which she gives an extract of a letter from Merry del Val....It is another instance of her 'butting in' which is exasperating me. I don't want to leave anything to do with Rome through her." Roosevelt responded,

> "Mrs. Storer is an awful trial. I wish to Heaven she would either quit her professional sectarian business or get Bellamy to leave public life! You are right in paying no attention to her. The fact that she has been meddling in it makes me uncomfortable about [working with] Merry del Val."[43]

Instead of recognizing how important it was to become very quiet and unassuming in Vienna, Maria still tried to influence the Vatican and the president. This was not Cincinnati, where her immense affluence and family's stature could overrun a rival like Louise McLaughlin. This was not Washington, where her vast fortune and family's power could nearly buy a seat in Congress or a diplomatic post. This was an international setting, where her enormous wealth

and the prestige of her family counted for nothing. Her refusal to follow Roosevelt's very clear direction would have disastrous consequences for the Storers.

Bellamy and Maria took another leave of absence and returned across the Atlantic in July. They traveled throughout the United States visiting family and friends, including Roosevelt and Maria's son Joe.[44] In the resort village of Murray Bay, Canada, situated on the St. Lawrence River one hundred miles north of Quebec, they saw Taft and his family. Bellamy and Taft enjoyed golf, and talked politics, while the women enjoyed picnics at the beach, bazaars, and local music performances.[45]

On September 2, Taft summarized what took place for Roosevelt: "Bellamy and his wife are here. They are about to descend on the states and on you. I wish they were abroad. I don't think Mrs. Storer has discretion enough to make it safe for her to be at large here." He also very astutely observed that Maria was "a good generous woman whom I like very much but she is very much lacking in her sense of proportion as to her power of influencing people and as to Bellamy's ability."[46] These were highly critical words of someone whom Maria valued as a friend.

The Storers received another clear message that they were considered too controversial for public events. Taft was speaking to the students and faculty at the University of Notre Dame, a Catholic institution in Indiana. Bellamy looked forward to attending the October 5 event. Ultimately, however, he was asked not to come because his "presence" might open Taft's appearance "to attack." Instead, Taft read his speech privately to the diplomat.[47] Of course, nothing could be more political than the secretary of war giving a speech at a college. However, the Roosevelt administration considered having Bellamy in attendance a liability, given his close ties to the Catholic hierarchy. It also suggested that Taft was a trusted Roosevelt official whose career was moving forward while Bellamy's was not valued and his future was questionable.

While in the United States, the Storers saw old friends, such as Charles Stoddard. The writer and former college professor was in Cambridge convalescing after almost dying in the hospital a few months earlier. Later in the year, after finding out that Stoddard was nearly destitute and not working, Maria established a fifty-dollar monthly pension for the gentleman for the rest of his life. Stoddard said the windfall was a "God-send."[48]

On October 20, Bellamy and Maria were invited to the White House for a formal dinner and to spend the night. The guest list included the new French ambassador and Mrs. Jusserand, and Secretary of War and Mrs. Taft, among others.[49] This occasion would be the last time the Storers ever saw the Theodore Roosevelts. According to Maria, after dinner when the other guests had departed, Roosevelt discussed his hopes that Ireland would be made a cardinal, saying, "I do most sincerely hope that Archbishop Ireland may be made a cardinal." The president later denied this conversation took place.[50]

At Saranac Lake, the diplomatic couple found Joe happily working with his rabbits at the lab. He loved the camaraderie of the other doctors, many of whom, like himself, had tuberculosis, yet engaged in significant medical activities. Trudeau had advised him that research took "faith, patience, perseverance, and some skill."[51] "Dr. Joe" hoped within the next two years to complete his experiment and publish his findings.

Joe and his mother took some time to visit the Vermont mountains. They hiked and enjoyed talking about their activities over the past year. Apparently, Bellamy returned by himself to Austria.[52] About a month later, Maria returned to Vienna after the Thanksgiving holiday. The annual reception that celebrated that American holiday was not given by the embassy because of her absence. This greatly upset the expatriate community.[53]

Maria asked Roosevelt about their future position in the government. She hoped for a Paris, Berlin, or London assignment. Her

letter was a somewhat pushy, complaining diatribe, like others she had written in Spain.[54] The president responded coldly that it was "Vienna or nothing."[55] To Taft, her "good friend," she cried, "I beg you to find out and let me know what has turned the president....I ask this favor of you...because we have really loved Theodore Roosevelt and believed in him." Taft responded, "In a letter which you wrote him recently you said a number of things that hurt him deeply....I fear you do not put yourself sufficiently in the [p]resident's place."[56] Maria, like her husband a year earlier, penned a note of apology and the president forgave her.[57]

In January 1905, with the dances and parties of the winter season looming before her, Maria boasted to Eugene F. Bliss,

> "I had ninety-five people at my last Saturday's reception....I never knew and liked so many people at a time as here! You would...wonder at...[the] calling lists, dinner lists, visits, clothes, charities....[It] take[s] up more time than an old woman with four heads, eight arms and eight legs could attend to in a day."[58]

The ambassadorial couple entertained many Americans traveling in Europe. For example, the president asked Bellamy to extend the courtesies of the embassy to Arthur von Briesen, a New Yorker and Roosevelt's political protégé. Maria was asked "to keep an eye" on Mrs. Robert Winthrop, diplomat Bookman Winthrop's mother, when she traveled to Vienna.[59] Additionally, they introduced wealthy Americans to members of Viennese society. Roosevelt's sister-in-law, Emily Carow, was treated like royalty by the Viennese on her visit. She "came for two or three weeks and is having an ovation." She attended a ball with Maria and was escorted by an archduke. Maria stated, "Miss Carow was impressed."[60]

Maria, moreover, found time to raise funds for the Viennese poor. She created "bronze jardinnières [flowerboxes] with a plaster incrustation set with semi-precious stones" for a charity exhibit and sale. Other society ladies similarly provided their artworks as well.[61] She also learned to bind books.[62]

Back in the United States at the Saranac Laboratory, Joe completed his experiment where animal subjects were vaccinated with *mycobacterium tuberculosis*. He was particularly gratified when he was asked to present his findings at the first conference of the National Association for Study and Prevention of Tuberculosis. Joe read his paper on May 19, 1905. He also published the results of the experiment in a medical journal.[63] It must have been difficult to tear himself away from the engrossing work, but Joe had promised his mother that he would spend the summer with her, Bellamy, and other family members in Europe. He would not return to Saranac Lake until the following year.[64]

During the hot, humid summer of 1905, after Joe and his aunt Susan arrived, Bellamy and Maria leased a house just outside of Vienna. Bellamy was still available to commute into the city when he was needed. Part of the time they "took the cure" in the Bohemian town of Marienbad. "The 'cure' helped [them]...shed a few pounds through mild dieting, mud baths and gentle walks through pine forests. There was also, of course, the water to be drunk while the band played."[65] Bellamy was in his glory because King Edward VII had just opened the local nine-hole golf course. Bellamy was among the group of golfers who elected the president and other officers of this club. He also participated in the first golf tournament between the Carlsbad and Marienbad golf courses.[66] This relaxing interlude became a fond memory in the future, for, after November 1905, their lives would change dramatically.

"DEAR THEODORE" VERSUS "DEAR MARIA"

IN NOVEMBER 1905, there was troubling gossip from the Vatican. Archbishop Ireland told Maria that the red hat might not be in his grasp because the pope believed "that the president was not over serious" since Roosevelt "asked for two Cardinals" to be selected.[1] Maria immediately wrote Roosevelt, begging him to favor only Ireland. She added, "I could take a cable from you to Rome and put it into the hands of the Pope, without any interference."[2]

Maria also solicited several Church leaders, Taft, and Mrs. Roosevelt for their support as well.[3] Taft immediately shared his letter with the president. To say Roosevelt was angry was an understatement. His wife, Edith, knowing how Maria's letters usually enraged the president, did not tell him about the letter she had received.

At the worst possible time, bad press from Vienna about the Storers was published in the American newspapers. They had not given the traditional Thanksgiving holiday reception for the second year in a row. Expatriates "complain that he never does anything for them, but devotes himself exclusively to the court society."[4]

Roosevelt's disgust knew no bounds. On December 11, 1905, he replied to Maria's memo with two messages, one for Bellamy and one for Maria. He addressed a note to Bellamy, asking him to read the

enclosed memorandum to Maria before giving it to her. In his harsh reprimand to Maria, Roosevelt condemned Maria's last post. He warned her, "I am very gravely concerned at the mischievous effect your letters…have in misrepresenting the position of the United States Government." He was incredulous that Maria had requested to be appointed as a special agent to Rome. He told her of gossip from "Washington, Paris, and Berlin" that she was called derisively the "Ambassadress to Italy." He ordered her to write him a memo saying she would immediately cease her conspiracies and pledge not to intrude in Church business. He warned, "If you cannot make up your mind absolutely to alter your conduct," Bellamy must leave the diplomatic corps.[5]

Ireland wrote to Maria that he had seen the president, who "told me of his letter to you which according to him was somewhat severe. But he [ha]s calmed down."[6]

For the third year in a row, the president was chastising one of the Storers. Maria complained to Taft and Ireland as in previous years. It was surprising that she continued to consider Taft her intercessor. He had gone straight to the president not to rectify her concern, but to report what she wrote. Maria, however, wrote him sadly, "No one ever walked more straight into the lion's mouth than I. It seems almost as though a trap had been set for me some time ago." She blamed Foraker, and others, rather than herself for the breach with the president. Next, she said, "You know the result." She then emphatically stated, "We are ready to go."[7] This statement proved to be prophetic.

Official diplomatic duties distracted the couple from their problems. For the first time, they entertained members of the imperial family at their residence. It was an important, and prestigious, event. The Austrian heir to the throne, Archduke Franz Ferdinand, and his wife, Princess Hohenberg, came to a luncheon at the embassy. She stated, "It was on both sides distinctly a love marriage of passion. [He] was captivated not only by his wife's unusual beauty, but by her

brilliant mind and the Christian zeal and integrity of her character.... It was an ideal marriage." The Storers had enjoyed visiting the royal's four-winged, three-story country mansion, Konopiště Château, and had spent happy days seeing the couple and their children.[8]

Later in the month there was positive news for the Roosevelts and Longworths. Maria's nephew, Nicholas Longworth, and President Roosevelt's daughter, Alice, had become engaged. As plans for Nick and Alice's White House wedding were splashed throughout the newspapers, the Storers accepted the wedding invitation and requested a leave of absence to attend. However, within a few days they cancelled their acceptance, possibly because Joe was not asked to be a groomsman. This snub plus the family's antipathy toward the president may have caused them to change their travel plans. The Storers and Joe decided to vacation in Egypt instead.

On February 3, some fifty days after receiving the Rooseveltian reprimand, the president sent a note to the Storers demanding an answer to his December reproach.[9] Still, the Storers did not reply. Three days after this, Archbishop John Ireland wrote that he hoped "you have totally put out of mind the memories of your Washington correspondence....The least said about the whole affair the better."[10] Bellamy was not convinced and told him that Roosevelt "demands an answer to his long letter.[11] However, Bellamy did not act on his concerns.

Despite telling the Storers to refrain from upsetting Roosevelt, Ireland unwittingly enraged the chief executive when he wrote to the president on their behalf. Roosevelt erupted that

> "nearly two and a half [months] has gone by since I wrote them both, and neither of them has so far answered me.... It is literally unpardonable for them under these circumstances to have left my letters so long unanswered and to allow my first knowledge of them having been received to come through a third party."[12]

When the archbishop received this exceptionally angry letter, why did he not cable the Storers in Egypt and encourage them to

respond quickly to the president? Ireland was such a fighter, and yet apparently, he chose not to help his friends.

On March 5, Roosevelt summarily recalled Bellamy as ambassador to Austria-Hungary.[13] The cable reached the diplomat in Luxor, Egypt. The disgraced diplomat submitted his resignation by mail on March 7.[14] In his anger and disgust about the situation, the president did not follow established diplomatic protocol and failed to inform the government of Austria-Hungary.

Bellamy wrote Ireland,

> "My only response has been of course to send in by letter to the secretary of state my resignation in obedience to the preemptory telegram of the president. We [Maria, Joe, and Bellamy] are going down to Cairo tonight by rail....I shall return to Vienna as soon as I can obtain steamer accommodations."[15]

A few days later, Maria neglected to mention the political situation when she wrote to Eugene F. Bliss,

> "How you would love Egypt. It is more wonderful than I expected and the perfect air is beyond description.... I don't grow homesick for my country nor its [r]uler! I have found out things about that individual which are beyond what I could have thought possible!!"[16]

The notice of Bellamy's recall reached the public on March 18. A Longworth cousin wrote acidly to her son, "I judge the Storers have given Americans no attention and this neglect will surely tell. If you have a chance to interview your dethroned cousins, you will surely have a circus! Never have any of our representatives been so punished, but I imagine the Storers have done something to deserve it."[17]

On March 22, writing from Paris, Winthrop Chanler, a friend of Roosevelt, wrote to the president, "I see that the Bellamy Storers are 'out.' There is only the *Paris Herald* to go by, but it looks like a meddling woman. Poor old Ireland! His friends will put him in a hole if they can!"[18] The French paper *La Revue Diplomatique* stated that the "recall of the ambassador of the United States to Vienna, Mr. Bellamy Storer, is

causing quite a stir in the diplomatic world.... [It is attributed] to his wife's excessively vocal pro-Catholic Church attitude."[19]

Print media in America raucously speculated about what happened. Bellamy was giggled at and Roosevelt was roasted as well. Cincinnati newspapers defended Maria against the inference she had put on airs by putting an elevated platform in her drawing room to greet guests. St. Paul newspaper headlines argued the archbishop could not be involved.[20]

The Austrian ambassador to the United States, Baron Ladislaus Hengelmüller von Hengervár, learned from the newspapers that there was to be a change of diplomats. The baron immediately telegraphed the Ministry of Foreign Affairs in Vienna that he had not been informed of the circumstances of the recall. "Proper form would have been to tell the Austro-Hungarian ambassador in Washington so he could quietly inform the Ministry of Foreign Affairs in Vienna," he noted.[21]

Hengelmuller could have registered a complaint against the American government and created an international incident. The

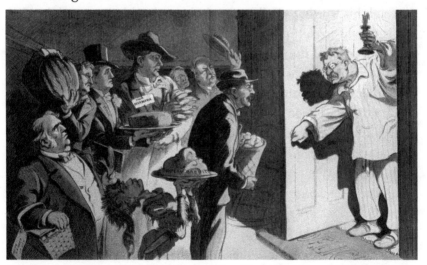

Fig. 8.1 Surprise party at Oyster Bay, New York. Cartoon showed a group of men making a surprise nighttime visit to Theodore Roosevelt, wearing pajamas. Bellamy Storer carried a cake labeled "From Dear Maria." *Library of Congress.*

Roosevelt government looked inept. However, his government opted to have him privately meet with Roosevelt about the Storer recall. The Foreign Office accepted Secretary of State Root's statement that "Mr. Storer's recall had absolutely nothing to do with his administration as ambassador to the mutual relation, but was necessary because of the indiscretions of his spouse."[22]

Reporters tantalized the international public with stories while the Storers traveled from Egypt to Austria. The day after the couple returned to Vienna, Bellamy spoke with a reporter in their drawing room and was taken ill. Maria continued the conversation, defending both their reputations. She released to the reporter an undated letter from Roosevelt "written six years earlier." She said, "Of course the letter...written to me...was intended for use in Rome."[23] It seemed incredible that she had only an old letter to support her husband. Many laughed at her.

On April 12, Ireland advised, "Let me counsel patience and delay. If necessary[,] Bellamy will talk. But the more patience he has, the better he knows the situation and the more he will be able to weigh his words."[24] Bellamy took the prelate's advice and decided to dispute his recall in writing. His rebuttal, totaling sixty-six pages, took him most of the summer to research and to write.

When Emperor Franz Joseph paid a farewell visit to the Storers and attended their last formal dinner, it was news.[25] The couple's belongings had been packed and they left for Paris. Bellamy's termination has been described as one of "the most striking examples of a summary recall by the home government in the annals of U.S. diplomacy."[26] What would they do now?

They decided to rent a lovely mansion south of Paris at 16, rue St. Louis, in a quiet section of Versailles. The Storers found that they were ostracized by some American expatriates living in France. When there were balls, dinners, and receptions in honor of Alice and Nick's European honeymoon journey, they were not invited. The newlyweds did come for a luncheon at their Versailles mansion,

but "it was a rather strained occasion."[27] On the other hand, the scandal did not impact Pierre and Min's standing with the American community. They were invited and attended several parties honoring the Longworths' French visit.[28]

One of the first people Maria reached out to was Lord Halifax. They arranged to meet for the first time later in the year.[29]

On June 23 and then again on August 3, Bellamy corresponded with the Depart-

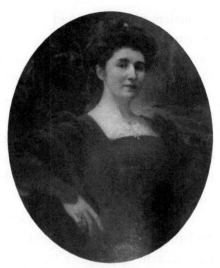

Fig. 8.2 Margaret de Chambrun portrait by Edward Maxence. Jacques de Chambrun.

ment of State about the grounds for his dismissal. The government charged he was recalled because he failed to reply to the president's letters.[30] He derided the organization as "a typewriter for the president."[31] Using these and other letters that he had acquired to support his position, he wrote his long rebuttal to the president.

The Storers' relationship with Archbishop Ireland eroded during the summer of 1906. When Maria tried to influence him to break with Roosevelt, he did not reply to her letters.[32] Additionally, he had refused to see them in Europe earlier in the year, or in America, after repeated invitations. On the other hand, Ireland maintained cordial relations with the president.[33]

In July, Maria sent Taft a packet of original letters containing the "reasons for not answering Theodore Roosevelt's 'strictly personal' letter of December 11, 1906." If one were counting, this is the second time she offered this information to him as if it were the revelation of a big secret. Taft rebuffed her entreaties, writing, "I ought to say that [the letters] contain several statements of fact with respect

to matters of which I had personal cognizance that are inaccurate because they are incomplete and lack the qualifications they should have had."[34] This ended her communication with Taft for the time being. Other interests came to the forefront of her life.

She decided to reach out to the English Catholic Church for spiritual, intellectual, and emotional comfort. She "very much [wanted] to meet some English Catholics and see something of our Church in England." She read in the newspapers that the biannual Catholic Conference was to be held in Brighton and probably convinced Bellamy to attend.[35]

The Brighton Catholic Conference was the meeting held to update participants on current religious and social concerns within the Church. September was the perfect time for the event; the weather cooperated, and the city rolled out the red carpet for the large numbers who attended in the vacation seaside resort. Hotel and train passes were discounted and restaurants catered to the meatless Friday group. The convention was a mixture of hymn singing, religious services, and scholarly presentations on topics as diverse as "The Reunion of Christendom," "Agnosticism," "Sunday Observance," and "Christian Science." These papers were made available for a nominal fee by the Catholic Truth Society for those who could not afford to attend.[36]

The Storers may have met a Catholic notable, the future editor of the *Dublin Review* and biographer Wilfrid Ward. Later Maria submitted an article and three poems to the Catholic periodical. They most likely met Father Francis Gasquet, who in the future answered Maria's questions about religion and toured Bellamy through his monastery after the monk was assigned to Rome. The Catholic Conference must be regarded, then, not simply a meeting filled with current information for their edification, but the source of their new Catholic-centric spiritual and intellectual quest.[37]

After the conference, they took the train to stay with Lord Halifax at his red brick mansion called Temple Newsam in West

Yorkshire. Halifax was highly generous, inviting the scandal-ridden couple to his estate. Under his patronage they met a member of the royal family, Princess Louise, and several aristocrats, who comprised the rest of the house party. When they left Maria gratefully wrote Halifax, "The days passed at Temple Newsam are among the happiest of our lives."[38]

From here they journeyed to Cambridge to talk with Father Robert Hugh Benson, whom she described as "the most beautiful young priest I ever saw. He is blond, and looks like a boy—and he is so wonderfully clever—but seems simple and entirely without self-consciousness." The convert priest was a prolific novelist, dramatist, poet, and theologian, who spoke about his concerns of the "predominance of Italian ideas at the Papacy." He hoped that English and American ideas could also influence the Church. The Storers were of a similar mindset.[39] They arranged for Benson to visit them the next year in France.[40]

After their "delightful visit" the Storers returned to their Versailles villa and entertained Father George Tyrrell, who had been expelled from the Jesuits in February 1906, and now seemed to be flirting with excommunication from the Catholic Church. When he finalized plans to see the couple he stated,

> "The kindness of your letter has touched me most profoundly and all I can do is tell you in all simplicity, how things stand with me at present, without any attempt to make out that I have been ideally prudent or theologically infallible; or that there is not heaps to be said on the other side."[41]

Bellamy and Maria found him to be intelligent and sweet. Maria concluded that he had been "treated with a great injustice and he shows no bitterness." Despite his own problems he felt empathy for her reduced and embarrassing social situation, declaring in part, "I am afraid you have had a great deal of anxiety and pain over Mr. Roosevelt's diplomacies."[42]

After Tyrrell's visit, the couple packed for an extended trip to the United States. They hoped to see Ireland in Baltimore,[43] visit

friends in Washington, see Joe's new home in Saranac Lake, and conduct business in Cincinnati.

On November 14, Maria and Bellamy opened their home on Grandin Road where they intended to stay for two months.[44]

Bellamy's printed rebuttal was sent on November 18 to the president and approximately twenty-five cabinet members and key members of Congress. Bellamy plainly asserted that Roosevelt directed the couple to see the pope on Ireland's behalf. He also discussed Archbishop Ireland's knowledge of the December 1903 mission.[45]

After reading the pamphlet Roosevelt deduced the high likelihood that this inflammatory document would be leaked to the press. The president therefore prepared a thoughtful rejoinder in the form of a memorandum to Secretary of State Root. On December 8, two newspapers published the contents of Bellamy's letter.[46] Roosevelt ordered Root, "Please send me back at once my Storer letter. The Storer pamphlet has been sent to all the newspapers and I want to use my letter at any moment." Root cautioned the attack would fall flat, "You should think seventy times seven before dignifying the attack by any answer." Even though Roosevelt trusted his advice, the president sent the reply to the newspapers and consternation ensued. Roosevelt "reiterated what he had maintained...previously about the impropriety of [the ambassador's] becoming involved in ecclesiastical affairs."[47]

"As the story 'burst upon an unprepared world, and ran its lurid course like a newspaper serial of diplomatic intrigue,'"[48] most people thought this latest explanation of his dismissal hurt Storer's case. As a Washington hostess thought, "The full Storer arraignment of the President [was] very foolish....The president's letter, which Maria characterized as mad, is very strong evidence against her, and I believe will destroy some of the sympathy she has had."[49] Senator Foraker's wife Julia commented that the nation's capital was "sophisticated; it doesn't take its gossip too solemnly," but hostesses "depended upon a new Theodore-and-Maria story for their dining room success."[50] Another Washingtonian said acidly, "It is not judicious to let the dear

C. H. Wellington in Memphis *News-Scimitar.*

THE MAKING OF A PRESIDENT.

By Mrs. Bellamy Storer.

Fig. 8.3 The Making of a President. Reproduced in Raymond Gros, *T.R. in Cartoon* (New York: Saalfield Publishing Company, 1910).

creature make the secretary of state's office a wardrobe in which to hang her petticoats."[51] At the White House, a guest commented to his diary that conversation around the dinner table at a formal event verged on "ultra-indiscrete" about the Storer incident.[52]

Talk was never ending. An editorial mused, "Everybody had to laugh at the letters the president wrote to Mrs. Storer where he

addressed her as 'My dear Maria,' and the letters the Storers wrote to him beginning 'My dear Theodore,' There was a general chuckle over the plight of Representative Longworth who is the nephew of Maria and the son-in-law of Theodore."[53] Henry Adams joked,

> "Here people won't stop agitating me....I have to dodge everyone and burn the newspapers for fear of somebody saying I thought [Maria] a charming lady....What will Washington be when Mrs. Bellamy...and the president get into a fight and kick me in the nose?"[54]

The attacks on Maria were brutal. One printed source snickered, "It is gallant, perhaps, to appoint a mediocre chum to an important diplomatic post because his buzzing, twittering spouse pleaded." A magazine advised, "As has too often happened in the history of American diplomacy, the personal ambition and misdirected zeal of a wife have brought a promising career of her husband to a sudden end."[55]

Maria and Bellamy were not prepared for either the release of the president's response, or the vitriolic reaction from the print media. Bellamy said, "It caused painful notoriety and most unpleasant and abusive comment."[56] Being in Africa and then Europe had distanced them from all the negative American press. Back home they received it full force. From nasty headlines, to sarcastic and sometimes thoughtful editorials, to humorous cartoons and poems, they were in a messy crisis with the president.[57]

Publicly, Susan Longworth supported the Storers. She gave an elaborate, formal luncheon where Clara Longworth de Chambrun and Maria were the guests of honor.[58] But privately, there were problems between them. Maria stated unequivocally to Susan, "You have had your mind poured into from the other side that it did not surprise me to find on Grandin Road and in the neighborhood[,] that you were considered quite on the other side."[59] Although the Storers had intended to stay two months in Cincinnati, they left after little more than a month. Suddenly, home was not a secure place to be. A cousin, Mrs. Nicholas Longworth Anderson, knew something

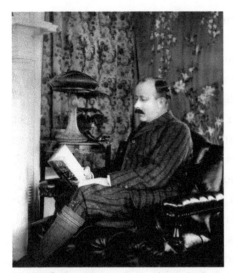

Fig. 8.4 Joseph Longworth Nichols in front of his fireplace in Saranac Lake, New York. *Courtesy of the Adirondack Collection, Saranac Free Library*

about what was going on. She wrote, "A note from Cousin Sue tells me she has been under a terrific strain, only avoiding a rupture with the Storers by refusing to discuss their altercation with President Roosevelt. The Storers have gone to Saranac [Lake] now, so Sue is relieved."[60]

The Storers retreated to the comfort of Joe's new home, far away from Cincinnati and from Washington. She wrote, "We are hurrying to Saranac Lake to make Joe a long visit. He has just bought a very nice house there and is getting settled." They liked Joe's home and they found Saranac Lake's society to be "without bother of social etiquette....There are some very nice people here from Boston and

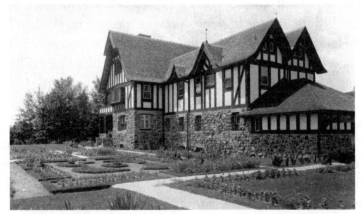

Fig. 8.5 Highland Manor, Joseph Longworth Nichols's home in Saranac Lake, New York. *Courtesy of the Adirondack Collection, Saranac Free Library.*

New York and every one of them speaks out sympathy with us and scorn for T.R."[61]

In the aftermath, the Storers communicated selectively to friends and family. Bellamy sent his rebuttal to Catholic friends whom he wanted "to learn of the truth."[62] Maria composed a somewhat disjointed pamphlet of her own that she distributed to a select few friends and family. It contained parts of Roosevelt's letters from 1896 to 1903, with her comments.[63]

Roosevelt heard gossip about this new document and asked his son-in-law, "Is it true that 'Aunt Ia' has published a fresh collection of correspondence? I am not particularly interested, because I think some of my most brilliant letters have already been published by the good lady."[64] He sought legal advice from Taft, who counseled him not to do anything. Nick replied, "Aunt Ia produced a new effusion, but it is largely in the nature of a brief with but a few quotations from your letters. The issues of this great work I believe, limited to ten, of one of which my mother was the unfortunate recipient."[65]

As before Maria paid special notice to both of her friends, Ireland and Taft. She still hoped to influence Ireland to break with Roosevelt. Because Ireland had not communicated with, nor seen her, she again felt a need to convince him that Roosevelt "lied."[66] The archbishop did not respond. Things came to a head when Maria sent Ireland, yet again, a packet of letter excerpts reminding him of what had happened to create this catastrophe. She blamed him for advising Bellamy to write his pamphlet. She said it was the last time she would ever write him about this issue. Ireland never responded. Their friendship ended.[67]

Maria felt Taft was no longer a confidant, but she still courted his friendship. She reached out to Judge (later Senator) Howard Hollister and asked him to convey to the Tafts "the truth," via a letter for the third time.[68] Taft did not respond.

Sadly, the Storers had lost their social and political positions. They were deserted by Ireland, Taft, and Roosevelt, men whom they loved.

On February 5, Bellamy returned to Cincinnati without Maria to take care of business. When he was approached by reporters, he refused to talk. Although they asked Stoddard and Eugene F. Bliss to come with them, they decamped to France only with their servants.[69] Storer wrote friends that the situation with Roosevelt was over and they might not be back to Cincinnati for five years, except for "short stays."[70]

After Bellamy's humiliating dismissal, the ostracism in Cincinnati and Washington, the international embarrassment of newspaper savagery, Maria said, "We are very happy and not in the least agitated—We have the approval of our consciences—and of the judgment of those whose honesty is above suspicion and in whose wisdom, we have confidence."[71] Then the couple headed back to Versailles, where a different life was before them.

GADFLIES

BACK IN VERSAILLES no one cared that they were a rich American expatriate couple living in a beautiful mansion. The Storers had been in the public eye most of their lives together. They had been in the center of several crises: the ruckus around their marriage, the Cox-Foraker conflict, the failed negotiations to avert the 1898 war, the delicate treaty conferences with Spain, and an international scandal with a president and a pope. Now, no one was curious about what they did or where they went. It was a relief, but it also presented unfilled days. What did they do?

One of their British friends, Father Robert Hugh Benson, came to visit. He helped them find a different focus. The Storers picked him up in Boulogne and drove to their home. Cars were a novelty and the travelers loved the freedom from train schedules to roam the open roads where sheep sometimes stopped their progress. Benson enjoyed their company and laughed at the heat and the bugs that were forever hitting their faces as the scenery swiftly passed by— sometimes at ten miles an hour. Benson remembered, "We had been travelling all day, through the August sunlight, humming along the straight French roads beneath the endless avenues."[1]

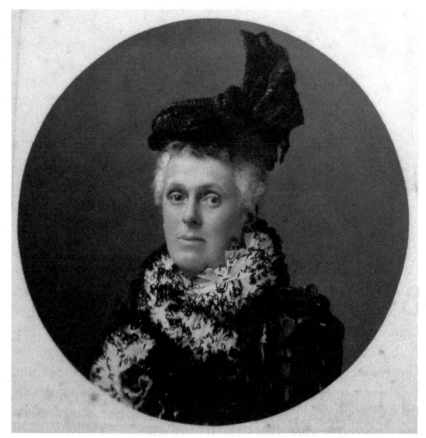

Fig. 9.1 Maria Longworth Storer. *Ursulines of Cincinnati Archives.*

The trio then motored to Lourdes, in the foothills of the Pyrenees Mountains. They reached the small hamlet in southern France in the heat and noise of the Pèlerinage National (National Pilgrimage). Benson described the first sight of the mountain village. There was "a long-drawn procession—carts and foot passengers, oxen, horses, dogs, and children—drawing every minute toward that ring of solemn blue hills." He added, "Lourdes is not beautiful....There is no sense of reflectiveness about [the architecture]; no patient growth of character, as in those glorious cathedrals, Amiens, Chartres."[2] How-

ever, even though Lourdes's buildings were less than awe-inspiring, they were not disappointed in the experience.

While Bellamy explored, Maria and the priest spent three days observing doctors interviewing individuals who claimed to be miraculously healed. Maria described how she "spent the days with [Benson] at Dr. Boissarie's in *Bureau de Constatations* [Verification Office] because he wanted me to interpret for him what was said—and take notes." In the evening, Maria shared, "The night of the torchlight procession...[Benson] rushed away from me, waving his torch, to join the ranks."[3] Benson continued,

> "We went 'round, then, singing. The procession was so huge that it seemed to have no head and no tail....I think it was all the most joyous and the most spontaneous (as it was certainly the largest) human function in which I have ever taken part....And so at last I dropped out and went home hoarse but well content."

The three pilgrims were surprised how "attached to a place in three summer days" they all had become. "To leave Lourdes at the end was like leaving home."[4]

When Benson indicated he would write about the experience, Maria was inspired to document her thoughts as well. Each created short books about Lourdes that were quite different. Maria translated letters and medical reports of one miracle recipient, Marie Borel, for a short, objective article that was first published in the magazine *Ave Maria*, and then as a pamphlet called *The Story of a Miracle at Lourdes* published in 1908.[5] Benson, on the other hand, focused on Lourdes as a religious happening for a series of articles, originally printed in the same periodical, and later collected together in a short book entitled *Lourdes* in 1914.[6] Maria's prose was scientific and impartial, while Benson's was lyrical and expressive. She filled readers with knowledge; he filled them with wonderment. It appeared they wrote almost as two parts of the same whole, without forethought of what the other would commit to paper.

This publication proved to be a springboard for Maria. Over the next twenty years she would be the author of many works of fiction, nonfiction, and poetry about her faith in hopes of attracting others to her Church.[7]

During this time, Bellamy was also under the spell of Benson. He decided to write about religious art. After leaving Lourdes, the Storers and Benson next ventured back to the center of France to tour the architectural treasures of Brou. Bellamy gathered notes and hired a noted photographer to take pictures for an article about the late Gothic church in that small town.

When the couple returned to Versailles, Father Benson left by train and Bishop Keane arrived from Nauheim to spend a few days with them before they all returned to the United States. He had been "taking the cure" for his heart condition, which involved mild exercise and medicinal baths.[8] They always enjoyed the company of the prelate whom Maria described as "so good, so genuine, in a way, so childlike, although robust in his convictions."[9] It is not known if the Storers shared their sadness over the loss of their friendship with Archbishop Ireland. But how could they not? He had been the focus of their intrigues and they must have felt deceived and misused by him when he dropped them as confidants.

The near anonymity of Europe evaporated when the Storers' boat docked in New York later that fall. As soon as the couple disembarked, they were besieged by reporters. Someone asked what they thought of a third term for Roosevelt. Bellamy laughed and cautioned his wife not to speak.[10] That was not all. There were articles speculating whether Representative Nicholas Longworth and his wife, Alice Roosevelt Longworth, would either visit or not visit them. The congressman dismissed the stories. Why hound the disgraced couple with flagrant lies?[11]

After a short visit to Cincinnati, the couple returned to the east coast to their rented mansion in Boston. They choose to live in this city, rather than Cincinnati or Washington where they owned

homes. Perhaps family members and friends, such as Isabella Stewart Gardner, welcomed them.[12] Maybe they were charmed by Boston's "famous old-world crookedness," as the author Henry James so fondly remembered.[13] The city also was a fast train away from Joe and to the steamboats that took them to Europe.

The Storers leased a twenty-room, four-story mansion considered "one of the finest on Marlboro St[reet]" in the exclusive enclave of Back Bay.[14] In this social epicenter of the Boston elites, not many of the upper crust invited Catholics, let alone disgraced Catholic diplomats, into their homes.

Isabella Stewart Gardner was not concerned about the scandal; she wanted them as her friends.[15] This lady has been described as "one of the seven wonders of Boston…[who has] the courage to go where none dare follow."[16] A Boston journalist gossiped that Gardner masterminded the Storers' return to American society. She opened her home-museum, Fenway Court, to them and hosted them at her country home of Green Hill in Brookline.[17]

Later Maria happily remembered the Boston hostess as her "playmate."[18] Their relationship had a fun-loving quality that Bellamy emulated. Once he flirted with "Queen" Isabella, saying all he wanted was to "lay at her feet."[19] Isabella's acceptance of them, seemingly without judgment, helped to reestablish the couple in the upper crust of American society.

The unrelenting print media continued to pester the Storers, calling them "Savants of the Roman Church." They supposedly arranged a series of lectures to be given by noted churchmen under the auspices of the Catholic Society of the Eastern United States. Besides Boston, these ardent papists reputedly worked with Archbishops Ireland and McQuade to "have some of the lectures" in their dioceses as well. There is no documentation that this ever happened.[20] Why write false stories as if they were Catholic conspirators?

Perhaps the story was written because they hosted Abbé Felix Klein, who delivered a series of lectures around the country about

the Catholic Church in France. His talks had been scheduled long before the Storers had rented the Boston property. The truth be told, the Storers enjoyed acting as hosts for visiting presenters. Providing lodging for touring lecturers demonstrated their tremendous interest in the current trends of their faith, and their desire to help inform the secular public about the Church.

Klein, who taught literature at Institut Catholique de Paris, in fact, proved a wonderful guest and a powerful speaker. The educator presented four lectures at the Lowell Institute, a free series held in Cambridge. The modest, somewhat eloquent man centered his discussions around the relationship of the Church with France, which had three years earlier broken off relations with the Vatican.[21]

After losing their friendship with Ireland, the Storers reached out to other Catholic bishops, archbishops, and cardinals wherever they lived. They no longer concerned themselves if the prelates were a part of the liberal faction of the Church. When they visited Cincinnati, they conversed with the conservative leader, Archbishop Henry Moeller, and when in Saranac Lake, they consulted the moderate Church leader, Archbishop John Farley. When they moved to Boston, the couple made their presence known to Archbishop William O'Connell, who represented the more conservative element of the Church hierarchy in America. "He was a key figure in what one historian has called the 'Romanization' of the Catholic hierarchy in the United States, a process by which leaders were chosen solely for the unswerving adherence to Vatican policy."[22]

Archbishop O'Connell had succeeded to the office of the archbishop of Boston with the death of Archbishop Williams in August 1907. The "massive figure" with "piercing eyes" and an imperious demeanor was a coming force in the Catholic Church who demanded unswerving adherence to Vatican policies.[23] The prelate was consolidating his power, and persistently looking for the "adulation of Bostonians to an almost embarrassing degree."[24] The Church leader would ride the wave of Vatican favoritism and be selected cardinal in

1911. His power, however, diminished with the death of Pius X and the removal of Cardinal Merry del Val as secretary of state during World War I.[25]

How did this conservative archbishop become good friends with the Storers? O'Connell found Bellamy to be "amiability personified" and felt somewhat sorry for him about the Roosevelt fiasco. The future cardinal said, "Why will well-meaning laymen mix themselves up in ecclesiastical politics which are always fatal to all who touch them?"[26] Bellamy enjoyed the company of the Church leader. He walked and talked with O'Connell nearly every afternoon when he was in Boston. O'Connell valued the former diplomat so much that he nominated Bellamy for the Winters' Night, an exclusive men's club.[27]

O'Connell was somewhat deferential and polite toward Maria. He certainly did not confide or involve her in any administrative business of the archdiocese as Archbishop Ireland had, but he saw her socially, accepted charitable contributions from her, and granted permission for speakers she suggested.[28]

The Storers were tremendously impressed by his conservative position. They learned through conversations with him why assimilation of Catholics into American society could be problematic. They now worried that adaptation of Church members to American society might reduce their loyalty to their religion. As Bellamy eloquently said, they now valued the "Church...apart quiescent."[29]

Maria kept busy with many different projects. She helped the bedridden Charles Stoddard by reading proofs for his latest book about Father Damien. The author would dedicate this volume to her and Bellamy because of their support.[30] She was producing "repoussé copper" objects where the metal was shaped by hammering on the reverse side. It was "her joy" to create elaborate panels of animals and fish, sometimes fitted with semi-precious stones.[31] It is not known when she began this work, but she continued to do it until she moved permanently to France.[32] Sheets of copper and a

few tools and molds were easier to transport than a kiln so it must have appealed to her with their transient lifestyle. At an exhibition in Washington at the V. G. Galleries,

> "several [of her] small panels setting forth marine pictures [were shown.]...Sea urchins, fish, lobsters and squids [were] modeled in low relief seen through a maze of beautiful metallic color....[This work was] produced entirely as a pastime and s[old] merely for the benefit of a charitable institution."[33]

From this point until the beginning of the world war, Maria moved on with her life and spent much of her time composing devotional literature, evangelizing essays, religious novels, and letters to the editors of magazines and newspapers. Her public writing lacked the wit and charm of her spoken word and the sly humor of her private letters. She argued in these publications that the permissiveness of the secular culture threatened current religious practice. She wanted others to have the inner peace and sense of security that the truths of the Church brought her.[34]

Bellamy also took up new interests and became involved in a variety of activities. He gave family papers, some dating to the eighteenth century, to the Historical and Philosophical Society of Ohio.[35] His article, "The Church of Brou," was published in *Christian Art*, a magazine devoted to expert discussions of architecture,

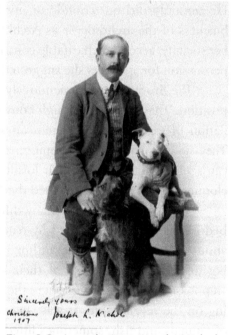

Fig. 9.2 Joseph Longworth Nichols, 1907. *Courtesy of the Adirondack Collection, Saranac Free Library.*

and ecclesiastical art.[36] The former diplomat also presented a controversial speech, criticizing the war with Spain. He believed that the battle cry, "Remember the *Maine*," more accurately should have been the "United States Lynched Spain." The print media greatly disliked what he said.[37]

The Storers visited Saranac Lake and found Joe happily ensconced in his quiet life far away from the big cities of Europe and the United States. He was making a name as a good medical researcher, publishing another article in a professional journal.[38] Within the community, he could be seen fishing and going out with the other doctors to local events. Joe also started a curling rink where stones were slid on ice toward a target. He was unable to take part in this strenuous activity, but he loved to be a spectator when there was a competition.[39]

In the first week of March 1908, Maria approached Henry Adams about Charles Stoddard's financial difficulties. Adams was only too happy to help and send money for him. In her thank-you note on Stoddard's behalf, Maria wrote that his check "should be quite enough just now."[40] When Stoddard died in 1909, Maria was distraught. She had hoped to see him once again, but he died in California and she heard of his passing through the newspapers.[41]

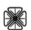

By the end of the month the couple prepared for their migration back to Europe.[42] Why return to France, if they found a supportive social network in Boston? They often complained of being in exile during the diplomatic years. Why not stay in America? Perhaps because they were a part of a group of wealthy Americans, such as Henry Adams, who stayed part of the year in France. They loved the orderliness of the old culture. Like Edith Wharton, France was for them "an intellectual and social ideal."[43]

For the French, "American visitors who come every summer [are like] the Nile…they enrich the [country] as the Nile does Egypt. The American elements entertain extravagantly.…There is an American Chamber of Commerce." One wonders if Bellamy joined. If so, he would have felt quite at home. "There is also an American art association." Perhaps Maria enjoyed their company.[44] Bellamy portrayed life in France as a wonderful routine he cherished. "Every day after coffee about nine, I walked and did all my little errands—bank, eyeglasses, carrying notes, pharmacy, etc., etc.…I went in an automobile to Fontainebleau lunched and golfed."[45] He and Maria also had the joy of watching Pierre and Min's children grow up before their eyes.

Their geographical mobility was part of their identity. So they continued to travel across the ocean until Bellamy suffered a stroke in 1919. He wrote and suggested what the transient life style was like:

> "What we shall do is a very often and vague question. With my dear Madame, it sometimes seems as if it made no difference whether so long as…[we are] flitting hence! There are gadflies in modern 20th century as well as in the classic fable."[46]

In the summer of 1908 Susan Longworth spent time with the former diplomatic couple in France. Whatever bad feelings that had separated the sisters-in-law two years earlier apparently had been resolved.[47] Joe also visited.[48]

The Storers attended the Eucharistic Congress in London, the first time a predominantly Protestant country hosted the international Catholic event. They were profoundly affected by the piety and dignity of the crowds in London. Maria was especially impressed by the speeches of their friends Abbot Gasquet and Cardinal Gibbon.[49]

When they returned to Boston, Maria and Bellamy rented an ultra-exclusive *appartement meublé avec cuisine* [furnished flat with a kitchen], Number 56 in Fenway.[50] It would be their American home base until 1911.

Many of the Storers' activities involved Church celebrations. The 100th anniversary of the Catholic Church in Boston led Archbishop O'Connell to preach that the "puritan has passed; the Catholic remains....The little church of Boston has grown and expanded into one of the most prosperous and numerous provinces of the Christian world." Bellamy pronounced the sermon, "magnificent....I cannot... put into words the impression the sermon made."[51] The celebration "provided a public forum for Catholics to display religious unity."[52]

Notwithstanding the comfort and social acceptance, the Storers were considering whether they should spend winters in Washington. Their friend, William Howard Taft, Roosevelt's handpicked successor, had been elected to the presidency. They went so far as to renovate their Washington mansion extensively.[53] What would bring them back to the nation's capital? Perhaps the Storers secretly hoped that Taft would appoint Bellamy to some governmental position. So, when he was elected in November, Maria only waited three days to seek his favor.

Maria wrote to him and explained yet again what happened in 1906. Taft did not respond. When she had not heard from him, she tried a different tactic and said, "We are going to Washington in February to be there for the inauguration hoping to get at least a distant glimpse of you. We have a delightful apartment here and should be glad to have you stay with us...if you are coming to Boston." Taft thanked her for the invitation to Boston in the typical kindly, yet distant way of his. He indicated he looked forward to seeing her at the inauguration. No mention of her first letter was ever made. In her next letter she stated, "Don't look upon us as wanting anything— which you have to give—except your friendship."[54]

The Boston social scene occupied the Storers' time during the last months of 1908. They spent time with Isabella Stewart Gardner at Green Hill and at Gloucester, celebrating Thanksgiving with her and some of her male friends and protégés.[55] They were guests of the collector and interior decorator Henry Davis Sleeper in his

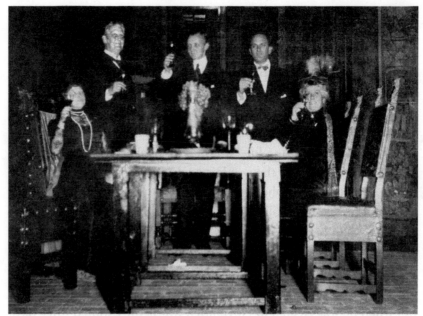

Fig. 9.3 Thanksgiving toast, 1908. Left to right: Isabella Stewart Gardner, Bellamy Storer, Henry Sleeper, A. Piatt Andrew, and Maria Longworth Storer. *A. Piatt Andrew Archive. Courtesy of Historic New England.*

home, Beauport, on the beautiful, rocky coast of Gloucester harbor. This witty, opinionated group kept the conversation ricocheting off the walls as they celebrated, and their irreverence and sense of fun brought out the best in Maria and Bellamy.

One of the group members who was not in attendance was Archbishop O'Connell. Gardner "courted" the Church leader, asking him to many events.[56] She "invited him so often to her notable parties at Fenway Court that a Bostonian ventured to ask O'Connell if the lady might be inclined toward the Catholic faith. 'Nonsense,' answered the archbishop, 'she only likes the decorative effect of my robes in her Renaissance palace.'"[57]

For Christmas, they spent time with Susan at the old Rookwood estate in Cincinnati. They brought along the Rev. Francis Xavier Lachance, the priest who had converted Bellamy in 1895.

He could no longer carry the load of parish work and had no other means of support, so the Storers invited him to be their guest until his health improved or he found a position that was less taxing. He remained with them for two years.[58]

In January 1909, O'Connell and the Storers came to Isabella Stewart Gardner's Fenway Court for a "French play," where nearly $1,500 was raised for charity.[59] Later in the month it was the Storers turn to entertain. Gardner and O'Connell attended a reception at their lavish apartment. The dinner guests enjoyed the couple's overnight visitor, the Rev. Herbert Vaughan, who was on a speaking tour of the United States.[60] Gardner always loved to tease Maria. Another visitor depicted how Isabella mocked her hostess:

> Mrs. John L. Gardner swept in—she looked at me smilingly and said,
> 'Evidently Mrs. Storer wrote you that the Cardinal did not approve of low necks. I crossed the ocean with him and we sat the same dining table and I know what he likes.' She threw off her wrap and revealed herself in the lowest of low necks in her usual beautifully-cut black dress and with her famous back in full view....She whirled around and went into the drawing room while we humbly followed but in time to see her sweep a low curtsy to Cardinal and kiss his ring.[61]

With the inaugural in March, Bellamy and Maria went to Washington and moved back to their newly remodeled home. The gossipers loved headlines that claimed the "Storers Come In as Roosevelt Goes Out."[62] The former diplomats were invited to the White House and attended several other parties.

When asked about why he was visiting Taft, Bellamy replied, "It is perfectly natural that we should call on President Taft. We have always been friends, and, in fact, have grown up together." Maria presented a gift to the first lady, a mahogany table that was inlaid with copper of her design.[63] Maybe she hoped that Mrs. Taft would influence the president to appoint Bellamy to a governmental position. In a few years, she also asked Archbishop O'Connell to speak with the president on Bellamy's behalf. Sadly, nothing came of her efforts.[64]

Maria's outstanding contribution to art pottery was not forgotten. At the first meeting of the American Ceramics Society in 1909, she was named the first Distinguished Life Member (then referred to as an Honorary Member) for her production of the first line of distinctive American art pottery.[65] A member of the Cincinnati Woman's Club presented a paper about the Rookwood Pottery Company at a meeting of the group. She provided "unstinting praise" for Maria's vision and art pottery designs.[66] Both events demonstrated how famous Maria, the artist, was in contemporary society.

The Storers' philanthropic efforts supported Catholic charities, parish construction, and educational institutions. They funded the Friars of Atonement, the Boston's archdiocese, Catholic University, and Cincinnati's Holy Angels Church.[67]

They visited Joe in Saranac Lake and spent six weeks in the small community. Maria spent most of her free time writing. The village's atmosphere that nurtured tubercular patients also nurtured her creative spirit. Religious essays and poems seemed to pour out of her.[68] She sent the Reverend Hudson, the editor of *Ave Maria*, a poem about the pope for possible publication and a copy of an article, "The Decadence of France," which was published the following year in the secular magazine, the *North America Review*. In this essay, she summarized the problems of the world as they related to atheism, as demonstrated in France.[69] Maria also created "a collection of arts and crafts ceramics for the benefits" of her son's philanthropic efforts on behalf of the tuberculosis patients.[70]

Back in Europe in the fall, Bellamy updated Eugene F. Bliss about how Maria became bored to death at the Carlsbad spa. He wrote, "The poor little Madame [Maria] could not stand it and ran away to Vienna....[She] left...in anticipation of [working on art pieces, but the copper] was totally intractable to her tools and methods."[71] Bellamy wanted to play golf and did not follow her. Maria's need for action had worn him out.

Min joined Maria in the Austrian capital. When Min suddenly went into labor, she rushed back to Paris just in time to give birth to her last child, Gilbert, who was born on November 2, 1909.[72] Later, Bellamy acted as proxy godfather at the child's baptism. He joked, "You see I study the art of...[the] grandfather still and by repetition...[I am] becoming more proficient."[73]

Bellamy observed that, although now the mother of three, "Min looked handsomer than when a girl."[74] She was an elegant and beautifully dressed woman in her late thirties who wore few jewels.[75] In Paris she cared for her small children, and entertained acquaintances and family from the United States. Old friend Henry Adams, cousin and diplomat, Larz and Isabel Anderson, and new acquaintances like Josephine Ward, the English wife of the *Dublin Review* editor Wilfred Ward, enjoyed their hospitality.[76] In the country at their Château Carrière, where the family spent their summers, domestic life also dominated her cares. Min used the Longworth money to update the old, rambling French mansion. New plumbing and kitchens were installed. The formal rooms were filled with paintings that once hung in Rookwood and the Storers' mansions, and a large piano was available for her to play. Comfortable servants' quarters, a formal rose garden, and other landscaping were added. Bellamy praised her work by saying the "domicile of Pierre and Margaret is in fine condition and Carrière much improved in rooms and looks and in comfort."[77]

As the wife of a deputy, Min wholeheartedly took on her role as wealthy aristocrat caring for the poor of Lozère. Min was reputed to have founded a lace factory "to procure work [for young girls] and prevent emigration to Paris." She also created "classes of household economy" in order "to improve the condition of the poor peasant families." By 1911, her book, *Manuel d'enseignement ménager: Recettes et conseils pratiques sur l'hygiène et l'économie domestique, l'alimentation, réunis et adaptés par la marquise de Chambrun* [Housekeeping instruction manual: Recipes and tips on hygiene and home economics, nutrition, combined and

adapted by the Marquise de Chambrun] on this subject was in its second edition.[78] She also actively campaigned for her husband.[79]

Pierre was someone whom Maria referred to as "a good man."[80] He had been continuously elected to office since the late 1890s. Bellamy described him as "entirely winning...as he grows older... [with] quiet touches of old fashion attitudes of the *ancien* régime prejudice....[He had] a quiet...way of evading giving any binding pledge and doing everything his own way."[81] The French politician was very thoughtful. Although he had pressing business with his work in the legislative area of the French government, he found time to spend with Henry Adams chatting with the author about European issues when Adams stayed in Paris.[82] In another instance of kindness, when the deputy noticed an American who was refused admission to the Chamber of Deputies, he toured the visitor around the huge room himself.[83]

Back in the United States in December 1909, the Storers' calendar was filled immediately with social engagements in Boston. They heard O'Connell speak at a conference of Saint Vincent de Paul in the Cathedral of the Holy Cross. Isabella Stewart Gardner also attended.[84] Throughout the winter months of 1910, Bellamy gave three presentations on various religious themes in Boston and Washington, DC. In his first lecture at the Catholic Union in Boston, he condemned the French government for taking religion out of the school system. His address was published in the *Ave Maria* monthly and later as a small book called *The Bishops and the Schools in France; An Address before the Catholic Union of Boston, February 5, 1910*.[85]

The Storers additionally visited the White House twice and told Isabella Stewart Gardner how much they had enjoyed "dining with Taft...in the East Room at 10:30 p.m."[86]

Maria continued to focus her enormous energies on writing. In 1910 she published several articles, poems, and letters to the editor that received notice and comment.[87] In two articles, entitled "The Decadence of France," published in the *North American Review*

and "The War against Religion" in the *Catholic World*, she described measures taken by the state to dismantle its relationship with the Catholic Church. She believed eliminating religion from all aspects of French life created a moral laxity and chaos in the secular society. Maria's dire predictions about the future of the world caused several editors and journalists to quote her without comment or editorialize on what she said. Some sarcastically mentioned the 1906 scandal, suggesting her writing proved she was an unhinged matron or a rabid papist who said silly things about secular society.[88]

When they were home in Cincinnati, the couple was entertained by many old friends including Mrs. Perkins, Judge and Mrs. Hollister, the widow of Bellamy's law partner, Mrs. L. B. Harrison, and the Wulsins. It is interesting that their close friends, who supported them all these years, were Protestant elites from their childhoods. Whether Maria had Catholic friends in Cincinnati is not known. The pair only stayed ten days because another family matter occurred.[89]

Joe's engagement and forthcoming wedding to Mae Mary (called "Mary") Morgan were announced. The forty-year-old doctor was infatuated with a twenty-nine-year-old Baltimore lady whom he had met, it is believed, through friends. She had traveled throughout Europe and loved gardening so much she studied landscape design at the Philadelphia Arboretum. She "was greatly admired and very popular in [Baltimore] society." On April 7, Joe and Mary married at a small ceremony attended by Maria and Bellamy at Saranac Lake. The happy couple left immediately to honeymoon in Europe.[90]

The Storers returned to Boston where Bellamy presented a speech entitled "Some Charities I Have Seen," before Saint Augustine's Lyceum.[91]

Maria and Bellamy also hosted the Rev. Robert Hugh Benson on his first trip to the United States. Maria rolled out the red carpet and ensured he was well received. She asked Isabella Stewart Gardner to host ten of his lectures in her palatial home over a two-week period.[92] He also spoke at Holy Cross Cathedral during that time.

Other society matrons, such as Julia Ward Howe, entertained him in their homes.[93] This was the beginning of Benson's love affair for all things American. He was to visit several times, and would lecture to more than 100,000 people before he died.[94]

Maria encouraged him not to spread himself too thin. She noted, "I think you have now come to the point when you ought to decide whether your career is creditable. You are a great popular preacher, a capacity simply sown with innumerable fatal pitfalls. You are also a great popular writer....Preach or write, and give yourself to one career or another."[95] It was surprising that the artist-writer would say this to the priest because she always did more than one activity at a time throughout her life. Benson did not take her advice and continued to write and lecture to an adoring public.

Theodore Roosevelt returned to Maria's life, but not in a pleasant way. The former president, now referred to as Colonel Roosevelt since leaving office in March 1909, had been on a safari in Africa and a tour in Europe. The colonel's triumphal journey to the various European capitals appeared like a current head of state's grand tour rather than a private citizen's visit. When he was in Rome, he had been scheduled to see the pope, but only if the former president "did not embarrass His Holiness by associating with any Methodists in Rome....[Roosevelt decided] he could not permit Vatican officials to tell him whom he might see or not see." So, he cancelled his audience with the pontiff.[96]

Maria was incensed, saying, "The outrageous personal abuse of the dignitary of the Catholic Church is as deplorable as it is unwarranted." She concluded it was an insult to all Catholics and demonstrated Roosevelt's hatred of her Church.[97] At that point, she decided that people "both in Europe and America should really know the manner of man [who] is Theodore Roosevelt."[98] While visiting her daughter in France, she wrote to a newspaper in the United States about Roosevelt's lack of credibility as demonstrated by the 1906 scandal. Her letter made headlines all over the country, but not in

Europe. Her attack sputtered out when Roosevelt refused to comment. When the couple arrived back in the United States, they also would not discuss her letter.[99] What was the effect? Very little, if anything. Mostly, people felt sorry for Roosevelt. Maria always had a flair for attracting controversy and attention. Few people cared about the old news.

Upon returning to Boston they saw the fall colors with Isabella Stewart Gardner at Green Hill.[100] The Storers embraced activities they both had grown to enjoy within the intellectual and religious climate of this city. Maria arranged for yet another lecture to be presented at Isabella's home. She was the guest of honor at a professional woman's club meeting. Bellamy gave a speech to the Knights of Columbus. Additionally, the Storers attended a Catholic ordination ceremony for a former Episcopalian priest, always happy to see another convert. They also financed the installation of a beautiful altar in one of the local churches.[101]

Maria was excited to receive a note from *Extension* magazine soliciting articles from her.[102] She thought her writing career was taking off and felt confident enough to ask Archbishop O'Connell to read some of her poetry. She bragged that the *Dublin Review* editor Wilfrid Ward suggested "my publishing a small book of such verses."[103] It is believed some of these poems comprised a publication called *Some Verses Written in Honor of the Church and Dedicated to Saint Catherine of Siena*.[104] The *Dublin Review* and the *Catholic World* also published two of her poems in 1911. She additionally contributed a short essay about the Church to a book entitled *An Appeal for Unity in Faith*, edited by Father John Phelan. At the end of the year, she published privately a small nonfiction pamphlet called *The Soul of a Child* that addressed her concern for the rise of atheism in the United States. She hoped that others would find the inner tranquility brought her by the doctrinal certainty of her Church, as suggested in her book.[105]

The couple visited Joe and Mary at Saranac Lake. The newlyweds were involved with the elite society in the small town. Dr.

Trudeau told Maria that Joe and Mary were "the sunshine for us at Saranac."[106] Joe was very involved with a group of doctors and businessmen who organized to build a hospital in their community. He was selected to be president of the board of directors of the facility named the General Hospital of Saranac Lake. It would open its doors in two years.[107] The Storers next spent the weekend with Isabella Stewart Gardner at Green Hill and then, in June 1911, sailed back to Europe.[108]

Bellamy wrote rapturously about the terrain where they were staying, that there were "miles of forest [and] no automobiles allowed...three hours from a railway....The best and wholesome cuisine I ever have had—and such air!"[109] They stopped in Brussels at the American legation to see Larz Anderson, who had been appointed minister to Belgium, but he was not at home. He not only filled Bellamy's former position, but also leased the same palace that the Storers had requisitioned as the American legation and his home. After looking around Brussels, Larz penned, "I believe the palace they had would be just the thing....The 'd'Assche' [palace] is one of the best to be rented."[110]

Just as the Storers were arriving back from Europe, the papers told them that Archbishops Farley of New York and O'Connell of Boston were elevated to cardinal. Both sent letters of congratulation to O'Connell. Ireland was nowhere to be found on the list, to the sadness of his friends.[111]

In November, the couple went home to Cincinnati rather than Boston. Maria's latest release of private letters barely brought a whiff of concern in their native city. Why not go home?[112] Bellamy wrote, "It is really curious to re-study after an absence of eighteen years" the social and political world of the city. He was not interested in local politics, even though Cox's influence was nearly gone and Foraker was marred by a scandal and voted out of the Senate.[113] Bellamy was more interested in Catholic Church affairs and the rising power of Theodore Roosevelt, who everybody knew wanted the White House again.[114]

From the end of 1911 until late spring 1912, the duo kept busy with multiple cultural and religious activities. They were guests of honor at dinners; they attended concerts and the Cincinnati May Festival for the first time in sixteen years; Bellamy gave a speech and attended club meetings; and Maria attended teas, exhibited some of her trays downtown, and sent a copy of her latest book to Archbishop Moeller. Additionally, Joe and Mary visited for Thanksgiving. It was Mary's first trip the Queen City and a long time since Joe had been home so it was a nostalgic and informative trip as well for the couple.[115] Moreover, the Storers used the Country Club as the setting for a reception of their friends. The people invited were from the elite whom the Storers had known all their lives. It is also interesting that no Catholic prelates were asked to the party. Maybe the Storers did not feel as close to the Catholic hierarchy in Cincinnati as they had the Church leaders in Boston?[116]

Colonel Roosevelt again dominated the news during this election year with his desire to return as president. How could he wrest the control of the Republican Party away from Taft, an incumbent president? Maria became irate. She chose to fight him, both in a letter to the editor of the *New York Evening Post* and in an article in *Harper's Weekly*. In her letter Maria argued that no one could trust the former president since he "unhesitatingly broke his pledges." In the *Harper's Weekly* article, she described how Roosevelt was selected as assistant secretary of the navy, against the better judgment of McKinley. She presented him as an exuberant child, slyly insinuating that men with his personality style should not be elected president.[117]

Just as in 1910, the Storers were not in the country when Maria's anti-Roosevelt writings were published. This was a wonderful way to avoid the glare of publicity.

Not surprisingly, Maria found support for her anti-Roosevelt beliefs in her Cincinnati social set and her family. Taft was a hometown boy and many wealthy elites bitterly disliked the fact that the colonel broke ranks with him. No one in her family supported

Roosevelt, except his daughter Alice. Larz Anderson remembered, "We had a good talk about matters at home. They say…'*Digue le noyau*' [Damn the 'kernel']!"[118] So it appeared that when people were angry with Roosevelt they would say, "*Digue le noyau*!" as if they were condemning something inedible, rather than the former president.

The summer of 1912 in Europe for the Storers was full of family and friends. Bellamy remembered, "We had on the whole a wonderfully delightful four-weeks in Nice, Rome, and Florence" enjoying the beautiful scenery with Joe and Mary. Then on to Paris where they saw the Wulsins, W. W. Taylor, and Min's family. At the end of June the Storers and Min visited Larz at the Belgian legation, which brought back many memories. They had an audience with the mother of the Belgian king, the countess of Flanders. When she saw Bellamy and Maria, the countess smiled and "came forward across the room and was very gracious and seemed to enjoy seeing the Storers again.…She kept us a long time."[119]

From Belgium, they went to the Switzerland-Italian border and met up with the Rev. Robert Hugh Benson, who climbed peak after peak in the western Alps. Maria remembered, "I hired a very sure guide to take care of him.…He went everywhere, only omitting the Matterhorn, and that was because of bad weather." While the priest challenged the mountains, Maria wrote poetry for her proposed book. When she tired of writing, she could pick up her small hammer and begin tapping on her latest copper project.[120]

The couple attended the Eucharistic Congress in Vienna and saw many aristocratic and royal friends. They were welcomed graciously by "everyone, from His Majesty downwards." Maria was led to comment, "it makes Bellamy and myself homesick for this splendidly Catholic society in the greatest Catholic country in the world."[121]

Besides Maria's anti-Roosevelt political writing in 1912, she published two religious poems and a letter to the editor about her experiences at the Eucharistic Congress.[122] She also tried her hand

at writing novels. She completed four works of fiction in quick succession between 1913 and 1916. She had the books published in the United States and Europe through a prominent Catholic publishing firm, B. Herder, which was based in Germany and had offices in the United States and Great Britain.[123]

Her first novel, entitled *Sir Christopher Leighton; or, The Marquis de Vaudreuil's Story*, disparaged atheistic convictions of eugenics and "novelty" religions. The melodrama clearly demonstrated her belief that the Catholic Church's theology was the best alternative to these principles.

After the Storers' return home in October they were confronted with the split in the Republican Party. Roosevelt had formed a third party called the Progressive or the Bull Moose Party. Bellamy and Maria continued to offer Taft their counsel and financial support in his fight against Woodrow Wilson, the Democratic candidate, and Roosevelt.[124] On election night, the Storers were with Taft when he accepted his defeat graciously, stating, "The people of the United States did not owe me another election. I hope I am properly grateful for the one term of the Presidency they gave me."[125]

Maria and Bellamy's lives were not disrupted with Taft's loss to Wilson. They went on living in wealth and comfort in their home city. They maintained their busy social schedule. Additionally, Maria wrote about "The Awakening of Austria" for a popular magazine. She believed that Austria had good leaders, something not generally acknowledged in the United States.[126]

Back in Europe, the Storers visited Father Robert Hugh Benson with Min and Pierre at Hare Street House in Hertfordshire, England. Since he last saw them, he had continued his frenetic pace of writing and speaking. At home, he only paused when he had visitors like Maria and her extended family. When he died the following year, Maria sadly contributed reminiscences for his biographer.

The Storers loved going to Italy, and especially Rome, from the time in the 1890s when Eugene F. Bliss had traveled with them.

They stayed away since 1903 because of the embarrassing scandal with Archbishop Ireland. They did not request an audience with the pope. The newspapers barely mentioned their arrival.[127] Rome would continue to draw them more and more, especially around Holy Week and Easter in future years.

While they were in Marienbad for their annual cure, they ran into Cardinal O'Connell, who probably gossiped about Isabella and their Boston friends.[128] Bellamy played golf. Maria was always busy either hammering copper or writing her second novel, called *Probation*, during this time.[129] This book dealt with issues of divorce and how liberal sexual attitudes were examples of the moral laxity she feared.

October found the couple taking in the beauty of the fall colors with their son and daughter-in-law. Joe appeared happy and content, like Bellamy, with clubs and outdoor activities of "driving, riding and fishing."[130] The winter in Cincinnati brought more concerts and club meetings for both, speeches by Bellamy, and family and famous house guests to entertain. Joe and Mary returned for the holidays; the *Dublin Review* editor Wilfrid Ward visited. He regaled his hosts about his American travels and they in turn shared anecdotes about King Leopold of Belgium. At one of the dinners, Nick and Alice Longworth also attended. Ward found Alice to be "most agreeable."[131]

Sad news was sent to them from Europe at Christmas time. Bellamy's last surviving sister, Bessie, had died. Min had nursed her in her last days at Lausanne, Switzerland. Funeral services were held in Cincinnati the end of December and her ashes were buried at Spring Grove Cemetery the following year.[132]

In January 1914, the Storers, who often stayed at the Alms Hotel when in Cincinnati, asked Archbishop Moeller where they could attend daily mass close by in the city. He suggested the Ursuline sisters not far from them on McMillan Street. The Storers made an appointment to visit Mother Fidelis Coleman, superior of the Ursulines at Saint Ursula Academy, to ask if they could attend

mass with the sisters. Mary-Cabrini Durkin explained what happened next:

> Mrs. Storer made her plea: their chauffeur had to wait in harsh weather while they attended Mass. Might they reside here, with access to St. Ursula's chapel? Mother Fidelis described the crowded conditions, the tiny chapel, and her hopes that someday the community could afford an addition and a proper chapel. Mrs. Storer called her husband in from the driveway and conferred quietly with him. Before the evening ended, there were plans for a new chapel and an addition to the west building, with a promise of $10,000 to begin.[133]

Bellamy drew up a contract between the parties. In the new wing, the Storers would create a comfortable apartment, and "they had the privilege of occupying the apartment for life." They also would be allowed to worship in the new chapel with the sisters.[134]

When Maria left for Europe in March, she expected to return to Cincinnati in the fall as she and Bellamy had done for the past several years. Little did she know they would be confronted by war.[135]

MODERN MONSTROSITIES

W HEN THE STORERS journeyed to Rome in April 1914, the population of the city had nearly doubled for Holy Week and Easter. Alice Longfellow, the poet's daughter and friend of the Storers, wrote to a relative, "I have had a beautiful and very interesting Holy Week...following the services each day." During the week, many devout young pilgrims ate "only bread and water." This was not the case for Alice, Maria, and Bellamy. They had a "pleasant lunch," probably sharing stories about mutual friends from Boston.[1]

On Maria's insistence, the couple took an apartment in the Eternal City for three years.[2] She wanted Rome rather than Paris to be their base of operations in Europe because it was so close to the Vatican. Religion, rather than her artistic creations or Bellamy's political career, was now the focus of her life. Her faith guided her sense of duty and gave her a purpose.

The Storers leased a sunlit upper floor of a large villa at the Villa Wolkonsky. Bellamy reveled in the fact they had their "own front door entrance and separate stairway." He also loved that they were "situated in a garden [which is] part of eight or nine acres... with tall Italian palms, date palms and banana trees....[They could

see] Nero's aqueduct,...[and the] catacomb[s.] People...come to see roses in spring, [and the] peacocks roost[ing] in the trees."3 It was a spectacular place to live in the heart of the Eternal City.

After nearly eleven years without a papal audience the Storers sought and received an invitation from the gray-haired, ailing Pope Pius X, who had suffered from constant chest pain since his heart attack the previous year. Several newspapers reported that "their reappearance at the Vatican...created quite a sensation."4 However, it was not page-one, international news, as it had been more than a decade earlier.

Maria wrote Eugene F. Bliss, "This morning we had a private audience with the Pope....I [have been] chumming with all my dear cardinals....[Also, my] third story is nearly finished."5 She referred to her book *The Borodino Mystery*, another novel espousing her Catholic beliefs. Bellamy, likewise, was enjoying himself as he joked to Bliss,

> "Yesterday by invitation from Abbot [Francis] Gasquet, we visited his new Benedictine quarters where he [is renovating] the old Palazzo San Collisto....The Madame threatens to take a veil if I go anymore into prelate society without her....Her chumminess with cardinals...makes her feel that she should have access everywhere."6

After Holy Week, the Storers traveled north into the coolness of the mountains and "took the cure" at Marienbad. Pierre, Min, and the three children joined them. Earlier in the year, Min had earned her diploma as a Croix Rouge [Red Cross] nurse. After caring for Bellamy's dying sister Bess, she desired more knowledge about the advances in nursing. The rigorous schooling opened up a new world to her with its emphasis on scientific and sanitary principles, patient management, and pharmacology.7

On June 28 Maria heard rumors that their dear friend, Archduke Franz Ferdinand, and his wife were assassinated. She left her comfortable quarters in search of the truth. "It was Sunday, a day there are no newspapers," she remembered, "but little communication with the outside world in this quiet spot....We went out at once

and tried to find authentic news, and at six o'clock came the official bulletin confirming the tragedy. As a crime, it belongs to the category of modern monstrosities."[8]

This modern monstrosity created tension among the European nations, and brought previous alliances into play. The result was an escalation of demands and counter-demands by each side, declarations of war and mobilizations of military forces in August. Later in the year Maria commented that life before seemed "a long time ago—the dreadful war...pushed the first half of the year backward into the dim past."[9] The summer of 1914, in many ways, proved a watershed from the old, ordered world to the new one, fractured by death and armed conflict.

Switzerland declared its neutrality, so Maria and her extended family moved to the Grand Hotel in Brunnen, where they thought they might be safe. Nearly two hundred Americans crowded into the hotel. Some lost access to their banks because the war disrupted services. Luckily for them the American August Benziger owned the Swiss hotel. Out of the goodness of his heart, he provided lodging and coordinated safe passage back home for stranded people, whether or not they had access to their money.[10]

All the guests had stories about their struggles to find the secure haven. "Their wild rushes to the station, and bribing of concierges" hoping that "the Swiss frontier would not close before they crossed the border."[11] Cardinal Farley, for instance, described how he "started for Switzerland in an automobile....Some army officers, needing gasoline, robbed [his] car and he had to walk [to a train depot and travel to Brunnen]."[12]

Regardless of the danger of the conflict, most lodgers could move on. When Pope Pius X died on August 20, Cardinal Farley went south into neutral Italy for the papal funeral and selection of the next pope. Min and Pierre took their family to Paris where Pierre was called back to work with other members of the foreign affairs committee and Min promptly volunteered at a Paris hospital.[13]

Bellamy and Maria did not depart with the others. "On the 18th of August[,]...she slipped on a waxed floor and hurt her leg and bruised her eye." The physician who examined her believed she had "a fracture of the bone near the hip joint." When she was able, she was moved to the Hotel Schweizerhof in Zurich. A second doctor "examined her leg and thought it was not broken." They remained for two months in Zurich and then went by rail to Rome, where they would stay for the winter.[14]

Maria responded with surprising calm,

> "My great consolation was that we could not come back! So, we went to Rome where we had already hired an apartment...where we camped out delightfully, spending our time with all sorts and conditions of cardinals—and prelates and monks and friars not to mention our splendid and enlightened Pope Benedict XV."[15]

Fig. 10.1 Pope Benedict XV (1914–1922) asked Bellamy to establish the Bureau of Inquiry to locate missing soldiers in 1914. *Archdiocese of Cincinnati Archive.*

At the end of November, when they had the first private audience with the new pope, Maria used "the elevator at the Vatican and walk[ed] around the upper loggio...[with] a cane." They were "most charmingly treated" by the small-framed, bespectacled, courtly man. Benedict XV had worked for the Vatican secretary of state during the Philippines negotiations. The pope and the Storers reminisced about their written consultations about Taft's visit and issues in the Philippines.[16]

The pope then asked the former diplomat to head his Vatican Bureau of Information, a

new department established to obtain information about missing soldiers and prisoners of war. This humanitarian effort was created in response to the numerous letters and notes from clergy and distraught families seeking the Holy Father's assistance in determining the status of missing military personnel.

Bellamy agreed to review all letters, cables, telegrams, and telephone messages that came to the pope. The former diplomat came twice a week to collect the queries at the Vatican. He created a process where messages were numbered and logged, questions documented, information sought, and responses sent to the correspondents.[17] Maria's expertise in languages was especially helpful to Bellamy. She wrote letters of inquiries to various governments on behalf of the petitioners. She was touched by their sad stories when she did this "most...interesting work."[18]

As a representative of the Vatican, Bellamy offered the American and British ambassadors the same service; however, they graciously refused, preferring not to become involved with ecclesiastical channels. American ambassador Thomas Nelson Page wrote to Secretary of State William Jennings Bryan about the offer: "I wondered whether he is not interested...to be recognized in some other way." It seemed like a valid question to ask.[19]

When a reputable Italian newspaper gossiped that Storer would be appointed as ambassador to the Vatican, Page wrote the Department of State again, saying, "I think it will not be considered improper for me to say that since I came here to Rome, no facts have come to my knowledge which would make it appear necessary from this end of the line to have in Rome an additional representative."[20] Did Maria have anything to do with the gossip? It is wholly conceivable she was the source since discretion was rarely a virtue she held dear.

Bellamy kept busy with these duties, and also found time several times a week for his passion of golf. Maria did little except to receive massage and electronic stimulation to take the stiffness out

of her muscles, and to aid movement of her joints. By the end of the year, she walked without a cane and became more active. She wrote, "Our life here is varied and amusing—and it is a heavenly rest to be in Rome—to go to all the beautiful churches and out in the villages of the Alban Hills."[21]

With all the sad news of death and destruction, Maria was shocked by the savagery of the war. She was convinced that the conflict was a mistake and peace was essential. To a friend she stated, "We, who have dear friends on all sides—(except in Russia), are full of sympathy everywhere and as neutral as the Vatican—and the United States should be....We simply pray for peace and not for any nation." To journalist Oswald Garrison Villard she described herself as "a non-combatant, a pacifist, and a 'weakling,'" since she believed "the hideous carnage of war is a blot on the whole of modern civilization."[22] This began her advocacy for world peace, pursued for the rest of her life.

To keep her mind off the war, Maria worked furiously and finished her third book, and immediately started her fourth and last Catholic novel, *The Villa Rossignol; or, The Advance of Islam*. The book demonstrated her belief that the chaos in society was caused by atheism and materialism. She also contracted with an Italian publisher to place into print her book of poetry in English, entitled *Some Verses Written in Honor of the Church and Dedicated to Saint Catherine of Siena*. The book contained devotional and poetic verses.[23]

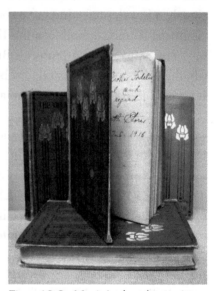

Fig. 10.2 Maria's books written during World War I. *Ursulines of Cincinnati Archives.*

As she worked on her last novel at home, her first work of fiction, *Sir Christopher Leighton; or, The Marquis de Vaudreuil's Story* was published in the United States and Great Britain. It earned mixed but respectful reviews from the *Cincinnati Enquirer* and several Catholic magazines. One critic described the novel as "readable, [but] peculiar, of uneven merit, and written with complete indifference to any rules of form." Another reviewer said, "A rather promising plot had been spoilt by the insertion of much aimless description and many uncalled-for digressions."[24] Her poetry was not reviewed, only noted as for sale.

When Min came from Paris at Easter for a brief vacation, Maria "learn[ed] much of the sorrow and misery" suffered by injured soldiers with complex wounds and associated medical conditions.[25] The volunteer nurses may have been society women, but they did not shun hard work as they took care of their patients. They scrubbed floors, emptied bed-pans, sharpened needles, carried coal, shrouded corpses, deloused bedding, wrote letters, set up traction, and administered medications. When Min returned to France from Italy, she accepted a call for nurses at La Croix-Rouge Hôpital Auxiliaire n°9 [the Red Cross Auxiliary Hospital no. 9] at Marvejols near her château.[26] The hospital was one of nearly 1,500

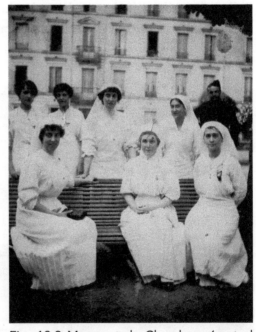

Fig. 10.3 Margaret de Chambrun (seated center) as a Red Cross nurse during World War I. *Katharine E. R. Wulsin Correspondence, 1914–1918. Cincinnati Museum Center.*

auxiliary medical facilities created in support of the war, in which more than 68,000 Red Cross nurses labored to care for soldiers.[27]

After Min left Maria worried "that Italy [would] plunge into the caldron."[28] From the newspapers she knew it was just a matter of time before the country declared war and became a part of the hostilities.[29] Despite her enjoyment of life in Rome, Maria decided to return to the United States. She hoped to come back in the late fall, since as she predicted to Isabella Stewart Gardner, "I foresee peace in October."[30] The war, however, only became more protracted.

Upon arriving in Cincinnati, the Storers vacated their Grandin Road mansion, shipped many objets d'art, paintings, and furniture to Joe, and moved the rest of their belongings into their huge apartment at Saint Ursula Convent and Academy. Maria was simply "charmed by the place."[31] It consisted of two floors. On the first was Bellamy's study, a bedroom, bath, kitchen, and dining room, and a reception hall that opened into the drawing (living) room. Their library, Maria's art studio, and living quarters for the servants were

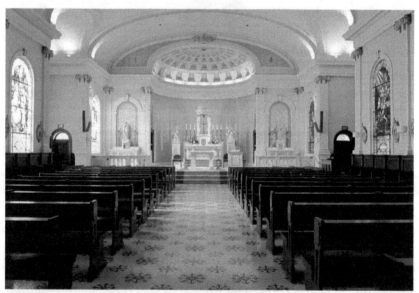

Fig. 10.4 Chapel. *Ursulines of Cincinnati Archives.*

on the second floor. They had their own entrance. Their elegant home was filled with colorful tapestries, important paintings, century-old antiques, and curiosities from their travels. It was light-filled and comfortable, where guests felt immediately at home in the beautiful surroundings. Maria added an unusual element—an aquarium, filled with colorful fish and a small green-yellow turtle. The menagerie was rounded out with a small white dog she called Toodles.[32]

On August 11, 1915, the cornerstone of the Chapel at Saint Ursula Convent and Academy was laid. The lovely baroque-style place of worship was designed by Joseph Steinkamp.[33] Despite the noise and the dust, everyone watched with excitement as the construction progressed. Maria and Bellamy advised on the plans for the altar and gave a stained-glass window featuring the Annunciation of Mary. Everyone hoped that the Carrara marble steps, communion rails, and altars would be shipped safely across the ocean and not be torpedoed by German submarines.[34]

From France, Clara Longworth de Chambrun became aware of the Storers' change of residence and cattily observed, "Something very mysterious is going on at Aunt Ia's....I wonder whether Uncle B[ellamy] is about to take himself to a nunnery or what the matter is. What happens to one's aunt?" In a later note, she penned, "I wrote to Min, but she has not responded so I suppose [she] did not care to be spoken to on the subject."[35] Min might not have responded because she was busy caring for her family, working at the hospital, and did not have time to gossip. This arrangement worked quite well for both the Storers and the sisters for the four years the couple occupied the flat.

When the Storers visited Joe and Mary in Saranac Lake, they rented a mansion for the summer.[36] Joe no longer worked at the lab and had increasing periods of illness, possibly related to tuberculosis. He occupied himself with philanthropic projects and hobbies. Joe enjoyed his membership in the Automobile Club, which was working with a group of airplane enthusiasts "to popularize

aviation."[37] The Storers delighted in the younger couple's social set at the country club. Bellamy golfed with Joe when the younger man was able. Maria kept busy with her art projects and reading books in French and English.[38]

Across the ocean, far away from the lazy summer in America, France was deeply involved in the war. Pierre wrote Maria recounting the horrors of the conflict,

> "Dreadful results of war are all around us. The fields have no harvests[, b]ut harvests of wounded soldiers, most of them young in age, are being gathered into overcrowded hospitals....Refugees from the invaded provinces are...sad and distressful examples of misery."[39]

An American touched by what she observed wrote, "One sees...men and women with sordid bundles on their backs, shuffling along hesitatingly in their tattered shoes, children dragging at their hands and tired-out babies pressed against their shoulders."[40] At Marvejols, Min described how busy they were when some injured "had been four days on a train and their wounds had not been looked at since they were dressed." There was family talk that the children, especially Marthe, helped at times at the hospital.[41]

Min recognized that many injured servicemen required rehabilitation after their hospitalization. Their severe injuries called for physical and/or occupational therapy, at that time called *l'éducation physique* [physical education] services, so they could function as well as possible. To meet this critical need, Min took additional training with a Dr. Konindjy and learned how to "physically rehabilitate maimed soldiers, [and] manually remold disabled bodies through massage and exercise."[42] She also organized a separate convalescent facility to care for them at Saint Vincent de Paul Convent. All the expense for the establishment of the new facility and the maintenance of the patients was covered privately by her or by donations. She solicited funds in France, and requested her mother's assistance with potential donors in the United States.[43]

Maria worked with determination, seeking contributions for her daughter.[44] Within a few months, the Duchess of Vendôme, sister to the Belgian king, whom Maria knew as a child, begged for her help, too. Maria, similarly, solicited help for her. Just as when Maria served as an indefatigable booster of Archbishop Ireland, she initiated a one-person letter-writing campaign for her daughter's and the duchess's hospitals. She petitioned Church leaders, wealthy friends, journalists and editors of several major newspapers and magazines so that the needs would be highlighted in the press.[45] This was the first of numerous appeals she undertook throughout the war.

As the hostilities settled into trench warfare, ill and injured soldiers continued to fill hospitals. Maria additionally recognized the vulnerability of orphans and displaced persons who were desperate for all types of material support. Unfortunately, very few answered her published requests or direct appeals.[46] Cardinal Farley explained that "New York, [for example, was] overwhelmed with committees and with appeals, and [newer] ones have had little success."[47] In June 1917 Maria sent $10,000 ($8,000 her money) to her daughter and $2,000 to the duchess. She also mailed canned goods and staples. She said, "I sent some cases of pork and beans and sugar....They were in great need." By the end of the war, her grandson estimated that Maria gave more than $65,000 of her own money to help his mother and other smaller charities.[48]

In February 1916, the Storers traveled to Hot Springs, Virginia, to "take the cure" because of concerns for Bellamy's health.[49] The regimented diet and exercise always made them feel better. When the couple returned to the convent in Cincinnati, they noted that the construction of the chapel was nearing completion. On May 2, 1916, the carved marble pieces arrived safely from Europe and were installed so that the first mass in the chapel could be celebrated on Sister Fidelis's silver jubilee on May 28. Maria underwrote the printing of a book, written by one of the sisters, in honor of the celebration.[50]

The following day, Archbishop Moeller dedicated the chapel at a solemn ceremony where more than thirty priests assisted. Maria loaned an elaborately carved chair and exquisite draperies for the archbishop's throne. The hall echoed with the silvery-toned voices of a boys' choir.[51] The Storers' personal seats were in the west transept. From that vantage point they could see the lovely colors from the stained-glass windows reflecting on the polished floors. One was reminded of what Edith Wharton once said about the entrancing nature of a beautiful church:

> "All that a great [church] can be, all the meanings it can express, all the tranquilizing power it can breathe upon the soul, all the richness of detail it can fuse into a large utterance of strength and beauty, the [chapel] gave the participants."[52]

The Storers were truly a part of this community. They gave the Ursulines acreage near Carthage, Ohio, and $1,000 to use as a "nest egg for a summer home on the farm." So both the sisters and the Storers were enriched tangibly and intangibly by the couple's presence in the convent.[53]

As in the previous year, Maria published two new novels, *Probation* and *The Borodino Mystery*. *Probation* received a small number of brief reviews. One commentator stated, "This is frankly a novel with a purpose....There are...faults to point out....The construction is somewhat crude....[But] we welcome any determined effort towards showing the utter chaos of the world without [faith]."[54] When the *Cincinnati Enquirer* reviewers criticized that she wrote only religious "propaganda," Maria responded with a letter to the editor, saying,

> "So many novels and plays are written in opposition to Christianity that I thought it might be well...to write a story that upholds...faith and morality."[55] *The Borodino Mystery*, which had one notice, was lauded as a "clever detective story."[56]

In France, Min took time with her children to celebrate Christmas in the face of the tragedy of war. Grandson Gilbert joyously

described the celebration in vivid terms: "The Christmas tree was... beautiful and it had candles all over and it was quite bright and it had sugar treats dangling from every branch, and the tinsel garland reflected the light from all the candles."[57]

Across the ocean, American society was focusing more and more on the war. The United States' citizenry became upset by unrestricted submarine warfare that had caused loss of American lives, as in 1915 when a submarine attacked the ocean liner *Lusitania*. In January 1917, when the Zimmerman Telegram was leaked, Maria and others saw how the German Kaiser proposed a military alliance with Mexico and reacted strongly against the Berlin government.[58] Pacifists like her "swung toward U.S. intervention in the spring of 1917."[59]

In February 1917, Maria and Bellamy spent time in Florida to avoid the long Cincinnati winter. It was the first time she had been in the South since she was married to George. Everywhere they went it appeared that the country was preparing for war. Florida was no exception; everyone was talking of America joining the conflict.

When the retired diplomatic couple arrived in Cincinnati at the end of March 1917 Maria promoted an idea with Archbishop Moeller. She sought to target the fundraising activities within the Cincinnati Archdiocese and proposed the creation of a ladies' group with the title of the Cincinnati Catholic Women's Association (CCWA). Maria explained, "A week before war was declared[,] I explained my desire to organize Catholic societies and individuals for patriotic work to Archbishop Moeller. He was about to print a diocesan letter and incorporated my idea into it."[60]

Archbishop Moeller directed parish priests near Cincinnati to provide names of leaders of their women's groups from each parish to Maria.[61] They were invited to meet and to join forces on April 14, 1917. Maria wrote, probably with Bellamy's help, a one-page constitution and by-laws that were passed during that meeting.[62] Calling themselves "War Grandmothers," during the course of the war members knitted and sewed clothes, taught canning and food conservation,

counseled and consoled families of deployed soldiers, made surgical dressing and comfort kits, and sold war bonds.[63]

Maria bragged to Cardinal Farley,

> "I have undertaken [this project] in order to concentrate Catholic efforts and at the same time unite it to the laudable work of non-Catholic women to help our country in its time of trial. I would suggest this idea for other states as well as Ohio as it is simple and effect[ive.]"

In her next letter to the prelate she wrote, "We have 17,125 members."[64]

Fundraising activities for the women's group included soliciting personal contributions and selling tickets for theatrical presentations and raffles. By far the most lucrative effort was the Soldier's Aid Bazaar in October 1917, which earned nearly $12,000.[65] The money would be used over the course of the war to fund its activities.

The executive committee of the organization toured Camp Sherman, in Chillicothe, Ohio, one of sixteen training camps built around the country when war was declared. They decided the lack of comfortable furnishings in the buildings was a need they would address. The women purchased "easy chairs, davenports, library tables, books, and Victrolas...[to give the rest areas a more] home-like and comfortable appearance." Maria proudly stated, "We do what we can at home....We furnish[ed] the Knights of Columbus recreation room at our Ohio Camp: Camp Sherman."[66]

In the middle of this effort, Maria was thrilled to hear that Pierre would be sent to the United States on a good will mission with General Joseph Joffre and a group of politicians and military officers.[67] This was Pierre's first trip back to the United States since leaving with his young wife in 1897.

The Storers traveled to Baltimore to meet him at the end of the month. They spoke briefly about his concerns for their family, France, and the war.[68] Pierre told her Min had to stop working due to an overuse injury in her left arm, caused by her work as a physical therapist. So that services were not curtailed, Min had "found a professional masseuse to take her place."[69]

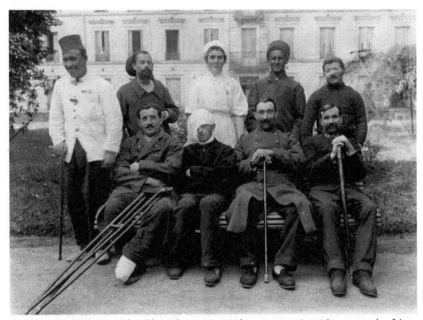

Fig. 10.5 Margaret de Chambrun (standing center) with several of her patients. *Katharine E. R. Wulsin Correspondence, 1914–1918. Cincinnati Museum Center.*

With America's declaration of war against Germany on April 2, Pierre's French mission arrived at the most opportune time. It was an overwhelming success. As they traveled throughout the country, the Frenchmen were cheered by "thick crowds; [they were] wined, dined and paraded." The president, congressmen, "mayors, university presidents, and labor leaders" sang their praises.[70] On May 6, the marquis took the night train to Cincinnati to visit Maria and Bellamy. They had a small reception in the convent's Assembly Hall for family and friends. Pierre looked tired but dignified as he spoke briefly, but eloquently, and painted "a vivid picture of the present conditions" in France.[71]

After Pierre left, Maria decided that they must go to Europe, despite the danger. She worried about her daughter, her grandchildren, and her close friends. She also wanted to gain a fresh perspective about the war since the entry of the United States.

Before going to Europe "madam president" confronted an issue with the Red Cross. She was incensed that nuns "had been refused permission to do Red Cross work unless they wore Red Cross uniforms instead of their conventional habits." This meant that nearly 1,000 "Sisters of Charity...of Mercy and...of St. Francis [were unable to] offer their hospital services"[72] To address this policy, both Maria and Bellamy complained to the president of the Red Cross, who happened to be their Cincinnati friend William Howard Taft.[73] Maria also authored multiple letters to the local newspapers and national periodicals.[74] The articles were picked up by other newspapers. Maria, ever the catalyst of controversy, stirred up a national hullabaloo once again.

"Several prominent Catholics" queried Red Cross officials about the policy. On June 27, the Red Cross capitulated. Chairman Eliot Wadsworth wrote to Cardinal Gibbons, declaring, "The questions of the attitude of the American Red Cross toward utilizing the services of nursing sisterhoods has been raised lately....It seems advisable to state unequivocally to you...[that] members of the nursing sisterhoods may wear their official dress while serving as nurses under the Red Cross."[75] However, when this detailed memorandum was published throughout the country, it did not end the controversy. As late as October, letters to the editor filled newspapers and periodicals with anti-Catholic rhetoric and anti-Storer sentiments, as if it were still an issue. Maria had touched a nerve. People with latent fear of the papacy questioned the Red Cross's decision.[76]

Although Maria won the battle, she lost the war. Only ten nursing sisters deployed to France during the entire war, far fewer than what she had predicted. It is not known why the Red Cross did not actively solicit the religious sisters.[77] Perhaps the nuns' training did not meet the educational standards required of nurses seeking war-related positions.

While Maria concentrated on women's contributions, Bellamy also assisted with the war effort. He was named Cincinnati's honor-

ary chairman of the Belgian Relief Committee, an organization with the goal of raising $15,000 each month for the destitute country.[78] Moreover, he joined the Saint Vincent de Paul local branch and rose to be a national figure, attending meetings out of state. More than "$18,000 was distributed in relief work by the society" in the Cincinnati area during his leadership.[79] Bellamy received updates from the Vatican Bureau of Information on their work tracing missing soldiers. Father Dominic Reuter, the supervisor, related in one such report that

> "we sent over a hundred letters with information to France alone....We correspond with the central bureau of France, Germany, Turkey, Switzerland, [and] Bulgaria. In England we write to the Secretary of the Knights of Malta, and when occasion demands we address ourselves to ecclesiastical authorities in all belligerent countries."[80]

In August, the Storers spent time in Saranac Lake with Joe and Mary. With the younger couple, they stayed on Lake George at the luxurious Hotel Windsor that contained "spacious parlors, a large dining room,...game rooms, and a music room." They enjoyed the marvelous views as Maria wrote letters and tapped on copper projects, while Bellamy played golf with Joe. Mary, Maria, and Bellamy listened as Joe shared memories of his and Min's "camping experiences" as children, "so long ago."[81] It was the last happy memory Maria had of Mary and Joe together.

The former diplomatic couple visited Isabella Stewart Gardner at Green Hill, most likely for the last time.[82] Soon after Isabella gave her Brookline home to her nephew, George Peabody Gardner, whose family adored living there.[83] The couple and their hostess probably shared stories of the people they both knew. Henry Davis Sleeper, who entertained them both at Beauport, had become a fundraiser for the American Ambulance Field Service (later to be known as the American Field Service). Through his influence, the Boston matron funded an ambulance in France.[84] Isabella Stewart Gardner, the

fun-loving, loyal friend and art connoisseur would die in 1924 after a series of strokes.

Maria looked around for a publisher of her fourth novel, *The Villa Rossignol*. She admitted to an editor, "My stories have not been apparently popular with some of the Catholic press."[85] She sent it to the publisher of *Extension Magazine* who rejected the manuscript possibly as "too sensational," as she predicted. Ultimately it was published by B. Herder, the firm that produced her other three novels. The book received only one lukewarm notice from the Catholic press, and sold poorly.[86] Overall Maria's books did not achieve the fame that her art did. None of her novels were in demand. According to her reviews, her publications generally lacked coherent structures and multidimensional, believable characters. Yet she was a credible literary talent. By presenting her faith as an attractive religious option she contributed to the religious literature of the period and demonstrated what was important to Catholics at that time.

Besides their donations to the war effort, the Storers' philanthropy demonstrated their support of libraries and how they honored departed friends. They gave several hundred Italian sixteenth-century, French eighteenth-century, and American nineteenth-century books to the Catholic University Library; presented to Saint Ursula Convent and Academy many books for their circulating library; and donated $3,000 for the Frederick Forchheimer Chair of Medicine, University of Cincinnati.[87]

In November, the Storers ordered new passports and prepared to travel to Europe. They asked Cardinal Farley if he needed assistance in Europe. Bellamy charmingly talked about their qualifications for such roles: "I am in my seventy-first year, yet still quite strong and well and Mrs. Storer is two years...younger—full of vigor, rather intelligent and can do any work." The cardinal was touched, but preferred not to use their help. He was also moved by concerns for their safety, and suggested they not go at all.[88]

The Storers insisted they must visit "their French family" for Christmas so in November they quietly left for the east coast, directing the Ursuline sisters not to tell anyone of their departure. They spent Thanksgiving with Joe and Mary, who cringed at the idea of the older couple crossing the submarine-infested ocean for Europe. Yet they knew the Storers had made up their minds and were leaving.[89] They departed on December 7 and arrived on December 14 with a group of American Red Cross and diplomatic officials. Maria's comments were detailed:

> We have seen nothing of the enemy: only the preparations have frightened a lot of the female passengers many of whom have actually slept in their chairs to be near the lifeboats—and go 'round in the day hugging old life-preservers that could not for five minutes 'preserve' anybody's life. We had a life-boat drill on Wednesday afternoon...where we all put on our lifebelts and assembled at the special boats to which we were assigned. You would have laughed to see us all bobbing about on the deck in front of our particular cockle-shell and getting instructions from a steward how to get in. After surveying the life-boat, I conclude to stick to the ship in case of emergency![90]

They arrived at Marvejols on December 22, overjoyed to see the family. Min was doing quite well after some months of rest from the exhausting hospital work. A few weeks earlier the French government awarded her a Chevalier de la Légion d'Honneur [Knight of the Order of the Legion of Honor] in recognition of her hospital work.[91] Maria must have been very proud of her daughter.

Maria described the family's arrival at Christmas services. "We all went to the midnight mass on Christmas eve in the old church over ice and snow but with wonderful moonlight. It was fearfully cold, but one forgot everything earthly in the touching celebration." She pronounced it as the "most impressive [religious ceremony] I have ever witnessed....The church was packed. Most of the women in mourning....A Christmas without luxuries....[At Château

Carrière,] we grope about in darkness after 4:00 p.m. and cower over wood fires in unheated rooms, but we are all happy and well."[92]

From Marvejols, the Storers took Min, and their seventeen-year-old granddaughter Marthe, farther south for a break from the war. They chose the Riviera, which was safe, sunny, and beautiful this time of year. They were lucky to find rooms in Cannes, since many of the city's hotels had been converted into hospitals and shelters for the wounded soldiers or refugees. Maria painted word-pictures of the scenery for the Ursuline sisters, saying, "The snow mountains behind Nice looked as high as the Alps. The sea was deep blue. Some of the places we passed had wonderful gardens. The mimosa is in bloom and the trees look like golden fountains. The contrast with the palms and palmettos is very picturesque." Maria kept busy "seeing people and taking my Italian lessons."[93]

In March, the Storers moved north to Paris with Min and her family. Maria conspired with Pierre in a plot to bring the Vatican to the table for peace negotiations. They opposed the Treaty of London that excluded the papacy from any treaty mediations, and wanted it modified so the pope could participate. Maria advocated American Church leaders to encourage President Woodrow Wilson to request the treaty be altered.[94]

When the Catholic University rector, Bishop Thomas Shahan, received a letter from Maria, he was filled with consternation about how to proceed, so he consulted with Cardinal Gibbons. The cardinal angrily stated that Maria was a "mischief-maker...whose meddling in ecclesiastical affairs has been the cause of much embarrassment to many in the past, even to one of our archbishops." He added, "It would be most impolitic for the American Bishops to take any action along the lines suggested by her." Shahan must have politely refused her, as did all others whom she asked.[95]

Why was Maria out of sync with broader political realities confronting her Church? Gibbons had always stressed assimilation, "loyalty and patriotism of the Church to the nation." Maria

developed a perspective that focused on interconnectivity among people that marginalized these nationalist sentiments.[96] Faith-based mediation, she believed, was the only means to stop the bloodshed. Maria would not be stopped. After the war, she would seek papal leadership in peace ventures again and again.[97]

In April, the Storers were shocked to hear of the death of their friend Eugene F. Bliss. Bellamy commented that the "world has grown...smaller" with his loss.[98] Yet life went on. Father Reuter updated the Storers on the increase of requests at the Vatican Bureau. For example, on one day alone, over one hundred letters were received from France and England. By the end of the war, they successfully processed more than 100,000 queries.[99]

In early June Bellamy and Maria returned to the United States after an uneventful sea voyage "with wonderfully calm weather but little to eat."[100] Upon their arrival, Mary called from Saranac Lake and asked them to come as quickly as possible because Joe was ill in the hospital. They immediately traveled to northern New York. When Joe seemed better the couple went to Cincinnati; however, he developed meningitis and his condition worsened. Maria and Bellamy quickly returned to his bedside before he died. He was buried two days later on June 17. The couple stayed on throughout the summer in the small village to support Mary in her grief.[101]

Fig. 10.6 Joseph Longworth Nichols. *Courtesy of the Adirondack Collection, Saranac Free Library.*

Maria was stunned by his unexpected death. Then,

another death shocked her. Bishop John Keane died on June 22.[102] Keane had remained their friend throughout and after the 1906 scandal. The impact of his energetic, inspiring sermons that first attracted her to the Catholic faith always remained important to her.

Maria buried her own anguish over her losses by contacting her friends and authoring a political pamphlet. Some letters dealt with fundraising for French orphans, or with reminiscences about those who had died. She also wrote, published, and distributed a brochure, entitled *The French 'Neutral' Schools*, which criticized the nation's public school curriculum. She mailed copies to Catholic editors over the entire country.[103] No references to the document in any newspapers or periodicals have been found. Perhaps the print media managers believed the information about the French religious education was irrelevant to their readers so the pamphlet was never quoted.

Joe's widow Mary announced that she wanted a change of scenery.[104] Being in the home she had shared with Joe may have become oppressive. Mary also wanted to support the country in time of war. She decided to volunteer with the Young Men's Christian Association (YMCA) to provide morale and welfare services in France. Why grieve when she could serve?

In Europe Mary was probably assigned to one of the forty-two YMCA huts where soldiers congregated during their free time. The small buildings were very primitive, as one highly romantic account presented:

> Th[e] last half–hour is a busy one for the ladies behind the counter....Long queues of men stand waiting to be served. Dripping cups and sticky buns are passed to them with inconceivable rapidity. The work is done at high pressure, but with the tea and the food the men receive something else, something they pay no penny for, something, the value of which to them is above all measuring with pennies—the friendly smile, the kindly word, of a woman....No one will ever know the amount of good they do; without praise, pay, or hope of honors, often without thanks.[105]

Mary served for nine months and then returned home to Saranac Lake, where her work was honored. Her name is inscribed on a memorial with other soldiers and volunteer women "who served their country in the World War, 1917–1918."[106]

Maria was stunned and pained when she learned about the deaths of Cardinal Farley and Archbishop Ireland in September. Farley was remembered as her friend, someone who tactfully advised her about soliciting contributions for charities. Since the close friendship between Maria and Ireland had ended, they corresponded very infrequently. Yet Maria wrote movingly about him, "Archbishop Ireland was the greatest mind and the strongest character that the Catholic Church in America produced. He spread the light of faith and its moral and intellectual power wherever he went."[107] With their deaths plus the passing of Keane, Joe, and Eugene F. Bliss, she lost important friends and family. After 1918, she found very few people to communicate with in America.

After coming home to Cincinnati, Maria shopped for lace at the John Shillito Company department store. She allegedly made disparaging remarks about the unstoppable Germans, stating that "it was useless for our country to oppose" their war machine. A younger woman whose husband and brother were serving in France became distraught and angry about what Maria had uttered. Her distress prompted her to a file a complaint with the government. The Bureau of Investigation (later the Federal Bureau of Investigation) sent an agent from Washington to investigate. After the agent interviewed the complainant and others who were present, he closed the case. The fact that he did not interview Maria is strong evidence of the trivial nature of the grievance. Maria holds the dubious distinction of being among the first women of note to have an FBI file. This investigative record is an example of how paranoid the country had become when a profoundly religious, yet somewhat indiscreet, wealthy woman was formally investigated and put under government scrutiny. [108]

The war finally ended in November. The magnitude of the losses was staggering. In France alone, "of the men of mobilization age...

sixty-three per cent were dead or had lost a limb."[109] Maria remained concerned about all the fatherless children and displaced persons. "The magnitude of the conflict, the extent of civilian suffering, particularly in occupied areas, and the destruction and consequences after the end of hostilities accelerated the [need] of humanitarian relief."[110]

Maria asked for and received support from the Cincinnati Catholic Women's Association for the refugees and orphans. The group sent clothing and financial aid to France and to Italy.[111] At the end of the war the society reported its impressive efforts. They sold $3,500,000 in Liberty Bonds; created nearly 91,000 surgical dressings; sewed and knitted 26,300 clothing pieces; trained twenty-five ladies in kitchen arts; furnished rest areas for soldiers awaiting deployment at four deployment posts, three in Ohio and one in Alabama; purchased supplies, and assembled 3,000 personal comfort bags.[112]

Before his death, Cardinal Farley praised the Cincinnati group as a sterling example of "a powerful organization of Catholic women."[113] Also, what was unusual about the group among Catholic philanthropic organizations in the United States was that laywomen completely financed and administered the society. "Nuns [generally] managed the charities [in other cities.]"[114] The organization continues its important charitable work and celebrated its centennial in 2017.

The former diplomatic couple went to Baltimore, where Bellamy sought care for "neuritis in his neck and eyes," symptoms related to his chronic diabetes. Maria had encouraged him to go to Dr. Adolf Meyer, who had cared for Joe during his last illness. Meyer coordinated the assessments of several physicians at Johns Hopkins University. In a letter to Mother Baptista Freaner, the new superior of the Ursulines at Saint Ursula Convent and Academy, Maria wrote, "The doctor here...advises a cure at Hot Springs. So, we shall stop there for three weeks on our way home, and not get back before December 20."[115]

They stayed at the Homestead, a luxury hotel located in Hot Springs, Virginia. Bellamy asked Dr. Meyer what "diet and regimen

in general" he should follow. The doctor may have ordered him to use a semi-starvation or starvation diet that was popular during the period. He also must have ordered exercise, massage, and electrical stimulation for him. There was little that could be done with Bellamy's eye problems so rest and restriction from any eyestrain were probably recommended.[116] His progress reports to Dr. Meyer indicated that he "was outdoors more" and feeling better.[117]

Back in Cincinnati, the Storers discovered that the Spanish influenza was rampant. Many patients did not recover from the pandemic, which globally killed nearly 50 million people.[118] Maria wrote that

> "one of the nuns in our convent died, and ten were ill, as well as a dozen small pupils. Several acquaintances of ours died in three days of pneumonia....My spouse was very ill with an attack which, happily, turned out to be an old-fashioned 'ague and fever.'"[119]

Bellamy and Maria renewed their passports in March and prepared to go overseas.[120] Before departing, ever mindful of Bellamy's new diet, exercise, and massage regime, the couple "took the cure" at Hot Springs once again before leaving. Maria wrote Dr. Meyer about conflicting advice they had received as to where it was safe for Bellamy to go. One physician suggested a high altitude was not good for him while another did not think it mattered. Meyer clarified the instruction and wished them well.[121]

The couple asked the sisters in the Ursuline convent to care for their dog while they were away.[122] They planned to return in the spring after spending the winter in Rome. Little did they know they would never walk on American soil again.

Just before they left, Maria was the center of attention at the Woman's City Club, where she had been asked to talk about the Rookwood Pottery Company. She pulled some of her papers together from the 1890s, finding a speech she wrote in 1896 about the history of the company. She asked her lifelong friend, sculptor Clement

Barnhorn, to read the speech, which was illustrated with "stereopti-con slides."[123]

The news reports of this speech may have prompted renewed interest in Maria's impact on Cincinnati. With her permission, a small pamphlet was published entitled *History of the Cincinnati Musical Festivals and the Rookwood Pottery by Their Founder Maria Longworth Storer*. It was beautifully bound. In 1930, she reprinted the pamphlet privately and gave it to the Cincinnati Art Museum to "sell or distribute."[124]

Maria was touched by former president Theodore Roosevelt's death on January 6, 1919. Later, she reflected, "Toward the last, The-odore Roosevelt's life was a series of heavy trials and pain and sick-ness borne with great courage."[125] Her thoughts were brought back to the 1906 scandal. She decided to write about it. She began sifting through all the hundreds of letters she had carefully kept from three presidents, four popes, and numerous politicians, aristocrats, and royals so she could write about the past to give a full and accurate version of the events. Two books and one article were to be written from the letter archive.[126]

Her life now revolved around Bellamy, his care, and her writ-ing. Upon arrival in France the Storers again went to "take the cure." This time they choose to remain in France at the north central spa center, Royat, near Clermont. They stayed a month or so, where they met and socialized with the bishop of Orléans, Staninlas Touchet, who was also there for the medicinal "baths and inhalations for which [Bellamy had] come to the famous springs....Touchet spoke of the great celebration for the canonization of Jeanne d'Arc [Joan of Arc] to be held at the cathedral of Orleans next spring."[127]

At the spa, she also took time to laugh and poke fun at a famous political celebrity, the French Prime Minister Georges Clemenceau. She dressed in a man's topcoat, bowler hat, white wig and mustache, and carried a walking stick. It was not for a costume party, but for a ride in the park. After an initial rehearsal in front of Bellamy, who laughed and laughed, she went down the elevator to the lobby of the

hotel. While waiting for her car to arrive, she smiled and saluted other guests who stared at her. As she drove around in an open sedan, men tipped their hats and women waved and shouted, "Clemenceau!" "Clemenceau!" She doffed her hat as she was driven around. So that her family would believe that she had dressed this way, she had her picture taken to verify that she had created the spoof. Ultimately, the story and photo were passed down to the current generation as proof of the indomitable woman's sense of fun.[128]

Although Bellamy seemed to be doing well on this visit, suddenly without warning, on October 26, 1919, he suffered a stroke that affected his speech and the left side of his body. Maria related,

> "I got him to bed and sent for the doctor, who said…that the recovery would be long. There was so little to do for him at first, as he lay like a log; that I would not have a nurse, but only an 'infirmer' who came in the morning and twice during the day. He began to sit up after five days in a wheeled chair.…After sixteen nights, I got tired and we found a very good English Red Cross nurse for night to keep up the wood fire and at midnight give him hot milk."[129]

Maria, thinking of the sisters, sent money "to be spent on a festival for Thanksgiving Day (turkey, ice-cream!!) for everyone." She missed their home and life in the convent. It reminded one of what she wrote earlier, "We wish we could carry the convent about with us and settle it where ever we are."[130] In 1920 Maria, with her beloved convent in mind, obtained an apostolic blessing for Mother Baptista's Golden Jubilee.[131]

In February 1920, Maria wrote that Bellamy received "massage and vibration electric" and was walking with a cane. She then hired a tall, male nurse to "take all the care." Maria felt relieved, "I can leave him to go out for an hour without feeling anxious all the time."[132]

Maria now felt she could take time to read. Her curiosity led her to read books on scientific spiritualism. Perhaps she wanted to explore a way to reach out to friends and family members who had died. She also made plans to bring their tapestries and rugs to

France. Was this a hint that she secretly believed they were staying permanently? Maria also started soliciting funds for the poor women in Paris. She asked Cardinal Gibbons for his help. It is believed that her request fell on deaf ears.[133]

She stated that "we enjoy our quiet and serene existence." In her next memo, she reported that Bellamy's condition had improved so much that they could travel once more.

> "So, we are packing up [April 20, 1920] to Switzerland. ...Mr. Storer is remarkabl[y] well and cheerful, although his progress in walking is slow. He is beginning to use his arm, which is very encouraging. We are very happy, reading and talking like two children and he says that every meal is a picnic."[134]

She also penned notes to some other friends. One was Archbishop (later Cardinal) Bonaventura Cerretti. When or where the Storers met Vatican diplomat Cerretti is not known. It is most likely to have happened during the war years when he worked for Secretary of State Pietro Gasparri at the Vatican.[135] She had written several letters to Gasparri that may have required his attention.

By summer Bellamy was walking. Maria wrote happily from a hotel that he was "well enough to get into a motor car or on a train and we can roll his wheelchair on to the lake steamers....All future plans depend" on his health. "I hear quite often from M[onsignor] Cerretti." Granddaughter Marthe had joined them. She was "studying her piano with great enthusiasm with her teacher, Monsieur [Auguste] de Radwan, a wonderful Pole and a delightful companion, a fervent Catholic who is in the hotel."[136]

For the first time, at the end of the year, thanks to the passage of the woman suffrage amendment, Maria voted. "I was more against Cox than Harding," she wrote, "but I really think it is best for the Republican Party to come back for a while."[137] She also supported papal relief efforts with a contribution of $28,000. American newspapers reported the Vatican aid agency had given millions for the care of Central European children.[138]

Maria submitted an article entitled "Archbishop Ireland and the Hat," to the *Dublin Review*. It was published in the April 1921 issue. The theme of the essay was Roosevelt's relationship with Ireland. She stated, "Foremost among his champions in America...was Theodore Roosevelt."[139] She included three long personal letters to substantiate her claim. The article received international positive and critical comments.[140]

During the summer of 1921, two friends of the couple were appointed to key positions in diplomacy and government. Archbishop Cerretti was named apostolic nuncio to France. He told a reporter for a Catholic periodical that "his mission was to harmonize the religious interests of French Catholics with the interests of the French Republic."[141] In July, William Howard Taft was brought out of retirement and appointed chief justice of the Supreme Court by Warren Harding. It was "his life's ambition" to achieve that role and this would prove to be a wonderful time for him. "The position was perfectly suited to his temperament: no professional assignment ever made him happier."[142] The Storers could not have been more pleased.[143]

In August, newspapers announced that Maria published a book called *Theodore Roosevelt the Child*. Because it contained thirty-three personal letters, she printed it privately, and gave it away to close friends and libraries. In her letter to Taft she stated, "I hope you got my little book and that you like it. The letters are, I think very characteristic and of historic interest. I wished them to appear in some form before I die." Taft's reply was the essence of tact and did not commend or criticize her actions.[144]

Over the winter months Maria took Bellamy to Rome and Cannes.[145] She related how he "loved to be out of doors and to travel in the motor [car] where the country was beautiful and he loved our visits to Rome where he remembered everything in the ancient [history.]"[146]

At the same time Maria resurrected her ideas of papal involvement in a league of peace. In later years, she stated plainly why she

involved herself in the somewhat impractical, idealistic work: "My greatest interest is to help truth and justice and religion to overcome the diabolic evils that strive to drive mankind back to barbarism."[147]

She asked Taft about his thoughts. He told her, as he would again and again during the next six years, that no organization in the United States would become involved with a body directed by the leader of her faith. Maria refused to take no for an answer and persisted to beg, beseech, and request his support, while Taft continued to quibble, evade, or refuse to help.[148] Taft's thoughts are clearly expressed in a note to their mutual friend, Katharine Wulsin:

> I had a letter from Mrs. Storer from Cannes. It is interesting to note that she is still full of energy. She wants to initiate a great moral league of nations and have its head center in Rome and the Vatican. I wrote her that the concept was all right, but that the practical carrying it out was impossible, that the feeling of the other denominations in respect to such a purpose was so set that there would not be the slightest prospect of success. I suppose she thinks that I am not very sympathetic in the matter, but I am only telling the truth.[149]

Katharine responded that when she had seen them, the couple had not complained about what Taft had written. Maria had spoken only about "receiving such nice letters from you." Katharine also mentioned that the Storers wanted to go "back to Washington and hoped to do so next winter.…[Bellamy spoke] little when he [did] his utterances…[were] clear and distinct."[150]

In June, they were informed of the death of their sister-in-law, Susan Longworth. One by one their Cincinnati family and friends had passed away.[151]

At the end of October, the Storers arrived in Paris. On November 12, 1922, Min had visited her mother and stepfather. Bellamy "was bright and interested" in their conversation. Although he seemed weaker to Maria, she was shocked when, about midnight, he died in his sleep of a stroke. Later in the week Archbishop Cerretti

performed the funeral mass in Paris. They would wait until spring when the ground was soft to bury him near Min's château. As she explained to Taft, "He will be taken to Marvejols, that dear peaceful place...where we used to tell Pierre we 'should like to be buried.' I shall never go back to America."[152]

Maria's grief was intense. No other loss came close to the desolating effect of Bellamy's passing. He had come into her life upon the failure and icy coldness of her first marriage. "It was he who knew and reflected back the continuity of her spirit."[153] He became her faithful friend and partner for thirty-six years. His political and diplomatic career moved her into national and international circles. What was the next part of her life to be?

Fig. 11.1 Bellamy Storer. *Ursulines of Cincinnati Archives.*

DRIFTING ALONG ALONE

IN 1923 MARIA WROTE, "I am drifting along alone when I am not in Paris where my daughter the Marquise de Chambrun and her family live."[1] She missed the companionship of her warm, gentle giant of a husband. However, she stated to several people that she could feel his presence at her side.[2]

Shortly after Bellamy died Mary arrived from America to be with her and the rest of the family. The two widows must have spent time together remembering how the four of them enjoyed the beauty of Saranac Lake, when the Storers visited the Nicholses.[3] After Mary left, Maria traveled twice to Rome in 1923, as if movement could keep her grief at bay.[4]

After receiving many letters of condolence from friends and acquaintances, she decided to compile the letters into a memorial book entitled *In Memoriam: Bellamy Storer, with Personal Remembrances of President McKinley, President Roosevelt, and John Ireland, Archbishop of St. Paul.* Before Bellamy died, Maria had submitted to Shane Leslie, editor of the *Dublin Review*, a manuscript containing nearly 175 private letters about the 1906 scandal. With Bellamy's death, she withdrew her book draft, changed the title, and added his biographical

sketch. Ultimately, she was advised to cut nearly 75 percent of the documents. The finished product contained the most representative letters, fifty in number, woven together by a loose narrative. Although ostensibly a memorial to her deceased husband, it remained a book about the events that led up to Bellamy's dismissal from the diplomatic corps.[5]

Maria published the small book privately and distributed copies to libraries and friends both in America and Europe. One critic stated it provided "no major contribution to the historical knowledge of the period[;]…nevertheless it does contain interesting revelations of a minor character."[6] Taft's opinion was quite disparaging. He wrote her,

> "I question the wisdom of your publishing those letters of Archbishop Ireland at this time, because they will probably rouse discussion and criticism.…I think it is better to allow such evidences to remain until we are all dead, when they can be taken up and considered calmly and without fear of rousing again personal bitterness."[7]

Maria responded indignantly, "Remember ours are not parallel cases. You incurred T.R.'s undying hatred and jealousy [in 1912.]…But he did not hurt you personally…and drive you from public life."[8] They never discussed the incident again. Her anger toward Roosevelt was never resolved. According to her grandson, "she never forgave him."[9]

By late 1923 Maria had exhausted herself physically from grieving for her husband and publishing his memorial. At this point she craved a release from responsibility. She did not establish a permanent home in Europe, but lived in one ultra-exclusive hotel after another, such as the Paris Ritz, where she maintained a suite of rooms. In a hotel, she was catered to and pampered by a large staff.[10]

One of the "Maria stories" handed down in her family from her grandson Gilbert de Chambrun demonstrated how much she enjoyed having every whim accommodated. One day, when he was about sixteen years old, his grandmother called and asked him to lunch with her at one of the most fashionable restaurants in Paris. When they

Fig. 11.2 Maria Longworth Storer. *Ursulines of Cincinnati Archives.*

arrived, he was shocked to see many of the restaurant's staff running out to their car, opening the door, and crying, "Madame Storer! Madame Storer!" There was a tremendous fuss over her as she was seated at a prominent table. Even her dogs were provided their own dishes of delectable food, much to the embarrassment of her teenage guest who "wanted to disappear under the table."[11]

Cincinnati relative Landon Longworth Wallingford, remembered how well she indulged herself:

> One day I went into the Ritz Bar and I saw this little old lady in a bonnet with a ribbon around her chin, and I went to her and said, 'Are you my Aunt Maria?' She said, 'Who… you?' [Obviously recognizing me,] she ordered up pint[s] of champagne and we sat and drank it. That became a regular routine for the next month that I was there. Every day we met at the Ritz and [our] pint[s] of champagne [would be waiting for us!]"[12]

One wonders if they saluted the first Nicholas Longworth, who created his fortune and fame in part by the sale of champagne!

After a time, Maria began to recover her energy. She traveled with Pierre when he could take time from politics. Maria adored him, as she told Taft, "Pierre is my dearest friend as well as son-in-law. He is wonderfully unselfish and kind to everyone and in addition to this a most intelligent and amusing companion."[13] When they "took the cure" at Aix-les-Bains, they spent quiet days walking by the Lac du Bourget and meeting people at outdoor cafés. For several years, they met and talked with annual vacationers who loved the brisk sea air as much as they did. There was Prime Minister Stanley Baldwin, who talked about the latest political happenings in Britain and France. There was the Catholic historian Georges Goyau who insightfully discussed French and Vatican relations.[14] She also reached out to C(harles) H. L. Emanuel, who served as the secretary and solicitor of the Board of Deputies of British Jews, about her concerns about atheism and Bolshevism.[15] One year, Pierre "came [to London] for a week and [they] spent a day with Lord Halifax…at York,…Lincoln, and…Peterborough to see the cathedrals.…For both of [them], it was unforgettable."[16]

When she visited Paris, Maria frequently enjoyed the company of the Nuncio Archbishop Cerretti, whom she described as her "dearest friend that is in the world."[17] He had comforted and prayed with her immediately after Bellamy died. When he confided in her that he had been diagnosed with diabetes like Bellamy, she immediately obtained for him an appointment in London with one of

Europe's preeminent endocrinologists, Dr. Walter Langdon-Brown. She not only paid for his travel, hotel, and medical expenses, but also purchased for him the latest wonder drug called insulin. Cerretti received injections of this medication over several weeks, and immediately felt better. The medical regime extended his life another eight years. He was forever in her debt.[18]

Maria also proved to be an important political intermediary and philanthropic agent for the nuncio. After the 1924 French election Cerretti worried about the implications to his office when opposing radicals assumed power. Maria set up an appointment for the archbishop with her son-in-law to strategize how best to respond.[19]

Moreover, she gave a costly bejeweled monstrance, which was used in the Benediction ceremony, to Cerretti's cathedral in his hometown of Orvieto. The richly decorated ceremonial item, made of gold and precious gems, was designed by famed Parisian jeweler Marcel Chaumet. Some of Maria's own jewels were inserted on the regal devotional object.[20]

Maria kept busy writing numerous letters to social friends, Church officials, and politicians about postwar problems. She was inspired by Pope Pius XI's antipathy toward communism when she worried about "the demoralization...begun and directed by Moscow." She wanted "to overcome the diabolic evils" by establishing a peace organization that Taft dubiously described:

> "Mrs. Storer...is convinced that the way to save the world is through the Catholic Church and is constantly suggesting...organizations which are to be chiefly officered by the hierarchy of the Church, but which are to be entirely free from religious prejudice, and are to invoke the support of all denominations in our country—a plan the feasibility and practical character of which you will at once appreciate."[21]

Besides Taft, Maria circulated her thoughts to British Prime Minister Stanley Baldwin, British aristocrat Lord Halifax, Secretary of State Charles Evans Hughes, Harvard University President A. Lawrence Lowell, and arts patron and wealthy banker Otto Kahn.

They all commented on or acknowledged her memos without making any commitment to her cause.[22]

Should she be depicted as an oddball religious peace activist? The argument could be made that Maria's ideas were no more peculiar than Elinor Byrns's proposal for an antiwar amendment to the Constitution.[23] Maria proposed transnational peace efforts, regulated by a religious organization, while Byrns explored peace endeavors within the national, civil framework. Perhaps what can be said is that Maria was one of many who wanted the insecure postwar world to become a place of international peace and understanding.

Maria, additionally, penned notes and memos to "her cardinals" and other prelates about challenges facing the Church in postwar Europe. Her correspondence suggested a grasp of Church politics in France as she lucidly discussed with George Goyau political concerns about the conservative movement Action Française.

Maria's letters were filled with words of admiration for Italian leader Benito Mussolini. Like many American and English citizens at this time, she was excited that he fought Bolshevism. She became so enamored with him that she called herself a "fascista."[24] Maria hoped to insinuate herself into Italian and Vatican politics when she enlisted investors to buy land in Italy for a larger papal state.[25] Again, she met with little or no response to her requests. In 1929, her desire for a Vatican home state was resolved by the Lateran Accords, an agreement between the Church and the Italian state, which recognized the sovereignty of Vatican City.[26]

Maria also concerned herself with Halifax's efforts toward religious reunion. Between 1921 and 1925, the aristocrat had instigated four informal meetings between prominent Roman Catholic and Anglican figures in Malines, Belgium, where doctrinal differences between the two churches were discussed. Halifax summarized the points of agreement in a pamphlet entitled *Notes on the Conversations at Malines, 1921–1925*.[27] Maria sought Cerretti's advice and assistance about publication issues surrounding Halifax's book. When Hali-

fax visited Paris, she introduced him to the archbishop. The meeting went well and laid the groundwork for the English lord's controversial audience with the pope in 1928.[28] Ultimately, Halifax's book was published. The reunion efforts, which Maria followed for thirty years, remained an elusive vision that still waits to be realized.

During the last ten years of her life, Maria proudly watched as her daughter-in-law in America continued Joe's philanthropic work, her daughter started a new career in health care, her son-in-law continued work in politics, and her grandchildren grew into adulthood.

With Mary's encouragement in 1923, Maria contributed in Joe's memory to the expansion of the General Hospital of Saranac Lake. When a "ten-room maternity wing" she sponsored became operational, Maria must have thought of Joe's prudent management of the board of directors when the hospital was a fledging organization.[29]

After working in nursing and physical rehabilitation, Min attended classes to learn something new in health care. At the Pasteur Institute in Paris she studied "the microscope for work in bacteriology." She was inspired to work with individuals suffering from tuberculosis, which was considered almost an epidemic during the war. The death of her brother and father also may have moved her to take up this work.[30]

In 1925, it is believed that Min helped to establish a public health group called Oeuvre Lafayette-Pasteur contre la Tuberculose [Lafayette-Pasteur Work against Tuberculosis] and served as president. The group hoped to eradicate tuberculosis in Lozère.[31] The organization established three dispensaries in the towns of Mende, Florac, and Marvejols, where patients could be diagnosed and treated. *Infirmieres* [nurses] were sent into the homes of the sick. Besides dispensing medication, they assessed living conditions and advised on cleanliness and hygiene.[32]

Min asked her mother to seek American investors, yet again, for a huge project, the building of a medical preventorium for pre-tubercular children. In the clean air and sunshine of Antrenas, a small community close to Marvejols, they proposed to "prevent" the illness from developing in youngsters exposed to the disease. At the facility children would follow a therapeutic regime of diet, rest, and exercise. The architectural design "as approved by the Ministry of Public Health, includes a large main building, constructed and equipped with the most modern scientific principles, a school building, a custodian's lodge, and a reservoir for pure spring water."[33] In 1934, partially through American benefactors, the large, 330-bed facility was opened.[34]

For Maria, her son-in-law took Bellamy's place in many ways during the mid-1920s. Besides serving as her delightful traveling companion, he managed her estate in Cincinnati. The politician discussed all purchases and sales of assets with her lawyers, bankers, and investment brokers in the United States and France.

Maria was always fascinated by Pierre's political career. He rode out storm after storm of the ever-changing French governments, constantly popular and consistently elected to the Chamber of Deputies by his constituents in Marvejols. Perhaps because of his American ties, in 1925, he was selected to visit the United States as a part of Joseph Caillaux's delegation to negotiate the French war debt. In 1932, he was elected to the Senate.[35]

Maria's family expanded with her granddaughter Marthe's marriage to Edmundo Ruspoli at a small wedding in 1924. There had been prewedding worries with her infatuation with her former piano teacher Auguste de Radwan who, Maria thought, had manipulated Marthe to believe he "was the greatest pianist of the age and needed her care in his old age...but [when] he discovered that we were all firm on the question of money," he stopped courting the young woman. Maria added, that Marthe "had her eyes opened a year ago....It was like recovery from a malignant disease....[Edmondo]

Ruspoli has loved her for four years...He is clever and very kind with a keen sense of humor."[36]

Isabel Anderson, who attended the wedding, described the groom as a "tall and distinguished man" and his bride as "lovely and fascinating." She added, "Everybody is delighted with the engagement....Cousin 'Ia'...is so happy about it but is at Aix [les-Bains, France] and doesn't feel able to come up even to the wedding." Marthe, who was the principal legatee from Bellamy's will, was married on his birthday, August 28, 1924. Maria's gift was the tapestries that she had made twenty-five years earlier while Bellamy was assigned in Spain.[37] She bragged to Taft about two great-grandchildren who were born in quick succession, in the "happiest family that I know."[38]

In 1929 her oldest grandson, Jean Pierre, married Gisèle Hugot Gratry. Deaf since the age of two, he nonetheless was well educated and remarkably gifted. Like his mother, he took classes at the Pasteur Institute. Similar to his grandmother, he also was an excellent artist who painted in oils.[39] Gilbert, her third grandchild, who was just twenty in 1929, attended college, where he studied law for a career of public service like his father.[40]

In the same year, Maria slowed down and stopped traveling to Rome. She bought a Parisian flat situated across the street from a convent, Notre Dame de l'Assomption, where she attended church daily. No longer did she pursue a frantic social life. No more nights were spent going to concerts, plays, and dinners with old friends.[41] She lived in solitude, cared for by competent servants, visited by family and a few friends. Perhaps, one could say, as she entered the last few years of her life, she found other things to occupy her.

An anecdote shared by her grandson, Jean Pierre, suggested that memories of the past were often on her mind. The two went to church and afterward Maria

"lit two candles. Then she knelt and prayed. After a long time, he knelt beside her. 'Grand'Maman,' he said point-

ing to one of the candles, 'Is this for grandfather Bellamy?' She nodded. 'And this one?' pointing to the second candle. Maria's eyes were large and sad. 'That one...is for *your* grandfather, George Nichols!'"[42]

In November 1930, Clara asked Pierre and Min, who were campaigning in Marvejols, to return to Paris because her Aunt Ia had left her an unintelligible note. The couple arrived and "found [Maria] much changed."

The elderly lady refused to see a doctor, which was not characteristic behavior. They thought that Maria might have suffered a stroke, since she "was unable to talk as usual." During the next few days, she was described as having periods of lucidity and confusion. Pierre stated, "The management even in small matters of daily life are too much for her." Maria was no longer considered competent to conduct her own affairs.[43]

Early in 1931, Min explained about her mother's mental state, "She lives a lot in Cincinnati, even though she is always in her Paris France apartment....She lives scenes of her girlhood over and over, talks of her father and mother." For her, the "old times, old art, and old music are the best!"[44]

Jean Pierre was the only family member with her in her apartment when she died on April 30, 1932. Pierre and Min had gone to campaign at Marvejols for his first election to his Senate seat. Her grandson described her as a "power-

Fig. 11.3 Tomb of the Chambrun family where Maria and Bellamy Storer are buried. *Ursulines of Cincinnati Archives.*

ful soul" whose last words were that he should travel to America
to improve his English! Maria was always managing—even to the
end.[45] Papers all over the United States and France included her
obituary and memories of "Dear Maria" were once again in the news,
however briefly.[46]

Maria was buried with Bellamy in the family sepulcher in Mar-
vejols in May. Maria had financed the rebuilding of the family tomb
"that had been vandalized during the French Revolution." It con-
sisted of a large cross with the family coat of arms carved on it.[47]
Shortly thereafter, in June, Pierre and Min boarded a steamer to visit
America. They specifically came to Cincinnati to conduct business
with Maria's estate and to attend a requiem mass for her at Saint
Ursula Convent and Academy.[48]

After Bellamy's death Maria had lived a busy life traveling and
writing. Although she was no longer a notable, she never settled for
a quiet, mediocre existence. Profoundly troubled by postwar issues,
she proposed that the Vatican should be a necessary component of
the peace efforts. Because her faith transcended national boundaries,
she argued it could offer hope in an age of ideological and economic
conflict. She energetically contacted prominent Americans and
voiced her strong convictions, regardless of how they were received.
Her insinuation into political and religious situations was her way to
accomplish what she believed in. Some called it meddling in 1906.
In the 1920s, she interceded anonymously when Cerretti met with
Pierre and Halifax. Did her efforts help? That answer is as secret as
her action.

Maria was sustained by and received great joy from her family.
Her exaggerated sense of self-importance at the restaurant, her cos-
tumed performance as Clemenceau, and her sadness about her first
husband are remembered by her progeny as much as the Rookwood
Pottery Company and the 1906 scandal.

Such a "powerful soul" deserves to be remembered, not only for what she tangibly accomplished, but for what she dreamed for the world. Maria Longworth Storer epitomized a verse from second Timothy in the Bible, "I have fought the good fight, I have finished the race, I have kept the faith."[49]

Fig. 11.4 Engraved names of Bellamy Storer and Maria Longworth Storer on the Chambrun tombstone. *Ursulines of Cincinnati Archives.*

EQUAL FOOTING WITH
INTELLIGENT MEN

CLARA DE CHAMBRUN observed that her aunt's generation of Cincinnati women "did not take suffragette apostles too seriously. Perhaps they had less reason to clamor for their rights than elsewhere for they enjoyed the privilege, even then, of standing on equal footing with intelligent men when possessing the mental capacity to do so, and this, to a greater extent perhaps, than in any other American city."[1]

Maria was the chief representative of the feminine element that transformed the metropolis into a major cultural center in the late nineteenth century. She was an accomplished musician and successful artist who created and guided the Rookwood Pottery Company and the Cincinnati May Festival. She also supported the Cincinnati Art Museum, the Cincinnati Music Hall, the Art Academy of Cincinnati, and the Cincinnati College of Music (now a part of the University of Cincinnati). These organizations flourish today and are testaments to her drive and vision.

Maria's charitable efforts have had a lasting effect on this city. She established educational and healthcare opportunities that were unheard of in the early nineteenth century. Cincinnati's extensive

social service system, specialty-care hospitals, and excellent primary school system were direct beneficiaries of her philanthropic projects. She gave paintings, furniture, and sculpture to the Cincinnati Art Museum, which constantly inspire novice artists and the general public. She presented religious art, organs, and stained-glass windows to local churches, which continue to enhance the aesthetic experience of the congregations. Maria founded the Cincinnati Catholic Women's Association, which retains her vision of helping others by underwriting local causes.

Maria pushed the boundaries of what women did in the public sphere when she supported her husband's political and diplomatic careers. People were scandalized with her active involvement. This did not deter her. In national and international affairs, she aggressively corresponded with influential people to present her point of view. Her written communications influenced American diplomatic policy after the Spanish-American War. She continued this work in the public arena until she was squashed by President Theodore Roosevelt in 1906. For the rest of her life, she maintained her outspoken forthright letter-writing, trying to make the world a better place. Her activist spirit for good never ceased.

Maria's legacy can be seen in her family. Mary Morgan Nichols, her beloved Joe's wife, donated art to museums. She maintained a lovely garden similar to Joe's grandfather's beautifully cultivated acreage around his country home of Rookwood.[2] Mary died in Saranac Lake in 1964, having outlived her husband by nearly fifty years.

In France in the 1930s, Min was heavily involved with fundraising for and management of the preventorium. Pierre served in the Senate representing the Marvejols area. Several times they traveled to the United States to visit family and old friends.[3] On July 10, 1940, Pierre was the only senator to vote against the revision of the Con-

stitution that abolished the republic. Afterward he and Min quietly retired to Château Carrière near Marvejols.[4] In 1941, they must have been fearful when the Gestapo charged their daughter Marthe with espionage. The officials were unable to determine if she was "helping people escape to Britain" so she was released.[5]]

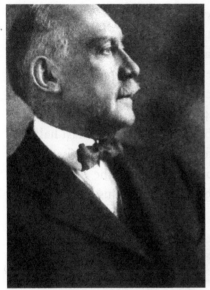

Fig. Epilogue 1 Pierre de Chambrun. *Ursulines of Cincinnati Archives.*

Fig. Epilogue 2 Margaret de Chambrun. *Ursulines of Cincinnati Archives.*

Gilbert, the younger son of Min and Pierre, joined his parents in Marvejols, after quitting a position in the Ministry of Foreign Affairs.[6] He became involved in guerilla actions of local resistance operatives against the Nazis. When the resistance efforts became organized, he was appointed regional chief of the Forces Françaises de l'Intérieur in 1944.[7] Pierre also quietly assisted the resistance and wrote letters on behalf of Jewish refugees.[8] When destitute people approached Min for assistance, she gave them coupons that could be redeemed for food or coal.[9]

Since Jean Pierre was deaf, and could not actively participate in the war, he traveled to the United States with his wife and family for the duration.[10] He displayed his paintings at several galleries throughout the country. Maria would have smiled knowing that he exhibited at Loring Andrews Company in Cincinnati, just as she had fifty years earlier.[11] After the end of the war, Gisèle and her children returned to France. The couple later divorced.[12]

After the Nazis were driven out of France, Pierre at the age of eighty was called on once again to serve as a member of the Assemblée consultative provisoire in 1944.[13] Ultimately, he retired to his country home, possibly to care for Min who became increasingly infirm. When she died in 1949, several thousand attended her funeral, acknowledging her quiet benevolence over the last half century. In her spirit Jean Pierre's wife, Gisèle, actively solicited American donors to help fund a $150,000 addition to the preventorium in the late 1940s.[14] Pierre died in 1954, grieved by his family and the community he served so long.[15]

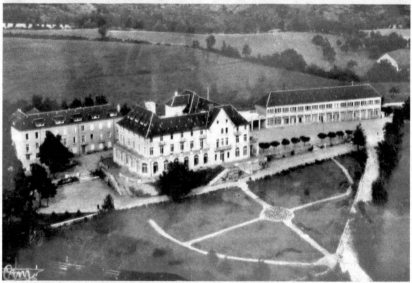

Fig. Epilogue 3 Préventorium d'Antrenas, 1938. *Ursulines of Cincinnati Archives.*

At this time, Marthe worked as an English editor for the *Radio-diffusion française*. Since she spoke five languages, like her grandmother, the position was probably a good fit for her linguistic skills. She also studied archeology and was fascinated with Africa.[16] Marthe wrote two books that argued Egypt's ancient beliefs were the basis of the great religions of the world. Her volumes were received skeptically by scholars. Yet her theory is still discussed today. Marthe moved to Tangiers in 1949 and was a fixture of the expatriate community. She died in 1984.[17]

Gilbert followed his father's lead and was elected to the Chamber of Deputies from 1945 to 1956. He was nicknamed the Red Baron for his political leanings, and wanted to create a "world council of peace" to work with the United Nations. Maria would have been thrilled that he pursued the same goal that she had.[18] Later he served as mayor of Marvejols from 1953 to 1965 and again from 1971 to 1983, where he focused on civic improvements for the community. He died in 2009, at age 100 years.[19]

Jean Pierre traveled extensively like his grandmother. With his second wife Muriel, he lived part time in the United States, chiefly in Cincinnati and Washington. In the 1970s, he lectured throughout America about his ancestor Marquis de Lafayette's relationship with other revolutionary heroes. He was presented an honorary doctorate by the University of Cincinnati for his efforts.[20] He died in 2004 at the age of 101.

In 2014, Jean François (Jean Pierre's son) and Jacques (Gilbert's son) extended an invitation to the authors to meet them in France. Nancy Broermann, her husband, Steve, and Constance Moore spent three days sharing stories about Maria, and learning about the Chambrun family. They toured around the community of Marvejols, seeing the stained-glass window presented by Min in the local church,

Notre-Dame-de-la-Carce, walking around the grounds of Château de Carrière (now a bed and breakfast), and visiting Maria's grave at Le Cimetière Neuf. Jacques toured them through the private residence of Château de L'Empéry, which was the original country home of the Chambruns that had been restored by Jacques's father, Gilbert.

On the last day, Jean François and Jacques took the Americans to visit Antrenas where the buildings of the former preventorium now contain Le Centre de Antrenas, which is a component of a nine-part regional healthcare system that deals with clients who are diagnosed with pulmonary diseases, or child/adolescent obesity, or who require health and functional rehabilitation or domiciliary care. Le Association Lozérienne de Lutte contre les Fléaux Sociaux, which Min founded in 1937, is responsible for the management of the association.

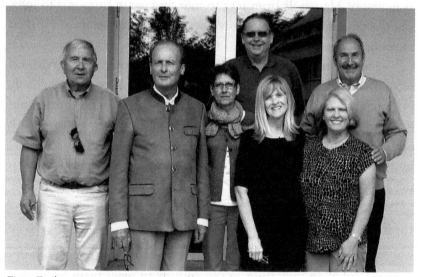

Fig. Epilogue 4 Visit at the former Préventorium d'Antrenas, now Centre d'Antrenas, 2014. Top step left to right: Steve Broermann and Jacques de Chambrun; bottom step left to right: Centre d'Antrenas Director Alain Nogaret, Jean François de Chambrun, unnamed woman, and the authors, Constance Moore and Nancy Broermann. *Courtesy of Nancy Broermann.*

The group next traveled to Montrodat where Le Centre de Mondrodat manages four parts of the system. Jean François proudly pointed out that his elder brother Charles helped to create one of the organizations, le Centre d'Education Motrice, in 1968 in the "line of my grandmother to help...children and people who are handicapped physically."[21]

Today, L'Association Lozérienne de Lutte contre les Fléaux Sociaux, established by Min and supported by her grandson Charles, is one of largest employers in the Lozère region.[22] Maria Longworth Storer's legacy lives on.

MARIA LONGWORTH STORER'S PUBLISHED WORKS

Balzac, Honoré de. "Farewell." Translated by Maria Longworth Storer. In *Tales for a Stormy Night*, ed. Eugene F. Bliss. Cincinnati: Robert and Clark, 1891.

Rubenstein, Anton. *Der Thurm zu Babel (Tower of Babel)*, sacred opera, Opus 80, in one act. Libretto by Julius Rosenberg. Translated by Maria Longworth Storer. N.p.: n.p., n.d.

Storer, Maria Longworth. "Archbishop Ireland and the Red Hat." *Dublin Review* 168, no. 337 (April/June 1921): 203–208. Accessed July 26, 2017. https://hdl.handle.net/2027/mdp.39015027529810?urlappend=%3Bseq=217.

——. "The Awakening of Austria." *North American Review* 197, no. 689 (April 1913): 477–485. JSTOR (25119975).

——. *Borodino Mystery*. St. Louis: B. Herder, 1916.

——. "The Court of the King." *The Lamp* 10, no. 4 (April 1912): 97.

——. "The Decadence of France." *North American Review* 191, no. 651 (February 1910): 168–184. Accessed July 26, 2017. https://play.google.com/books/reader?id=zrsxAQAAMAAJ.

——. "A Favor of Our Queen: The Cure Story of Marie Borel." *Ave Maria* 61, no. 17 (April 25, 1908): 528–533.

——. "Finis Vitae." *Catholic World* 94, no. 560 (November 1911): 201. Accessed December 4, 2015. https://play.google.com/books/reader?id=DngQAAAAYAAJ.

——. *The French 'Neutral' Schools.* N.p.: n.p., 1918.

——. "The Gate of Sin." *Dublin Review* 146, nos. 292/293 (January/April 1910): 300–301. Accessed July 26, 2017. https://hdl.handle.net/2027/mdp.39015027529158?urlappend=%3Bseq=308.

——. "The Gate of Sin." *Living Age* 266, no. 3443 (July 1910): 2.

——. *History of the Cincinnati Musical Festivals and of the Rookwood Pottery.* Paris: Herbert Clarke, 1919.

——. "How Theodore Roosevelt Was Appointed Assistant Secretary of the Navy." *Harper's Weekly* 56, no. 293 (June 1, 1912): 8–12.

——. *In Memoriam Bellamy Storer, with Personal Remembrances of President McKinley, President Roosevelt, and John Ireland, Archbishop of St. Paul.* Boston: Merrymount Press, 1923.

——. "The Kingdom of the Blind." *Dublin Review* 148, nos. 296/297 (January/April 1911): 113–114. Accessed July 26, 2017. https://hdl.handle.net/2027/mdp.39015010732975?urlappend=%3Bseq=121.

——. "Maria Longworth Storer." In *Beyond the Road to Rome*, edited by Georgina Curtis, 376–381. St. Louis: B. Herder, 1914.

——. "Maria Longworth Storer." In *Some Roads to Rome in America*, edited by Georgina Curtis, 460–463. St. Louis: B. Herder, 1909.

——. "The Peril of the Twentieth Century." *Catholic Extension* (February 1909): 9–10.

——. *Probation.* St. Louis: B. Herder, 1918.

——. "The Real Reformer." In *An Appeal for Unity in Faith*, edited by John Phelan, 321–322. Chicago: M. A. Donohue, 1911.

——. "The Recent Tragedy in Bosnia." *Catholic World* 99, no. 593 (August 1914): 674–677. Accessed December 4, 2015. https://play.google.com/books/reader?id=Ayo7AQAAMAAJ.

——. *Sir Christopher Leighton; or, The Marquis de Vaudreuil's Story*. St. Louis: B. Herder, 1915.

——. *Some Verses Written in Honor of the Church and Dedicated to Saint Catherine of Siena*. Rome: Instituto Pio IX., n.d.

——. *The Soul of a Child*. London: R. and T. Washbourne, 1911.

——. *The Story of the Miracle at Lourdes, August 1907*. New York: Catholic World Press, 1908.

——. *Theodore Roosevelt the Child; a Sketch, Including Thirty-One Letters from President Roosevelt to Mrs. Bellamy Storer*. London: W. Straker, 1921.

——. "The *Titanic's* Dead." *Dublin Review* 151, nos. 302/303 (July/October 1912): 80. Accessed July 26, 2017. https://hdl.handle.net/2027/coo.31924065585667?urlappend=%3Bseq=90.

——. *The Villa Rossignol; or, The Advance of Islam*. St. Louis: B. Herder, 1918.

——. "The War against Religion in France." *Catholic World* 90, no. 539 (February 1910): 611–620. Accessed December 4, 2015. https://play.google.com/books/reader?id=04gEAAAAMAAJ.

Weber, Carl Maria von, and Friedrich Rochlitz. *Hymn: In Seiner Ordnung Scafft der Herr*, vocal score. Translated by Maria Longworth Storer. Cincinnati: J. Church, 1888.

ABBREVIATIONS USED IN NOTES

The citations in the text have been quoted as written except for changes in capitalizations and punctuation according to contemporary usage.

People

AG Alfred Goshorn

AJ Alois Janssens

ALL A. Lawrence Lowell

AM Adolf Meyer

AML Alice Mary Longfellow

AR Annie Roelker (Nan-sa)

ARC Anna Roosevelt Cowles

ARLW Annie Rives Longworth Wallingford

BC Bonaventura Cerretti

BF Baptista Freaner

BS Bellamy Storer

CNN Clara Chipman Newton

CdeC Clara de Chambrun

CF Charles Frances

CHLE C(harles) H.L. Emanuel

CL Clara Longworth

CS Charles Stoddard

CW, VH Charles Wood, Viscount Halifax

DH Daniel Hudson

DO'C Denis O'Connell

DR Dominic Reuter

DT David Thompson

EC Elizabeth Cameron

EdeG Eugeniè de Grunne

EFB Eugene F. Bliss

EL Edith Longfellow

ER Elihu Root

ES Edward Sisson

ET Edward Trudeau

FC Fidelis Coleman

FF Francis Force

FG Francis Gasquet

FF Francis Force

FG Francis Gasquet

FMC F[rancis] Marion Crawford

FR Frederick Rooker

FT Frederick Temple

GdeC Gilbert de Chambrun

GT George Tyrell

GWN George Ward Nichols

HA Henry Adams

HCL Henry Cabot Lodge

HH Howard Hollister

HM Henry Moeller

IMcK Ida McKinley

ISG Isabella Stewart Gardner

JAP John A. Porter

ABBREVIATIONS USED IN NOTES

JD	Julius Dexter
JdeC	Jacques de Chambrun
JF	John Farley
JFdeC	Jean François de Chambrun
JG	James Gibbons
JH	John Hay
JHG	Joseph H. Gest
JI	John Ireland
JK	John Keane
JLN	Joseph Longworth Nichols
JPdeC	Jean Pierre de Chambrun
JTS	John Talbot Smith
JW	Joseph Wilby
KER	Katharine Elizabeth Roelker
KERW	Kathrine Elizabeth Roelker Wulsin
LT	Louise Taft
LW1	Leonard Wood
LW	Lucien Wulsin
LWJr	Lucien Wulsin, Jr.
MAF	Mary Ann Cook (Fahm)
MEI	Melville E. Ingalls
MEPD	Mrs. Edward Parker Davis
MF	Manning Force
MFF	Michael Francis Fallon
MJM	Marcellus J. Maxwell
MR	Mario Rampolla
MLMcL	M. Louise McLaughlin
MLN	Maria Longworth Nichols
MLS	Maria Longworth Storer
MTR	Marie Thompson Rives
NL1	Nicholas Longworth
NL3	Nicholas Longworth III
OGV	Oswald Garrison Villard
OK	Otto Kahn
PdeC	Pierre de Chambrun
PG	Parke Goodwin
RAB	Rose Angela Boehle
RB	Robert Bacon
RBH	Rutherford B. Hayes
RK	Richard Kerens
RMDV	Rafael Merry del Val
RP	Ross Purdy
SB	Simon Baldus
SE	Stephen Elkins
ShL	Shane Leslie
SL	Susan Longworth
SM	Sebastiano Martinelli
SMacK	Steele MacKaye
TO'G	Thomas O'Gorman
TR	Theodore Roosevelt
TS	Thomas Shahan
TT	Theodore Thomas
WC	Winthrop Chandler
WE	William Elder
WHB	William Henry Bliss
WHT	William Howard Taft
WL	William Laffan
WMCK	William McKinley
WO'C	William O'Connell
WPA	W.P. Anderson
WW	William Welch
WWN	William W. Nichols
WWR	William W. Rockville
WWT	W[illiam] W[atts]. Taylor

Collections

AJP	Alois Janssens Papers	LFP	Longworth Family Papers
ALLP	A. Lawrence Lowell Papers	MCC	Miles Cameron Correspondence
AMC	Adolf Meyer Collection	MFP	Manning Force Papers
AMcK	Administration of William McKinley	MFFP	Manning Ferguson Force Collection
AMLP	Alice Mary Longfellow Papers	MLMcLP	M. Louise McLaughlin Papers
ARPO	Applications and Recommendations for Public Office	MRKP	Margaret Rives King Papers
BDBJ	Board of Deputies of British Jews	OKP	Otto Kahn Papers
		OGVP	Oswald Garrison Villard Papers
BGP	Bryant-Godwin Papers	PWAMA	Papers of the Women's Art Museum Association
CCNP	Clara Chipman Newton Papers		
CMCP	College of Music of Cincinnati Papers	RABP	Rose Ann Boehle Papers
		RG	Record Group
CMFAP	Cincinnati Music Festival Association Papers	RWBP	Robert Wood Bliss Papers
DHP	Daniel Hudson Papers	SBP	Simon Baldus Papers
EFBP	Eugene F. Bliss Papers	ShLP	Shane Leslie Papers
EHFP	Earls of Halifax Family Papers	SMacKFP	Steele MacKaye Family Papers
EHS	Ella Hollister Scrapbook	TA	Trudeau Archive
GRSD	General Record of State Department	TRP	Theodore Roosevelt Papers
		WFP	Wulsin Family Papers
HAP	Henry Adams Papers	WHTP	William Howard Taft Papers
JDP	Julius Dexter Papers	WMcKP	Wiliam McKinley Papers
JFP	John Farley Papers	WO'CP	William O'Connell Papers
JHP	John Hay Papers	WWRP	William W. Rockville Papers
JHTP	James H. Thompson Papers		
JIP	John Ireland Papers		
JWP	Joseph Wilby Papers		
LBC	Little and Browne Collection		

Archives

AASMU	Associated Archives at St. Mary's Seminary and University
ABA	Archdiocese of Boston Archives
ACA	Archdiocese of Cincinnati Archives
ACDR	Archives Catholic Diocese of Richmond
ACHRCUA	American Catholic History Research Center and University Archives
AASP	Office of Archives and Records, Archives Archdiocese of St. Paul
AMCMA, JHMI	Alan Mason Chesney Medical Archives, Johns Hopkins Medical Institute
ARR, SLFL	Adirondack Research Room, Saranac Lake Free Library
AUND	Archives of the University of Notre Dame
BIA	Borthwick Institute of Archives
CMC	Cincinnati Museum Center
FAARC	Friars of the Atonement Archives/Record Center
HLHU	Houghton Library, Harvard University
HNE	Historic New England
HUA	Harvard University Archive
ISGM	Isabella Stewart Gardner Museum
KADOC	KADOC, Documentation and Research Centre for Religion, Culture, and Society, Belgium
LMA	London Museum Association
LHWHNHS	Longfellow House-Washington's Headquarters National Historic Site
LOC	Library of Congress
MHS	Massachusetts Historical Society
MNHS	Minnesota Historical Society
MRSLA, CAM	Mary R. Shiff Library and Archives, Cincinnati Art Museum
NACP	National Archives College Park
NYA	New York Archdiocese
NYPL	New York Public Library
RBHPC	Rutherford B. Hayes Presidential Center
USCA	Ursuline Sisters of Cincinnati Archives

Newspapers

CE Cincinnati Enquirer
NYT New York Times

NOTES

Prologue

1 Bellamy Storer quoted in Maria Longworth Storer (MLS) to William Howard Taft (WHT), November 6, 1908, WHTP (William Howard Taft Papers), Library of Congress (LOC). Her name was pronounced Mar-EYE-ah and hence the nickname "Ia."

2 Theodore Roosevelt (TR) to MLS, November 11, 1905, Theodore Roosevelt Papers (TRP), LOC.

3 MLS to WHT, December 28, 1905, WHTP, LOC.

4 Ibid.

5 TR to Bellamy Storer (BS), February 6, 1906, TRP, LOC. TR to BS, March 6, 1906, TRP, LOC.

6 Graham Stuart, *American Diplomatic and Consular Practice*, 2nd ed. (New York: Appleton-Century-Crofts, 1952), 266.

7 Marvin O'Connell, *John Ireland and the American Catholic Church* (St. Paul: Minnesota Historical Society, 1988), 395.

8 Maria Longworth Storer, "Maria Longworth Storer," in *Some Roads to Rome in America*, ed. Georgina Curtis (St. Louis: B. Herder, 1909), 461.

9 Patrick Allitt, *Catholic Converts: British and American Intellectuals Turn to Rome* (Ithaca, NY: Cornell University Press, 1997), 112.

10 TR to MLS, March 27, 1899, TRP, LOC.

11 William McKinley (WMcK) to TR, June 13, 1899, William McKinley Papers (WMcKP), LOC.

12 Bellamy Storer, *Letter of Bellamy Storer to the President and the Members of His Cabinet, November 1906* (Cincinnati: N.p., 1906), 26; John Ireland (JI) to MLS, November 10, 1903, John Ireland Papers (JIP), Minnesota Historical Society (MNHS); TR to David Thompson (DT), March 23, 1903, TRP, LOC. MLS to JI, January 4, 1907, JIP, MNHS.

13 MLS TO WHT, LOC, January 25, 1923.

14 Jean Pierre de Chambrun (JPdeC) interview by Rose Angela Boehle (RAB), May 19 and May 23, 1988, Rose Angela Boehle Papers (RABP), Ursuline Sisters of Cincinnati Archives (USCA); Jean François de Chambrun (JFdeC), and Jacques de Chambrun (JdeC) interviews with authors, September 13–15, 2014.

15 See the following books that provide excellent information about the history of the Rookwood Pottery: Herbert Peck, *The Book of Rookwood Pottery* (Tucson, AZ: Herbert Peck Books, 1986); Anita Ellis, *Rookwood Pottery: The Glaze Lines/with Value*

Guide (Atglen, PA: Schiffer, 1995); Anita Ellis, *Rookwood Pottery: The Glorious Gamble* (Cincinnati: Cincinnati Art Museum, 1992); Anita Ellis, *The Ceramic Career of M. Louise McLaughlin* (Athens: Ohio University Press, 2003); Anita Ellis and Susan Meyn, *Rookwood and the American Indian: Masterpieces of American Art Pottery* (Athens: Ohio University Press, 2007).

Chapter One

1 Louis Leonard Tucker, "'Old Nick' Longworth: The Paradoxical Maecenas," *Cincinnati Historical Society Bulletin* 25 (October 1967): 247.

2 Fred Milligan, *Ohio's Founding Fathers* (Bloomington, IN: iUniverse, 2003), 112. Nicholas Longworth I (NL1) to Mary Ann Cook (Fahm) (MAF), July 20, 1804, Longworth Papers (LP), Cincinnati Museum Center (CMC). Charles Greve, *Centennial History of Cincinnati and Representative Citizens*, vol. 1 (N.p.: Bibliography Publishing, 1904), 452.

3 *Memorial of the Golden Wedding of Nicholas Longworth and Susan Longworth Celebrated at Cincinnati on Christmas Eve, 1857* (Baltimore: Hunckel and Son, 1857), n.p.

4 Clara de Chambrun, *Cincinnati: Story of the Queen City* (New York: Charles Scribner's Sons, 1939), 111. Tome Demeropolis, "This Office Building Could Be Home to Downtown Cincinnati's Newest Apartments," *Cincinnati Business Courier*, October 28, 2014, accessed November 4, 2014, http://www.bizjournals.com/cincinnati/news/2014/10/28/this-office-building-could-be-home-to-downtown.html?page=all.

5 NL1 to MAF, January 3, 1816, LFP, CMC.

6 William Houghton, *Kings of Fortune; or, The Triumphs and Achievements of Noble, Self-Made Men* (Chicago: A. E. Davis, 1886), 141, accessed September 22, 2016, https://play.google.com/books/reader?id=3DuI_c7grwsC. "At the peak of his fortune, Longworth's net worth as a percentage of GDP place[d] him among the forty wealthiest Americans of all time." See Christopher Levenick, "Nicholas Longworth," *Philanthropy Roundtable*, accessed November 28, 2015, http://www.philanthropyroundtable.org/almanac/hall_of_fame/nicholas_longworth.

7 In 1848, Longworth stated, "It was twenty-five years since I planted my first vineyard." Charles Wyllys Elliott, "Wine-Making in the West," *The Horticulturist and Journal of the Rural Art* 2, no. 7 (January 1848): 315, accessed December 14, 2014, https://archive.org/details/horticulturistj002alba. On the Catawba grape, see Todd Kliman, *The Wine Vine: A Forgotten Grape and the Untold Story of American Wine* (New York: Clarkson Potter, 2010), 102. Houghton, *Kings of Fortune*, 144. On Catawba champagne, William Flagg, *Three Seasons in European Vineyards* (New York: Harper and Brothers, 1869), 148, accessed December 4, 2015, https://play.google.com/books/reader?id=olnZAAAAMAAJ; and Elliott, "Wine-Making in the West," 318; "Almost 200 Years Ago, the First Great Wine Was Born," *Paso Wine Barrels*, accessed November 12, 2014, http://pasowinebarrels.wordpress.com/2013/11/26/almost-200-years-ago-the-first-great-american-wine-was-born/.

8 Erica Hannickel, "A Fortune in Fruit: Nicholas Longworth and Grape Speculation in Antebellum Ohio," *American Studies* 51, nos. 1/2 (Spring/Summer 2010):

97; "The Longworth Wine House Grape Premiums," *The Horticulturist, and Journal of Rural Art and Rural Taste* 23, no. 259 (January 1868): 60, accessed November 10, 2014, http://books.google.com/books?id=wCgCAAAAYAAJ.

9 Elliott, "Wine-Making in the West," 315–319; "Editorial Correspondence," *Cultivator* 6, no. 9 (September 1858): 275–277, accessed December 14, 2014, https://archive.org/stream/cultivator05socigoog#page/n275/mode/2up/search/longworth; "Curculio, Etc.," *Western Horticulture Review* 1, no. 1 (October 1850): 31, accessed December 4, 2015, https://play.google.com/books/reader?id=wxQ4A-QAAMAAJ.

10 In the late 1850s, disease ravaged the grape vines and decreased production and in the 1860s, the death of Nicholas and the loss of workers to Civil War armies had a negative impact on the family's wine production. Ultimately, by 1870, the wine empire was dismantled and sold. His son-in-law continued the operation of the winery into the 1870s, but the production was never as large or the demand as great as when Nicholas was alive. See Hannickel, "A Fortune in Fruit," 93; John von Daacke, "Grape-Growing and Wine-Making in Cincinnati, 1800–1870," *Cincinnati Historical Society Bulletin* 25, no. 3 (July 1967): 209–210; William Flagg, "Wine in American and American Wine," *Harper's Magazine* 4 (June 1870): 112. Chambrun, *Nicholas Longworth*, 104.

11 Henry Ford and Kate Ford, *History of Cincinnati, Ohio, with Illustrations and Biographical Sketches* (Cleveland: L. A. Williams, 1881), 435. *Rich Men of the World* (New York: American News Co., 1867), 10, 11, https://hdl.handle.net/2027/hvd.hboouf. "The Late Nicholas Longworth," *Harper's Weekly* 7, no. 323 (March 7, 1863).

12 Quoted in Abby Schwartz, "Nicholas Longworth: Art Patron of Cincinnati," *Queen City Heritage* 46, no. 1 (Spring 1988): 20. Tucker, "Paradoxical Maecenas," 255.

13 Ford and Ford, *History of Cincinnati*, 163. Hiram Powers, "Letters of Hiram Powers to Nicholas Longworth, Esq., 1856–1858," *Quarterly Publication of the Historical and Philosophical Society of Ohio* 1, no. 2 (April/June 1906): 33; Worthington Whittredge, *The Autobiography of Worthington Whittredge* (Brooklyn, NY: Brooklyn Institute of Arts and Sciences, 1942), 17, 34, 41.

14 Frazer Kirkland, *Cyclopedia of Commercial and Business Anecdotes* (New York: D. Appleton, 1865), 45. "Joseph Longworth Genealogy Search Listing," *Spring Grove*, accessed December 3, 2014, http://www.springgrove.org/geneology-listing.aspx?firstname=&lastname=longworth&cemetery=SPRINGGROVE. NLI to MAF, January 3, 1816, LFP, CMC.

15 "Death of Joseph Longworth," *Cincinnati Enquirer (CE)*, December 31, 1883. Clara de Chambrun, *The Making of Nicholas Longworth* (New York: Ray Long and Richard Smith, 1933), 115, 116.

16 "Kate Field's Notions of Cincinnati," *CE*, June 21, 1875.

17 Margaret Rives King, *A Memento of Ancestors and Ancestral Homes* (Cincinnati: Robert Clark, 1890), 114, 115, accessed April 10, 2017, https://books.google.com/books/reader?id=ePMxAQAAMAAJ.

18 Ibid., 120, 117.

19 In 1829, Nicholas purchased Belmont, a Federal-style mansion large enough so that "all the Longworths in the United States could live there." Maria's father sold the Belmont mansion in 1869. Today, it is open to the public and is called the Baum Taft House. See Tucker, "Paradoxical Maecenas," 247; Milligan, *Ohio's Founding Fathers*, 111.

20 Rives King, *A Memento of Ancestors*, 121. Nicholas Longworth, "Address of Nicholas Longworth 1856," LFP, CMC.

21 Rives King, *A Memento of Ancestors*, 122. Gregory Rogers, *Cincinnati's Hyde Park: A Brief History of a Queen City Gem* (Charleston: History Press, 2011), n.p.

22 Rives King, *A Memento of Ancestors*, 31. Chambrun, *Making of Nicholas Longworth*, 5. On August 16, 1929, the three bodies were reburied near Joseph's father, Nicholas Longworth, at Spring Grove Cemetery. "Anne R. Longworth, Genealogy Search Listing," *Spring Grove*, accessed December 3, 2014, http://www.springgrove.org/geneology-listing.aspx?firstname=&lastname=longworth&cemetery=SPRINGGROVE.

23 Chambrun, *Making of Nicholas Longworth*, 53. Rives King, *A Memento of Ancestors*, 127.

24 Whittredge, *Autobiography*, 41. Chambrun, *Cincinnati Story*, 204.

25 Julius Dexter, "Record on the Death of Joseph Longworth," in Cincinnati Museum Association, *Fourth Annual Report, Annual Reports*, vols. 4–11 (Cincinnati: Robert Clarke, 1885), https://hdl.handle.net/2027/uc1.a0011949732?urlappend=%3Bseq=38.

26 Samuel Kip, "Old Notable and Newcomers: The Economic and Political Elite of Greensboro, NC," *Journal of Southern History* 43, no. 3 (August 1977): 373. JSTOR (2207647).

27 Dexter, "Record on the Death of Joseph Longworth," 28. Joseph Holliday, "Collector's Choice of the Gilded Age," *Cincinnati Historical Society Bulletin* 28, no. 4 (Winter 1970): 301, 313n15.

28 W. H. Venable, "Cincinnati Historical and Descriptive," *New England Magazine* 6, no. 5 (September 1888): 442.

29 Joseph Holliday, "The Cincinnati Philharmonic and Hopkins Hall Orchestras, 1856–1869," *Cincinnati Historical Society Bulletin* 26, no. 2 (April 1968): 166. The orchestra and choral festivals that are presented annually in Cincinnati are officially called the Cincinnati Music Festival Association for tax purposes. However, Cincinnati May Festival is generally used for advertisement, brochures, and programs. For this book, the Cincinnati May Festival will be used as the title since it was used at the time on tickets. Steven Sunderman, executive director, Cincinnati Music Festival Association, telephone interview with Constance Moore, June 8, 2015. Joseph Holliday, "The Musical Legacy of Theodore Thomas," *Cincinnati Historical Society Bulletin* 27, no. 3 (Fall 1969): 193, 198; Joseph Stern, "The Queen of the Queen City: Music Hall," *Cincinnati Historical Society Bulletin* 31, no. 1 (Spring 1973): 17. "Music Hall's Organ," *Society for the Preservation of Music Hall*, accessed December 8, 2014, http://www.spmhcincinnati.org/Music-Hall-History/Organs-in-Music-Hall.php.

30 Chambrun, *Making of Nicholas Longworth,* 117; "GFZ," Secretary, A Brief Summary on the Eden Park Longworth Lease, July 16, 1961, Bettman Library Parks.

31 "Photo of Marquis de Chambrun Tomb," September 13, 2015, by Nancy Broermann, JPEG file. The tomb shows birth and death dates.

32 Herbert Peck, *Book of Rookwood Pottery* (Tucson, AZ: Herbert Peck Books, 1986), 2.

33 Rives King, *A Memento of Ancestors,* 159.

34 Chambrun, *Making of Nicholas Longworth,* 134.

35 Quoted in Edith Perkins Cunningham, *Owl's Nest* (Cambridge, MA: Riverside Press, 1907), 281.

36 *Academy Exhibition Sent to Jacksonville, Ill.,* February 7, 1889, Mary R. Shiff Library and Archives, Cincinnati Art Museum (MRSLA, CAM); "Men and Things about Town," *CE,* June 17, 1890; "The Sketch Club," *CE,* June 1, 1890; Henry Hall, ed., *America's Successful Men of Affairs,* vol. 2 (New York: New York Tribune, 1895), 265, accessed December 14, 2014, https://archive.org/details/cu31924024759460; Frederick Forchheimer, *In Memoriam Dr. Landon R. Longworth* (N.p.: n.p., n.d.), n.p.

37 He translated *Electra* by Sophocles. See Charles Stratton, *Harvard Class 1866, The Secretary's Report, June 1886–June 1901* (Boston: Mills, Knight, 1891), 26.

38 Forchheimer, *In Memoriam Dr. Landon R. Longworth,* n.p.

39 "A Week of Song," *CE,* May 21, 1888; Carl Maria von Weber and Friedrich Rochlitz, *Hymn: In Seiner Ordnung Scafft der Herr,* vocal score, trans. Maria Longworth Storer (Cincinnati: J. Church, 1888); Honoré de Balzac, "Farewell," trans. Maria Longworth Storer, in *Tales for a Stormy Night,* ed. Eugene F. Bliss (Cincinnati: Robert and Clark, 1891), 185–203; See Appendix for a listing of Maria's published work.

40 Nicholas: "Collections Database: Object Record," *Adirondack Museum,* accessed December 31, 2014, http://adirondack.pastperfect-online.com/31694cgi/mweb.exe?request=record&id=569A25FC-A6EA-45C8-8A84-105934812160&type=101. Landon: Hall, ed., *Successful Men of Affairs,* 2:265. Maria Longworth Nichols, Manufacture of Pottery, U.S. Patent 361231, filed December 21, 1885, and issued April 12, 1887.

41 "Death of Joseph Longworth," *CE,* December 31, 1883.

42 Ralph Waldo Emerson and Thomas Carlyle, *Correspondence of Thomas Carlyle and Ralph Waldo Emerson,* vol. 2 (Boston: James Osgood, 1883), 263, accessed December 4, 2015, https://play.google.com/books/reader?id=OJMYAAAAYAA.

43 MLS to TR, April 14, 1899, TRP, LOC.

44 Storer, "Maria Longworth Storer," in *Some Roads to Rome in America,* 460.

45 "Our History," *Church of the Advent,* accessed December 31, 2014, http://advent-cincinnati.diosohio.org/About%20us/history.html.

46 Allen Guelzo, "Ritual, Romanism, and Rebellion: the Disappearance of the

Evangelical Episcopalians, 1853–1873," *Anglican and Episcopal History* 62, no. 4 (December 1993): 554. JSTOR (2611573); Walter B. Posey, "The Protestant Episcopal Church: An American Adaptation," *Journal of Southern History* 25, no. 1 (February 1959): 14. JSTOR (2954477).

47 Chambrun, *Making of Nicholas Longworth*, 5.

48 Louis Tucker, "The Director's Page: Cincinnati and the Civil War," *Bulletin of the Historical and Philosophical Society of Ohio* 19, no. 2 (April 1961): 154. Houghton, *Kings of Fortune*, 141. The estate remained viable through World War II. See JPDeC to Lucien Wulsin Jr. (LWJr), October 29, 1941, Wulsin Family Papers (WFP), CMC.

49 Mildred MacLean Hazen (Dewey), *Memoir, November 1, 1890*, Mildred MacLean Hazen Dewey Collection, Rutherford B. Hayes Presidential Center (RBHPC), 35.

50 "Women in the Civil War," *History*, accessed August 14, 2014, http://www.history.com/topics/american-civil-war/women-in-the-civil-war.

51 Hazen, *Memoir*, 13.

52 Charles Goss, *Cincinnati, the Queen City, 1788–1912*, vol. 1 (Cincinnati: S. J. Clarke, 1912), 128, 382–383.

53 Clara Chipman Newton, *Early Days at Rookwood Pottery*, transcribed by Kenneth Trapp, CCNP, CMC, 1.

54 Cunningham, *Owl's Nest*, 48.

55 Hazen, *Memoir*, 10–11.

56 "Education, Women's Education, and 'Accomplishments,'" *Pride and Prejudice—Notes on Education, Marriage, Status of Women, etc.*, accessed December 28, 2014, http://www.pemberley.com/janeinfo/pptopic2.html#protofem3; Maria Longworth Nichols (MLN) to Julius Dexter (JD), n.m., n.d., n.d.; MLN to JD, July 19, 1872, Julius Dexter Collection (JDP), CMC; there are two undated letters believed to be from the 1870s. These documents were written when Maria was still married to Nichols: MLN to "Altsche," November 7, 1881, WFP, CMC; MLN to Katharine Elizabeth Roelker (KER), December 31, 1881, WFP, CMC. "Won by His Wife," *Saint Paul Daily Globe*, November 23, 1890, Library of Congress, Chronicling America: Historic American Newspapers site, accessed April 15, 2014, http://chroniclingamerica.loc.gov/lccn/sn90059522/1890-11-23/ed-1/seq-7; "Cincinnati Woman Genius for Politics Turns the Diplomatic World Topsy-Turvy," *St. Louis Dispatch*, December 23, 1906, A12B, 1. Proquest Historical Newspapers (577651728). There are three undated programs, and an invitation to the Nicholses' Masquerade that indicated the month and day, but no year for the event in the Margaret Rives King Papers, CMC.

57 On MLN's character: MLN to Manning Force (MF), September 19, 1876, Manning Force Papers (MFP), CMC; MF to Rutherford B. Hayes (RBH), February 23, 1889, Manning Ferguson Force Collection (MFFC), RBHPC; MLS to TR, April 14, 1899, TRP, LOC. MLS to Eugene F. Bliss (EFB), July 1, 1886, Eugene F. Bliss Papers (EFBP), CMC; MLS to EFB, July 17, 1898, EFBP, CMC.

On MLN's flirtations: MLN to JD, n.m. n.d., n.d.; There are two undated letters believed to be from the 1870s. These documents were written when Maria was still married to Nichols: MLN to JD, July 19, 1872, JDP, CMC; MLN to "Altsche," November 7, 1881, WFP, CMC; MLN to KER, December 31, 1881, WFP, CMC.

58 "Many Things of Many Kinds," *Daily Currier*, December 7, 1867, 4. Proquest Historical Newspapers (1121524248).

59 Peck, *Book of Rookwood Pottery*, 25.

60 MLS to Annie Roelker AR (Nan-sa), N.m. n.d., n.y., WFP, CMC.

Chapter Two

1 George Ward Nichols, *The Sanctuary: A Story of the Civil War* (New York: Harper and Brothers, 1866), 261, 277.

2 "George Ward Nichols," *A Biographical Cyclopedia and Portrait Gallery with a Historical Sketch of the State of Ohio*, vol. 4 (Cincinnati: Western Biographical Publishing, 1887), 877.

3 Ibid.; "George Ward Nichols," *Dictionary of American Biography* (New York: Charles Scribner's Sons, 1936), *Biography in Context*, accessed December 13, 2014, link. galegroup.com/apps/doc/BT2310006698/BIC1?u=cinc37305&xid=772e7348.

4 Ann Boulton, "The Dealer and Daniel Webster," *Gilcrease Journal* 20, no. 1 (Summer/Fall 2012): 50.

5 George Ward Nichols, "The Indian: What We Should Do with Him," *Harper's New Monthly Magazine* 40, no. 5 (April 1870): 732. Louise Barry, "The New England Emigrant Aid Company Parties of 1855," *Kansas Historical Quarterly* 12, no. 3 (August 1943): 227–268, accessed May 3, 2015, http://www.kancoll.org/khq/1943/43_3_barry.htm. George Ward Nichols, "A Card from George Ward Nichols," *Chicago Tribune*, November 21, 1865, 0–2. Proquest Historical Newspapers (175489803).

6 Catherine Hoover Voorsanger and John Howat, *Art and the Empire City: New York, 1825–1861* (New York: Metropolitan Museum of Art, 2000), x.

7 "Special Notice," *The Crayon* 7, no. 1 (January 1860): 32. JSTOR (25528008).

8 Boulton, "The Dealer and Daniel Webster," 58, 59.

9 Nichols, "A Card from George Ward Nichols"; A. H. Mattox, *A History of the Cincinnati Society of Ex-Army and Navy Officers* (Cincinnati: P. G. Thomson, 1880), 182–183; U.S. Department of War, *A Compilation of the Official Records of the Union and Confederate Armies*, ser. 1, vol. 12 (Washington, DC: Government Printing Office, 1885), 35; Henry Hitchcock, *Marching with Sherman: Passages from the Letters and Campaign Diaries of Henry Hitchcock, Major and Assistance Adjutant General of Volunteers, November 1864–May 1865* (Lincoln, NE: Bison Books, 1995), 113, 147, 220, 221.

10 "The Story of the Great March, Books and Stationery," *Cleveland Leader*, August 3, 1865, Library of Congress, Chronicling America: Historic American

Newspapers site, accessed June 15, 2016, http://chroniclingamerica.loc.gov/lccn/sn83035144/1865-08-03/ed-1/seq-4; George Ward Nichols, "Preface to the Twenty-Second Edition," *The Story of the Great March* (New York: Harper and Brothers, 1865), n.p. J. Henry Harper, *The House of Harper: A Century of Publishing in Franklin Square* (New York: Harper and Brothers, 1912), 243, accessed July 27, 2017, https://hdl.handle.net/2027/hvd.32044058247024.

11 Brian Yothers (Melville expert), email message to Constance Moore, February 12, 2015.

12 "Nichols' Story of the Great March," *North American Review* 102, no. 210 (January 1866): 313.

13 "It is a very reliable description" according to Mark Bradley (Civil War historian) in discussion with Constance Moore, February 19, 2015. See also Wesley Moody, *Demon of the Lost Cause: Sherman and Civil War History* (Columbia: University of Missouri Press, 1984), 36; Michael Grisson, *Southern by the Grace of God* (Gretna, LA: Pelican Publishing, 1989), 538.

14 "The Romance of the War," *Chicago Tribune*, November 24, 1865, 0–4. Proquest Historical Newspapers (175559433).

15 "Cincinnati Woman Genius for Politics Turns the Diplomatic World Topsy-Turvy," *St. Louis Dispatch*, December 23, 1906, A12B. Proquest Historical Newspapers (577651728).

16 Vincent Orlando, "An Historical Study of the Origin and Development of the College of Music of Cincinnati" (PhD diss., University of Cincinnati, 1946), 39; "The Movement of the Army of Georgia Homeward," *CE*, June 1, 1865.

17 "Marriages," *CE*, May 6, 1868.

18 "Townsend's Letter," *Boston Weekly Globe*, September 20, 1885, accessed February 24, 2017, http://pqasb.pqarchiver.com/boston/doc/493217625.html.

19 Descriptions from, respectively, Nellie Van de Grift Sanchez, *The Life of Mrs. Robert Lewis Stevenson* (New York: Charles Scribner's Sons, 1920), 127, accessed December 14, 2014, https://archive.org/details/lifemrsrobertloo2sancgoog; Sidney Maxwell, *Suburbs of Cincinnati: Sketches* (Cincinnati: George E. Stevens, 1870), 70; "Artistic Nooks," *CE*, March 1, 1891.

20 George Ward Nichols, *Art Education Applied to Industry* (New York: Harper and Brothers, 1877), 35.

21 Charles Wyllys Elliott, *The Book of American Interiors, from Existing Houses* (Boston: James R. Osgood, 1876), 88, accessed July 10, 2016, https://archive.org/details/bookofamericaninooelli.

22 Maria was a good cook who taught Clara Chipman Newton the culinary art. See Newton, *Early Days at Rookwood Pottery*, 5.

23 MLS to EFB, December 31, 1899, EFBP, CMC; Maria Longworth Storer, *Theodore Roosevelt the Child; a Sketch, Including Thirty-One Letters from President Roosevelt to Mrs. Bellamy Storer* (London: W. Straker, 1921), 6.

24 Chambrun, *Making of Nicholas Longworth*, 140; MLS to AR (Nan-sa), June 28, 1889, WFP, CMC. "Notes and Personalities," *CE*, December 11, 1882; MLN to JD,

n.m. n.d., n.d., JDP, CMC. There are two undated letters believed to be from the 1870s, when Maria was still married to Nichols. These documents relate how Bellamy was invited to go on an outing. The Harmonic Society is also mentioned in one. George Ward Nichols was president of the organization during this time. Bellamy Storer and Julius Dexter were members. Annie Roelker was a founder of the Women's Exchange. Susan Walker Longworth was a local philanthropist.

25 Manning Force was a justice of the superior court in Cincinnati and Civil War breveted major general. He ran unsuccessfully for the congressional seat of the first district. MLN to MF, September 19, 1876, MFP, CMC.

26 MLN to JD, n.d. m.n, n.y., JDP, CMC. It is believed this letter was sent in 1876 because it is signed "MLN," and the joke described the presidential election of that year.

27 "City Affairs," *Charleston Daily News*, March 21, 1870. Library of Congress, Chronicling America: Historic American Newspapers site, accessed June 29, 2015, http://chroniclingamerica.loc.gov/lccn/sn84026994/1870-03-21/ed-1/seq-3.

28 George Ward Nichols, "Down the Mississippi," *Harper's New Monthly Magazine* 41, no. 246 (November 1870): 835–836. George Ward Nichols, "Six Weeks in Florida," *Harper's New Monthly Magazine* 41, no. 245 (October 1870): 665.

29 Joseph Longworth Nichols was born on November 10, 1870; Margaret Rives Nichols was born on August 18, 1872. See "Joseph Nichols," *Historic Saranac Lake*, accessed August 20, 2015, https://localwiki.org/hsl/Joseph_Nichols; "Photo of Marquis de Chambrun Tomb."

30 The information on Joe and Min's schools and French lessons was taken from Clara de Chambrun's books. She speaks of French lessons for her brother and sisters by Blanche Mathieu. It has been assumed that Joe and Min received French lessons and Min attended the school. See Clara de Chambrun, *Shadows Like Myself* (New York: Charles Scribner's Sons, 1936), 16. Her brother, Nicholas, attended White and Sykes School for boys in Walnut Hills. It is believed Joe attended with his cousin. See Chambrun, *Making of Nicholas Longworth*, 109.

31 Kate Swan McGuirk, "They Can Make Mud Pies," *Detroit Free Press*, April 8, 1894. There are three undated programs, and an invitation to the Nicholses' Masquerade that indicated the month and day, but no year for the event. See Programs, Margaret Rives King Papers (MRKP), CMC; Robert Vitz, *The Queen and the Arts: Cultural Life in Nineteenth-Century Cincinnati* (Kent, OH: Kent State University Press, 1989), 92; MLN to JD, September 19, 1872, JDP, CMC.

32 "George Ward Nichols," *Biographical Cyclopedia*, 877. "Harmonic Society," *CE*, April 20, 1872; "Melodeon Hall," music program, December 17, 1875, Ella Hollister Scrapbook (EHS), CMC.

33 "Nilson and the Harmonic Society," *CE*, February 20, 1871. "The Harmonic Society," *CE*, January 9, 1872. "Under Street Talk," *CE*, September 20, 1885.

34 Jeanne Peterson, "No Angels: The Victorian Myth and the Paget Women," *American Historical Review* 89, no. 3 (June 1984): 689. JSTOR (1856121).

35 Vitz, *The Queen and the Arts Cultural Life*, 8.

36 Catherine Roma, Earl Rivers, Frank Pendle, Karin Pendle, and Craig Doolin, *A City That Sings: Cincinnati's Choral Tradition* (Wilmington, OH: Orange Frazer Press, 2012), 132.

37 The year of the meeting could be any time from 1870 to 1872. Maria stated, "When I was twenty-one." This implies 1870. See MLS, to Otto Kahn (OK), May 1, 1925, Otto Kahn Papers (OKP), Princeton University Library (PUL). Theodore Thomas wrote, "On my next visit, in 1871," in *Theodore Thomas, A Musical Autobiography, Life Work*, vol. 1 (Chicago: A. C. McClurg, 1905), 78–79, accessed April 11, 2017, https://archive.org/details/theodorethomasmo2thomuoft. Louis Thomas believed it "was either October 29, 1871 or November 5, 1871." Louis Thomas, "A History of the Cincinnati Symphony Orchestra to 1931" (PhD diss., University of Cincinnati, 1972), 41. Roma thought the year was 1872. See Roma et al., *A City That Sings*, 132.

The orchestra and choral festivals that are presented annually in Cincinnati are officially called the Cincinnati Music Festival Association. However, Cincinnati May Festival is generally used for advertisement, brochures, and programs. For this book the Cincinnati May Festival will be used since it was not subject to taxes at the time of its inception. It is also what was used at the time on tickets. Steven Sunderman, executive director, Cincinnati Music Festival Association, telephone interview with Constance Moore, June 8, 2015.

38 Pippa Drummond, *The Provincial Music Festival in England, 1784-1914* (Burlington, VT: Ashgate, 2011), 1.

39 Thomas, *A Musical Autobiography*, 78–79.

40 Roma et al., *A City That Sings*, 135; Louis Thomas stated the amount was $30,000. Thomas, "History of the Cincinnati Symphony Orchestra," 41.

41 Thomas, "A History of the Cincinnati Symphony Orchestra," 41. "First Day of the Regatta—The Exposition—Great Music Festival Proposed," *CE*, September 27, 1872. Craig Doolin, "Festival by Committee: The Planning and Performances of the First Cincinnati May Festival of 1873" (PhD diss., Marshall University, 1997), 19.

42 Doolin, "Festival by Committee," 19.

43 Rose Fay Thomas, *Memoirs of Theodore Thomas* (New York: Moffat, Yard, 1911), 73, accessed April 11, 2017, https://archive.org/details/memoirstheodoreoothom-goog.

44 Theodore Thomas (TT) to George Ward Nichols (GWN), January 20, 1873, Cincinnati Musical Festival Association Papers (CMFAP), CMC.

45 Frank Aston, "Foyer Becomes 'Peacock Alley' at Festival," *Cincinnati Post*, May 5, 1931, http://infoweb.newsbank.com.research.cincinnatilibrary.org/resources/doc/nb/image/v2%3A13E376E28E0F8354%40EANX-NB-1677410406BB-596D%402426467-167553100C001532%4012-167553100C001532%40?p=EANX-NB&hlterms=%22Bellamy%20storer%22; Marcellus J. Maxwell (MJM) to GWN, January 26, 1875, Harmonic Society Papers (HSP), CMC.

46 "Twentieth May Festival," *CE*, May 5, 1912.

47 "The Cincinnati Music Festival," *CE*, May 16, 1875.

48 Ashton, "Foyer Becomes 'Peacock Alley' at Festival"; MLN to Francis Force (FF), February n.d,, 1875, Papers of the Women's Art Museum Association (PWAMA), CMC.

49 Chambrun, *Making of Nicholas Longworth*, 145–146.

50 "Random Notes, "*CE*, September 17, 1876.

51 Mrs. L. B. Harrison was the wife of a banker and financier.

52 Elizabeth Perry, "Decorative Pottery of Cincinnati," *Harper's New Monthly Magazine* 62 (May 1881): 834–845; Peck, *Book of Rookwood Pottery*, 4.

53 Newton, *Early Days at Rookwood Pottery*, 9.

54 Clara Chipman Newton attended school with Maria, and worked at Rookwood Pottery for several years. Mary Louise McLaughlin was Maria's chief pottery rival. Jane (Potter Hart) Dodd shared a room with Maria at Frederick Dallas's Hamilton Road Pottery.

55 Newton, *Early Days at Rookwood Pottery*, 14.

56 Mary Sayre Haverstock, Jeannette Mahoney Vance, and Brian Meggitt, *Artists in Ohio: A Biographical Dictionary* (Kent, OH: Kent State University Press, 2000), 385.

57 Quoted in "Rookwood: The Pride of Cincinnati: Sketch of Its History," *CE*, March 8, 1896.

58 The official title of the fair was the International Exhibition of Arts, Manufactures, and Products of the Soil and Mine. See the *Visitor's Guide to the Centennial and Philadelphia Exhibition* (Philadelphia: J. B. Lippincott , 1876), 5.

59 Anita Ellis, *The Ceramic Career of M. Louise McLaughlin* (Athens: Ohio University Press, 2003), 27.

60 Newton says that all the pottery for the tea parties was fired by Maria's teacher Gustav Hartwig. See Newton, *Early Days at Rookwood Pottery*, 15.

61 Anita Ellis, interview with the authors, March 24, 2018.

62 The contribution was 16 percent of the total cost for constructing the building. See Cincinnati Art Museum, *Art Palace of the West* (Cincinnati: Cincinnati art Museum, 1981), 14.

63 Elizabeth Duane Gillespie, *A Book of Remembrance* (Philadelphia: J. B. Lippincott, 1901), 290, accessed December 13, 2014, https://archive.org/details/bookofremembrancoogill.

64 "Centennial Letter," *CE*, July 10, 1876.

65 Charles Wyllys Elliott, "Pottery at the Centennial," *Atlantic Monthly* 38, no. 229 (November 1876): 576, accessed July 26, 2017, https://babel.hathitrust.org/cgi/pt?id=mdp.39076000049606;view=1up;seq=588.

66 Susan Nancy Carter, "Brass and Bronze at the Centennial Exhibition," *Art Journal* 2 (1876): 348. JSTOR (20568986).

67 George Ward Nichols, *Pottery: How It is Made, Its Shapes and Decoration* (New York: G. P. Putnam's Sons, 1878), cover and five drawings initialed "MLN"; see also George Ward Nichols, ed., *The Cincinnati Organ* (Cincinnati: Robert Clarke, 1878), cover, vi, 5, 15, 19, 27, 31, 46, and 82, https://babel.hathitrust.org/cgi/pt?id=pst. 000017289535;view=1up;seq=15. The drawings in the second book are unsigned, but are like the drawings of the other book, so the authors believe Maria was the artist.

68 Anita Ellis, interview with the authors, March 24, 2018.

69 E. Payson Bradstreet, ed., *Golden Jubilee Souvenir Cincinnati Music Hall 1878–1928* (N.p.: n.p., 1928); Robert Vitz, "Im Wunderschönen Monat Mai: Organizing the Great Cincinnati May Festival of 1878," *American Music* 4, no. 3 (Autumn 1986): 324. JSTOR (3051613); Karen Ahlquist, "Playing for the Big Time: Musicians, Concerts, and Reputation-Building in Cincinnati," *Journal of the Gilded Age and the Progressive Era* 9, no. 2 (April 2010): 156; Mishona Collier, "Shaping American Identity through Music: Nationality, Taste, and Power at the Cincinnati May Festival, 1873–1905" (Master's thesis, Carleton University, 2013), 46.

70 "Our May Musical Festival for 1878," *CE*, June 9, 1877.

71 Vitz, *The Queen and the Arts Cultural Life*, 98.

72 "A Big Time in Cincinnati: Opening of the Grandest Temple of Music in America," *CE*, May 15, 1878.

73 Kevin Grace and Tom White, *Cincinnati Revealed: A Photographic Heritage of the Queen City* (Charleston, SC: Arcadia, 2002), 124; Nichols, ed., *The Cincinnati Organ*; *Cincinnati Music Hall 100th Anniversary Program* (N.p: n.p., 1978), n.p.; *Testimonial to Colonel George Ward Nichols by Some of His Fellow Citizens, Cincinnati, April 20, 1882* (Cincinnati: Robert Clarke, 1882), 11; "The Big Organ, *CE*, April 24, 1877.

74 Nichols, ed., *The Cincinnati Organ*, cover, vi, 5, 15, 19, 27, 31, 46, and 82. The drawings in the book are unsigned, but are believed to be done by Maria.

75 Ford and Ford, *History of Cincinnati, Ohio*, 253.

76 Michael Cahall, "Battle for Mount Olympus: The Nichols-Thomas Controversy at the College of Music of Cincinnati," *Queen City Heritage* 53 (Fall 1995): 26.

77 Chambrun, *Cincinnati*, 262.

78 Quoted in Chambrun, *Making of Nicholas Longworth*, 142.

79 GWN to TT, September 22, 1879, College of Music of Cincinnati Papers (CMCP), CMC.

80 "TT Plans," *CE*, May 5, 1879; "Thomas and the New York Philharmonic," *Chicago Tribune*, May 11, 1879, 3. Proquest Historical Newspapers (172058015); "George Ward Nichols: A Talk with the Gentleman About the College of Music and Its Affairs," *CE*, June 2, 1879; "Cincinnati College of Music," *CE*, June 5, 1879; "The Town Talk," *CE*, March 8, 1880.

81 "Nichols vs Thomas: Thomas Speaks," *CE*, March 5, 1880; "Musical Discord in Cincinnati," *New York Times (NYT)*, March 5, 1880; "Inharmonious," *CE*, March 6, 1889; "The Discord," *CE*, March 11, 1880.

82 L. Thomas, "A History of the Cincinnati Symphony Orchestra," 63–66; Holliday, "The Musical Legacy of Theodore Thomas," 200.T. Thomas, *Theodore Thomas, a Musical Biography*, vol. 1, 183. "Exploded," *Cincinnati Daily Star*, March 6, 1880, Library of Congress, Chronicling America: Historic American Newspapers site, accessed June 20, 2015, sitehttp://chroniclingamerica.loc.gov/lccn/sn85025759/1880-03-06/ed-1/seq-5.

83 "Inharmonious," *CE*, March 6, 1880; Thomas, "A History of the Cincinnati Symphony Orchestra," 66.

84 "The Town Talk," *CE*, March 8, 1880; see also "Nichols vs Thomas," *CE*, March 5, 1880.

85 Cahall, "Battle for Mount Olympus," 32, n. 23.

86 "The Discord," *CE*, March 11, 1880.

87 Anton Rubenstein, *Der Thurm zu Babel (Tower of Babel)*, sacred opera, Opus 80, in one act, libretto by Julius Rosenberg, trans. Maria Longworth Storer (N.p.: n.p., n.d.). The opera was to be performed in 1880, but for some reason it was not. See "The Appollos," *Chicago Daily InterOcean*, December 4, 1880, 12, Nineteenth Century U.S. Newspapers, accessed August 29, 1915, http://research.cincinnatilibrary.org:2075/ncnp/newspaperRetrieve.do?sgHitCountType=None&sort=DateAscend&tabID=T003&prodId=NCNP&resultListType=RESULT_LIST&searchId=R1&searchType=BasicSearchForm¤tPosition=1&qrySerId=Locale%28en%2C%2C%29%3AFQE%3D%28tx-%2CNone%2C21%29%22george+ward+nichols%22%3AAnd%3ALQE%3D%28da%2CNone%2C10%2912%2F04%2F1880%24&retrieveFormat=MULTIPAGE_DOCUMENT&userGroupName=cinc37305&inPS=true&-contentSet=LTO&&docId=.

88 "Taking in the Zoo," *CE*, May 24, 1890; "Points about People," *CE*, May 25, 1890; "Random Notes," *CE*, February 18, 1912; "Random Notes," *CE*, March 31, 1912; Thomas, *Memoirs of Theodore Thomas*, 73–74, 348–349.

89 GWN to Parke Godwin (PG), January 20, 1879, Bryant-Godwin Papers (BGP), Manuscript and Archives Division, New York Public Library (MAD, NYPL).

90 MLS to "Altsche," November 7, 1881, WFP, CMC.

91 Maria Longworth Storer, *History of the Cincinnati Musical Festivals and of the Rookwood Pottery* (Paris: Herbert Clark, 1919), n.p.

92 McGuirk, "They Can Make Mud Pies."

93 In 1893, Maria and Louise argued and became estranged over the ownership of the Limoges process. See Ellis, *The Ceramic Career of M. Louise McLaughlin*, 69–70, 73, 103–104; Peck, *Book of Rookwood Pottery*, 47–48. The technique was used by Thomas Wheatley at the Coultry Pottery and by Rookwood employees. See Ellis, *The Ceramic Career of M. Louise McLaughlin*, 65, 78, 94, 126; Peck, *Book of Rookwood Pottery*, 10–12.

94 See "Miss McLaughlin's Ceramics: A Cincinnati Young Lady Suddenly Becomes Famous," *CE*, November 29, 1878; "Cincinnati Ceramics—An Exact Statement as to the Discovery," *CE*, December 3, 1878.

95 Ellis, *The Ceramic Career of M. Louise McLaughlin*, 70.

96 "Cincinnati Industrial Expositions," *Ohio History Central*, accessed September 17, 2015, http://www.ohiohistorycentral.org/w/Cincinnati_Industrial_Expositions?rec=489.

97 "Mrs. Nichols' Pottery," *Cincinnati Daily Gazette*, September 13, 1880.

98 "Art in the Cities," *Art Journal* 6 (1880): 127. JSTOR (20569508); "Art Reception," *Cincinnati Daily Star*, February 24, 1880; "The Art Loan," *CE*, May 20, 1880; "Cincinnati Pottery," *CE*, October 14, 1879.

99 Peck, *Book of Rookwood Pottery*, 8. MLS to OK, May 1, 1925, OKP, PUL. Storer, *History of the Cincinnati Musical Festivals and of the Rookwood Pottery*, n.p.

100 Newton, *Early Days at Rookwood Pottery*, 4. Joseph Gutmann, *Moses Jacob Ezekiel: Memoirs from the Baths of Diocletian*, ed. Stanley F. Chyet (Detroit: Wayne State University Press, 1975), 193.

101 "Activities of the Society Necrology: Mrs. Bellamy Storer," *Bulletin of the American Ceramics Society* 11 (June 1932): 157; "Mrs. Bellamy Storer," *Morning Call*, September 18, 1892, Library of Congress, Chronicling America: Historic American Newspapers site, accessed April 10, 2016, http://chroniclingamerica.loc.gov/lccn/sn94052989/1892-09-18/ed-1/seq-13.

102 Storer, *History of the Cincinnati Musical Festivals and of the Rookwood Pottery*, n.p.

103 Newton, *Early Days at Rookwood Pottery*, 1.

104 Storer, *History of the Cincinnati Musical Festivals and of the Rookwood Pottery*, n.p.; Haverstock, Vance, and Meggitt, *Artists in Ohio*, 193.

105 Peck, *Book of Rookwood Pottery*, 17. "Pottery Industry Jobs Index," *the potteries.com*, accessed July 13, 2015, http://www.thepotteries.org/jobs/index1.htm.

106 Ellis, *The Ceramic Career of M. Louise McLaughlin*, 65, 78, 94, 126; Peck, *Book of Rookwood Pottery*, 10–12.

107 "War among the Potters: T. J. Wheatley Secures a Patent on American Limoges," *Cincinnati Daily Gazette*, October 7, 1880.

108 In 1893, McLaughlin stated in no uncertain terms that she discovered the process. Storer disagreed. Neither McLaughlin nor Wheatley took legal action. Rookwood continued to use the technique. See Peck, *Book of Rookwood Pottery*, 37, 38, 49, 58, 66.

109 "Max Maretzek: Passages of Interest in the Life of a Manager," *CE*, August 23, 1880.

110 "The Opera Festival," *CE*, January 31, 1881. "The Opera Festival: A Rededication of Springer Music Hall," *CE*, February 27, 1881.

111 Chambrun, *Cincinnati*, 264; Chambrun, *Making of Nicholas Longworth*, 131. J. H. Mapleson, *The Mapleson Memoirs*, vol. 1 (Chicago: Belford, Clarke, 1888), 249, accessed March 14, 2016, https://archive.org/details/maplesonmemoirs01mapliala.

112 "Random Notes: Men, Women, and Society," *CE*, March 12, 1882; "Nichols and Maretzek St. Louis Post-Dispatch," *CE*, March 13, 1882.

113 Thomas, "History of the Cincinnati Symphony Orchestra," 470.

114 Vitz, *The Queen and the Arts Cultural*, 122.

115 "Musical Annual Examination of the College of Music," *CE*, June 26, 1885. Today, Cincinnati College of Music is a part of the College-Conservatory of Music at the University of Cincinnati.

116 Chambrun, *Making of Nicholas Longworth*, 120.

117 Newton, *Early Days at Rookwood Pottery*, 10.

118 Mary Blanchard, *Oscar Wilde's America: Counterculture in the Gilded Age* (New Haven, CT: Yale University Press, 1998), 268.

119 Perry, "Decorative Pottery of Cincinnati," 836.

120 Storer, *History of the Cincinnati Musical Festivals and of the Rookwood Pottery*, n.p. Newton, *Early Days at Rookwood Pottery*, 11. "Mrs. Nichols' Pottery," [unknown newspaper], August n.d., 1881, in "Mrs. Dodd's Scrapbook," MRSLA, CAM.

121 "Editor's Easy Chair," *Harper's New Monthly Magazine* 64, no. 382 (April 1882): 730.

122 Newton, *Early Days at Rookwood Pottery*, 6.

123 William Laffan (WL) to Clara Chipman Newton (CCN), April 12, 1882, Clara Chipman Newton Papers (CCNP), CMC; Newton, *Early Days at Rookwood Pottery*, 6.

124 Ibid.

125 "Random Notes," *CE*, February 26, 1882.

126 "Outrageously, he dared to say that the Dayton pottery he had seen was better than Rookwood's." Robert Herron, "Have Lily, Will Travel: Oscar Wilde in Cincinnati," *Bulletin of the Historical and Philosophical Society* 15, no. 3 (July 1957): 232. "The next day in his lecture Mr. Wilde scored the Pottery to the intense amusement of Mrs. [Nichols]." See Newton, *Early Days at Rookwood Pottery*, 7.

127 Peck, *Book of Rookwood Pottery*, 19.

128 Ibid., 18; "The Rookwood Pottery," *Cincinnati Daily Gazette*, October 13, 1881; "Mrs. Nichols' Pottery"; Newton, *Early Days at Rookwood Pottery*, 6, 11.

129 Blanchard, *Oscar Wilde's America*, 268; Peck, *Book of Rookwood Pottery*, 14; "Mrs. Nichols' Pottery"; Edwin Barber, *The Pottery and Porcelain of the United States* (New York: G. P. Putman's Sons, 1893), 295, accessed April 15, 2014, https://archive.org/details/potteryporcelainoobarb.

130 "War among the Potters," *Cincinnati Daily Gazette*, October 7, 1880; "Random Notes," *CE*, September 18, 1881; "Random Notes," *CE*, February 26, 1882; "American Art Chronicle," *American Art Review* 1, no. 12 (October 1880): 552. JSTOR (20559738); Joan Hansen, "Howell and James of London," *Journal of Decorative Arts Society 1850–the Present*, no. 34 (2010): 29. JSTOR (41809422); Newton, *Early Days at Rookwood Pottery*, 2; "Artistic Pottery from Cincinnati," *CE*, September 15, 1884; "Donations in 1882," *Trustees of the Museum of Fine Arts: 7th Annual Report of the Museum of Fine Arts* (Boston: Alfred Mudge and Son, 1883), 13; "Cincinnati Pottery at the Bartholdi Exhibition," *Art Amateur* 10, no. 3 (February 1884):

69–70. JSTOR (25628090). The Gold Medal was awarded for decorated white or tinted ware. See *Report of the Board of Commissioners of the Ninth Cincinnati Industrial Exposition, Held in Cincinnati, Ohio* (Cincinnati: Elm Street Printing , 1881), 180;

131 Nancy Owen, "On the Road to Rookwood: Women's Art and Culture in Cincinnati, 1870–1918," *Ohio Valley History* 1 (Winter, 2001): 17n88.

132 Peck, *Book of Rookwood Pottery*, 40, 74, 95; Owens, "On the Road to Rookwood," 4–18; Nancy Owens, "Marketing Rookwood Pottery: Culture and Consumption, 1883–1913," *Studies in the Decorative Arts*, 4, no. 2 (Spring/Summer 1997): 2–21. JSTOR (40662580).

133 Peck, *Book of Rookwood Pottery*, 25, 27, 28, 35; Carol Boram-Hays, *Bringing Modernism Home: Ohio Decorative Arts, 1890–1960* (Athens: Ohio University Press, 2005), 208; Owens, "Marketing Rookwood Pottery," 2.

134 Cunningham, *Owl's Nest*, 282.

135 "The Concerts," *CE*, December 12, 1881; "Prevention of Cruelty." *CE*, January 5, 1884; "S.P.C.A. Regular Meeting Yesterday—Standing Committees for the Ensuing Year," *CE*, January 5, 1884; "Fresh Air," *CE*, July 31, 1884; "The Patroness," *CE*, January 16, 1885; "S.P.C.A.," *CE*, January 20, 1886; Alden Monroe, "Effect to Causes: The Evolution of a Social Agency," *Queen City Heritage* 37, no. 3 (Fall 1979): 214; "The Fair," *The Kitchen Garden* 1, no. 2 (December 20, 1883): 16, https://hdl.handle.net/2027/nyp.33433006783033?urlappend=%3Bseq=24; "The Children's Hospital of the Protestant Episcopal Church," *The Kitchen Garden* 2, no. 5 (July, 1885): 34, https://hdl.handle.net/2027/nyp.33433006783033?urlappend=%3Bseq=94.

136 Maria Longworth Storer, *The Villa Rossignol; or, The Advance of Islam* (St. Louis: B. Herder, 1918), 59.

137 "The Concerts," *CE*, December 12, 1881; "Prevention of Cruelty," *CE*, January 5, 1884; "S.P.C.A. Regular Meeting Yesterday—Standing Committees for the Ensuing Year," *CE*, January 5, 1884; "Fresh Air," *CE*, July 31, 1884; "The Patroness," *CE*, January 16, 1885; "S.P.C.A.," *CE*, January 20, 1886; Alden Monroe, "Effect to Causes: The Evolution of a Social Agency," *Queen City Heritage* 37, no. 3 (Fall 1979): 214; "The Fair," *Kitchen Garden* 1, no. 2 (December 20, 1883): 16, https://hdl.handle.net/2027/nyp.33433006783033?urlappend=%3Bseq=24; "The Children's Hospital of the Protestant Episcopal Church," *Kitchen Garden* 2, no. 5 (July 1885): 34, https://hdl.handle.net/2027/nyp.33433006783033?urlappend=%3Bseq=94.

138 "Home for Sick Children," *Medical Bulletin of the University of Cincinnati* 1, no. 3 (February 1992): 45.

139 "Help for the Needy: The SPCA and the Home for Sick Children," *CE*, November 10, 1883; "Local Brevities," *CE*, December 16, 1883; "Local Brevities," *CE*, July 8, 1884. *Reports of the Home for Sick Children, October 1, 1883 to October 1, 1887* (N.p.: n.p., n.d.), 4, 11, 18; Laura Logan, "Nursing Education in Cincinnati," *University of Cincinnati Medical Bulletin* 1, no. 1 (November 1920): 70.

140 *Reports of the Home for Sick Children*, 4.

141 Ibid., 21.

142 "Random Notes," *CE*, February 8, 1880; "Mr. Hartdegen's Recitals," *CE*, November 19, 1880; "Professor Adolf Hartdegen," *CE*, April 22, 1881.

143 Peck, *Book of Rookwood Pottery*, 53.

144 George Ward Nichols owned his papers, his clothes, and some paintings and other art objects. See Joseph Longworth, Will, March 31, 1883, LFP.

145 "Houses and Lands," CE, May 18, 1884.

146 "Houses and Lands," *CE*, May 18, 1884; "Nichols Mansion," *CE*, June 14, 1885; MLS to EFB, October n.d., 1886, EFBP, CMC.

147 Rose Angela Boehle, *Maria Longworth: A Biography of Maria Longworth* (Dayton, OH: Landfall Press, 1990), 61.

148 No divorce decree for George Ward Nichols and Maria Longworth Nichols was found at the Clerk of Courts, Hamilton County Courthouse, July 6, 2015. "Won by His Wife," *Saint Paul Daily Globe*, November 23, 1890, Library of Congress, Chronicling America: Historic American Newspapers site, accessed April 15, 2014, http://chroniclingamerica.loc.gov/lccn/sn90059522/1890-11-23/ed-1/seq-7.

149 M. Louise McLaughlin (MLMcL) to Ross Purdy (RP), February 25, 1938, M. Louise McLaughlin Papers (MLMcLP), CMC.

150 GWN to (Steele MacKaye) SMacK, August 12, 1884, Steele MacKaye Family Papers (SMacKFP), CMC; "Random Notes," *CE*, July 13, 1884.

151 "George Ward Nichols: Sudden Death of the President of the College of Music," *CE*, September 16, 1885. Maria and the children were contacted and returned home. See JPdeC interview by Sister Rose Angela Boehle, May 19, and May 23, 1988, Rose Angela Boehle Papers, USCA.

152 "Last Impressive Scene," *CE*, September 16, 1885; "George Ward Nichols: Sudden Death of the President of the College of Music."

153 Longworth and other family members are buried around Nicholas Longworth in Section 24, while George Ward Nichols was laid to rest in Section 70. The same type of headstone, a large boulder, was used for Nichols as found at the Longworth graves. See "Longworth, Nichols, Genealogy Search Listing," *Spring Grove*, accessed July 4, 2015, http://www.springgrove.org/geneology-listing. aspx?firstname=&lastname=Longworth&cemetery=SPRINGGROVE; "Nichols, George Ward, Genealogy Search Listing," *Spring Grove*, accessed July 4, 2015, http://www.springgrove.org/geneology-listing.aspx?firstname=&lastname=nichols&cemetery=SPRINGGROVE.

154 On Christmas, she held a party. "Random Notes," *CE*, December 27, 1885; "S.P.C.A," *CE*, January 20, 1886.

155 MLS to the Probate Judge, September 21, 1885 with George Ward Nichols Will, 1885, no. 30235, Hamilton County, Office of the Probate Court, Cincinnati, Ohio. Subscription List September 1885, CMCP, CMC. "Memorial Services in Honor of George Ward Nichols at the Odeon, March 4, 1887," University of Arizona, Tucson, AZ. *Worldcat*, accessed July 4, 2015, http://www.worldcat.org/title/memorial-services-in-honor-of-george-ward-nichols-at-the-odeon-friday-evening-march-4-1887/oclc/23681503.

156 "On Dit," *CE*, January 16, 1886; "Random Notes," *CE*, January 17, 1886; "The Latest Social Sensation," *CE*, March 20, 1886.

157 MLMcL to RP, March 9, 1938, CCNP, CMC.

158 Nichols, *The Sanctuary*, 261.

Chapter Three

1 "Social Sensation," *Cincinnati Evening News*, n.d., in Longworth Scrapbook on *Maria L. Storer and the Vatican Affair*, 315, CMC.

2 Photo of Marquis de Chambrun Tomb.

3 The following presidents knew Bellamy Storer Sr.: John Quincy Adams, William Henry Harrison, and Abraham Lincoln. See "Bellamy Storer," in *The National Cyclopaedia of American Biography*, vol. 11 (New York: James T. White, 1901), 338, https://babel.hathitrust.org/cgi/pt?id=uc1.c3545635;view=1up;seq=346.

4 Francis Henry Lincoln, Harvard College Class of 1867, Secretary's Report, No. 6 (Boston: Alfred Mudge and Sons, 1879), 30.

5 Storer was "built like an athlete." See "A Lenten Bride," *CE*, March 21, 1886; Eric Miklich, "1867–1870 Cincinnati Club; AKA 'Red Stockings' Tour," *19C Baseball*, accessed May 9, 2018, http://www.19cbaseball.com/tours-1867-1870-cincinnati-red-stockings-tour.html.

6 Madeleine Stern, "Louisa M. Alcott: An Appraisal," *New England Quarterly* 22, no. 4 (December 1949): 481. JSTOR (361945); Chambrun, *The Making of Nicholas Longworth*, 140.

7 Francis Henry Lincoln, *Harvard College, Class of 1867, Secretary's Report, no. 7* (Boston: Alfred Mudge and Sons, 1882), 31.

8 BS to Isabella Stewart Gardner (ISG), January 13, 2015, Isabella Stewart Gardner Museum (ISGM); see also BS to Elizabeth Cameron (EC), n.d, Miles Cameron Correspondence (MCC), LOC; MLN to JD, N.m. n.d., n.y., JDP, CMC. There are two undated letters believed to be from the 1870s. These documents were written when Maria was still married to Nichols. MLS to "Altsche," November 7, 1881, WFP, CMC.

9 See "Bellamy Storer," *The National Cyclopaedia of American Biography*, 338.

10 "Baseball," *CE*, March 6, 1881; Miklich, "1867–1870 Cincinnati Club."

11 Joseph P. Smith, ed., *History of the Republican Party in Ohio, and Memoirs of Its Representative Supporters*, vol. 2 (Chicago: Lewis Publishing, 1898), 504.

12 Ibid.; Andrew Cayton, *Ohio: The History of the People* (Columbus: Ohio State University Press, 2002), 198; Kevin Kern and Gregory Wilson, *Ohio: A History of the Buckeye State* (Hoboken, NJ: Wiley Blackwell, 2013), 249.

13 "Personnel of the Republican Ticket," *CE*, March 19, 1875; "The Elections," *CE*, April 7, 1875.

14 "Political," *Cincinnati Daily Star*, August 19, 1879.

15 "Local Politics," *CE*, August 9, 1876.

16 "Political Notes, *CE*, March 4, 1877; "Republican City Convention," *CE*, March 24, 1877.

17 MF to RBH, February 23, 1889, MFFC, RBHPC.

18 "Still They Come," *CE*, December 29, 1882.

19 "Other 5—No Title," *CE*, December 29, 1882. Memberships Record of the Harmonic Society, n.p., HSP, CMC. "Old Harvard Club," *CE*, February 6, 1881; "Harvard Club Dinner," *CE*, December 17, 1885.

20 MLN to JD, n.d., JDP, CMC. There are two undated letters believed to be from the 1870s. These documents were written when Maria was still married to Nichols.

21 MLS to "Altsche," November 7, 1881, WFP, CMC.

22 Maria Longworth Nichols, 1885, Manufacture of Pottery. U.S. Patent 361231, filed December 21, 1885, and issued April 12, 1887.

23 "Matters Diplomatic," *The International: An Illustrated Monthly Magazine* 3, no. 1 (July 1897): 82, https://hdl.handle.net/2027/chi.79258330?urlappend=%3Bseq=90.

24 Jean François de Chambrun in discussion with the authors, September 13, 2014.

25 "Random Notes," *CE*, December 27, 1885.

26 "Society Talks of a Notable Engagement on the East Hill," *CE*, January 16, 1886; "Random Notes," *CE*, January 24, 1886.

27 "The Bride," *CE*, January 24, 1886. "The Latest Social Sensation," *CE*, March 20, 1886. "Social Sensation," *Cincinnati Evening News*, March 20, 1886.

28 "May Festival," *CE*, April 6, 1886; "S. P. C. A.," *CE*, January 20, 1886; "The Day Nursery," *CE*, February 14, 1886.

29 "Japanese Pottery," *CE*, January 25, 1886; Dorothy Wayman, *Edward Sylvester Morse: A Biography* (Cambridge, MA: Harvard University Press, 1942), 306; "Yum-Yum," *CE*, March 14, 1886; Kenneth Trapp, "Rookwood and the Japanese Mania," *Cincinnati Historical Society Bulletin* 39 (Spring 1981): 63.

30 "A Lenten Bride," *CE*, March 21, 1886; George Thayer, *The First Congregational Church of Cincinnati* (Cincinnati: Ebbert and Richardson, 1917), 44, accessed July 27, 2017, https://babel.hathitrust.org/cgi/pt?id=hvd.32044086422193;view=1up;s eq=52.

31 Storer, "Maria Longworth Storer," in *Some Roads to Rome in America*, 460–461.

32 Chambrun, *Making of Nicholas Longworth*, 140.

33 MLS to Marie Thompson Rives (MTR), April 28, 1886, James H. Thompson Papers (JHTP), CMC.

34 "Random Notes," *CE*, May 30, 1886; "Points about People," *CE*, November 4, 1886.

35 MLS to EFB, November 4, 1888, EFBP, CMC.

36 MLS to EFB, July 1, 1886, EFBP, CMC.

37 Christopher Endy, "Travel and World Power: Americans in Europe," *Diplomatic History* 22, no. 4 (Fall 1998): 570, JSTOR (24913627).

38 Boehle incorrectly identified the date of the memorial service as March 4, 1886, rather than March 4, 1887. See Boehle, *Maria: A Biography of Maria Longworth*, 82; Jacob D. Cox, *Memorial Services in the Honor of George Ward Nichols at the Odeon, Friday Evening March 4, 1887* (Cincinnati: N.p., n.d.), CMC.

39 "May Festival," *CE*, April 6, 1886; "Random Notes," *CE*, April 25, 1886.

40 Peck, *Book of Rookwood Pottery*, 9–10. Roger Austen, *Genteel Pagan: The Double Life of Charles Warren Stoddard* (Amherst: University of Massachusetts Press, 1991), 114. Charles Stoddard (CS) to Daniel (DH), November 15, 1887, University of Notre Dame Archives Calendar, accessed September 25, 2015, http://www.archives. nd.edu/cgi-bin/calindex.pl?keyword=storer.

41 Sanchez, *The Life of Mrs. Robert Louis Stevenson*, 129.

42 "Historic Documents, Books Donated to St. John's College," *Annapolis Evening Capital*, July 21, 1979, 7, Newspaper Archive, accessed June 21, 2016, https:// newspaperarchive.com/annapolis-capital-jul-21-1979-p-7/?tag=rowland+mor-gan&rtserp=tags/?psi=49&pci=7&pf=rowland&pl=morgan/ news.

43 MLS to Louise Taft (LT), March 30, 1886, WHTP, LOC; "History of the Cincinnati Kindergarten Association," *OhioLINK Finding Aid Repository*, accessed November 13, 2015, http://ead.ohiolink.edu/xtf-ead/view?docId=ead/OhCi-UAR0075.xml;chunk.id=bioghist_1;brand=default.

44 "May Festival," *CE*, April 6, 1886.

45 Rubenstein, *Der Thurm zu Babel*. The opera was to have been performed in 1878, but for some reason it was not. See "The Appollos," *Chicago Daily InterOcean*, December 4, 1880. It was presented in 1886. See "Repertoire by Composer, 1873–Present, Festival History," *May Festival*, accessed August 29, 2015, http:// www.mayfestival.com/pdfs/Repertoire-thru2015.pdf.

46 See BS to Joseph H. Gest (JHG), February 25, 1890, MRSLA, CAM. Although this letter was written nearly four years after the time referred to the statement ("I am seldom at home except Sundays"), it was a typical work schedule for him.

47 "Superior Court Candidates," *CE*, February 17, 1887; "Political Strife: The Pulling and Hauling Become Intense," *CE*, March 13, 1887.

48 Maria Longworth Storer, "How Theodore Roosevelt Was Appointed Assistant Secretary of the Navy," *Harper's Weekly* 56, no. 293 (June 1, 1912): 8.

49 Maria Longworth Storer, *In Memoriam Bellamy Storer, With Personal Remembrances of President McKinley, President Roosevelt, and John Ireland, Archbishop of St. Paul* (Boston: Merrymount Press, 1923), 17.

50 Margaret Leech, *In the Days of McKinley* (New York: Harper and Brothers, 1959), 28; "Ida Saxton McKinley," *The White House*, accessed November 25, 2015, https://www.whitehouse.gov/1600/first-ladies/idamckinleyida; Sandra

Quinn-Musgrove and Sanford Kanter, *America's Royalty: All the President's Children* (Portsmouth, NH: Greenwood, 1995), 147.

51 Kern and Wilson, *Ohio: A History of the Buckeye State*, 254. Zane Miller, "Boss Cox's Cincinnati: A Study in Urbanization and Politics, 1880–1914," *Journal of American History* 54 (March 1968): 823–838. JSTOR (1918072).

52 Peck, *Book of Rookwood Pottery*, 37.

53 MLS to AR (Nan-sa), August 8, n.y., WFP, CMC. There are three letters written to Annie Roelker when the Storers were vacationing on the east coast. One refers to the "second year" of the marriage. The authors contend these letters were all sent in 1887 since the topics of discussion were similar.

54 Peck, *Book of Rookwood Pottery*, 142–148.

55 *Circular and Fourth Annual Catalogue of the Art Academy of Cincinnati, 1888–1889* (Cincinnati: Woodrow, Baldwin, 1889), 27; *Circular and Sixth Annual Catalogue of the Art Academy of Cincinnati, 1890–1891* (Cincinnati: C. F. Bradley, 1890), 27.

56 Estill Curtis Pennington, *Lessons in Likeness: Portrait Painters in Kentucky and the Ohio River Valley, 1802–1920* (Lexington: University Press of Kentucky, 2011), 71.

57 "At the Art School," *Cincinnati Tribune*, June 1, 1895.

58 "The Work of Elizabeth Nourse," *Commercial Tribune*, August 23, 1896.

59 "The Cincinnati Art School and Foreign Scholarships," *Cincinnati Commercial Gazette*, March 7, 1890.

60 The school was first governed by the University of Cincinnati and called the McMicken School of Drawing and Design. See "Art School of Cincinnati: Preparing for the Opening of the Old School of Design under New Auspices," *CE*, August 14, 1884; "Art Academy History," *Art Academy of Cincinnati*, accessed on November 11, 2015, http://www.artacademy.edu/about-aac/history/history.php; Tuliza Fleming, "Thomas Satterfield Noble (1835–1907): Reconstructed Rebel" (PhD diss., University of Maryland, 2007), 92n99, accessed on June 5, 2015, http://drum.lib.umd.edu/bitstream/1903/7152/1/umi-umd-4493.pdf.

61 "The New York Tribune of Tuesday Says," *CE*, April 30, 1874; "The Pioneers," *CE*, July 5, 1882.

62 *Reports of the Home for Sick Children*, 20.

63 "About Cincinnati Children's," *Cincinnati Children's*, accessed November 4, 2015, http://www.cincinnatichildrens.org/about/history/.

64 "The Baby's Home," *CE*, May 8, 1887.

65 Samuel Batchelder, *Secretary's Report Harvard College Class of 1893, no. 3* (Boston: Rockwell and Churchill Press, 1903), 152.

66 "The Young Folks Made Happy," *CE*, January 22, 1888.

67 "Great Work," *CE*, January 21, 1888; "A Horse Ambulance," *CE*, July 19, 1884; "Good Work," *CE*, May 31, 1890.

68 "A Week of Song," *CE*, May 21, 1888.

69 MLS to AG, n.d., n.m., 1889, MRSLA, CAM.

70 Quoted in Pennington, *Lessons in Likeness*, 90.

71 MLS to AG, n.d., n.m., 1889, MRSLA, CAM.

72 MLS to EFB, July 6, 1888, EFBP, CMC; Points about People," *CE*, September 5, 1888; "In Society," *CE*, January 30, 1889.

73 MLS to EFB, November 4, 1888, EFBP, CMC.

74 "In Society," *CE*, January 30, 1889; "Mrs. Bellamy Storer," *CE*, March 13, 1889. "A Brother's Kindness," *CE*, April 6, 1889.

75 MF to RBH, February 23, 1889, MFFC, RBHPC. MLS to AR (Nan-sa), June 28, 1889, WFP, CMC.

76 MLS to EFB, June 2, 1889, EFBP, CMC.

77 "Timeline for Glasses," *Museum of Vision*, accessed October 2, 2015, http://www.museumofvision.org/exhibitions/?key=44&subkey=4&relkey=35#1900s.

78 "Men and Things About Town," *CE*, June 1, 1889.

79 Peck, *Book of Rookwood Pottery*, 39.

80 MLS to AR (Nan-sa), June 28, 1889, WFP, CMC.

81 Charles Goss, *Cincinnati, the Queen City*, 381; "A Worthy Project: The Cincinnati Training School for Nurses," *CE*, November 18, 1888.

82 Peck, *Book of Rookwood Pottery*, 40, 42–43.

83 Jill Conway, "Women Reformers and American Culture," *Journal of Social History* 5 (Winter 1971–72): 168. JSTOR (3786409).

84 Ellis, *Rookwood and the American Indian*, 74.

85 "The Slate," *CE*, March 4, 1890. This was not the only board in Cincinnati for which Maria was nominated. Sometime in the early 1890s, the superintendent of the Chamber of Commerce nominated her as an honorary member of the organization. Again, the proposed action was turned down. Charles Murray, *Life Notes of Charles B. Murray, Journalist and Statistician* (Cincinnati: N.p., 1915), 98, accessed December 4, 2015, https://play.google.com/books/reader?id=Qh-kuAAAAYAAJ.

86 "No Woman. Art Museum Stockholders Refuse to Elect Mrs. Storer," *Cincinnati Commercial Gazette*, March 4, 1890; J.R.S., "The Art Museum: Here Is Somebody Who Doesn't Like the Management," *Cincinnati Commercial Gazette*, March 7, 1890.

87 "The Cincinnati Art School and Foreign Scholarships," *Cincinnati Commercial Gazette*, March 7, 1890.

88 "A New Art School Mrs. Storer's Plans for a Rival to the Art Academy," *Cincinnati Commercial Gazette*, May 18, 1890.

89 MLS to Walter Sipe, March 30, 1930, Cincinnati Art Museum Archive, Mary R. Schiff Library and Archives.

90 Ellis, *Rookwood and the American Indian*, 75; Anita Ellis interview with authors, March 24, 2018.

91 Cincinnati Museum Association, *Tenth Report, for the Year Ending December 31, 1890*, in *Annual Reports*, vols. 6–10 (Cincinnati: C. F. Bradley, 1891), 10, accessed December 4, 2015, https://books.google.com/books?id=qHZFAQAAMAAJ.

92 "Under Favorable Auspices: The New Painting Begins Its Work," *Cincinnati Star Times*, October 22, 1890.

93 Anita Ellis interview with authors, March 24, 2018.

94 Moses Ezekiel was a Civil War soldier and sculptor who lived and worked in Italy most of his life, but spent time and exhibited his sculpture in Cincinnati. The authors speculate that the 1885 commissioning date stated in Ezekiel's memoir was incorrect, since Maria did not marry Bellamy until 1886. See Gutman, *Moses Jacob Ezekiel*, 192–193.

95 "Will Accept," *CE*, September 15, 1890.

96 Storer, "Maria Longworth Storer," in *Some Roads to Rome in America*, 460–461.

97 There were many books about Cardinal Newman in the Ursulines of Cincinnati Archive that were believed to have belonged to the Storers.

98 Bellamy ran for city solicitor in 1875 and 1877. "Personnel of the Republican Ticket," *CE*, March 19, 1875; "The Elections," *CE*, April 7, 1875; "Political Notes," *CE*, March 4, 1877; "Republican City Convention," *CE*, March 24, 1877. Won by His Wife," *Saint Paul Daily Globe*, November 21, 1890, Library of Congress, Chronicling America: Historic American Newspapers site, accessed April 15, 2014, http://chroniclingamerica.loc.gov/lccn/sn90059522/1890-11-23/ed-1/seq-7. Kevin Kern and Gregory Wilson, *Ohio: A History of the Buckeye State*, 249.

99 "The Slate," *CE*, September 19, 1890.

100 "Congress in Session," *Salt Lake Herald*, December 5, 1890, Library of Congress, Chronicling America: Historic American Newspapers site, accessed April 15, 2014, http://chroniclingamerica.loc.gov/lccn/sn85058130/1890-12-05/ed-1/seq-6.

101 "Won by His Wife."

102 Ibid.

103 "Personals," *CE*, October 10, 1890.

104 Maria quoted in "Won by His Wife." Miller, *Boss Cox's Cincinnati*, 81; Robert Remini, *The House: The History of the House of Representatives* (Washington, DC: Library of Congress, 2007), 253; "Won by His Wife."

105 The Twentieth Amendment to the Constitution, ratified on January 23, 1933, stated, "[T]he terms of Senators and Representatives [shall end] at noon on the 3rd of January." "Constitution of the United States," *Charters of Freedom*, accessed November 16, 2015, http://www.archives.gov/exhibits/charters/constitution_amendments_11-27.html.

106 "At the Ball," *CE*, December 27, 1890; "Random Notes," *CE*, December 28, 1890.

107 MLS to EFB, March 2, 1891, EFBP, CMC. "Ida Saxton McKinley," *The White House*.

108 The address was 1629 Massachusetts NW, Washington, DC. It was "an English

basement house, with an artistically-carved and designed front of white marble." See "Cincinnati's Representatives," *CE*, March 20, 1892.

109 Maria Longworth Storer, "Maria Longworth Storer, Cincinnati, Ohio," in *Beyond the Road to Rome*, ed. Georgina Curtis (St. Louis: B. Herder, 1914), 376.

110 For the physical description of Archbishop John Ireland, see O'Connell, *John Ireland and the American Catholic Church*, 88. Quotation from Julia Foraker, *I Would Live It Again* (New York: Harper and Brothers, 1932), 248.

111 Storer, "Maria Longworth Storer," *Some Roads to Rome in America*, 461.

112 In her conversion memoir, Maria stated that the Storers met Ireland when they attended a service at Saint Augustine Catholic Church, after coming to live in Washington in October 1891. The authors believe her memory was faulty. First, the Storers did not arrive until late November 1891 according to newspaper accounts. Ireland did not preach a sermon that year. When he "said mass" (i.e., performed the religious service, and preached from the pulpit), it was big news in May 1890. He preached to the predominately African American congregation at Saint Augustine Catholic Church. This was considered "a stinging indictment of Catholic segregationists" (O'Connell, *John Ireland*, 268). That is why the information is included here in the couple's house-hunting time in the spring of 1890. See also "Archbishop Ireland on Social Equality," *Sacred Heart Review*, May 24, 1890.

113 *The Annual American Catalogue, 1891* (New York: Office of the Publishers' Weekly, 1892), 185, accessed December 4, 2015, https://books.google.com/books?id=cj_QAAAAMAAJ.

114 "In Society," *CE*, Oct 24, 1891.

115 "The Week in Art Circles," *CE*, October 20, 1912.

116 "People Talked About," *CE*, May 3, 1891; "Points About People," *CE*, September 17, 1891.

117 MLS to JHG, November 17, 1891, MRSLA, CAM.

118 MLS to Melvin E. Ingalls (MEI), October 27, 1891, MRSLA, CAM.

119 Mrs. Garret (Jennie) Hobart, *Memories* (Paterson, NJ: Carroll Hall, 1930), 49, https://babel.hathitrust.org/cgi/pt?id=uc1.$b727615;view=1up;seq=11.

120 "Society News," *Sunday Herald and Weekly National Intelligencer*, November 29, 1891.

Chapter Four

1 Frank George Carpenter and Frances Carpenter, eds., *Carp's Washington* (New York: McGraw-Hill, 1960), 13.

2 Remini, *House of Representatives*, 254.

3 Louis Coolidge and James Reynolds, *Show at Washington* (Washington, DC: Washington Publishing, 1894), 170, accessed December 14, 2014, https://archive.org/details/showatwashingtonoocool.

4 "Storer Will Be Missed," *CE*, November 12, 1894.

5 MLS to EFB, March 2, 1891, EFBP, CMC.

6 Hobart, *Memories*, 49.

7 CS to DH, December 27, 1891, University of Notre Dame Archives Calendar, accessed September 25, 2015, http://www.archives.nd.edu/cgi-bin/calindex. pl?keyword=storer; "Necrology Charles Warren Stoddard," *Catholic University Bulletin* 15, no. 6 (June 1909): 599, accessed December 14, 2014, https://archive. org/details/CatholicUnivBulletinV15.

8 MLS to MF, January 13, 1892, MFFC, RBHPC; MLS to MF, December 26, 1891, and January 4, 1892, MFFC, RBHPC.

9 "Steve: No Longer Received the Whispered Confidence of James G. Blaine," *CE*, December 14, 1891.

10 U.S. Department of Justice, "About the Office," accessed December 15, 2015, http://www.justice.gov/osg/about-office-1; "Judge Taft," *CE*, April 3, 1892.

11 "Health and Medical History of William Taft," *Doctor Zebra*, accessed December 15, 2015, http://www.doctorzebra.com/prez/g27.htm. Doris Kearns Goodwin, *The Bully Pulpit: Theodore Roosevelt, William Howard Taft, and the Golden Age of Journalism* (New York: Simon and Schuster, 2013), Kindle e-book, chapter 4; Richard Oulahan, "William H. Taft as a Judge on the Bench," *American Monthly Review of Reviews* 36, no. 2 (August 1907): 208, accessed August 15, 2016, https://hdl.han-dle.net/2027/mdp.39015027769697?urlappend=%3Bseq=229.

12 Edmund Morris, "Introduction," in *The Seven World of Theodore Roosevelt*, by Edward Wagenknecht (Guilford, CT: Lyon Press, 2009), viii.

13 MLS to JI, January 4, 1907, JIP, MNHS; Storer, *Theodore Roosevelt the Child*, 11.

14 Alice Roosevelt Longworth, *Crowded Hours: Reminiscences of Alice Roosevelt Longworth* (New York: Charles Scribner's Sons, 1933), 125.

15 On Hay, see John Talliaferro, *All the Great Prizes: The Life of John Hay from Lincoln to Roosevelt* (New York: Simon and Schuster, 2013), 11, 12. On Lodge, see Thomas Ford, review of *The Gentleman for Massachusetts*, by Karl Schriftgiesser, *American Historical Review* 50, no. 2 (January 1945): 363. JSTOR (1842399). Don Cameron was a senator from Pennsylvania. See "Don Cameron Dies," *NYT*, August 31, 1918. See also Patricia O'Toole, *Five of Hearts: An Intimate Portrait of Henry Adams* (New York: Simon and Schuster, 1990), 92.

16 On the Hay-Cameron affair, see O'Toole, *Five of Hearts*, 217. BS to EC, N.m. n.d., n.y., MCC, LOC.

17 "New Year's in Washington," *Washington Sun*, January 2, 1892, Library of Congress, Chronicling America: Historic American Newspapers site, accessed April 15, 2014, https://chroniclingamerica.loc.gov/lccn/sn83030272/1892-01-02/ed-1/ seq-5; "College Boys to Sing," *Washington Evening Star*, December 25, 1893, Library of Congress, Chronicling America: Historic American Newspapers site, accessed April 15, 2014, https://chroniclingamerica.loc.gov/lccn/sn83045462/1893-12-25/ ed-1/seq-7.

18 Storer, "Maria Longworth Storer," *Some Roads to Rome in America*, 460–461.

19 Storer, "Maria Longworth Storer," *Some Roads to Rome in America*, 461.

20 W.J.H. Traynor, "The Aims and Methods of the A.P.A.," *North American Review* 159, no. 452 (July 1894): 67–68. JSTOR (25103366).

21 "Papal States," *Encyclopedia Britannica*, accessed December 6, 2015, http://www.britannica.com/place/Papal-States.

22 The voters did not directly elect senators until the Seventeenth Amendment was passed in 1913.

23 John Sherman was General William Tecumseh Sherman's brother.

24 Quoted in "Sherman Will Win," *Indianapolis Journal*, January 4, 1892.

25 "Warfare," *CE*, January 24, 1892.

26 Caroline brought the china-painting instructor from Indiana to Washington because she was serious about growing as an artist. See "C-Span First Ladies Caroline Harrison," *C-SPAN* video, June 14, 2014, accessed May 7, 2016, http://firstladies.c-span.org/FirstLady/25/Caroline-Harrison.aspx.

27 "Entertained by the President," *NYT*, March 19, 1892. Gilson Willets, *Inside History of the White House: The Complete History of the Domestic and Official Life in Washington of the Nation's Presidents and Their Families* (New York: Christian Herald, 1908), 72, accessed December 14, 2014, https://archive.org/details/insidehistoryofwwill. Hobart, *Memories*, 34.

28 Lucy Steele, "Dining at the White House," *Good Housekeeping* 10, no. 9 (March 1890): 197, 198. https://babel.hathitrust.org/cgi/pt?id=mdp.39015024013974;view=1up;seq=211; Waldon Fawcett, "The White House Kitchen," *American Kitchen Magazine* 16, no. 6 (March 1902): 210, accessed July 27, 2017, https://hdl.handle.net/2027/uiug.30112088797490?urlappend=%3Bseq=218.

29 "Presents from Mrs. Storer," *CE*, October 24, 1890.

30 For Mrs. Harrison, see "General News," *Indianapolis Journal*, February 9, 1890, Library of Congress, Chronicling America: Historic American Newspapers site, accessed April 15, 2014, http://chroniclingamerica.loc.gov/lccn/sn95047222/1917-07-24/ed-1/seq-1/; For Mrs. McKinley, see "Random Notes," *CE*, July 25, 1897; For Mrs. Roosevelt, see Juliet Frey, ed., *Theodore Roosevelt and His Sagamore Hill Home* (Oyster Bay, NY: National Park Service, 2007), 84, n. 64., accessed on July 19, 2016, http://www.nps.gov/sahi/parkmgmt/upload/SAHI-Historic-Resource-Study-2007-Final.pdf; For Mrs. Taft see "Art Table for Mrs. Taft, Gift of Mrs. Storer," *St. Louis Post*, April 16, 1909. Proquest Historical Newspapers (579721633).

31 The Rev. Robert Hugh Benson was a member of the British Anglican clergy who converted to Catholicism. Storer, "Maria Longworth Storer," in *Beyond the Roads of Rome*, 380. See also Anne Rose, "Some Private Roads to Rome: The Role of Families in American Victorian Conversions to Catholicism," *Catholic Historical Review* 85, no. 1 (January 2001): 55; Lincoln Mullen, "The Contours of Conversion to Catholicism in the Nineteenth Century," *U.S. Catholic Historian* 32, no. 2 (Spring 2014): 1-27.

32 "[Converts] pioneered in several areas of Catholic life, providing the first woman to win Notre Dame's Laetare Medal (Eliza Allen Starr), the first woman to get a doctorate from Villanova (Elizabeth Kite), the first woman columnist in a Catholic journal (Katherine Burton), the founder of the Catholic Worker Movement (Dorothy Day), and the first woman president of a Catholic scholarly association (Eva Ross)." See Patrick Allitt, "American Women Converts and Catholic Intellectual Life," *U.S. Catholic Historian* 13, no. 1 (Winter 1995): 59. JSTOR (25154049); Allitt, *Catholic Converts*, 127–157; Maura Jane Farrelly, *Anti-Catholicism in America, 1620-1860* (New York: Cambridge University Press, 2018), xii.

33 Gerald Fogarty, *The Vatican and the Americanist Crisis: Denis J. O'Connell, American Agent in Rome, 1885-1903* (Rome: Gregorian University, 1974), xii, 33, 142.

34 Philip Gleason, *The Conservative Reformers* (Notre Dame, IN: University of Notre Dame Press, 1968), 31.

35 The red hat is a broad-brimmed, tasseled headgear worn only by cardinals.

36 "The Next American Cardinal," *NYT*, June 5, 1891.

37 Richard Kerens (RK) to James Gibbons (JG), March 28, 1892, Archives Catholic Diocese of Richmond (ACDR).

38 Denis O'Connell (DO'C) to JI, September 13, 1892, ACDR.

39 JI to DO'C, August 13, 1892, ACDR.

40 Quoted in John Talbot Smith, "Archbishop John Ireland," *Dublin Review* 168, no. 336 (January 1921): 29–30. https://babel.hathitrust.org/cgi/pt?id=coo.31924065586020;view=1up;seq=31.

41 MLS to MEI, n.d. 1892, MRSLA, CAM.

42 *Twenty-Fourth Annual Report Cincinnati Museum*, 25.

43 "Festival Fancies," *CE*, May 15, 1892.

44 "Random Notes," *CE*, May 29, 1892.

45 Gillespie, *A Book of Remembrance*, 65, 57–58, 290.

46 Ibid., 271.

47 Gutman, ed., *Moses Jacob Ezekiel*, 193.

48 "Random Notes," *CE*, July 3, 1892.

49 "Still Hang," *CE*, July 24, 1892.

50 MLS to EFB, July 5, 1894, EFBP, CMC.

51 "No Re-Elections," *CE*, May 17, 1892.

52 "Warfare," *CE*, January 24, 1892; "Surprised: Are the Republican Workers," *CE*, June 10, 1892.

53 On McKinley's visit: "Men and Things," *CE*, September 11, 1892. On 1892 campaign: "Begun with Picnic," *NYT*, September 11, 1892; "Grand Republican Mass Meeting," *CE*, October 1, 1892; "Talkers," *CE*, October 8, 1892; "Norwood," *CE*, October 22, 1892; "Oh Why Won't the Voter Enthuse," *CE*, October 25, 1892;

"Warming Up," *CE*, October 26, 1892; "Switched," *CE*, November 1, 1892; "Tonight," *CE*, November 3, 1892; "Brice Sure," *CE*, November 5, 1892.

54 "Church and Clergy," *CE*, July 17, 1892. In the Church of the Advent Membership book the words "gone to Rome" were shown near her name.

55 "Betting on the Presidential Outlook," *CE*, November 4, 1892.

56 "Settle: Here Are the Figures," *CE*, November 15, 1892.

57 "Mrs. Harrison Dead," *Evening Star*, October 25, 1892, 1. Proquest Historical Newspapers (535412635); "Mrs. Harrison at Rest," *Evening Herald*, October 29, 1892, Library of Congress, Chronicling America: Historic American Newspapers site, accessed April 15, 2014, http://chroniclingamerica.loc.gov/lccn/sn87078000/1892-10-29/ed-1/seq-3.

58 Champ Clark, *My Quarter Century of American Politics* (New York: Harper and Brothers, 1920), 270, accessed December 14, 2014, https://archive.org/details/myquartercentur01clargoog.

59 Dates were December 22, 1892 to January 4, 1893. See "Congress," *National Tribune*, December 22, 1892. Library of Congress, Chronicling America: Historic American Newspapers site, accessed April 15, 2014, http://chroniclingamerica.loc.gov/lccn/sn82016187/1892-12-22/ed-1/seq-12.

60 JLN (Joseph L. Nichols), Application for Admission, Records of the Johns Hopkins University School of Medicine, Alan Mason Chesney Medical Archives, Johns Hopkins Medical Institute, (AMCMA, JHMI).

61 "Panic of 1893," *Ohio History*, accessed December 25, 2015, http://www.ohiohistorycentral.org/w/Panic_of_1893.

62 Howard Allen and Robert Slagter, "Congress in Crisis: Changes in Personnel and Legislative Agenda in the U.S. Congress in the 1890s," *Social Science History* 16, no. 3 (Autumn 1992): 411–412. JSTOR (1171389).

63 Quentin Skrabec, *William McKinley, Apostle of Protectionism* (New York: Algora Publishing, 2007), 122; Storer, *In Memoriam*, 18; Storer, "Assistant Secretary of the Navy," 8; Leech, *In the Days of McKinley*, 60.

64 "Francis Marion Crawford," *Catholic Encyclopedia*, accessed December 24, 2015, http://www.newadvent.org/cathen/16030a.htm; Julia Ward Howe is best known today for writing the lyrics of "The Battle Hymn of the Republic." She was also a prominent advocate of women's rights. F. Francis Marion (FMC) to ISG, February 25, 1894, ISGM

65 Foraker, *I Would Live It Again*, Kindle e-book, chapter 17.

66 TR to BS, November n.d., 1893, "Lot 293 Roosevelt, Theodore," *Bonhams*, accessed July 24, 2016, https://www.bonhams.com/auctions/22714/lot/293/.

67 "Mrs. Dahlgren Gives a Reception to Mgr. Satolli," *NYT*, January 26, 1893.

68 Francis Gasquet (FG) to MLS, June 22, 1916, Daniel Hudson Papers (DHP), Archives of the University of Notre Dame (AUND); MLS to DH, July 27, 1916, DHP, AUND.

69 MLS to Alois Janssens (AJ), July 2, 1928, in D. Verhelst, *Lord Halifax and the Scheut Father Alois Janssens* (Bruges: Desclée de Brouwer, 1967), 238.

70 O'Connell, *John Ireland*, 375–376, 578n83. For more information about Ireland's financial status, see "Archbishop Ireland's Loan," *CE*, December 1, 1894; "How Ireland Got Money," *NYT*, December 2, 1894.

71 "Bishop Keane's Lecture," *Evening Star*, February 16, 1893. Library of Congress, Chronicling America: Historic American Newspapers site, accessed April 15, 2014, http://chroniclingamerica.loc.gov/lccn/sn83045462/1893-02-16/ed-1/seq-8.

72 "University Chronicle," *Catholic University Bulletin* 1, no. 4 (October 1895): 565, https://hdl.handle.net/2027/uc1.b2870889?urlappend=%3Bseq=577.

73 "Real Estate Gossip," *Washington Evening Star*, October 21, 1893. Library of Congress, Chronicling America: Historic American Newspapers site, accessed April 15, 2014, http://chroniclingamerica.loc.gov/lccn/sn83045462/1893-10-21/ed-1/seq-9; "Mrs. Storer's Pottery," *Middlebury Register*, December 1, 1893, Library of Congress, Chronicling America: Historic American Newspapers site, accessed April 15, 2014, http://chroniclingamerica.loc.gov/lccn/sn93063557/1893-12-01/ed-1/seq-7. The address was 1640 Rhode Island NW, Washington, DC. Today, the Human Rights Commission building sits on that site. "Very Handsome," *CE*, October 22, 1893.

74 MLS to EFB, June 14, 1893, EFBP, CMC.

75 "Random Notes," *CE*, July 23, 1893.

76 MLS to EFB, June 14, 1893, EFBP, CMC.

77 Kate Swan McGuirk, *Kate Field's Washington* 9, no. 4 (January 24, 1894): 87. https://play.google.com/books/reader?id=3PYVAAAAIAAJ.

78 Remini, *House of Representatives*, 255.

79 "Rep. Bellamy Storer," *Govtrack.us*, accessed November 20, 2015, https://www.govtrack.us/Congress/members/bellamy_storer/410430.

80 Maria Longworth Storer, August 16, 1893, *Green Hill Guest Book* 1 (August 16, 1893): 12, ISGM.

81 Douglass Shand-Tucci, *The Art of Scandal: The Life and Times of Isabella Stewart Gardner* (New York: HarperCollins, 1997), 30.

82 Clara Chipman Newton, *A Memorial Tribute* (Cincinnati: N.p., 1938), 17; "Medals," *CE*, August 20, 1893; Elizabeth Perry, "The Work of Cincinnati Women in Decorated Pottery," in *Art and Handicraft in the Woman's Columbian Building of the World's Columbian Exposition, Chicago, 1893*, ed. Maud Howe Elliott (Chicago: Rand McNally, 1894), 105, accessed December 14, 2014, https://archive.org/details/arthandicraftinw93elli. On Maria's donation: "That Guarantee," *CE*, January 10, 1893.

83 Peck, *The Book of Rookwood Pottery*, 47.

84 MLMcL to W. W. Taylor (WWT), June 30, 1893, CCNP, CMC; WWT to MLMcL, July 3, 1893, CCNP, CMC; MLMcL to MLS, July 9, 1893, CCNP, CMC.

85 MLS to MLMcL, September 3, 1893, CCNP, CMC; MLMcL to MLS, September 4, 1893, CCNP, CMC; MLS to MLMcL, September 14, 1893, CCNP, CMC; MLMcL to MLS, September 16, 1893, CCNP, CMC.

86 "Hon. Bellamy Storer Erection of House at Washington, DC, 17th Street and R.I. Ave 1894," Little and Browne Account Book, Little and Brown Collection (LBC), Historic New England (HNE). "Washington Homes," *CE*, March 2, 1896. MLS to JHG, November 1, 1893, MRSLA, CAM; BS to EFB, July 31, 1893, EFBP, CMC.

87 TR to Anne Roosevelt Cowles (ARC), December 17, 1893, TRP, LOC; TR to ARC, May 10, 1894, TRP, LOC; TR to ARC, February 17, 1895, TRP, LOC.

88 Storer, *Theodore Roosevelt the Child*, 6.

89 TR to ARC, February 11, 1894, TRP, LOC.

90 TR to ARC, December 17, 1893, TRP, LOC. There was concern that Catholics would demand tax money to support their parochial schools. Roosevelt thought that Catholics, in his words, wanted to "overthrow" the public schools.

91 The other godfather was Henry Cabot Lodge, See TR to ARC, April 22, 1894, TRP, LOC.

92 Storer, *In Memoriam*, 13–14.

93 MLS to JHG, April 23, 1896, MRSLA, CAM.

94 Jennifer Howe, "Breaking the Mold: The Metalwork of Maria Longworth Storer," *Studies in Decorative Arts* 8, no. 1 (Fall/Winter 2000/2001): 54, 55. JSTOR (40662759).

95 Bellamy was not the permanent chairman of the convention because he left after one day on business. See "Created a Stir," *CE*, June 6, 1894. "Fixed," *CE*, April 29, 1894; "McKinley Men in Convention," *Boston Daily Globe*, June 6, 1894, accessed February 24, 2017, http://pqasb.pqarchiver.com/boston/doc/497871708.html; "Storer's Speech," and "Boomed by McKinley," *CE*, June 6, 1894.

96 MLS to EFB, July 5, 1894, EFBP, CMC.

97 "Cold Spring's Big Hotel Opened," *NYT*, July 15, 1894.

98 MLS to EFB, July 5, 1894, EFBP, CMC.

99 A Noble Guest," *CE,* October 30, 1894.

100 "Storer's Turn-Down," *CE*, September 1894.

101 "Storer and Hinkle to Fight It Out," *CE*, August 26, 1894; "Political Gossip," *CE*, August 28, 1894.

102 "Storer," *CE*, September 28, 1894.

103 "The Main Convention," *CE*, September 28, 1894; "Perfectly," *CE,* September 28, 1894. On factions in Ohio politics: "Too Late, *CE*, September 29, 1894; "Taft Tumbles," *CE*, November 19, 1894; "Tom McDougall," *CE*, December 12, 1894; "A Few Hot Tips," *CE*, October 1, 1894; "A Second Scipio," *CE*, November 16, 1894; "Storer's Warning," *CE*, November 19, 1894; Gustav Karger, "George

Barnesdale Cox, Proprietor of Cincinnati," *Leslie's Magazine* 57, no. 3 (January 1904): 282, accessed December 4, 2015, https://books.google.com/books?id=x-cvQAAAAMAAJ. On anti-Catholicism as a factor: "George B. Cox Talks," *CE*, November 19, 1894; "A Way Down Deep," *CE*, November 18, 1894. On Maria's purported social snub: "Heirs," *CE*, November 29, 1894.

104 "Storer," *CE*, November 18, 1894.

105 *Cincinnati Tribune*, November 18, 1894, in Christopher Hett, "Political Boss of Cincinnati: The Era of George Cox" (Master's thesis, Xavier University, 1968), 61. See also "McKinley Caused Storer's Downfall," *CE*, November 19, 1894.

106 TR to Henry Cabot Lodge (HCL), October 2, 1894, and October 11, 1894, TRP, LOC.

107 BS to EFB, November 19, 1894, EFBP, CMC.

108 CS to DH, November 24, 1894. University of Notre Dame Archive Calendar, accessed September 25, 2015, http://www.archives.nd.edu/cgi-bin/calindex. pl?keyword=storer; "Social Affairs," *CE*, November 28, 1895; CS to DH, April 16, 1896, University of Notre Dame Archive Calendar, accessed September 25, 2015, http://www.archives.nd.edu/cgi-bin/calindex.pl?keyword=storer.

109 Maria Longworth Stoddard, untitled poem, *Charles Warren Stoddard Autograph Album*, 106, Charles Warren Stoddard Album, mssHM 35075, Huntington Library.

110 "John A. Flora Claim," *NYT*, November 29, 1894; "Scandalous," *CE*, April 7, 1895.

111 "Descendant of the Noble Lafayette," *CE*, October 21, 1895.

112 Ibid.

113 Chambrun, *Making of Nicholas Longworth*, 174.

114 Chambrun, *Shadows Like Myself*, 28–29.

115 BS to W. P. Anderson (WPA), February 17, 1895, Julius Dexter Scrapbook, CMC.

116 "Storer," *CE*, March 5, 1895.

117 TR to ARC, March 10, 1895, TRP, LOC.

118 "The Wives," *CE*, March 3, 1895.

Chapter Five

1 "We have just contracted for the fourth [house], since we have been exiles," MLS to EFB, January 18, 1901, EFBP, CMC.

2 BS to EFB, April 4, 1914, EBFP, CMC. "N.t.," *Washington Times*, February 20, 1895.

3 MLS to JI, April 13, 1865, JIP, MNHS; Storer, "Maria Longworth Storer," *Some Roads Lead to Rome in America*, 461.

4 JFdeC and JdeC interviews with authors, September 13–15, 2014.

5 The description of the audience is taken from "An Audience with Leo XIII," *Chicago Daily Tribune*, November 28, 1892, accessed April 2, 2017, http://archives.chicagotribune.com/1892/11/28/page/9/article/praise-for-keeley.

6 The dates of the Storers' papal visits are as follows: April 1895, March 1898, August 1900, December 1903, April 1914, October 1921, and December 1921.

7 "The World of Society," *Washington Star*, September 3, 1895.

8 Chambrun, *Shadows Like Myself*, 29.

9 "Vanderbilt Wedding," *North Platte Semi-Weekly Tribune*, June 7, 1895, Library of Congress, Chronicling America: Historic American Newspapers site, accessed April 15, 2016, http://chroniclingamerica.loc.gov/lccn/2010270504/1895-06-07/ed-1/seq-3. In 1895, Florence Adele Sloane's trousseau cost $40,000. See "N.t.," *Banner-Democrat*, June 15, 1895, Library of Congress, Chronicling America: Historic American Newspapers site, accessed April 15, 2016, http://chroniclingamerica.loc.gov/lccn/sn88064237/1895-06-15/ed-1/seq-2.

10 "Unity Club," *CE*, October 13, 1895; "Random Notes," *CE*, December 1, 1895.

11 MLS to JHG, November 25, 1895, MRSLA, CAM.

12 "Name the Delegates," *CE*, October 26, 1895. BS's speeches reported in: "Taxation," *CE*, October 22, 1895; "Manufacturers," *CE*, November 10, 1895; "From Rejoicing to Mourning," *CE*, November 3, 1895.

13 William Elder (WE) to MLS, November 29, 1995, Archdiocese of Cincinnati Archive (ACA).

14 Chambrun, *Shadows Like Myself*, 31.

15 "Random Notes," *CE*, December 15, 1895.

16 "Washington Charity Ball," *NYT*, February 4, 1996; "A Week of Many Dinners," *NYT*, March 22, 1896; "In Washington," *Daily Public Ledger*, January 20, 1897, Library of Congress, Chronicling America: Historic American Newspapers site, accessed April 15, 2017, http://chroniclingamerica.loc.gov/lccn/sn86069117/1897-01-20/ed-1/seq-2; "Dinner in Honor of the President," *Morning Times*, February 4, 1896, Library of Congress, Chronicling America: Historic American Newspapers site, accessed April 15, 2017, http://chroniclingamerica.loc.gov/lccn/sn84024442/1896-02-04/ed-1/seq-5; "Amusements," *Evening Star*, January 8, 1897, Library of Congress, Chronicling America: Historic American Newspapers site, accessed April 15, 2017, http://chroniclingamerica.loc.gov/lccn/sn83045462/1897-01-08/ed-1/seq-12; "Descended from Lafayette," *Evening Star*, February 19, 1896, Library of Congress, Chronicling America: Historic American Newspapers site, accessed April 15, 2017, http://chroniclingamerica.loc.gov/lccn/sn83045462/1896-02-19/ed-1/seq-3.

17 Pierre stated, "After my marriage I will return to France to supervise the proprietary interests of my family." See "Descendent of the Noble Lafayette," *CE*, October 21, 1895.

18 A département is a division of government in France. "Letters to the Editor," *America* 2, no. 26 (April 9, 1910): 709, accessed December 4, 2015, https://play.google.com/books/reader?id=xlo_AQAAMAAJ.

19 "Margaret…[was] involved in the political activity of her husband, the Mar-
quise de Chambrun. On election day, she is in town to attend Mass and to take
the electoral pulse." See Yves Pourcher, *Les belles familles de Marvejols*, in *Construction,
reproduction et représentation des patriciats urbains de l'Antiquité au XXe siècle* (Tours, France:
Centre d'histoire de la ville moderne et contemporaine, 1999), accessed February
22, 2016, http://books.openedition.org/pufr/2145?lang=en.

20 "Men and Matters," and "Cincinnati Men in Gotham," *CE*, February 1, 1896.

21 BS to WMcK, February 16, 1895, WMcKP, LOC; BS to William W. Rockville
(WWR), February 18, 1896, William W. Rockville Papers (WWRP), Houghton
Library, Harvard University (HLHU).

22 WE to MLS, October 3, and December 30, 1996, ACA; MLS to WE, January 2,
1997, ACA; BS to WE, February 20, and April 1, 1897, ACA; WE to BS, March
7, 1897, ACA.

23 "Beautiful," *CE*, July 26, 1895.

24 "Rookwood," *CE*, March 8, 1896.

25 "*Flora v. Anderson et al.*, 4770," *Open Jurist*, accessed April 2, 1917, http://openjurist.
org/75/f1d/217.

26 MLS to Myron T. Herrick (MTH), March 18, 1897, WMcKP, LOC.

27 "Ben's Messages," *CE*, June 21, 1896.

28 MLS to Ida McKinley (IMcK), July 10, 1896, WMcKP, LOC.

29 Storer, "Assistant Secretary of the Navy," 8–9.

30 "Our Bellamy," *CE*, September 21, 1896. On other campaign activities, see
"McKinley Congratulated," *CE*, August 28, 1896; "Heard Bellamy Storer," and
"Storer Talked Again," *CE*, September 20, 1896; "Prospects," *CE*, October 10,
1896; "Bellamy Storer Talked," *CE*, October 14, 1896; "Ringing," *CE*, October 21,
1896; Storer, *Theodore Roosevelt the Child*, 22; Stacy Cordery, *Theodore Roosevelt in the
Vanguard of the Modern* (Belmont, CA: Thomson Wadsworth, 2003), 47; and Henry
Cabot Lodge, ed., *Selections from the Correspondence of Theodore Roosevelt and Henry Cabot
Lodge* (New York: Charles Scribner's Sons, 1925), 235–236.

31 Talliaferro, *All the Great Prizes*, 98. "McKinley's Cabinet," *CE*, November 7, 1896;
"Old Guards," *CE*, November 8, 1896.

32 TR to BS, December 4, and December 15, 1896, TRP, LOC; TR to HCL,
December 4, 1896, TRP, LOC; TR to MLS, December 5, and December 13,
1896, TRP, LOC; Storer, *Theodore Roosevelt the Child*, 19–27; "Bellamy Storer," *CE*,
November 22, 1896; Storer, "Assistant Secretary of the Navy," 9, 12.

33 Lodge, ed., *Selections from the Correspondence of Theodore Roosevelt and Henry Cabot Lodge*,
254.

34 "Nay! Nay! Is the Cry of Foraker," *NYT*, March 26, 1897; "Storer and Foraker
Truce," *NYT*, April 14, 1897; MLS to JI, June 23, 1887, JIP, MNHS.

35 Douglas Road to John Sherman, March 2, 1897; C. W. Baldwin to WMcK,
April 7, 1897; Edwin Marshall to WMcK, April 14, 1897; S. Plecistta to WMcK,
April 17, 1897; and Charles Morse to WMcK, April 21, 1897, Applications and

Recommendations for Public Office (ARPO), 1791–1901, Administration of William McKinley (AMcK), 1897–1901, Entry A1 760, Box 105, General Record of State Department (GRSD), Record Group (RG) 59, National Archives College Park (NACP).

36 William W. Nichols (WWN) to WMcK, April 13, 1894, ARPO, 1791–1901, AMcK, 1897–1901, Entry A1 760, Box 105, GRSD, RG 59, NACP. Nichols probably wrote to Lodge and Long because they were prominent in national politics from his home state. The Library of Congress, the Cincinnati Museum Center, and the Massachusetts Historical Society where the papers of these three men are maintained could not produce any documents related to this letter.

37 MLS to TR, April 22, 1897, WMcKP, LOC. "Confirmed by the Senate," *NYT*, May 5, 1897.

38 MLS to JHG, April 29, 1897, MRSLA, CAM.

39 Julius Dexter died on October 21, 1898. See "Dexter, Julius, Genealogy Search Listing," *Spring Grove*, accessed February 18, 2016, http://www.springgrove.org/stats/62478.tif.pdf; Margaret King died on May 1, 1898. See "King, Margaret Rives, Genealogy Search Listing," *Spring Grove*, accessed February 18, 2016, http://www.springgrove.org/stats/61910.tif.pdf.

40 "Exit Asano," *CE*, December 12, 1897; Peck, *The Book of Rookwood Pottery*, 57; "Dragon Cup," *CE*, July 4, 1897; "For the Woman's Eye," *CE*, December 15, 1897; Howe, "Breaking the Mold," 57. "Technical analysis has revealed that Storer's metalwork was not made of bronze as originally presumed, but of tin…that owed more to Storer's imagination than to the guidance of [Asano]." See "2005 Conference Abstracts," *Midwest Art History Society*, accessed March 8, 2016, https://www.mahsonline.org/display/files/conference_abstracts_32nd.pdf. Boehle, *Maria: A Biography of Maria Longworth*, 143.

41 "Coming Social Events." *Washington Times*, May 10, 1897, Library of Congress, Chronicling America: Historic American Newspapers site, accessed April 15, 2014, http://chroniclingamerica.loc.gov/lccn/sn85054468/1897-05-10/ed-1/seq-5; "Doings of Diplomats," *Washington Times*, May 16, 1897, Library of Congress, Chronicling America: Historic American Newspapers site, accessed April 15, 2014, http://chroniclingamerica.loc.gov/lccn/sn85054468/1897-05-16/ed-1/seq-9; "A White House Reception," *Washington Times*, May 17, 1897, Library of Congress, Chronicling America: Historic American Newspapers site, accessed April 15, 2014, http://chroniclingamerica.loc.gov/lccn/sn85054468/1897-05-17/ed-1/seq-5; CS to DH, May 21, 1897, University of Notre Dame Archives Calendar, accessed February 18, 2016, http://www.archives.nd.edu/cgi-bin/calindex.pl?keyword=-storer.

42 "Gifted Women," *CE*, July 25, 1897; "Life Size," *CE*, October 22, 1896; "Jury," *CE*, May 18, 1897.

43 "Random Notes," *CE*, May 2, 1897; "Americans Going Aboard," *NYT*, June 16, 1897.

44 *National Cyclopedia of American Biography* (New York: James T. White, 1920), 356.

45 MLS to EFB, July 17, 1897, EFBP, CMC.

46 Ibid.

47 "Mr. Storer Received at Court," *New York Tribune*, July 24, 1897, Library of Congress, Chronicling America: Historic American Newspapers site, accessed April 15, 2017, http://chroniclingamerica.loc.gov/lccn/sn83030214/1897-07-24/ed-1/seq-7. This description of Bellamy's presentation ceremony is adapted from Larz Anderson's ceremony in 1911. See Isabel Anderson, *Spell of Belgium* (Boston: Page, 1915), 4–5. The relationship between Storer and the king remained cordial after Bellamy was reassigned as Ambassador to Austria-Hungary. Five years later, in 1902, (now) President Roosevelt wrote to Maria, "Please tell Bellamy to give my cordial regards to the King of the Belgians if or when he see him. I have always followed his career, especially after you had told me all about him." TR to MLS, December 8, 1902, TRP, LOC.

48 "Royalty and Democracy in the Arbitration of Disputes," *San Francisco Call*, August 29, 1897, Library of Congress, Chronicling America: Historic American Newspapers site, accessed March 15, 2014, http://chroniclingamerica.loc.gov/lccn/sn85066387/1897-08-29/ed-1/seq-20.

49 Mother Christopher Shanahan, "The Diplomatic Career of Bellamy Storer in Belgium and Spain, 1897–1902" (PhD diss., Catholic University, 1960), 24.

50 TR to BS, December 8, 1902, TRP, LOC. Today the country is called the Democratic Republic of the Congo. It is estimated that as many as 10 million people died under Leopold's cruel management in which natives were forced to extract rubber and massacre wildlife for ivory. Adam Hochschild, *King Leopold's Ghost: A Story of Greed, Terror, and Heroism in Colonial Africa* (Boston: Houghton Mifflin, 1998), 225–233.

51 See Anderson, *Spell of Belgium*, 20–23. The building is currently used by the Lithuanian Embassy.

52 BS to EFB, August n.d., 1897, EFBP, CMC.

53 MLS to EFB, August 29, 1897, EFBP, CMC.

54 MLS to EFB, May 28, 1898, EFBP, CMC.

55 Anderson, *Spell of Belgium*, 112, 133.

56 Maria Longworth Storer, "The Awakening of Austria," *North American Review* 197, no. 689 (April 1913): 479.

57 Anderson, *Spell of Belgium*, 45.

58 Anderson, *Spell of Belgium*, 24.

59 Stuart, *American Diplomatic and Consular Practice*, 210–213.

60 MLS to (Charles Wood, Viscount Halifax) CW, VH, March 4, 1899, Earls of Halifax Family Papers (EHFP), Borthwick Institute of Archives (BIA); MLS to JI, June 15, 1898, JIP, MNHS; MLS to TR, April 14, 1899, TRP, LOC.

61 MLS to CW, VH, October 15, 1898, EHFP, BIA.

62 Eugénie de Grunne (EdeG) to MLS, n.d., EHFP, BIA.

63 MLS to JI, June 15, 1898, JIP, MNHS.

64 John A. Porter (JAP) to MLS, January 4, 1899, WMcKP, LOC.

65 Storer, *In Memoriam*, 46.

66 TR to BS, September 28, 1897, TRP, LOC.

67 "This Day in History, February 15, 1898 the *Maine* Explodes," *History.com*, accessed March 6, 2016, http://www.history.com/this-day-in-history/the-maine-explodes.

68 John Offner, "McKinley and the Spanish-American War," *Presidential Studies Quarterly* 34, no. 1 (March 2004): 56. JSTOR (27552563).

69 Minister to the Secretary of State, February 19, 1898, *United States Diplomatic Records for Belgium, 1832–1935*, vol. C8.15, 331–332, RG 84, NARA.

70 Theodore Roosevelt Diary, April 16, 1898, quoted in Stefan Lorant, *The Life and Times of Theodore Roosevelt* (New York: Doubleday, 1959), 292.

71 Edmund Morris, *Rise of Theodore Roosevelt* (New York: Random House, 1979), 608. The Spanish government disputed the American Navy's findings. Their investigation determined that the explosion was created on board, rather than by a mine. In 1976, Admiral Hyman Rickover reinvestigated the situation and cleared Spain. Some historians disagree. Perhaps, it is best to say, the cause is unknown. See "Better Late Than Never? Rickover Clears Spain of the *Maine* Explosion," *History Matters*, accessed March 4, 2016, http://historymatters.gmu.edu/d/5470/.

72 JK to JI, March 8, 1898, JIP, MNHS.

73 "Random Notes," *CE*, March 20, 1898, "Social Affairs," *CE*, March 22, 1898; "Loring Andrews and Co. Display Ad 2 No Title," *CE*, March 25, 1896; "Random Notes," *CE*, March 27, 1898.

74 Howe, "Breaking the Mold," 63.

75 Boram-Hays, *Bringing Modernism Home*, 38. Maria's "casting metal was...tin....She always referred to them as bronzes, as did exhibition catalogues and reviewers, and her objects were made to look like bronzes." See Howe, "Breaking the Mold," 57.

76 "Review 4 [No Title]," *NYT*, October 1, 1898; "Rookwood Pottery Process," *CE*, December 3, 1898.

77 "Gifted Women," *CE*, August 1, 1897.

78 MLS to JHG, November 25, 1898, MRSLA, CAM; Tiffany and Co. to JHG, December 10, 1898, MRSLA, CAM.

79 "No War," *CE*, March 19, 1898.

80 MR to JI, March 27, 1898, JIP, MNHS; John Keane (JK) to JI, March 27, 1898, JIP, MNHS.

81 John Farrell, "Archbishop Ireland and Manifest Destiny," *Catholic Historical Review* 33, no. 3 (October 1947): 283. JSTOR (25014801); John Offner, "Washington Mission: Archbishop Ireland on the Eve of the Spanish American War," *Catholic Historical Review* 73, no. 4 (October 1987): 575. JSTOR (25022638).

82 BS to JI, April 14, 1898, JIP, MNHS.

83 JK to BS, March 30, 1898, JIP, MNHS.

84 "Social Affairs," *CE*, April 1, 1898.

85 Offner, "McKinley and the Spanish-American War," 58.

86 Frank Reuter, *Catholic Influence in Colonial Policies, 1898–1904* (Austin: University of Texas Press, 1967), 20.

87 "Archbishop Ireland Here," *Washington Times*, April 4, 1898, Library of Congress, Chronicling America: Historic American Newspapers site, accessed April 3, 2017, http://chroniclingamerica.loc.gov/lccn/sn85054468/1898-04-04/ed-1/seq-3; "Archbishop Ireland's Work," *New York Sun*, April 6, 1898, Library of Congress, Chronicling America: Historic American Newspapers site, accessed April 3, 2017, http://chroniclingamerica.loc.gov/lccn/sn83030272/1898-04-06/ed-1/seq-1; "Telegraphic New," *Las Vegas Weekly Optic and Stock Grower*, April 9, 1898, Library of Congress, Chronicling America: Historic American Newspapers site, accessed April 3, 2017, http://chroniclingamerica.loc.gov/lccn/sn92070422/1898-04-09/ed-1/seq-5; "Armistice Promulgated," *Copper Country Evening News*, April 12, 1898, Library of Congress, Chronicling America: Historic American Newspapers site, access on April 3, 2017, http://chroniclingamerica.loc.gov/lccn/sn86086632/1898-04-12/ed-1/seq-5/.

88 Mario Rampolla (MR) to JI, March 27, 1898, JIP, MNHS; MR to Sebastiano Martinelli (SM), April 14, 1898, JIP, MNHS; JI to Stephen Elkins (SE), April 5, 1898, JIP, MNHS; MR to SM, April 10, JIP, MNHS; Offner, "Washington Mission," 565n6; 566n8; 567n10; 568nn14, 15; 569n16; 570n21; 571n22; 572nn27, 28; 573nn29, 32, 33.

89 BS to JI, May 11, 1898, JIP, MNHS.

90 BS to JI, April 14, 1898, JIP, HMHS.

91 "Random Notes," *CE*, April 24, 1898; "Marquis de Chambrun," *CE*, June 5, 1898.

92 "The Declarations," *NYT*, April 25, 1898.

93 Margaret Chanler, *Roman Spring Memoirs* (Boston: Little, John, 1934), 285.

94 Ralph Nurnberger, "Life and Assassination of President William McKinley," *C-SPAN* video, May 4, 2015, http://www.c-span.org/video/?325980-1/discussion-assassination-president-william-mckinley.

95 MLS to TR, May 6, 1900, TRP, LOC.

96 "A Decisive Victory Off Manila," *Los Angeles Herald*, May 2, 1898.

97 BS to JH, May 11, 1898, JHP, LOC.

98 BS to EFB, May 30, 1898, EFBP, CMC; MLS to EFB, May 28, 1898, EFBP, CMC.

99 MLS to EFB, May 28, 1898, EFBP, CMC.

100 BS to EFB, May 30, 1898, EFBP, CMC.

101 MLS to EFB, May 28, 1898, EFBP, CMC; "Social and Personal," *Washington Times*, September 3, 1898, Library of Congress, Chronicling America: Historic

American Newspapers site, accessed April 3, 2017, http://chroniclingamerica. loc.gov/lccn/sn85054468/1898-09-03/ed-1/seq-5; Chambrun, *Shadows Like Myself,* 45, 54.

102 Shanahan, "The Diplomatic Career of Bellamy Storer," 34–35.

103 "Spanish-American War 1898—Main Events," *EmersonKent.com,* accessed March 4, 2016, http://www.emersonkent.com/history/timelines/spanish_american_war_ timeline.htm.

104 Kathleen Dalton, *Theodore Roosevelt: A Strenuous Life* (New York: Random House, 2007), Kindle e-book, chapter 6.

105 MLS to EFB, March 24, 1899, EFBP, CMC; MLS to EFB, December 6, 1898, EFBP, CMC.

106 "Charles Lindley Wood, Lord Halifax, 1839–1934," *Project Canterbury,* accessed March 9, 2016, http://anglicanhistory.org/bios/halifax.htm; William Davage, "Anglo-Catholicism and Aristocracy," First Clumber Lecture, 2009, 2.

107 Verhelst, *Lord Halifax and the Scheut Father Alois Janssens,* 239.

108 CW, VH to Frederick Temple (FT), October 5, 1898, EHFP, BIA.

109 MLS to JK, October 6, and October 7, 1898, JIP, MNHS; MLS to CW, VH, October 15, 1898, EHFP, BIA; EdeG to MLS, N.m. n.d., n.y., EHFP, BIA.

110 MLS to JK, October 6, and October 7, 1898, JIP, MNHS; Photo of Marquis de Chambrun Tomb."

111 Joe was the author of the following study: "A Study of the Spinal Cord by Nissl's Method in Typhoid Fever and in Experimental Infection with the Typhoid Bacillus," *Journal of Experimental Medicine* 4, no. 2 (March 1899): 189–215, *JEM.com,* accessed April 10, 2017, https://www.ncbi.nlm.nih.gov/pmc/articles/PMC2118044/ pdf/189.pdf; Fred Moore, *Harvard College Record of the Class of 1893, June 1893 to June 1899, no. 2* (Cambridge, MA: Harvard University Press, 1899), 22.

112 "Nichols, Joseph Longworth," *National Cyclopaedia of American Biography,* 356.

113 Bellamy Storer, "The Ocean Is Ours," *Harper's Weekly* 43, no. 2194 (January 7, 1899): 6.

114 Reuter, *Catholic Influence on American Colonial Policies,* 7.

115 "Treaty of Peace between the United States and Spain December 10, 1898," *Avalon Project,* accessed March 13, 2016, http://avalon.law.yale.edu/19th_century/ sp1898.asp.

116 Gerald Fogarty, *The Vatican and the Americanist Crisis: Denis J. O'Connell, American Agent in Rome, 1885–1903* (Rome: Università Gregoriana, 1974), vii-ix; Gerald Fogarty, "Americanism," in *HarperCollins Encyclopedia of Catholicism,* ed. Richard McBrien (San Francisco: HarperSanFrancisco, 1995), 40.

117 BS to WMcK, January n.y., 1899, WMcKP, LOC.

118 BS to TR, telegram, March 10, and March 11, telegram, March 13, 1899, TRP, LOC; TR to BS, March 13, 1899, TRP, LOC; TR to WMcK, March 13, TRP, LOC.

119 Thomas O'Gorman (TO'G) to DO'C, March 13, 1899, ACDR.

120 Claude Fohlen, " Catholicisme américain et catholicisme européen: La convergence de 'l'américanisme,'" *Revue d'histoire moderne et contemporaine* 34, no. 2 (April 1987): 226. JSTOR (20529295); MLS to CW, VH, March 17, 1899, EHFP, BIA; MLS to TR, March 17, and April 14, 1899, TRP, LOC.

121 MLS to TR, April 14, 1899, TRP, LOC.

122 "Next U.S. Minister to Spain," *Boston Daily Globe*, April 12, 1899, accessed February 24, 2017, http://pqasb.pqarchiver.com/boston/doc/499078201.html; "Americans Arrive in Paris," *CE*, May 8, 1899.

123 MLS to TR, April 14, 1899, TRP, LOC.

124 TR to MLS, April 24, 1899, TRP, LOC; TR to BS, April 21, 1899, TRP, LOC.

125 BS to EC, February 2, 1899, MCC, LOC; J. C. Levenson, Ernest Samuels, Charles Vandersee, and Viola Winner, eds., *The Letters of Henry Adams*, vol. 4, *1892–1899*, (Cambridge, MA: Harvard University Press, 1988), 692n7.

126 James Moynihan, *Life of Archbishop John Ireland* (New York: Harper and Brothers, 1953), 146–151.

127 "Archbishop Ireland Honored," *NYT*, May 22, 1899.

128 "Vaughan Praises the Americans," *San Francisco Call*, June 28, 1899, Library of Congress, Chronicling America: Historic American Newspapers site, accessed April 15, 2014, http://chroniclingamerica.loc.gov/lccn/sn85066387/1899-06-28/ed-1/seq-5; M. E. Grant Duff, *Notes from a Diary, 1896 to January 23, 1901*, vol. 2 (London: John Murray, 1904), 144, accessed June 1, 2014, https://archive.org/details/in.ernet.dli.2015.279102.

129 TR to MLS, May 1, 1899, TRP, LOC.

130 TR to WMcK, June 8, 1899, TRP, LOC; WMcK to TR, June 13, 1899, WMcKP, LOC.

131 BS to TR, May 31, 1899, TRP, LOC.

Chapter Six

1 "Bellamy Storer Presented," *Chicago Tribune*, June 17, 1899, 1. Proquest Historical Newspapers (172960109).

2 William Collier, *At the Court of His Catholic Majesty* (London: A. C. McClurg, 1912), 281, accessed December 14, 2014, https://archive.org/details/atcourtofhiscathoocollrich.

3 "Spain," *Cyclopedic Review* 9, no. 2 (2nd Quarter 1899): 459, accessed July 27, 2017, https://hdl.handle.net/2027/inu.30000108664925?urlappend=%3Bseq=475.

4 "Mrs. Bellamy Storer's View of Spain," *Chicago Daily Tribune*, July 23, 1899, 6. Proquest Historical Newspapers (172946399).

5 U.S. Department of State, *Foreign Relations of the United States: Diplomatic Papers, 1899* (Washington, DC: Government Printing Office, 1899), 710–711, accessed March

24, 2016, http://digital.library.wisc.edu/1711.dl/FRUS.FRUS1899; Shanahan, "The Diplomatic Career of Bellamy Storer," 39, 40.

6 MLS to TR, November 19, 1899, TRP, LOC.

7 Clara Longworth (CL) to Katharine Elizabeth Roelker Wulsin (KERW), July 6, 1899, WFP, CMC.

8 CL to KERW, July 6, 1899, WFP, CMC; Susan Longworth (SL) to KERW, May 31, 1900, WFP, CMC.

9 SL to KERW, May 31, 1900, WFP, CMC.

10 MLS to EFB, October 22, 1899, EFBP, CMC; MLS to EFB, N.m. n.d., n.y., EFBP, CMC. MLS to EFB, December 27, 1899, EFBP, CMC.

11 MLS to LW, August 21, 1899, WFP, CMC; MLS to EFB, N.m. n.d., n.y., EFBP, CMC; MLS to EFB, October 22, 1899, EFBP, CMC.

12 MLS to EFB, October 22, 1899, EFBP, CMC.

13 MLS to JH, May 13, 1900, JHP, LOC.

14 William Portier, "George Tyrrell in America," *U.S. Catholic Historian* 20, no. 3 (Summer 2002): 72. JSTOR (25154819).

15 MLS to CW, VH, February 28, 1900, EHFP, BIA.

16 Allitt, *Catholic Converts: British and American Intellectuals Turn to Rome*, 121.

17 MLS to John Hay (JH), November 8, 1899, JHP, LOC; MLS to JH, October 3, 1899, JHP, LOC.

18 MLS to JH, January 11, and March 31, 1900, JHP, LOC.

19 MLS to JH, January 11, 1900, JHP, LOC.

20 MLS to WMcK, January 27, 1901, WMcKP, LOC.

21 MLS to EFB, October 22, 1899, EFBP, CMC.

22 TR to MLS, October 28, 1899, TRP, LOC. Roosevelt spoke on October 22, 1899 at Music Hall. See "Receptions: Accorded Governor Roosevelt during His Stay in the City," *CE*, October 22, 1899.

23 MLS to TR, November 11, 1899, TRP, LOC.

24 Shanahan, "The Diplomatic Career of Bellamy Storer," 36–61, 45, 49. The Treaty of Amity was signed in July 1902.

25 MLS to EFB, December 3 and 27, 1899, EFBP, CMC.

26 MLS to EFB, June 29, 1900, EFBP, CMC; SL to KERW, May 31, 1900, KERW, CMC.

27 "A New Commission," *Washington Evening Star*, February 6, 1900, Library of Congress, Chronicling America: Historic American Newspapers site, accessed April 15, 2014, http://chroniclingamerica.loc.gov/lccn/sn83045462/1900-02-06/ed-1/seq-1. Goodwin, *The Bully Pulpit*, Kindle e-book, chapter 9. MLS to WHT, February 8, May 17, 1900, WHTP, LOC; BS to WHT, May 4, 1900, WHTP, LOC.

28 MLS to WHT, February 8, 1900, WHTP, LOC; WHT to MLS, March 20, 1900, WHTP, LOC.

29 MLS to TR, February 8, 1900, TRP, LOC; TR to MLS, February 26, 1900, TRP, LOC.

30 Leonard Wood (LW1) to MLS, N.m. n.d., n.y., TRP, LOC.

31 TR to MLS, March 27, 1899, TRP, LOC; WHT to MLS, March 20, 1900, WHTP, LOC.

32 MLS to TR, April 5, 1900, TRP, LOC.

33 I to MLS, August 11, 1900, WHTP, LOC.

34 MLS to EFB, N.m. n.d., n.y., EFBP, CMC; BS to EFB, January 12, 1900, EFB, CMC.

35 BS to JH, April 18, 1900, *United States Diplomatic Records of Foreign Service Posts*, vol. 53, 130–133, RG 84, NARA; "Holler," *CE*, April 19, 1900.

36 SL to KERW, March 22, 1900, WFP, CMC.

37 Shanahan, "The Diplomatic Career of Bellamy Storer," 26.

38 MLS to EFB, June 29, 1900, EFBP, CMC.

39 Dominicans, Franciscans, Augustinians, and Recollect were the religious orders. See O'Connell, *John Ireland*, 479.

40 Frederick Rooker (FR) to TR, May 9, 1904, TRP, LOC. Rooker was the bishop of Jaro.

41 Dean Worchester, "Knotty Problems of the Philippines," *Century Magazine* 56 (October 1898): 879, accessed July 27, 2017, http://www.unz.org/Pub/Century-1898oct.

42 WHT to MLS, December 4, 1900, WHTP, LOC.

43 John Farrell, "Background of the Taft Mission to Rome I," *Catholic Historical Review* 36, no. 1 (April 1950): 12, 14, 17, and 24, JSTOR (25015111); John Farrell, "Background of the Taft Mission to Rome II," *Catholic Historical Review* 37, no. 1 (April 1951): 1, JSTOR (25015235).

44 Farrell, "Background of the Taft Mission to Rome II," 17.

45 MLS to EFB, September 11, 1900, EFBP, CMC; "Gallant: Compliments Were Paid," *CE*, June 4, 1900; MLS to EFB, September 11, 1900, EFBP, CMC; MLS to JHG, October 26, 1900, MRSLA, CAM.

46 "Mrs. Storer Objects to Duty on Her Pottery," *CE*, March 18, 1901.

47 "Off to Oyster Bay," and "Everybody Pleased," *Washington Evening Star*, June 22, 1900, Library of Congress, Chronicling America: Historic American Newspapers site, accessed April 15, 2016, http://chroniclingamerica.loc.gov/lccn/sn83045462/1900-06-22/ed-1/seq-1.

48 TR to BS, July 27, 1900, TRP, LOC.

49 MLS to WHT, Oct 3, 1900, WHTP, LOC.

50 Storer, *In Memoriam*, 45–46. In the book, Maria stated their audience took place in September, which is incorrect according to newspaper accounts and her own letters.

51 MLS to TR, December 1, 1900, TRP, LOC.

52 MLS to TR, November 8, 1900, TRP, LOC.

53 TR to MLS, November 23, 1900, TRP, LOC.

54 MLS to TR, November 8, 1900, TRP, LOC.

55 The authors compiled the following list of those with whom Maria shared Roosevelt's letters: Lord Halifax, Archbishop Ireland, Archbishop Lorenezelli, Archbishop Keane, Bishop O'Gorman, Cardinal Rampolla, Cardinal Farrata, Cardinal Vives, Governor Taft, General Wood, Pope Leo XIII, and Pope Pius X. Later, Maria quoted what he said in a memorandum she sent directly to Pope Leo XIII, dated October 19, 1901. She liked it so well she edited it and sent the missive to Pope Pius X, dated November 20, 1903. She never admitted to sending a copy to Halifax or the popes.

56 Frank Reuter, "William Howard Taft and the Separation of Church and State in the Philippines," *Journal of Church and State* 24, no. 1 (Winter 1982): 112.

57 WHT to MLS, March 20, June 21, July 12, and December 6, 1900, January 18, January 21, January 22, February 22, May 19, June 22, and October 21, 1901, WHTP, LOC; WHT to BS, June 22, 1900, and January 19, 1901, WHTP, LOC; MLS to WHT, February 13, 1902, WHTP, LOC.

58 MLS to TR, December 11, 1900, TRP, LOC.

59 MLS to WMcK, January 27, 1901, WMcKP, LOC; MLS to TR, January 28, 1901, TRP, LOC.

60 "Royal Betrothal Ball," *NYT*, February 12, 1901; "The Royal Wedding," *NYT*, February 15, 1901; "Ball Held for Mercedes and Carlo," *Royal Musings*, accessed April 7, 2016, http://royalmusingsblogspotcom.blogspot.com/2009/02/ball-held-for-mercedes-and-carlo.html; Shanahan, "The Diplomatic Career of Bellamy Storer," 51; BS to WMcK, telegram, February 14, 1901, WMcKP, LOC.

61 "Storer," *CE*, April 3, 1902.

62 "Spanish Hatred Subsiding," *St. Louis Republic*, February 23, 1901, Library of Congress, Chronicling America: Historic American Newspapers site, accessed April 15, 2014, http://chroniclingamerica.loc.gov/lccn/sn84020274/1901-02-23/ed-1/seq-12.

63 Shanahan, "The Diplomatic Career of Bellamy Storer," 52.

64 TR to BS, March 6, 1901, TRP, MNHS.

65 MLS to JI, March 6, 1901, JIP, MNHS.

66 BS to JH, December 24, 1900, Dispatches of the Department of State, November 3, 1900–March 7, 1901, vol. C8.8. 207–208. RG 84, NARA.

67 MLS to WHT, March 21, 1901, WHTP, LOC.

68 Boeglin was the editor of *Le Moniteur de Rome*, and the Roman correspondent for the United and Associated Presses. Farrell, "Background of the Taft Mission to Rome II," 3n4; WHT to MLS, May 19, 1901, WHTP, LOC.

69 BS to TR, June 5, 1901, TRP, LOC.

70 MLS to EFB, July 12, 1901, EFBP, CMC.

71 "President Shot at Buffalo Fair," *NYT*, September 7, 1901; "Words of Sorrow for the Dead President," *NYT*, September 15, 1901.

72 MLS to TR, September 22, 1901, TRP, LOC.

73 TR to MLS, October 4, 2001, TRP, LOC.

74 MLS to TR, October 17, 1901, TRP, LOC.

75 Quoted in Storer, *In Memoriam*, 59.

76 MLS to EFB, December 12, 1901, EFBP, CMC.

77 Boram-Hays, *Bringing Modernism Home*, 174.

78 MLS to JHG, January 10, 1901, MRSLA, CAM.

79 See "Asano Was Lost at Singapore," *CE*, December 28, 1903.

80 TR to BS, January 16, 1902, TRP, LOC.

81 MLS to TR, January 31, 1902, TRP, LOC; MLS to TR, January 30, 1902, TRP, LOC; TR to MLS, March 28, 1902, TRP, LOC.

82 MLS to WHT, February 13, 1902, WHTP, LOC.

83 Worthington Chauncey Ford, *The Letters of Henry Adams, 1892–1918* (Boston: Houghton Mifflin, 1938), 383.

84 MLS to WHT, February 1, 1903, WHTP, LOC; MLS to JI, March 25, 1902, JIP, MNHS.

85 MLS to JI, March 25, 1902, JIP, MNHS; MLS to WHT, March 24, 1902, WHTP, LOC.

86 MLS to TR, March 28, 1902, TRP, LOC.

87 BS to TR, December 18, 1901, TRP, LOC.

88 Storer, *In Memoriam*, 64.

89 BS to JI, March 25, 1902, JIP, MNHS.

90 "Castilian," *CE*, May 26, 1902.

91 "Handsome Gift," *CE*, June 13, 1902; MLS to JHG, November 25, 1902, MRSLA, CAM; "Many Changes," *CE*, July 1, 1902.

92 Anita Ellis interview with authors, March 24, 2018.

93 "Bellamy Storer, *CE*, May 23, 1902. Georgina Pell Curtis, *American Catholic Who's Who* (St. Louis: B. Herder, 1911), 626; R. Laurie and Thomas Simmons, "Artus and Anne Van Briggle and Colorado College," in *Colorado College Reader*, ed. Robert D. Loevy, accessed on May 2, 2016, https://faculty1.coloradocollege.edu/~bloevy/ccreader/CC-Reader-010-Simmons-VanBriggle.pdf.

94 "Social Affairs," *CE*, June 4, 1902.

95 BS to EFB, June 11, 1902, EFBP, CMC.

96 Farrell, "Background of the Taft Mission to Rome II," 12n19.

97 MLS to WHT, April 14, 1902, WHTP, LOC.

98 WHT to JH, April 14, 1982, WHTP, LOC.

99 JI to TR, December 8, 1901, JIP, MNHS.

100 Quoted in Storer, *In Memoriam*, 72.

101 "Mgr. Guidi," *Washington Evening Star*, August 28, 1902, Library of Congress, Chronicling America: Historic American Newspapers site, accessed April 15, 2016, http://chroniclingamerica.loc.gov/lccn/sn83045462/1902-08-28/ed-1/seq-2; Reuter, *Catholic Influence in Colonial Policies*, 187. "Under Taft's deliberate leadership, a solution had been islanders, the administration, and the Catholic Church alike." See Goodwin, *The Bully Pulpit*, Kindle e-book, chapter 10.

102 TR to WHT, July 31, 1902, TRP, LOC; WHT to TR, September 13, 1902, TRP, LOC.

103 WHT to MLS, February 8, 1904, WHTP, LOC.

104 "The Spanish American War," *NYT*, July 3, 1902.

105 MLS to EFB, July 15, and September 1, 1902, EFBP, CMC.

106 "Bellamy Storer," *CE*, August 9, 1902.

107 Samuel Batchelder, *Secretary's Report Harvard College Class of 1893, no. 7* (Cambridge, MA: Crimson Printing, 1923), 211.

108 MLS to EFB, September 1, 1902, EFBP, CMC.

109 TR to L. W. Shaw, October 22, 1902, TRP, LOC.

110 John Van Voorhis to TR, March 21, 1902, TRP LOC; MLS to WHT, March 24, 1902, WHTP, LOC; MLS to JI, March 25, 1902, and April 4, TRP, LOC; Leopold Markbriatt to TR, April 2, 1902, TRP, LOC; TR to BS, April 7, April 15, 1902, TRP, LOC; J. J. Keogh to JI, April 21, 1902, TRP, LOC; John Schroers to R. C. Kerens, April 23, 1902, TRP, LOC; RK to JI, TRP, LOC; JI to TR, April 26, 1902; TRP, LOC; MLS to TR, June 8, 1902, TRP, LOC; TR to MLS, June 10, 1902, TRP, LOC; TR to JH, August 5, August 7, August 15, August 21, and September 18, 1902, TRP, LOC; JH to TR, May 29, August 18, and September 14, 1902, TRP, LOC; TR to Emil Steinmetz, August 21, 1902, TRP, LOC; Louis Lange to E. W. Holls, August 29, 1902, TRP, LOC; Emil Schleinitz to E. W. Holls, August 30, 1902, TRP, LOC; E. W. Holls to TR, September 3, 1902, TRP, LOC; M. G. Seckendorff to TR, September 10, 1902, TRP, LOC; Storer, *In Memoriam*, 69–70, and 71–72; JH to TR, August 18, 1902, TRP, LOC; JH to TR, September 14, 1902, TRP, LOC.

111 TR to JH, September 18, 1902, TRP, LOC.

112 MLS to LW, November 10, 1902, WFP, CMC; LW to MLS, November 29, 1902, WFP, CMC.

113 MLS to TR, November 24, 1902, TRP, LOC.

114 "Spanish King's Health Good," *NYT*, December 14, 1902.

115 "President Theodore Roosevelt from an Unpublished Painting of the President by Fedor Encke, Which is Now Placed in the Dining-Room at the White-House," Digital Collection, NYPL, accessed on May 7, 2018, https://digitalcollections.nypl.org/items/9ac31dca-71b9-4d68-e040-e00a18064cc6.

116 Ibid.

117 "Theodore Roosevelt in a Rough Rider Uniform," Smithsonian Institution, accessed on April 24, 2016, http://collections.si.edu/search/record/siris_ari_66925.

Chapter Seven

1 MLS to EFB, February 12, 1903, EFBP, CMC.

2 MLS to JI, January 8, 1903, JIP, MNHS.

3 "Emperor Receives Mr. Storer," *NYT*, January 4, 1903; MLS to "Bug," January 5, 1903, UCA. It is not known for whom the nickname of "Bug" was used. Boehle (*Maria Longworth*) attributed the name to Joe's wife, Mary (Morgan) Nichols. However, Joe did not marry her until 1910 so it is doubtful the nickname is for her.

4 MLS to "Bug," January 5, 1903, UCA.

5 Albert Alexander Vinzenz (General Baron von Margutti), *The Emperor Francis Joseph and His Times* (New York: George Doran, 1921), 118, accessed December 14, 2014, https://archive.org/details/theemperorfrancioomargiala.

6 Vinzenz, *The Emperor Francis Joseph and His Times*, 179.

7 George Grenville Grenville-Moore, *Society Recollections in Paris and Vienna, 1879-1904* (New York: Appleton, 1908), 182, accessed on July 26, 2017, https://archive.org/details/societyrecollectoomoor.

8 Amelia Sarah Levetus, *Imperial Vienna* (New York: John Lane/The Bodley Head, 1905), 406, accessed December 14, 2014, https://archive.org/details/imperialviennaaoolevegoog.

9 MLS to JI, January 8, 1903, JIP, MNHS.

10 "Carnival Season in Vienna," *Washington Post*, January 9, 1903, 9. Proquest Historical Newspapers (144443778).

11 MLS to "Bug," January 8, 1903, UCA.

12 MLS to JI, February 3, 1903, JIP, MNHS.

13 William Draper, *Recollections of a Varied Career* (Boston: Little, Brown, 1909), 286, accessed June 1, 2014, https://archive.org/details/recollectionsofoodrapiala.

14 Allitt, *Catholic Converts: British and American Intellectuals Turn to Rome*, 4; MLS to CW, VH, February 3, February 17, May 2, and July 8, 1903, EHFP, BIA.

15 "Doings of Society in France," *NYT*, March 15, 1903.

16 BS to EB, May 23, 1903, EBP, CMC; MLS to EB, June 29, 1903, EBP, CMC; "Dinner-Luncheons," *Colorado Springs Gazette*, August 2, 1903; "Random Notes," *CE*, July 26, 1903; MLS to WHT, August 16, 1903, WHTP, LOC.

17 "Random Notes," *CE*, July 26, 1903; [No Title,] *Colorado Springs Gazette*, July 14, 1903.

18 MLS to JHG, July 8, 1903, CAMA.

19 Quoted in Storer, *In Memoriam*, 78–79.

20 JI to MLS, July 28, 1903, TRP, LOC.

21 William H. Welch, the first dean of the Johns Hopkins School of Medicine, was Joe's mentor. William Welch (WW) to MLS, September 3, 1903, Joseph L. Nichols, Application for Admission, Records of the Johns Hopkins University School of Medicine, AMCMA, JHMI.

22 Ibid., 144.

23 Edward Baldwin, "Saranac Lake and Saranac Laboratory for the Study of Tuberculosis," *Milbank Memorial Fund Quarterly Bulletin* 10, no.1 (January 1932): 2. JSTOR (3347491).

24 Samuel Batchelder, *Secretary's Report Harvard College Class of 1893, no. 4* (Cambridge, MA: Harvard University Press, 1910), 161.

25 MLS to John Farley (JF), September 15, 1903, John Farley Papers (JFP), New York Archdiocese (NYA).

26 Thomas Shelley, "John Cardinal Farley and Modernism," *Church History* 61, no. 3 (September 1992): 351, 361. JSTOR (3168375).

27 Storer, *Letter of Bellamy Storer to the President and the Members of His Cabinet*, 16.

28 Ibid., 83.

29 TR to DT, March 23, 1903, TRP, LOC.

30 Rafael Merry del Val (RMDV) to BS, December 14, 1903, JIP, MNHS; J. Derek Holmes, "Cardinal Raphael Merry del Val: An Uncompromising Ultramontane: Gleanings from His Correspondence with England," *Catholic Historical Review* 60, no. 1 (April 1974): 55. JSTOR (25019512). Pope Leo XIII died on July 20, 1903. His successor was Pope Pius X, who selected Cardinal Raphael Merry del Val to be his secretary of state.

31 CS to DH, October 3, 1903, University of Notre Dame Archives Calendar, accessed September 25, 2015, http://www.archives.nd.edu/cgi-bin/calindex. pl?keyword=storer.

32 Boram-Hays, *Bringing Modernism Home*, 176.

33 MLS to JI, November 20, 1903, JIP, MNHS.

34 Ibid., 89.

35 BS to JI, December 9, 1903, JIP, MNHS.

36 Ibid.

37 "Pope Receives the Storers," *Hartford Journal Courier*, December 3, 1903, Library of Congress, Chronicling America: Historic American Newspapers site, accessed April 15, 2014, http://chroniclingamerica.loc.gov/lccn/sn84020358/1903-12-03/ed-1/seq-1; "Farley as Cardinal: This Belief at Vatican, Despite Storer's Visit," *New York Tribune*, December 4, 1903, Library of Congress, Chronicling America: Historic American Newspapers site, accessed April 15, 2014, http://chroniclingamerica.loc.gov/lccn/sn83030214/1903-12-04/ed-1/seq-1.

38 Cited in Willard Gatewood, *Theodore Roosevelt and the Art of Controversy* (Baton Rouge: Louisiana State University Press, 1970), 196.

39 TR to BS, December 27, 1903, TRP, LOC; BS to TR, January 16, 1904, TRP, LOC; TR to BS, January 29, 1904.

40 Storer, *In Memoriam*, 95, 102. They took the archbishop's advice to heart and would not visit Rome for another ten years.

41 MLS to WHT, January 21, 1904, WHTP, LOC; WHT to MLS, February 8, 1904, WHTP, LOC.

42 "Secretary Root Dines with the President," *Washington Times*, February 1, 1904, Library of Congress, Chronicling America: Historic American Newspapers site, accessed May 20, 2016, http://chroniclingamerica.loc.gov/lccn/sn84026749/1904-02-01/ed-1/seq-7.

43 MLS to WHT, June 18, 1904, WHTP, LOC; WHT to TR, July 11, 1904, TRP, LOC; TR to WHT, July 11, 1904, TRP, LOC.

44 MLS to EFB, September 2, 1904, EFBP, LOC.

45 Judy Bross, *Murray Bay: The Gilded Age Summer Resort of the Tafts, Sedwicks, Blakes, Minturns, and Their Friends* (North Charleston, SC: CreateSpace Independent Publishing Platform, 2015), viii. Among the Berkshires," *New York Tribune*, September 9, 1904, Library of Congress, Chronicling America: Historic American Newspapers site, accessed May 20, 2016, http://chroniclingamerica.loc.gov/lccn/sn83030214/1904-09-09/ed-1/seq-8; "Hotel Aspinwall, Lenox, Mass," *Lost New England*, accessed May 20, 2016, http://lostnewengland.com/2016/02/hotel-aspinwall-lenox-mass-1.

46 WHT to TR, September 2, 1904, TRP, LOC.

47 BS to DH, November 30, 1904, University of Notre Dame Archives Calendar, accessed on May 12, 2016, http://www.archives.nd.edu/cgi-bin/calindex.pl?keyword=storer.

48 Austen, *Genteel Pagan*, 153, 154; CS to DH, September 29, October 28, and November 18, 1904, University of Notre Dame Archives Calendar, accessed May 12, 2016, http://www.archives.nd.edu/cgi-bin/calindex.pl?keyword=storer.

49 "World of Society," *Washington Evening Star*, October 20, 1904. Library of Congress, Chronicling America: Historic American Newspapers site, accessed April 15, 2014, http://chroniclingamerica.loc.gov/lccn/sn83045462/1904-10-20/ed-1/seq-5.

50 Storer, *Letter of Bellamy Storer to the President and the Members of His Cabinet*, 27; Theodore Roosevelt, *Presidential Addresses and State Papers*, vol. 5 (New York: Review of Reviews Company, 1910), 881.

51 Edward Trudeau (ET) to JLN, September 28, n.y., Trudeau Archive (TA), Adirondack Research Room (ARR), Saranac Lake Free Library (SLFL).

52 BS to EFB, October n.d., 1904, EFBP, CMC.

53 Charles Francis (CF) to TR, December 12, 1906, TRP, LOC.

54 MLS to Edith Kermit Roosevelt (EKR), December 25, 1904, TRP, LOC.

55 TR to MLS, January 9, 1905, TRP, LOC; Gatewood, *Theodore Roosevelt and the Art of Controversy*, 202.

56 MLS to WHT, March 27, 1905, WHTP, LOC; WHT to MLS, April 13, 1905, WHTP, LOC.

57 MLS to TR, April 30, 1905, TRP, LOC; TR to MLS, May 13, 1905, TRP, LOC.

58 MLS to EFB, February 15, 1905, EFBP, CMC.

59 TR to BS, June 7, 1904, TRP, LOC; WHT to MLS, December 22, 1904, WHTP, LOC.

60 MLS to EFB, February 15, 1905, EFBP, CMC.

61 "Art Show in Vienna," *NYT*, January 17, 1905.

62 MLS to EFB, February 15, 1905, EFBP, CMC.

63 "Preventing Disease," *Washington Evening Star*, May 16, 1905, Library of Congress, Chronicling America: Historic American Newspapers site, accessed April 15, 2014, http://chroniclingamerica.loc.gov/lccn/sn83045462/1905-05-16/ed-1/seq-12; Joseph Longworth Nichols, "Studies in Tuberculosis: A Histological Study of Lesions of Immunized Rabbits," *Medical News* 87 (September 30, 1905): 636–638, accessed April 10, 2017, https://archive.org/stream/medicalnews871phi-luoft#page/638/mode/2up.

64 Batchelder, *Secretary's Report Harvard College Class of 1893, no. 7*, 211.

65 James Munson and Richard Mullen, *The Smell of the Continent: The British Discover Europe* (Seattle: Amazon Digital Services, 2010), Kindle e-book, chapter 3.

66 "Golf Club," *Marienbader Tagblatt*, August 31, 1905, accessed May 27, 2016, https://translate.google.com/translate?hl=en&sl=cs&u=http://www.hamelika.cz/%3Fcz_hamelika-otevreni-golfoveho-hriste-v-roce-1905,86&prev=search.

Chapter Eight

1 JI to MLS, November 6, 1905, in MLS to JI, February 3, 1907, JIP, Office of Archives and Records, Archdiocese of St. Paul (AASP). This was a packet of copies of Ireland's letters, dated from December 1905 to February 1906. Some are excerpts, and others are complete copies. Some notes have duplicate information; two have the same dates.

2 MLS to TR, November 20, 1905, TRP, LOC.

3 O'Connell, *John Ireland and the American Catholic Church*, 495.

4 "Americans Growl at Bellamy Storer," *St. Louis Post*, December 3, 1905, 7B. Proquest Historical Newspapers (577609503).

5 TR to BS, December 11, 1905, TRP, LOC; TR to MLS, December 11, 1905, TRP, LOC.

6 JI to MLS, December 20, and December 28, 1905 in MLS to JI, February 3, 1907, JIP, AASP. Copies of both letters were included in the February 1907 packet of letters Maria sent Ireland.

7 MLS to WHT, July 24, 1906, November 6, 1908, WHTP, LOC; MLS to WHT, December 28, 1905, WHTP, LOC.

8 Maria Longworth Storer, "The Recent Tragedy in Bosnia," *Catholic World* 99, no. 593 (August 1914): 674–675, accessed December 4, 2015, https://play.google. com/books/reader?id=Ayo7AQAAMAAJ.

9 TR to BS, February 3, 1905, TRP, LOC.

10 JI to MLS, December 20, and December 28, 1905 in MLS to JI, February 3, 1907, JIP, AASP. Copies of both letters were included in the February 1907 packet of letters Maria sent Ireland.

11 MLS to WHT, July 24, 1906, November 6, 1908, WHTP, LOC; MLS to WHT, December 28, 1905, WHTP, LOC.

12 TR to JI, February 21, 1906, TRP, LOC.

13 TR to BS, telegram, March 5, 1906, TRP, LOC.

14 Storer, *Letter of Bellamy Storer to the President and the Members of His Cabinet*, 42.

15 BS to JI, March 11, 1906, JIP, MNHS.

16 MLS to EFB, March 13, 1906, EFBP, CMC.

17 Elizabeth Kilgour Anderson, *Letters of Mrs. Nicholas Longworth Anderson to Her Son Larz Anderson, 1882–1916*, ed. Isabel Anderson, bound carbon copy typescript, Anderson Collection, Society of the Cincinnati, 394. Elizabeth Kilgour married Civil War Major General Nicholas Longworth Anderson, Maria's first cousin.

18 TR to Winthrop Chanler (WC), March 22, 1906, TRP, LOC.

19 "N.t.," *La Revue Diplomatique*, March 25, 1906.

20 "Random Notes," *CE*, March 25, 1906; "St. Paul People Do Not Believe Mrs. Storer Has Sought His Elevation," *The World*, March 19, 1906, JIP, MNHS; "Wife's Notion Ruined Storer as a Diplomat," [unknown newspaper], March 19, 1906, JIP, MNHS; "Washington Topics, Survey of the World," *The Independent* 60, no. 2990 (March 23, 1906): 645, accessed July 27, 2017, https://hdl.handle. net/2027/msu.31293500313212?urlappend=%3Bseq=669; "What Austria Thinks of Mr. Storer, Foreign Affairs," *Public Opinion* 40, no. 16 (April 21, 1906): 492, accessed December 4, 2015, https://books.google.com/books?id=Pos3AQA-AMAAJ.

21 Nichole Phelps, *Sovereignty, Citizenship, and the New Liberal Order: U.S.-Habsburg Relations and the Transformation of International Politics, 1880–1924* (New York: Cambridge University Press, 2013), Kindle e-book, chapter 2.

22 Elihu Root was selected as secretary of state after the death of John Hay. Phelps, *Sovereignty, Citizenship, and the New Liberal Order*, Kindle, e-book, chapter 2;

"Austria Annoyed by US," *NYT*, March 23, 1906; "Traditions," *CE*, March 23, 1906; "We Shock Austria Again," *NYT*, March 27, 1906; "Storer Muddle Continues," *NYT*, April 4, 1906.

23 "Storer Back in Vienna," *Chicago Daily Tribune*, March 30, 1906, 5. Proquest Historical Newspapers (173310523); "Storer Seriously Ill," *NYT*, March 31, 1906; "Mrs. Storer Gives Roosevelt's Letter," *NYT*, March 31, 1906.

24 Quoted in Storer, *In Memoriam*, 118.

25 "Emperor Received Storer," *Washington Post*, April 13, 1906, 3. Proquest Historical Newspapers (144696265).

26 Stuart, *American Diplomatic and Consular Practice*, 266.

27 Longworth, *Crowded Hours: Reminiscences of Alice Roosevelt Longworth*, 125.

28 "Receptions for the Longworths," *New York Sun*, July 8, 1906, Library of Congress, Chronicling America: Historic American Newspapers site, accessed April 15, 2014, http://chroniclingamerica.loc.gov/lccn/sn83030272/1906-07-08/ed-1/seq-1; "Embark at Cherbourg on the American Liner St. Paul," *Bemidji Daily Pioneer*, August 6, 1906, Library of Congress, Chronicling America: Historic American Newspapers site, accessed April 15, 2014, http://chroniclingamerica.loc.gov/lccn/sn86063381/1906-08-06/ed-1/seq-1.

29 MLS to CW, VH, June 29, August 12, 1906, EHFP, BIA.

30 BS to ER, June 23, 1906, *Dispatches from US Ministers to Austria, 1838–1906*, Micro T-157, Roll 51, 5/1/05-8/8/06, NARA II; Robert Bacon (RB) to BS, July 18, 1906, JIP, MNHS; BS to RB, August 3, 1906, JIP, MNHS; Roosevelt, *Presidential Addresses and State Papers*, vol. 5, 877–878.

31 BS to JI, August 6, 1906, JIP, MNHS.

32 MLS to JI, July 10, 1906, and January 4, 1907, JIP, MNHS.

33 TR to JI, June 11, 1906, TRP, LOC; JI to TR, June 15, 1906, TRP, LOC; JI to TR, June 14, 1906, TRP, LOC.

34 There are no letters because Maria requested that these documents be returned to her. The quotation is taken from a note that was typed on the envelope. WHT to MLS, July 24, 1906, WHTP, LOC.

35 MLS to CW, VH, August 17, 1906, EHFP, BIA.

36 James Britton, "The Catholic Conference, 1906," *The Month, a Catholic Magazine* 108, no. 509 (November 1906): 484, 490, accessed December 4, 2015, https://books.google.com/books?id=fDMoh2-5SMgC.

37 Maria published one article and three poems in the *Dublin Review*. See Appendix. Pierre de Chambrun wrote two articles for the periodical. See the Selected Bibliography. BS to EFB, April 4, 1914, EFBP, CMC; FG to MLS, June 22, 1916; MLS to BF, October 114, 1919, SUA; FG to MLS, June 22, 1916, University of Notre Dame Archives Calendar, accessed September 25, 2015, http://www.archives.nd.edu/cgi-bin/calindex.pl?keyword=storer.

38 MLS to CW, VH, October 19, 1906, EHFP, BIA.

39 MLS to JI, October 5, 1906, JIP, MNHS; Janet Grayson, *Robert Hugh Benson: Life and Works* (New York: University Press of America, 1998), 84.

40 C. C. Martindale, *The Life of Monsignor Robert Hugh Benson*, vol. 2 (New York: Longman, Green, 1916), 156, accessed February 1, 2016, https://archive.org/details/lifeofmonsignorro1mart.

41 Mary Jo Weaver, *Letters from a "Modernist"* (London: Sheed and Ward, 1981), 167–168.

42 MLS to CW, VH, October 19, 1906, EHFP, BIA; Weaver, *Letters from a "Modernist,"* 167–170; Portier, "George Tyrrell in America," 71. His fight with the Vatican resulted in his excommunication in 1907.

43 MLS to JI, October 5, 1906, JIP, MNHS.

44 MLS to CW, VH, November 15, 1906, EHFP, BIA.

45 Storer, *Letter of Bellamy Storer to the President and Members of His Cabinet*, 16–17.

46 The two newspapers were the *Chicago Tribune* and the *Boston Herald*. Senator Shelby Cullom released the document. See Henry Pringle, *Theodore Roosevelt* (New York: Harcourt, Brace, 1931), 454.

47 TR to Elihu Root (ER), December 8, 1906, TRP, LOC; ER to TR, December 9, 1906, TRP, LOC; Gatewood, *Theodore Roosevelt and the Art of Controversy*, 208.

48 Mark Sullivan, *Our Times, 1900–1925*, vol. 3 (New York: Charles Scribner's Sons, 1930), 123.

49 Anderson, *Letters of Mrs. Nicholas Longworth Anderson to Her Son Larz Anderson*, 404.

50 Foraker, *I Would Live It Again*, Kindle e-book, chapter 17.

51 "Petticoat Statecraft," *Los Angeles Times*, December 12, 1906, 114. Proquest Historical Newspapers (159148912).

52 Lawrence Wood, *Horace Plunket in America* (Glendale, CA: Arthur H. Clark, 2010), 170.

53 "Senator's Secretary," *Saturday Evening Post* 179, no. 27 (January 5, 1907): 19, https://hdl.handle.net/2027/uiug.30112109515871?urlappend=%3Bseq=25.

54 Levenson, Samuels, Vandersee, and Winner, eds., *The Letters of Henry Adams, 1906–1918*, vol. 6, 35.

55 "Petticoat Statecraft," 114; "The Case of Mrs. Bellamy Storer," *New Outlook* 84 (December 15, 1906): 901, accessed December 4, 2015, https://play.google.com/books/reader?id=wa9XXoMKwv8C.

56 BS to CW, VH, December 16, 1906, EHFP, BIA.

57 "Storer, Defending Wife Attacks the President," *NYT*, December 9, 1906; "Jail for Ambassador Who Divulges Secrets," *NYT*, December 10, 1906; "Storer Is Bitter," *Chicago Daily Tribune*, December 11, 1906, 1. Proquest Historical Newspapers (173293728); "Veracity of the President Assailed by Ex-Ambassador," *Chicago Daily Tribune*, December 7, 1906, 1. Proquest Historical Newspapers (173332436); "'We Made Roosevelt,' Says Mrs. Storer," *NYT*, December 11, 1906; "A Woman's

Career in Politics and Politics," *NYT*, December 16, 1906; (Cartoons) *Chauffeur Teddy: Anything Ahead Bill?* Library of Congress Prints and Photographs Division; Maria Longworth Storer, *Nicholas Longworth's Dilemma*, in Isabel Anderson, *Presidents and Pies: Life in Washington 1897–1919* (Boston: Houghton Mifflin, 1920), 158; (Poems) "On the Funny Bone," *Currier Journal*, December 20, 1906, 4. Proquest Historical Newspapers (19302177); "A Little Nonsense," *Washington Herald*, December 18, 1906, Library of Congress, Chronicling America: Historic American Newspapers site, accessed April 15, 2014, http://chroniclingamerica.loc.gov/lccn/sn83045433/1906-12-18/ed-1/seq-6.

58 "For Mrs. Bellamy Storer, This Week in Society," *Town and Country Life*, December 1, 1906.

59 MLS to SL, February n.d., 1907, LFP, CMC.

60 Anderson, *Letters of Mrs. Nicholas Longworth Anderson to Her Son Larz Anderson*, 405.

61 MLS to MTR, December 20, 1906, JHTP, CMC; MLS to JI, January 4, 1907, JIP, MNHS.

62 BS to CW, VH, December 16, 1906, EHFP, BIA.

63 MLS to EFB, February 18, 1907, EFBP, CMC; MLS to EFB, February n.d., 1907, EFBP, CMC; MLS to SL, February n.d., 1907, LFP, CMC; MLS to JG, February n.d., 1907, Associated Archives at Saint Mary's Seminary and University (AASMSU).

64 TR to Nicholas Longworth III (NL3), May 14, 1907, TRP, LOC.

65 NL3 to TR, May 16, 1907, TRP, LOC.

66 MLS to JI, January 4, 1907, JIP, MNHS.

67 "Ireland to Visit Storers," *NYT*, January 20, 1907; "Notables," *CE*, February 1, 1907; "Monsignor Ireland Stays Home," *NYT*, February 1, 1907; BS to JW, February 16, 1907, CMC.

68 MLS to Howard Hollister (HH), December 27, 1906, WHTP, LOC.

69 MLS to EFB, February n.d, 1907, EFBP, CMC; CS to DH, February 26, 1907, University of Notre Dame Archives Calendar, accessed September 25, 2015, http://www.archives.nd.edu/cgi-bin/calindex.pl?keyword=storer.

70 "Storer," *CE*, April 4, 1907.

71 MLS to JI, January 4, 1907, JIP, MNHS.

Chapter Nine

1 Martindale, *The Life of Monsignor Robert Hugh Benson*, 157.

2 Robert Hugh Benson, *Lourdes* (St. Louis: B. Herder, 1914), 1, 2, 5.

3 Quoted in Martindale, *The Life of Monsignor Robert Hugh Benson*, 157.

4 Benson, *Lourdes*, 73, 74, 76, 8.

5 MLS to JG, January 30, 1908, AASMSU; Maria Longworth Storer, "A Favor of

Our Queen: The Cure of Marie Borel," *Ave Maria* 61, no. 17 (April 25, 1908): 528; Maria Longworth Storer, *The Story of a Miracle at Lourdes, August 1907* (New York: Catholic World Press, 1908), 1–21.

6 Martindale. *The Life of Monsignor Robert Hugh Benson*, 157; Benson, *Lourdes.*

7 Storer, "A Favor of Our Queen," 528–533.

8 Patrick Ahern, *The Life of John J. Keane* (Milwaukee: Bruce Publishing, 1954), 352; MLS to CW, VH, August 12, 1906, EHFP, BIA.

9 MLS to JG, September 8, 1918, AASMSU.

10 "Bellamy Storer Home," *NYT*, September 22, 1907; "Bellamy Storer Laughs," *Washington Evening Star*, September 22, 1907.

11 "May Be Storers' Guests," *NYT*, October 11, 1907.

12 *Green Hill Guest Book* 9 (November 3, 1907), 15, ISGM. Bellamy's relatives included Francis (Frank) Storer, who was a chemistry professor at Harvard, and Catholic convert Horatio Storer, who was a noted gynecologist and anti-abortion crusader. Maria's relatives were Larz and Isabel Anderson, who owned a home called Weld in Brookline, Massachusetts.

13 Alexander Theroux, "Henry James's Boston," *Iowa Review* 20, no. 2 (Spring/Summer 1990): 159, 161, *Iowa Research Online*, accessed July 15, 2016, http://ir.uiowa.edu/cgi/viewcontent.cgi?article=3902&context=iowareview.

14 "Savants of the Roman Church," *Washington Evening Star*, October 30, 1907, Library of Congress, Chronicling America: Historic American Newspapers site, accessed April 15, 2014, http://chroniclingamerica.loc.gov/lccn/sn83045462/1907-10-30/ed-1/seq-14; "Bellamy Storer Now Resident of Boston," *Boston Daily Globe*, October 11, 1907, accessed February 24, 2017, http://pqasb.pqarchiver.com/boston/doc/500908537.html.

15 "In the World of Society," *Washington Evening Star*, December 16, 1907, Library of Congress, Chronicling America: Historic American Newspapers site, accessed April 15, 2014, http://chroniclingamerica.loc.gov/lccn/sn83045462/1907-12-16/ed-1/seq-7; "Table Gossip," *Boston Sunday Globe*, December 15, 1907, accessed February 24, 2017, http://pqasb.pqarchiver.com/boston/doc/500948619.html.

16 Rollin Van N. Hadley ed., *The Letters of Bernard Berenson and Isabella Stewart Gardner, 1887–1924, with Correspondence by Mary Berenson* (Boston: Northeastern University Press, 1987), xviii.

17 "Society," *Evening Star*, January 26, 1908, Library of Congress, Chronicling America: Historic American Newspapers site, accessed April 15, 2014, http://chroniclingamerica.loc.gov/lccn/sn83045462/1908-01-26/ed-1/seq-59; *Green Hill Guest Book* 9 (November 3, 1907), 15, ISGM; Marian Janssen, *Not at All What One Is Used To: The Life and Times of Isabella Gardner* (Columbus: University of Missouri Press, 2010), 8.

18 MLS to A. Lawrence Lowell (ALL), April 19, 1925, A. Lawrence Lowell Papers (ALLP), Harvard University Archives (HUA).

19 BS to ISG, N.m. n.d., 1909, ISGM.

20 "Savants of the Roman Church," *Washington Evening Star*, October 30, 1907, Library of Congress, Chronicling America: Historic American Newspapers site, accessed April 15, 2014, http://chroniclingamerica.loc.gov/lccn/sn83045462/1907-10-30/ed-1/seq-14; "Notes," *The Advance* 54, no 2194 (November 28, 1907): 656, accessed November 8, 2016, https://books.google.com/books?id=qaFLAAAAYAAJ.

21 "Merry del Val Sustained," *New York Sun*, August 2, 1904, Library of Congress, Chronicling America: Historic American Newspapers site, accessed April 15, 2014, http://chroniclingamerica.loc.gov/lccn/sn83030272/1904-08-02/ed-1/seq-2. See also See C. J. T. Talar, "An Americanist in Paris: The Early Career of the Abbé Félix Klein," in Hatch, Derek Christopher, Timothy R. Gabrielli, and William L. Portier, *Weaving the American Catholic Tapestry: Essays in Honor of William L. Portier* (Eugene, OR: Pickwick Publications, 2017), 110-124.

22 James O'Toole, "'These Stray Letters of Mine': Forgery and Self-Creation in the Letters of Cardinal William O'Connell," *New England Quarterly* 81, no. 3 (September 2008): 491-492. JSTOR (20474657).

23 James O'Toole, "'That Fabulous Churchman': Toward a Biography of Cardinal O'Connell," *Catholic Historical Review* 70, no. 1 (January 1984): 28. JSTOR (25021735).

24 Paula Kane, *Separatism and Subculture: Boston Catholicism, 1900–1920* (Chapel Hill: University of North Carolina Press, 1994), 17.

25 There were sexual scandals and other improprieties during his leadership of the archdiocese. See Donald Slawson, *Ambition and Arrogance: Cardinal William O'Connell of Boston and the American Catholic Church* (Oregon, IL: Quality Books, 2007); James O'Toole, *Militant and Triumphant: William Henry O'Connell and the Catholic Church of Boston, 1859–1944* (Notre Dame, IN: University of Notre Dame Press, 1994).

26 William O'Connell, *Sermons and Addresses of His Eminence William Cardinal O'Connell, Archbishop of Boston*, vol. 9, *1925–1928* (Cambridge, MA: Riverside Press, 1930), 123, accessed April 10, 2017, https://archive.org/details/sermonsaddresses090-conuoft.

27 Wayman, "Some Unpublished Correspondence between the Bellamy Storers and Cardinal O'Connell," 161, 139n28.

28 Ibid., 129–177.

29 Ibid., 161.

30 CS to DH, April 9, May 22, August 14, 1907, DHP, AUND.

31 "Storers Are Content," *Daily Press Newport*, February 13, 1908, Library of Congress, Chronicling America: Historic American Newspapers site, accessed April 15, 2014, http://chroniclingamerica.loc.gov/lccn/sn83045830/1908-02-13/ed-1/seq-4; "Savants of the Roman Church," *Washington Evening Star*, October 30, 1907, Library of Congress, Chronicling America: Historic American Newspapers site, accessed April 15, 2014, http://chroniclingamerica.loc.gov/lccn/sn83045462/1907-10-30/ed-1/seq-14; "1577: M. L. Storer Repoussé Copper with Monkey," *Live Auctioneers*, accessed July 1, 2016, https://www.liveauctioneers.

com/item/62911_ml-storer-repousse-copper-with-monkey; "Class Experience, Come Tool Along with Me," *Lesson Corner*, accessed July 1, 2016, http://archives.lessoncorner.com/c9b0da6b95e9042b6.pdf.

32 When Maria returned to Europe in 1919, she left behind several of her completed and incomplete copper projects at the Saint Ursula Convent and the Academy. After that time, there is no reference to the artwork in her letters or the newspapers so it is not known if she continued working in copper.

33 "Exhibition," *American Art News* 6, no. 24 (March 28, 1908): 2. JSTOR (25590339).

34 Arnold Sparr, "From Self-Congratulation to Self-Criticism: Main Currents in American Catholic Fiction, 1900–1960," *U.S. Catholic Historian* 6, nos. 2/3 (Spring/ Summer 1987): 215. JSTOR (25153793).

35 *Quarterly Publication of Report of the Historical and Philosophical Society of Ohio, 1906–1908*, vols. 1–3 (Cincinnati: Press of Jennings and Graham, 1907), 125, accessed December 14, 2014, https://play.google.com/books/reader?id=dGdHAQAAMAAJ.

36 Bellamy Storer, "The Church of Brou," *Christian Art* 4, no. 3 (December 1908): 95, accessed December 4, 2015, https://books.google.com/books?id=TxrnAAAAMAAJ.

37 "Storers Are Content"; "Spain's Great Future," *Boston Daily Globe*, January 17, 1908, accessed February 24, 2017, http://pqasb.pqarchiver.com/boston/doc/500972681.html; "Editorial Points," *Boston Daily Globe*, January 18, 1908, accessed February 24, 2017, http://pqasb.pqarchiver.com/boston/doc/500977043.html.

38 Joseph Longworth Nichols, "Angeimata in Valves of Heart of a Newly Born Child," *Journal of Experimental Medicine* 10, no. 3 (May 1908): 368–370, *JEM.com*, accessed April 10, 2017, https://www.ncbi.nlm.nih.gov/pmc/articles/PMC2124526/pdf/368.pdf.

39 "New Curling Rink," *Historic Saranac Lake*, accessed July 12, 2016, https://localwiki.org/hsl/New_Curling_Rink.

40 MLS to Henry Adams (HA), March 9, 11, 1908, Henry Adams Papers (HAP), Massachusetts (MHS).

41 MLS to DH, April 27, 1909, DHP, AUND.

42 "Ocean Travelers," *NYT*, April 9, 1908; "Table Gossip," *Boston Sunday Globe*, April 18, 1909, accessed February 24, 2017, http://pqasb.pqarchiver.com/boston/doc/501232248.html.

43 Viola Hopkins Winner, "The Paris Circle of Edith Wharton and Henry Adams," *Edith Wharton Review*, no. 1 (Spring 1992): 2–3. JSTOR (43512790).

44 "Americans in Paris," *Boston Daily Globe*, September 28, 1902, accessed February 24, 2017, http://pqasb.pqarchiver.com/boston/doc/499729433.html.

45 BS to EFB, November 28, 1909, EFBP, CMC.

46 BS to EFB, June 8, 1912, EFBP, CMC. Since a gadfly is a person who challenges those in power, it is a perfect label for the Storers during the time 1907–1914.

They were critical about the increasing secular society and the politics of Theodore Roosevelt.

47 "American Season Closes in London," *NYT*, September 20, 1908; "Notables Back from Europe," *Washington Evening Star*, September 26, 1908, Library of Congress, Chronicling America: Historic American Newspapers site, accessed April 15, 2014, http://chroniclingamerica.loc.gov/lccn/sn83045462/1908-09-26/ed-1/seq-1; "No Woman's Rights for Her," *New York Sun*, September 27, 1908, Library of Congress, Chronicling America: Historic American Newspapers site, accessed April 15, 2014, http://chroniclingamerica.loc.gov/lccn/sn83030272/1908-09-27/ed-1/seq-6.

48 New York Passenger Arrival Lists (Ellis Island), 1892–1924, accessed July 5, 2016, https://familysearch.org/search/collection/results?count=20&query=%2B-givenname%3A%22joseph%20longowrth%22~%20%2Bsurname%3Anichols~&collection_id=1368704.

49 *Report of the Nineteenth Eucharistic Congress, Held at Westminster from 9–13 September 1908* (London: Sands and Co., 1909), 581, 591, accessed July 10, 2016, https://archive.org/details/reporteucharistoounknuoft.

50 MLS to EFB, October 15, 1908, EFBP, CMC.

51 Wayman, "Some Unpublished Correspondence between the Bellamy Storers and Cardinal O'Connell," 134–135.

52 Kane, *Separatism and Subculture Boston Catholicism, 1900–1920*, 23.

53 CS to DH, April 9 and August 14, 1907, DHP, AUND; "Washington News," *National Tribune*, December 5, 1907, Library of Congress, Chronicling America: Historic American Newspapers site, accessed April 15, 2014, http://chroniclingamerica.loc.gov/lccn/sn82016187/1907-12-05/ed-1/seq-5.

54 MLS to WHT, November 23, 1908, WHTP, LOC; WHT to MLS, November 27, 1906, WHTP, LOC; MLS to WHT, December 2, 1908, WHTP, LOC.

55 *Green Hill Guest Book* 9 (October 11, 1908), 50, ISGM; "Thanksgiving," see Isabella Stewart Gardner, November 22, 2014, Facebook, accessed July 6, 2016, https://www.facebook.com/gardnermuseum/.

56 Shand-Tucci, *The Art of Scandal*, 110.

57 Wayman, "Some Unpublished Correspondence between the Bellamy Storers and Cardinal O'Connell," 133.

58 Ibid., 137–138, 142, 143, 154, 155; "Priest Taken by Garibaldi," *Ogdenburg Journal*, February 28, 1916, NYS Historic Newspapers, http://nyshistoricnewspapers.org/lccn/sn85054113/1916-02-28/ed-1/seq-3.

59 Wayman, "Some Unpublished Correspondence between the Bellamy Storers and Cardinal O'Connell," 133.

60 William O'Connell (WO'C) to ISG, January 28, 1909, ISGM; "Catholic Church Notes," *Washington Herald*, January 30, 1909, Library of Congress, Chronicling America: Historic American Newspapers site, accessed April 15, 2014, http://chroniclingamerica.loc.gov/lccn/sn83045433/1909-01-30/ed-1/seq-7; "Rev.

Dr. Vaughan's Sermon," *Washington Herald*, February 5, 1909, Library of Congress, Chronicling America: Historic American Newspapers site, accessed April 15, 2014, http://chroniclingamerica.loc.gov/lccn/sn83045433/1909-02-05/ed-1/seq-12. This gentleman was the nephew of Cardinal Herbert Vaughan who died in 1903.

61 Louise Tharp, *Mrs. Jack* (Boston: Isabella Stewart Gardner Museum, 1965), 275.

62 "Storers Come In as Roosevelt Goes Out," *Burlington Weekly Free Press*, February 18, 1909, Library of Congress, Chronicling America: Historic American Newspapers site, accessed April 15, 2014, http://chroniclingamerica.loc.gov/lccn/sn86072143/1909-02-18/ed-1/seq-6.

63 "Art Table for Mrs. Taft, Gift of Mrs. Storer," *St. Louis Post*, April 16, 1909, 7. Proquest Historical Newspapers (579721633).

64 "Random Notes," *CE*, February 4, 1912; Wayman, "Some Unpublished Correspondence between the Bellamy Storers and Cardinal O'Connell," 162–163. This is the last time that Maria tried to obtain a position for her husband.

65 "Preeminent Professionals," *American Ceramic Society Bulletin* 89, no. 6 (August 2010): 31.

66 "Mrs. Storer," *CE*, April 2, 1909.

67 "Random Notes," *CE*, March 31, 1912; "Society," *Washington Post*, April 8, 1912; "Father General" to MLS, June 29, 1928, Friars of the Atonement Archives/Record Center (FAARC); Wayman, "Some Unpublished Correspondence between the Bellamy Storers and Cardinal O'Connell," 137, 140; "Holy Angels Church," *CE*, September 19, 1909; *Twentieth Annual Report of the Rector: The Catholic University September 30, 1909* (Baltimore: J. H. Furst, 1909), 5, accessed December 4, 2015, https://play.google.com/books/reader?id=d2rPAAAAMAAJ.

68 "Random Notes," *CE*, June 20, July 25, 1909; "Social Notes," *NYT*, July 17, 1909. Philip Gallos, *Cure Cottages of Saranac Lake* (Saranac Lake, NY: Historic Saranac Lake, 1985), 24–25.

69 MLS to DH, August n.d., 1909, DHP, AUND.

70 "Art Put to Good Use," *San Mateo Item*, July 17, 1909, Library of Congress, Chronicling America: Historic American Newspapers site, accessed April 15, 2014, http://chroniclingamerica.loc.gov/lccn/sn95047348/1909-07-17/ed-1/seq-15.

71 BS to EFB, September 22, November 28, 1909, EFBP, CMC.

72 See JPdeC interview by Sister Rose Angela Boehle, May 19, and May 23, 1988, Rose Angela Boehle Papers, USCA.

73 BS to EFB, November 2, 1909, EFBP, CMC.

74 BE to EFB, November 28, 1909, EFBP, CMC.

75 JFdeC, interview with authors, September 13, 2014.

76 Levenson, Samuels, Vandersee, and Winner, eds., *The Letters of Henry Adams, 1892–1918*, vol. 6, 254, 459; Larz Anderson, *Letters and Journals of a Diplomat* (New York: Fleming Revell, 1940), 346, 455, 645; Massie Ward, *Insurrection versus Resurrection* (New York: Sheed and Ward, 1937), 444.

77 BS to EFB, November 2, 1909, EFBP, CMC.

78 Georgina Curtis, *The American Catholic Who's Who* (St. Louis: B. Herder, 1911), 94; "Margaret de Chambrun," *WorldCat*, accessed July 10, 2016, https://www.world-cat.org/search?q=margaret+de+chambrun&qt=results_page.

79 "Nick's Sister Is a Politician, Too; Wins for Hubby," *Cincinnati Post*, May 13, 1910, American Historical Newspapers, http://infoweb.news-bank.com.research.cincinnatilibrary.org/resources/doc/nb/image/v2%3A13E376E28E0F8354%40EANX-NB-13FD7091ABoCF2A3%402418805-13FAC600D5549605%400-13FAC600D5549605%40?p=EANX-NB&hlterms=%22lozere%22. The title of the article is incorrect. The article is about Min, not Clara de Chambrun.

80 JFdeC, interview with authors, September 13, 2014.

81 BS to EFB, November 2, 1909, EFBP, CMC. "De Chambrun, 88, Diplomat Dead," *NYT*, August 25, 1954.

82 Charles Vandersee, "Henry Adams' Education of Martha Cameron: Letters 1888–1916," *Texas Studies in Literature and Language* 10, no. 2 (Summer 1968): 280. JSTOR (40753989).

83 "Oregon Is on French Maps," *East Oregonian*, May 19, 1908, Library of Congress, Chronicling America: Historic American Newspapers site, accessed April 15, 2014, http://chroniclingamerica.loc.gov/lccn/sn88086023/1908-05-19/ed-1/.

84 "Personal," *America* 2, no. 10 (December 18, 1909), 269, accessed April 8, 2017, https://play.google.com/books/reader?id=xlo_AQAAMAAJ; "Table Gossip," *Boston Sunday Globe*, January 16, 1910, accessed February 24, 2017, http://pqasb.pqarchiver.com/boston/doc/501416151.html; Wayman, "Some Unpublished Correspondence between the Bellamy Storers and Cardinal O'Connell," 139.

85 "Bellamy Storer Speaks," *Boston Daily Globe*, February 10, 1910, accessed February 24, 2017, http://pqasb.pqarchiver.com/boston/doc/501436501.html; "A Notable Address on the Situation in France," *Ave Maria* 70, no. 11 (March 12, 1910): 370–371; Bellamy Storer, "The Bishops and the Schools in France; An Address before the Catholic Union of Boston, February 5, 1910," *WorldCat*, accessed July 12, 2016, https://www.worldcat.org/search?q=bellamy+storer+the+bish-ops+and+the+schools&qt=results_page.

86 BS to ISG, February 26, n.y., ISGM. The letter's topics suggest it was written at about this time.

87 Letters to the Editor," *America* 2, no. 26 (April 9, 1910): 709, accessed December 4, 2015, https://play.google.com/books/reader?id=xlo_AQAAMAAJ; "Mrs. Storer Calls Roosevelt a Danger," *NYT*, September 22, 1910; Maria Longworth Storer, "The War against Religion in France," *Catholic World* 90, no. 539 (February 1910): 611–620, accessed December 4, 2015, https://play.google.com/books/reader?id=04gEAAAAMAAJ; Maria Longworth Storer, "The Decadence of France," *North American Review* 191, no. 651 (February 1910): 168–184, https://play.google.com/books/reader?id=zrsxAQAAMAAJ. Maria Longworth Storer, "The Gate of Sin," *Living Age* 266, no. 3443 (July 1910): 2. Maria Longworth Storer, "The Gate of Sin," *Dublin Review* 146, nos. 292/293 (January/April 1910): 300–301,

accessed on July 26, 2017, https://hdl.handle.net/2027/mdp.39015027529158?ur-lappend=%3Bseq=308.

88 "Sees America's Peril in Lack of Religion," *Washington Herald*, February 26, 1910, Library of Congress, Chronicling America: Historic American Newspapers site, accessed April 15, 2014, http://chroniclingamerica.loc.gov/lccn/sn83045433/1910-02-26/ed-1/seq-1; "Reviews and Magazine," *America* 2, no. 21 (March 5, 1910): 567, accessed April 8, 2017, https://play.google.com/books/reader?id=xlo_AQAAMAAJ; "Letters to the Editor," *America* 2, no. 26 (March 26, 1910): 709 accessed December 4, 2015, https://play.google.com/books/reader?id=xlo_AQAAMAAJ.

89 "Random Notes," *CE*, March 6, 13, 1910.

90 Gallos, *Cure Cottages of Saranac*, 146; "Miss Morgan to Wed," *New York Sun*, March 5, 1910, 6. Proquest Historical Newspapers (538790248); "Dr. J. L. Nichols Takes a Bride," *Post Standard*, April 6, 1910.

91 "Ecclesiastical Items," *Sacred Heart Review* 43, no 17 (April 16, 1910), 2, accessed April 4, 2017, http://newspapers.bc.edu/cgi-bin/bostonsh?a=d&d=BOSTONSH19100416-01.2.4&e=en-20--1--txt-txIN.

92 Grayson, *Robert Hugh Benson*, 153

93 Julia Ward Howe and Maud Howe, "American Drawing Rooms: The Story of My Boston Drawing Room," *Woman's Home Companion* 37, no. 10 (October 1910): 7, accessed July 26, 2017, https://hdl.handle.net/2027/osu.32435056329501?ur-lappend=%3Bseq=227.

94 Joseph H. McMahon, "Robert Hugh Benson," *Bookman* 41, no. 2 (April 1915): 166, 167, accessed April 9, 2017, https://archive.org/stream/bookmanareview-b01unkngoog#page/n190/mode/2up/search/benson.

95 Quoted in Grayson, *Robert Hugh Benson*, 151n2.

96 TR to HCL, April 6, 27, 1910, TRP, LOC; HCL to TR, April 7, 1910, TRP, LOC; Wayman, "Some Unpublished Correspondence between the Bellamy Storers and Cardinal O'Connell," 147.

97 Storer, *In Memoriam*, 119–120.

98 "Mrs. Storer Calls Roosevelt a Danger"; "Roosevelt Won't Answer Storers," *NYT*, September 23, 1910.

99 Ibid.; "Storers Return," *CE*, October 4, 1910.

100 *Green Hill Guest Book* 11 (October 23, 1910), 1, ISGM.

101 "Mrs. Foss a Guest," *Boston Daily Globe*, November 11, 1910, accessed February 24, 2017, http://pqasb.pqarchiver.com/boston/doc/501599850.html; Wayman, "Some Unpublished Correspondence between the Bellamy Storers and Cardinal O'Connell," 149–156; "Ordained a Roman Priest," *Boston Evening Transcript*, December 24, 1910, accessed April 7, 2017, Google News; "Storer Scores New Religions," *Boston Daily Globe*, March 13, 1911, https://secure.pqarchiver.com/boston/doc/501449080.html.

102 Simon Baldus (SB) to MLS, January 19, 1911, Simon Baldus Papers (SBP), American Catholic History Research Center and University Archives (ACHR-CUA); "Social Affairs," *CE*, January 21, 1911.

103 Wayman, "Some Unpublished Correspondence between the Bellamy Storers and Cardinal O'Connell," 158.

104 Maria Longworth Storer, *Some Verses Written in Honor of the Church and Dedicated to Saint Catherine of Siena* (Rome: Instituto Pio IX, n.d.).

105 Maria Longworth Storer, "The Real Reformer," in *An Appeal for Unity in Faith*, ed. John Phelan (Chicago: M. A. Donohue, 1911), 321–322. Maria Longworth Storer, *The Soul of a Child* (London: R. and T. Washbourne, 1911).

106 Quoted in MLS to TC, June 22, 1918, JFP, NYA.

107 "Table Gossip," *Boston Sunday Globe*, April 9, 1911, http://pqasb.pqarchiver.com/boston/doc/501689144.html; "Table Gossip," *Boston Sunday Globe*, April 16, 1911, accessed February 24, 2017, http://pqasb.pqarchiver.com/boston/doc/501699078.html; *Board Minutes Notes, April, 1911–April 1931*, Adirondack Health and Its Affiliates, Saranac Lake; "General Hospital of Saranac Lake," *Historic Saranac Lake*, accessed July 16, 2016, https://localwiki.org/hsl/General_Hospital_of_Saranac_Lake.

108 *Green Hill Guest Book* 9 (June 11, 1911), 9, ISGM.

109 BS to EFB, August 27, 1911, EFBP, CMC.

110 "Random Notes," *CE*, June 28, 1911; BS to EFB, August 27, 1911, EFBP, CMC; Larz Anderson, "A Mission to Belgium: Legation in the Palais d'Assche," vol. 16, in *Some Scraps* (N.p.: n.p., n.d), Anderson Collection, Society of the Cincinnati, 5–6.

111 "Archbishop Ireland Silent," *NYT*, October 28, 1911; Wayman, "Some Unpublished Correspondence between the Bellamy Storers and Cardinal O'Connell," 159–160.

112 "Storers Plan to Return," *NYT*, September 16, 1911; "Storers Are Coming Back," *Stevens Pt. Daily Journal*, September 18, 1911.

113 "Jury," *CE*, June 3, 1913; "News of the Court," *CE*, October 30, 1913; "Political Burial of Foraker," *CE*, November 17, 1908; "Free Field for Foraker's Toga," *CE*, November 6, 1908.

114 Wayman, "Some Unpublished Correspondence between the Bellamy Storers and Cardinal O'Connell," 161; Goodwin, *The Bully Pulpit*, Kindle e-book, chapter 26.

115 "Random Notes," *CE*, November 5, 6, 12, 19, 26, 30, December 10, 1911; February 4, April 21, May 12, 15, 1912; "Social Affair," *CE*, November 29, 1911; MLS to HM, December 29, 1911, ACA; Wayman, "Some Unpublished Correspondence between the Bellamy Storers and Cardinal O'Connell," 162–163.

116 "Random Notes," *CE*, February 11, 18, 1912.

117 Maria Longworth Storer, "How Theodore Roosevelt Was Appointed Assistant Secretary of the Navy," *Harper's Weekly* 56, no. 293 (June 1, 1912): 8–12; "Reopens

Fire on T.R.," from the *New York World* quoted in the *Washington Post*, May 29, 1912, Proquest (145150942); Wayman, "Some Unpublished Correspondence between the Bellamy Storers and Cardinal O'Connell," 164. Maria wrote to Cardinal O'Connell, "I have tried to express what seems to me to be the only Catholic point-of-view in a letter to the [*New York*] *Evening Post* (which I enclose)." "Mrs. Storer Calls 'King Theodore' Leader of Fools," *New York Evening World*, May 28, 1912, Library of Congress, Chronicling America: Historic American Newspapers site, accessed April 15, 2014, http://chroniclingamerica.loc.gov/lccn/sn83030193/1912-05-28/ed-1/seq-3.

118 Anderson, "A Mission to Belgium: Legation in the Palais d'Assche," 414.

119 BS to EFB, June 8, 1912, EFBP, CMC.

120 Martindale, *The Life of Monsignor Robert Hugh Benson*, 172.

121 Wayman, "Some Unpublished Correspondence between the Bellamy Storers and Cardinal O'Connell," 164–165; Maria Longworth Storer, "The Blessing of Bad Weather," *America* 8, no. 1 (October 12, 1912): 13, accessed December 4, 2015, https://books.google.com/books?id=ZVQ_AQAAMAAJ; Nelia Hyndman-Rizk, ed., *Pilgrimage in the Age of Globalization: Constructions of the Sacred and Secular in Late Modernity* (Cambridge: Cambridge Scholars Publishing, 2012), 42.

122 See poems in Appendix; Storer, "Blessing of Bad Weather," 13.

123 See novels in Appendix. It is believed the four novels were published simultaneously in Europe and America. Sister Rose Angela Boehle stated that "[s]he wanted them published simultaneously." See Boehle, *Maria: A Biography of Maria Longworth*, 141. It is not known if Maria paid to have the books published.

124 WHT to MLS, July 3, 1912, WHTP, LOC; "Partial List of Contributions to 1904 GOP Fight," *Washington Times*, Late Edition, October 18, 1912, Library of Congress, Chronicling America: Historic American Newspapers site, accessed April 15, 2014, http://chroniclingamerica.loc.gov/lccn/sn84026749/1912-10-18/ed-1/seq-1.

125 WHT to Annie Rives Longworth Wallingford (ARLW), November 9, 1912, WHTP, LOC.

126 "Random Notes," *CE*, November 10, and December 1, 1912, January 26, and February 16, 1913; "Blessed Guanella's Trip to America: Planting the Seeds of Charity," Blessed Luigi Guanella, accessed July 24, 2016, http://www.luigiguanella.com/America.html; Storer, "The Awakening of Austria," 477–485; Storer, "The Recent Tragedy in Bosnia," 674–677.

127 "Bellamy Storers in Rome; Don't See the Pope," *New York Sun*, June 1, 1913, Library of Congress, Chronicling America: Historic American Newspapers site, accessed April 15, 2014, http://chroniclingamerica.loc.gov/lccn/sn83030272/1913-06-01/ed-1/seq-50.

128 Wayman, "Some Unpublished Correspondence between the Bellamy Storers and Cardinal O'Connell," 165–166.

129 BS to EFB, June 8, 1912, EFBP, CMC.

130 "Notes of the Social World," *New York Sun*, October 16, 1913, Library of Congress, Chronicling America: Historic American Newspapers site, accessed April 15, 2014, http://chroniclingamerica.loc.gov/lccn/sn83030272/1913-10-16/ed-1/seq-9; Batchelder, *Secretary's Report Harvard College Class of 1893, no. 4*, 161.

131 "Stageland Gossip," *CE*, November 6, 1913; "Random Notes," *CE*, November 23, December 1, 1913, and January 4, 1914; "Forefathers' Day Event," *CE*, December 19, 1913; Wilfrid Ward, "A Visit to America," *Dublin Review* 154, nos. 308/309 (January/April 1914): 222, accessed on July 26, 2017, https://hdl.handle.net/2027/coo.31924065585592?urlappend=%3Bseq=219.

132 "Elizabeth D. Storer," *Vassar Miscellany* 43, no. 5 (March 1, 1914): n.p.; "Miss Elizabeth D. Storer Passed Away after Lingering Illness," *CE*, December 26, 1913; "Obituary 1 [No Title]," *CE*, December 27, 1913; "Storer, Elizabeth D.," Genealogy Search Listing, *Spring Grove*, accessed February 18, 2016, http://www.springgrove.org/geneology-listing.aspx?firstname=&lastname=storer&cemetery=SPRINGGROVE.

133 Mary-Cabrini Durkin, *The Story of the Ursulines of Cincinnati* (Cincinnati, OH: Ursulines of Cincinnati, 2009), 12.

134 MLS to Fidelis Coleman (FC), May 14, 1914, USCA; Baptista Freaner (BF) to FC, May 14, 1914, USCA.

135 "Table Talk," *Boston Daily Globe*, March 1, 1914, http://pqasb.pqarchiver.com/boston/doc/502559699.html; "Random Notes," *CE*, March 1, 1914.

Chapter Ten

1 "Throngs in Rome Churches," *NYT*, April 12, 1912. Alice Mary Longfellow (AML) to Edith Longfellow (EL), April 12, 1914, Alice Mary Longfellow Papers (AMLP), Longfellow House–Washington's Headquarters National Historic Site (LHWHNHS); BS to EFB, April 4, 1914, EFBP, CMC; Frederick Stubbs, "Easter in Rome," *[Hobart, Tasmania] Mercury*, The Trove, accessed July 30, 2016, http://trove.nla.gov.au/newspaper/article/10367970.

2 MLS to ISG, January 13, 1915, ISGM.

3 BS to EFB, December 30, 1914, EFBP, CMC. Today, Villa Wolkonsky serves as the British ambassador's residence in Rome. See Nick Squires, "Ancient Roman Statues Emerge from British Ambassador's Garden in Rome," *London Telegraph*, December 10, 1914, accessed August 6, 2016, http://www.telegraph.co.uk/news/worldnews/europe/italy/11285587/Ancient-Roman-statues-emerge-from-British-ambassadors-garden-in-Rome.html.

4 "Thirty-Thousand Visiting Rome," *Washington Post*, April 12, 1914, 14. Proquest Historical Newspapers (145348358); "Mrs. Bellamy Storer in Rome," *New York Sun*, April 12, 1914, Library of Congress, Chronicling America: Historic American Newspapers site, accessed April 15, 2014, http://chroniclingamerica.loc.gov/lccn/sn83030272/1914-04-12/ed-1/seq-8; "Society," *Washington Herald*, April 5, 1914, Library of Congress, Chronicling America: Historic American Newspapers site,

accessed April 15, 2014, http://chroniclingamerica.loc.gov/lccn/sn83045433/1914-04-05/ed-1/seq-13.

5 MLS to EFB, April 2, 1914, EFBP, CMC.

6 BS to EFB, April 4, 1914, EFBP, CMC.

7 Appeal for Wounded," *Washington Post*, July 13, 1915, 7. Proquest Historical News-papers (145380396); MLS to ISG, August 8, 1915, ISGM.

8 Storer, "The Recent Tragedy in Bosnia," 674.

9 MLS to JI, January 9, 1915, JIP, MNHS.

10 Besides owning the hotel, August Benziger was an internationally renowned portraitist. "N.t.," *New York Herald*, January 17, 1915.

11 Eleanor Dwight, *Edith Wharton: An Extraordinary Life* (New York: Harry N. Abrams, 1994), 181.

12 "Rich Americans Returning Tell of Living Abroad on Next to Nothing for Days," *Washington Evening World*, August 24, 1914, Library of Congress, Chron-icling America: Historic American Newspapers site, accessed April 15, 2014, http://chroniclingamerica.loc.gov/lccn/sn83030193/1914-08-24/ed-1/seq-3.

13 "Appeal for Wounded"; Jean-Yves Ferry, email to authors, December 20, 2014.

14 SL to KERW, October 1, 1914, WFP, CMC; BS to EFB, December 30, 1914, EFBP, CMC.

15 MLS to ISG, August 8, 1915, ISGM.

16 BS to JI, November 29, 1914, JIP, MNHS.

17 Storer, *In Memoriam*, 5, 7; "Former U.S. Envoy Aids Vatican," *Washington Herald*, March 14, 1915; Library of Congress, Chronicling America: Historic American Newspapers site, accessed April 15, 2014, http://chroniclingamerica.loc.gov/lccn/sn83045433/1915-03-14/ed-1/seq-3; Walter Peters, *The Life of Benedict XV* (Mil-waukee: Bruce Publishing, 1959), 184; "Random Notes," *CE*, December 6, 1914.

18 When the Storers left Rome for the United States in the spring of 1915, the responsibility of the department was turned over to an American Franciscan, Father Dominic Reuter. At its busiest, the priest directed a staff of up to two hundred religious volunteers. Bellamy, according to Maria, supported the Bu-reau to the end of the war. However, other reports do not mention that fact. See MLS to ISG, August 8, 1915, ISGM; "Random Notes," *CE*, December 6, 1914. See Maria Longworth Storer, *In Memoriam*, 7; John Mitty, "Deeds Not Words," *Catholic Educational Review* 17 (January 1919), 108, accessed December 14, 2014, https://archive.org/stream/catholiceducatio17cathuoft#page/108/mode/2up.

19 Letter from Thomas Nelson Page to Secretary of State, February 8, 1915, Re-cords of the State Department Relating to World War I and Its Termination, 1914–1929; International Relations, Serbia and Austria, R0021, No. 763.71/1703 (M367, Rl. 21), RG59, NARA, accessed August 8, 2016, https://www.fold3.com/search/#query=bellamy+storer&preview=1&t=486.

20 Letter from Thomas Nelson Page, to Secretary of State, March 17, 1915, Re-cords of the State Department Relating to World War I and Its Termination,

1914–1929; International Relations, Serbia and Austria, R0021, No. 763.72/1643 (M367, Rl. 21), RG59, NARA, accessed August 8, 2016, https://www.fold3.com/image/56424613.

21 MLS to JI, January 9, 1915, JIP, MNHS.

22 Ibid.; MLS to Oswald Garrison Villard (OGV), October 3, 1915, Oswald Garrison Villard Papers (OGVP), HLHU.

23 Storer, *The Villa Rossignol, or, The Advance of Islam*, 1–400; Maria Longworth Storer, *Sir Christopher Leighton; or, The Marquis de Vaudreuil's Story* (St. Louis: B. Herder, 1915), 1–325; Storer, *Some Verses*.

24 "New Books: *Sir Christopher Leighton*," *Catholic World* 102, no. 609 (December 1915): 399, accessed December 4, 2015, https://books.google.com/books?id=E-J8EAAAAMAAJ; "Books and Authors," *America* 14, no. 1 (October 16, 1915): 20, accessed December 4, 2015, https://play.google.com/books/reader?id=MVY_AQAAMAAJ.

25 MLS to OGV, October 3, 1915, OGVP, HLHU.

26 Jean-Yves Ferry, email to authors, December 20, 2014.

27 "Première Guerre Mondiale," *Croix-Rouge Française*, accessed August 28, 2016, http://www.croix-rouge.fr/La-Croix-Rouge/La-Croix-Rouge-francaise/Historique/Premiere-guerre-mondiale/Premiere-Guerre-mondiale.

28 MLS to JI, January 9, 1915, JIP, MNHS.

29 "Italy Declares War on Austria-Hungary," *This Day in History*, accessed August 10, 2016, http://www.history.com/this-day-in-history/italy-declares-war-on-austria-hungary. Italy joined the war effort in May 1915 on the side of the British and French against Germany.

30 MLS to ISG, August 8, 1915, ISGM.

31 *Ursuline Diary*, May 31, 1915, UCA.

32 MLS to BF, Feb 14, 1920, UCA.

33 "Read Estate and Building," *CE*, April 8, 1914.

34 *Annuals of 1915 Concerning the Chapel*, UCA.

35 Clara de Chambrun (CdeC) to KERW, N.m. n.d., 1915, WFP, CMC.

36 "The Bellamy Storers Lease Estate," *Washington Post*, June 20, 1915, E7. Proquest Historical Newspapers (145361583).

37 "Automobile Clubs Cooperating with the AeroClub in Developing the Movement to Popularize Aviation," *Aerial Age Weekly* 1, no. 13 (June 14, 1915): 302, https://hdl.handle.net/2027/njp.32101048986184?urlappend=%3Bseq=134.

38 "Preparing for July 4th," *NYT*, June 13, 1915.

39 Quoted in MLS to OGV, October 3, 1915, OGVP, HLHU.

40 Quoted in Caroline Hellman, "Chintz Goes to War: Edith Wharton's Revised Designs for Home and Home Front," *Edith Wharton Review* 23, no. 1 (Spring 2007): 10. JSTOR (43512999).

41 "A Glimpse into French Hospitals," *CE*, November 21, 1915; JFdeC, interview with authors, September 14, 2014.

42 Beth Linker, "The Business of Ethics: Gender, Medicine, and the Professional Codification of the American Physiotherapy Association, 1918–1935," *Journal of the History of Medicine and Allied Sciences* 60, no. 3 (July 2005): 322. JSTOR (24632198).

43 "Appeal for Wounded"; "A Glimpse into French Hospitals." "N.t.," *Ave Maria* 2, no. 6 (August 7, 1915): 184; BS to William Howard Bliss (WHB), N.m. n.d., n.y., Robert Wood Bliss Papers (RWBP), HUA.

44 In articles and letters of this period, Maria referred to Min's responsibility for three hospitals. Records indicate that there were only two hospitals, Hôpital Auxiliaire n° 9 and n° 69 in Marvejols. Perhaps Maria meant both the established hospitals plus the Convent of the Saint Vincent de Paul. See "Hôpitaux de la 16ème Région Militaire," accessed August 12, 2016, http://pages14–18. mesdiscussions.net/pages1418/Forum-Pages-d-Histoire-service-sante-1914-1918/hopitaux-militaires-16eme-sujet_70_1.htm.

45 MLS to ISG, August 8, 1915, ISGM; MLS to OGV, October 3, 1915, OGVP, HLHU; "Financial Aid," *CE*, December 31, 1915; MLS to JF, December 29, 1915, and January 3, and 9, 1916, JFP, NYA; "Mrs. Storer's Appeal," *CE*, January 26, 1916; MLS to TC, February 4, 1916; "Duchess," *CE*, March 19, 1916; Wayman, "Some Unpublished Correspondence between the Bellamy Storers and Cardinal O'Connell," 171.

46 Wayman, "Some Unpublished Correspondence between the Bellamy Storers and Cardinal O'Connell," 171–172; TC to MLS, June 2, July 23, 1917, JFP, NYA; "Communications: The French War Orphans," *America* 15, no. 14 (July 15, 1916): 327–328, accessed December 4, 2015, https://play.google.com/books/reader?id=elY_AQAAMAAJ; "Communications Orphelinat des Armées," *America* 15, no. 18 (August 12, 1916): 424, accessed December 4, 2015, https://play.google. com/books/reader?id=elY_AQAAMAAJ.

47 JF to MLS, December 29, 1915, JFP, NYA.

48 "Part of the Red Cross Fund," *CE*, June 24, 1917; Maria Longworth's Charitable Donations, Sister Rose Angela Boehle Papers, UCA.

49 "Hot Springs Guests Busy," *New York Sun*, February 9, 1916, Library of Congress, Chronicling America: Historic American Newspapers site, accessed April 15, 2014, http://chroniclingamerica.loc.gov/lccn/sn83030272/1916-02-09/ed-1/seq-7.

50 "Chapel Is Dedicated," *CE*, June 1, 1916; *Annuals of 1915 Concerning the Chapel*, UCA; Durkin, *The Story of the Ursulines of Cincinnati*, 12–13.

51 Ibid.

52 Edith Wharton, *Fighting France* (New York: Charles Scribner's Sons, 1915), 3.

53 "Chapel Is Dedicated"; *Annuals of 1915 Concerning the Chapel*, UCA; Durkin, *The Story of the Ursulines of Cincinnati*, 12–13.

54 "Some New Books: *Probation*," *Irish Monthly* 44 (October 1916): 673–674, https://hdl.handle.net/2027/mdp.39015065370481?urlappend=%3Bseq=683.

55 "Living Faith," *CE*, April 14, 1916.

56 "New Books: *The Borodino Mystery*," *Catholic World* 104, no. 620 (November 1916): 255, https://play.google.com/books/reader?id=iaEEAAAAMAAJ.

57 Gilbert de Chambrun (GdeC) to "Miquet," December 29, 1916, WFP, CMC.

58 "U.S. Entry into World War One, 1917," *Office of the Historian*, accessed July 12, 2017, https://history.state.gov/milestones/1914-1920/wwi.

59 Charles Chatfield, "Peace as a Reform Movement," *OAH Magazine of History* 8, no. 3 (Spring 1994): 12. JSTOR (25162959).

60 Maria Longworth Storer, typed statement about the CCWA, [N.m. n.d, n.y.], ACA.

61 HM to "the Archdiocese of Cincinnati," March 28, 1917, ACA.

62 "Random Notes," *CE*, April 1, 1917; *Report [of] the Cincinnati Catholic Women's Association* (N.p.: n.p., n.d.), 5.

63 *Report [of] the Cincinnati Catholic Women's Association*, 3–13; "Catholic Women," *Catholic Telegraph*, July 12, 1917; "Social Affairs," *CE*, November 1, 1917.

64 MLS to JF, April 4, 1917, JFP, NYA; MLS to JF, May 19, 1917, JFP, NYA.

65 "Random Notes," *CE*, April 15, 1917; "Random Notes," *CE*, September 30, 1917; *Report [of] the Cincinnati Catholic Women's Association*, 5.

66 "Ground Broken for 'Tent,'" *CE*, June 26, 1917; *Report [of] the Cincinnati Catholic Women's Association*, 6; "Needs of Ft. Thomas Men," *CE*, September 30, 1917; "Get New Rest Room," *CE*, November 11, 1917; MLS to TC, October 7, 1917, NYA.

67 "Coming to America," *CE*, April 15, 1917.

68 MLS to JF, April 29, 1917, JFP, NYA; MLS to WO'C, William O'Connell Papers (WO'CP) April 30, 1917, Archdiocese of Boston Archives (ABA).

69 MLS to JF, November 10, 1917, JFP, NYA. Overuse injuries are described as tissue damage that results from repetitive demand over the course of time. See "Overuse Injury," *Medscape*, accessed September 5, 2016, http://emedicine.medscape.com/article/313121-overview#a5.

70 Barnett Singer, "Military History: Mon Général: The Case of Joseph Joffre," *American Scholar* 65, no. 4 (Autumn 1996): 598. JSTOR (41212565).

71 "In Society," *CE*, May 8, 1917; "Visitor," *1918: The St. Ursula Yearbook*, UCA.

72 MLS to JF, April 4, 1917, JFP, NYA; George Creed, "The Second Message from the United States Government to the American People: A War of Peoples," *Independent* 93, no. 2 (February 16, 1918): 268, accessed April 9, 2017, https://archive.org/stream/independen93v94newy#page/n271/mode/2up.

73 BS to WHT, May 4, 1917, WHTP, LOC; WHT to MLS, May 6, 1917, WHTP, LOC; WHT to BS, May 6, 1917, WHTP, LOC. Apparently, Maria's letter to Taft was lost.

74 MLS to JF, June 27, 1917, JFP, NYA; TC to MLS, July 23, 1917, JFP, NYA; "In Society," *CE*, June 19, 1917; "Red Cross and Sisters of Charity," *The Telegraph*, May 24, 1917 enclosed in letter MLS to JF, JFP, May 19, 1917, NYA; "Random Notes,"

CE, June 24, 1917; "In Society," *CE*, June 24, 1917; "Part of the Red Cross Fund," *CE*, June 24, 1917; Maria Longworth Storer, "Communications: The Red Cross and Catholic Sisters," *America* 17, no. 8 (June 2, 1917): 190–91; accessed December 4, 2015, https://books.google.com/books/reader?id=2VY_AQAAMAAJ; "Communications: Catholic Sisterhoods and the Red Cross," *America* 17, no. 13 (July 7, 1917): 324–325; accessed December 4, 2015, https://books.google.com/books/reader?id=2VY_AQAAMAAJ. William Warrener, "The Red Cross," *Herald of Gospel Liberty*, October 18, 1917, 997, accessed December 4, 2015, https://play.google.com/books/reader?id=LsYpAAAAYAAJ.

75 Red Cross Accepts Catholic Nurses," *New York Sun*, June 28, 1917, Library of Congress, Chronicling America: Historic American Newspapers site, accessed April 15, 2014, http://chroniclingamerica.loc.gov/lccn/sn83030431/1917-06-28/ed-1/seq-3.

76 Warrener, "The Red Cross."

77 Lavinia Dock, *History of American Red Cross Nursing* (New York: Macmillan, 1922), 666. "Although a few sister-nurses were recruited to nurse the wounded during World War I, the Spanish American conflict represents the last general recruitment of sisters as wartime nurses." See Margaret McGuinness, *Called to Serve: A History of Nuns in America* (New York: New York University Press, 2013), 103.

78 "Aid for Belgian Children," *CE*, March 21, 1917; Storer, *In Memoriam*, 5.

79 "On the Convention," *CE*, October 11, 1917; "Majority of States," *CE*, October 13, 1917; "The St. Vincent de Paul Society," *Catholic Charities Review* 1, no. 9 (November 1917): 282, accessed December 4, 2015, https://books.google.com/books/reader?id=S7RCAQAAIAAJ; "Gives $18,000 for Relief," *CE*, February 19, 1918.

80 Storer, *In Memoriam*, 6.

81 "Mr. and Mrs. Bellamy Storer Visit Elizabethtown," *Elizabethtown Post*, August 2, 1917, NYS Historic Newspapers, accessed October 13, 2016, http://nyshistoricnewspapers.org/lccn/sn92061913/1917-08-02/ed-1/seq-1; Bryant Tolles, *Resort Hotels of the Adirondacks* (Lebanon, NH: University Press of New England, 2003), 128; MLS to CCN, July 23, 1918, CCNP, CMC.

82 *Green Hill Guest Book* 59 (September 9–10, 1907), 38, ISGM; "In Society," *CE*, August 29, 1917.

83 Janssen, *Not at All What One Is Used To*, 8.

84 Tharp, *Mrs. Jack*, 306, 309.

85 MLS to SB, June 7, 1917, SBP, ACHRCUA; SB to MLS, June 11, 1917, ACHRCUA; MLS to SB, September 18, 1917, ACHRCUA.

86 "New Books: *The Villa Rossignol*," *Catholic World* 108, no. 643 (October 1918): 109, accessed December 4, 2015, https://books.google.com/books?id=zacEAAAAMAAJ; "Books and Authors," *America* 19, no. 7 (May 25, 1918): 171, accessed December 4, 2015, https://books.google.com/books?id=eFc_AQAAMAAJ.

87 *University of Cincinnati Record Announcement of Courses College of Medicine, 1917–1918* (Cin-

cinnati: University of Cincinnati, 1917), 9; "Gifts to the Library," *Catholic University Bulletin* 22, no. 6 (June 1916): 109, https://hdl.handle.net/2027/uc1.b2870815?urlappend=%3Bseq=327; "Additions to the Museum," *Catholic University Bulletin* 22, no. 7 (October 1916): 117–118, https://hdl.handle.net/2027/uc1.b2870815?urlappend=%3Bseq=335; *Ursuline Diary*, July 26, 1916, UCA.

88 MLS to TC, October 7, 1917, JFP, NYA; MLS to JF, October 7, 1915, JFP, NYA; BS to JF, October 20, 1915, JFP, NYA; TC to MLS, October 31, 1917, JFP, NYA; TC to BS, October 31, 1917, JFP, NYA.

89 "In Society," *CE*, November 28, 1917; MLS to BF, November 27, 1917, UCA.

90 MLS to BF, December 17, 1917, UCA.

91 "Silver Medals Awarded," *CE*, November 30, 1917; "American Women Given French Hospital Medals," *Boston Daily Globe*, December 1, 1917, accessed February 24, 2017, http://pqasb.pqarchiver.com/boston/doc/503327949.html.

92 MLS to HM, February 22, 1918, ACA; MLS to BF, December 26, 1917, UCA.

93 MLS to BF, February 3, and 11, 1918, UCA.

94 MLS to JG, September 8, 1918, AASMSU; Thomas Shahan (TS) to JG, May 15, 1918, AASMSU; JG to TS, May 21, 1918, AASMSU; MLS to TC, June 22, 1918, JFP, NYA; TC to MLS, June 27, 1918, JFP, NYA; MLS to TC, July 1, 1918, JFP, NYA.

95 JG to TS, May 21, 1918, AASMSU; TC to MLS, June 27, 1918, JFP, NYA.

96 John Piper, "The American Churches in World War I," *Journal of the American Academy of Religion* 38, no. 2 (June 1970): 147–155. JSTOR (1461170); Wayman, "Some Unpublished Correspondence between the Bellamy Storers and Cardinal O'Connell," 161.

97 John Pollard, *The Unknown Pope and the Pursuit of Peace* (London: Burns and Oates, 2005), 126–129, 139.

98 BS to Joseph Wilby (JW), April 8, 1918, Joseph Wilby Papers (JWP), CMC.

99 MLS to Dominic Reuter (DR), May 6, 1918, Alois Janssens Papers (AJP), Kadoc Documentation and Research Center On Religion Culture and Society, Belgium (KADOC); "Justice, Charity, Pope's Words for the World Need," *Chicago Daily Tribune*, October 22, 1919, 1. Proquest Historical Newspapers (174510638).

100 MLS to BF, June 6, 1918, UCA.

101 "Joseph Nichols," *Historic Saranac Lake*; "Obituaries," *NYT*, June 19, 1918; MLS to TC, June 22, 1918, JFP, NYA.

102 MLS to JG, September 8, 1918, AASMSU.

103 Maria Longworth Storer, *The French 'Neutral' Schools* (N.p.: n.p., 1918), n.p. This copy was found in the Archdiocesan Archives of Chicago.

104 MLS to Adolf Meyer (AM), May 23, 1919, Adolf Meyer Collection (AMC), Alan Mason Chesney Medical Archives, Johns Hopkins Medical Institute, AMCMA, JHMI. Dr. Adolf Meyer was the founding director of the Phipps

Clinic, Johns Hopkins Hospital. He was a psychiatrist who cared for Joe during his last illness. He also consulted on Bellamy's health.

105 *Told in the Huts The YMCA Gift Book* (London: Jarrold and Sons, n.d.), 25, accessed April 7, 2017, https://archive.org/details/toldinhutsymcagioolondiala. See also Allen Davis, "Welfare, Reform, and World War I," *American Quarterly* 19, no. 3 (Autumn 1967): 519. JSTOR (2711070); Lettie Gavin, *American Women in World War I: They Also Served* (Boulder: University Press of Colorado, 1997), Kindle e-book, chapter 6.

106 "World War I Veterans," *Historic Saranac Lake*, accessed September 16, 2016, https://localwiki.org/hsl/World_War_I_Veterans.

107 Maria Longworth Storer, "Archbishop Ireland and the Hat," *Dublin Review* 168, no. 334 (April/June 1921): 208, accessed on July 26, 2017, https://hdl.handle.net/2027/mdp.39015027529810?urlappend=%3Bseq=217.

108 An incomplete report was available for the authors to review. However, Maria would have been interviewed and detained if her loyalty was questioned. R. N. Sroufe, "Mrs. Bellamy Storer –Alleged Seditious Utterance," *Fold Three*, Alleged Sedition Utterances, R. 735, p. 1, v. 33, *Investigative Case Files of the Bureau of Investigation 1908–1922*, NARA, M1085, accessed September 9, 2016, https://www.fold3.com/image/3214605/?terms=bellamy%20storer&pqsid=CWbxPz-BJ31c9kcSPlt-1dQ:96000:1871062537.

109 Charles Sowerwin, *France since 1870: Culture, Society, and the Making of the Republic* (London: Palgrave Macmillan, 2009), 112.

110 "Humanitarian Intervention and Relief—World War I," *New American Nation*, accessed September 10, 2016, http://www.americanforeignrelations.com/E-N/Humanitarian-Intervention-and-Relief-World-war-i.html.

111 MLS to HM, October 27, 1918, ACA; Random Notes," *CE*, November 3, 1918; Marie Burke, *Years of Achievement 1917–1958* (N.p.: n.p., n.d.), 11; *Report [of] the Cincinnati Catholic Women's Association*, 12; "Random Notes," *CE*, March 16, April 13, and April 20, 1919; "In Society," *CE*, May 22, 1919.

112 *Report [of] the Cincinnati Catholic Women's Association*, 4–13; "Social Affairs," *CE*, November 11, 1917.

113 TC to N.f.n. Anthony, March 19, 1918, JFP, NYA.

114 Kathleen McCarthy, *Women, Philanthropy, and Civil Society* (Bloomington: Indiana University Press, 2001), 4.

115 MLS to BF, November 22, 1918, UCA.

116 BS to AM, November 26, 1918, AMCMA, JHMI; Robert Tattersall, *Diabetes, the Biography* (New York: Oxford University Press, 2009), Kindle e-book, chapter 1.

117 BS to AM, December 11, 1918, AMCMA, JHMI.

118 Niall Johnson and Juergen Mueller, "Updating the Accounts: Global Mortality of the 1918–1920 'Spanish' Influenza Pandemic," *Bulletin History of Medicine* 76, no. 1 (Spring 2002): 115.

119 MLS to ISG, March 15, 1919, ISGM.

120 "Storers Seek Passports," *CE*, March 28, 1919.

121 MLS to AM, May 17, 1919, AMC, AMCMA, JHMI; AM TO MLS, May 20, 1919, AMC, AMCMA, JHMI.

122 MLS to BF, February 14, 22, April 17, 1920, UCA.

123 "Rookwood," *CE*, March 8, 1896.

124 MLS to JHG, February 13, 1930, MRSLA, CAM.

125 Storer, *Theodore Roosevelt the Child*, 9. Twenty-year-old First Lieutenant Quentin Roosevelt, who served as a pilot, was killed in action when his plane was shot down in France on July 14, 1918.

126 Storer, "Archbishop Ireland and the Red Hat," 203–208; Storer, *Theodore Roosevelt the Child*; Storer, *In Memoriam*, 1–120.

127 Wayman, "Some Unpublished Correspondence between the Bellamy Storers and Cardinal O'Connell," 172–173.

128 JFdeC, interview with authors, September 13, 2014.

129 MLS to BF, February 14, 1920, UCA; MLS to JG, February 9, 1920, AASMSU.

130 MLS to BF, October 28, 1919, UCA; MLS to BF, December 6, 1917, UCA.

131 N.n. to MLS, June 30, 1918, AJP, KADOC; MLS to BF, March 24, March 25, April 17, May 8, June 13, and July 15, 1920, UCA; CPG to MLS, May 1, 1920, UCA. Bellamy likewise sent his congratulations in a letter written in his own hand with a check to help defray the costs of a new organ. See BS to BF, March 28, 1920, UCA.

132 MLS to BF, February 14, 22, 1920, UCA.

133 MLS to JG, February 9, 1920, AASMSU.

134 MLS to BF, March 24, 1920, UCA; MLS to BF, April 17, 1920, UCA.

135 MLS to BF, March 24, 25, 1920, UCA; BS to BF, March 28, 1920, UCA.

136 MLS to BF, July 15, 1920, SUA.

137 MLS to BF, July 15, December 2, 1920, SUA.

138 "Mrs. Storer Makes Large Gift to Pope's Relief Fund," *Boston Daily Globe*, December 30, 1920, accessed February 24, 2017, http://pqasb.pqarchiver.com/boston/doc/504733420.html; "Pope's Relief Fund 5,000,000 Lire," *NYT*, February 23, 1920.

139 Storer, "Archbishop Ireland and the Hat," 204.

140 Shane Lesley (ShL) to John Talbot Smith (JTS), March 10, 1921, University of Notre Dame Archives Calendar, accessed May 12, 2016, http://www.archives.nd.edu/cgi-bin/calindex.pl?keyword=storer.

141 "France," *America* 25, no. 621 (August 20, 1921): 412, accessed December 4, 2015, https://play.google.com/books/reader?id=PFg_AQAAMAAJ.

142 Goodwin, *The Bully Pulpit*, photographs, no. 68.

143 Robert Taft, *The Papers of Robert A. Taft*, vol. 1, ed. Clarence Wunderlin (Kent, OH: Kent State University Press, 1997), 265.

144 Storer, *Theodore Roosevelt the Child*, 1–55; MLS to WHT, September 29, 1921, LOC; WHT to MLS, October 20, 1921, WHTP, LOC.

145 "Bellamy Storer Received in Audience by Pope," *Washington Times*, December 3, 1921, Library of Congress, Chronicling America: Historic American Newspapers site, accessed April 15, 2014, http://chroniclingamerica.loc.gov/lccn/sn84026749/1921-12-03/ed-1/seq-1.

146 MLS to WHT, December 2, 1920, WHTP, LOC.

147 MLS to OK, May 1, 1925, OKP, PUL.

148 MLS to WHT, December 8, 1921, WHTP, LOC; WHT to MLS, December 26, 1921, WHTP, LOC; MLS to WHT, January 11, 12, February 10, April 12, and June 19, 1922, WHTP, LOC; WHT to MLS, January 26, 1922, WHTP, LOC.

149 WHT to KERW, January 5, 1922, WHTP, LOC.

150 KERW to WHT, February 6, 1922, WHTP, LOC.

151 "Condition Is Grave," *CE*, June 20, 1922; "Mrs. Longworth at Rest," *CE*, June 21, 1922.

152 MLS to WHT, December 2, 1922, WHTP, LOC; "Bellamy Storer Passes," *CE*, November 14, 1922; Storer Funeral Today," "Bellamy Storer Dies Suddenly," *NYT*, November 14, 1922; "Bellamy Storer, Noted Envoy, Dies in Paris," *Cincinnati Commercial*, November 14, 1922.

153 Gloria Erlich, *The Sexual Education of Edith Wharton* (Berkeley: University of California Press, 1992), 121.

Chapter Eleven

1 MLS to OK, June 13, 1923, OKP, PUL.

2 MLS to ISG, December 11, 1922, ISGM; MLS to WHT, December 2, 1922, and April 10, 1923, WHTP, LOC.

3 "United States Passport Applications, 1795–1925," Database with images, *FamilySearch*, http://FamilySearch.org, citing NARA microfilm publications M1490 and M1372, Washington, DC: National Archives and Records Administration, n.d., accessed August 10, 2016, https://familysearch.org/search/collection/2185145.

4 MLS to WHT, May 21, 1923, WHTP, LOC.

5 Michael Francis Fallon (MFF) to Shane Lesley (ShL), September 25, 1922, Shane Lesley Papers (ShLP), AUNDiv; MLS to WHT, December 2, 1922, and May 21, 1923, WHTP, LOC.

6 Lester Shippee, review of *In Memoriam: Bellamy Storer, with Personal Remembrances of President McKinley, President Roosevelt, and John Ireland, Archbishop of St. Paul* by Maria Longworth Storer, *Minnesota History* 6, no. 3 (September 1925): 286.

7 WHT to MLS, December 27, 1923, WHTP, LOC.

8 MLS to WHT, January 9, 1924, WHTP, LOC.

9 JPdeC interview by Sister Rose Angela Boehle, May 19, and May 23, 1988, Rose Angela Boehle Papers, USCA.

10 Ibid; Rex Pope, "A Consumer Service in Interwar Britain: The Hotel Trade, 1924–1939," *Business History Review* 74, no. 4 (Winter 2000): 667. JSTOR (3116470).

11 JFdeC, interview with authors, September 13, 2014.

12 "Longworth Legacy Still Colors City," *CE*, February 25, 1980. Landon Longworth Wallingford is Maria's brother Nicholas II's grandson. He was her great-nephew.

13 MLS to WHT, August 25, 1927, WHTP, LOC.

14 MLS to WHT, July 24, August 25, 1927, WHTP, LOC; GG to MLS, July 12, 1927, AJP, KADOC.

15 MLS to C(harles) H. L. Emanuel (CHLE), July 12, and July 28, 1926, Board of Deputies of British Jews (BDBJ), London Museum Association (LMA).

16 MLS to WHT, August 25, 1927, WHTP, LOC.

17 MLS to OK, May 1, 1925, OKP, PUL.

18 Bonaventura Cerretti (BC) to MLS, October 9, 1923, March 31, April 4, April 12, May 10, and June 4, 1924, AJP, KADOC. Dr. Langdon-Brown was considered one of the founders of endocrinology in England. See Mark Jackson, *The Age of Stress: Science and Search for Stability* (Oxford: Oxford University Press, 2013), 77. Insulin had been discovered in 1921. See "The History of the Wonderful Thing We Call Insulin," *Stop Diabetes Here*, accessed October 17, 2016, http://diabetesstopshere.org/2012/08/21/the-history-of-a-wonderful-thing-we-call-insulin/; CW, VH to MLS, May 26, 1924, EHFP, BIA; BC to MLS, May 28, June 4, 1924, AJP, KADOC; CW, VH to MLS, May 26, 1924, EHFP, BIA.

19 President Édouard Herriot recalled the French ambassador to the Vatican, but after his government fell the following year, the minister was returned. BC to MLS, May 18, May 20, May 28, 1924, AJP, KADOC.

20 C to MLS, December 24, 1923, March 31, 1924, March 28, June 20, 1927, AJP, KADOC.

21 WHT to KERW, February 20, 1923, WHTP, LOC.

22 MLS to WHT, December 16, 1922, January 20, January 25, February 7, April 10, September 2, October 13, October 28, November 18, and December 16, 1923, October n.d., October 10, November 29, December 31, 1924, July 24, and August 25, 1927, WHTP, LOC; WHT to MLS, January 1, February 7, June 27, September 20, November 5, and December 27, 1923, September 4, October 8, and December 12, 1924, WHTP, LOC; MLS to OK, July 26, August 8, 1923, April 24, April 25, May 1, July 27, and August 15, 1925, OKP, PUL; OK to MLS, July 29, and August 11, 1923, April 30, May 7, and August 7, 1925, OKP, PUL; MLS to ALL, April 19, 1925, ALLP, HUA; ALL to MLS, July 20, 1925, ALLP, HUA.

23 Elinor Byrns was one of the leaders of the Women's Peace Union, who campaigned for a constitutional amendment to ban war in the 1920s. See Harriet Alonso, *Women's Peace Union and the Outlawry of War, 1921-1942* (Syracuse, NY: Syracuse University Press, 1997).

24 Besides Maria, there were other prominent American and English politicians who admired Mussolini during his rise to power in his early years. See Gwydion M. Williams, "Why Churchill Admired Mussolini," *Long Revolution: 21st Century Socialism*, accessed October 17, 2016, https://gwydionwilliams.com/44-fascism-and-world-war-2/why-churchill-admired-mussolini/; Mark Weber, "America's Changing View of Mussolini and Italian Fascism," *Institute for Historical Review*, accessed on October 17, 2016, http://www.ihr.org/jhr/v15/v15n3p6_weber.html; MLS to WHT, May 30, 1923, WHTP, LOC; WHT to MLS, June 27, 1923, WHTP, LOC; OK to MLS, September 20, 1923, OKP, PUL; MLS to OK, November 20, 1915, OKP, PUL.

25 MLS to OK, March 10, and March 11, 1928, OKP, PUL; OK to MLS, March 27, 1928, OKP, PUL.

26 "CIA—The World Factbook—Holy See (Vatican City)," *Central Intelligence Agency*, accessed November 3, 2016, https://www.cia.gov/library/publications/the-world-factbook/geos/vt.html.

27 MLS to OK, May 1, 1925, March 10, 1928, OKP, PUL; CW, VH to MLS, May 10, and May 17, 1927, EHFP, BIA; N.f.n. Carmody to MLS, February 24, 1928, AJP, KADOC; Charles Wood, Viscount Halifax, *Notes on the Conversations at Malines 1921 -1925* (London: Mowbray, 1928), 1-60; "Maline Conversations," *The Episcopal Church*, accessed October 21, 2016, http://www.episcopalchurch.org/library/glossary/malines-conversations.

28 The significance of the meetings is viewed by some as the ending of a four-century schism between the British Anglican Church and the Roman Catholic Church. Or, as David Cannadine said, that it could be "Halifax's obsession with reunion combined the maximum of aristocratic stubbornness with the minimum of political realism." See David Cannadine, *The Decline and Fall of the British Aristocracy* (New York: Vintage Books, 1999), 490-491; "Charles Lindley Wood, Lord Halifax, 1839-1934"; BC to MLS, July 22, 1925, June 20, and July 7, 1927, AJP, KADOC; CW, VH to MLS, June 29, August 26, 1925, June 12, and August 26, 1926, EHFP, BIA.

29 "General Hospital of Saranac Lake," *Historic Saranac Lake*.

30 More than "150,000 French soldiers were discharged because of active TB infections....Health officials feared the impending public health disaster of infected soldiers returning to their homes." See "Tuberculosis in France," *100 Years: The Rockefeller Foundation*, accessed October 16, 2016, http://rockefeller100.org/exhibits/show/peace-and-conflict/tb-in-france; MLS to WHT, January 20, 1923, WHTP, LOC.

31 Today, this group is called Association Lozérienne de Lutte contre les Fléaux Sociaux [Association for the Fight against Social Plagues]. See "Historique," Association Lozérienne de Lutte contre les Fléaux Sociaux, accessed October 26, 2016, http://www.allfs.fr/pages-par-defaut/historique.html.

32 MLS to WHT, August 25, 1927, WHTP, LOC; MLS to OK, February 15, 1928, OKP, PUL.

33 *Le Preventorium Lozère*, brochure written in English (N.p.: n.p., n.d.), 3.

34 MLS to OK, August 12, 1928, OKP, PUL; OK to MLS, September 1928, OKP, PUL.

35 MLS to OK, August 15, 1925, OKP, PUL; "De Chambrun, 88, Diplomat, Is Dead," *NYT*, August 25, 1954.

36 MLS to WHT, August 17, 1924, WHTP, LOC.

37 Larz Anderson, "Frayed Ends in 1924," vol. 24, in *Some Scraps* (N.p.: n.p., n.d), 5–6, Anderson Collection, Society of the Cincinnati, 17, 18; "Marquis' Daughter Heir," *NYT*, July 19, 1923; "Mlle. de Chambrun Weds Don E. Ruspoli," *NYT*, August 28, 1924; "Mlle. de Chambrun Wed," *NYT*, August 29, 1924.

38 MLS to WHT, August 25, 1927, WHTP, LOC; JFdeC, interview with authors, September 13, 2014.

39 "Wedding Announcement for Jean Pierre de Chambrun, and Gisèle Hugot Gratry," April 22, 1929, USCA; WHT to MLS, April 29, 1929, WHTP, LOC; Marion Glaser, "Jean Pierre de Chambrun," *Cincinnati Magazine* 7, no. 5 (February 1974): 46.

40 "Gilbert de Chambrun, Diplomate, homme politique et grande figure de la Résistance dans le Languedoc, Gilbert de Chambrun Est Mort, Disparitions," *Le Monde*, December 22, 2009, accessed November 8, 2016, http://www.lemonde.fr/disparitions/article/2009/12/31/gilbert-de-chambrun_1286320_3382.html#Q-fRqJP8GyLHiRohT.99.

41 Boehle, *Maria: A Biography of Maria Longworth*, 156.

42 Ibid.

43 Pierre de Chambrun (PdeC) to Edward Sisson (ES), November 5, 1930, WFP, CMC.

44 "Beauty of Cincinnati of Old Has Been Retained and Amplified, Marquise Says," *Cincinnati Times Star*, October 30, 1931; MLS to OK, February 15, 1928, OKP, PUL.

45 See JPdeC interview by Sister Rose Angela Boehle, May 19, and May 23, 1988, Rose Angela Boehle Papers, USCA; Drawing of the Tomb and explanation by JPdeC, Rose Angela Boehle Papers, USCA.

46 "Mrs. Bellamy Storer Expires at Daughter's Home in Paris," *CE*, May 4, 1932; "Last Rites for Noted Cincinnati Woman," *Cincinnati Times*, May 7, 1932; "Cincinnatians in Paris during Late Spring," *CE*, May 22, 1932.

47 See JPdeC interview, May 19, May 23, 1988, by Rose Angela Boehle, Rose Angela Boehle Papers, USCA; Drawing of the Tomb and explanation by JPdeC, Rose Angela Boehle Papers, USCA.

48 "Gigli to Sail Today on the Mauretania," *NYT*, June 1, 1932; "Marquis Visit to Attend Requiem Mass for Wife," N.n., October 27, 1949, USCA.

49 Holman Bible Editorial Staff, *The Holy Bible: HCSB Digital Text Edition* (Nashville: Holman Bible Publishers, 2010) Kindle e-book, 2 Timothy 4:7.

Epilogue

1 Chambrun, *Cincinnati: Story of the Queen City*, 250.

2 "American," *Fleming*, Accessed on December 17, 2017, http://www.uvm.edu/~fleming/index.php?category=collection&page=slide&id=1963.10.4; Gallos, *Cure Cottages of Saranac Lake*, 146.

3 "What's News on the Social Rialto," *CE*, November 9, 1931; "In Society," *CE*, May 12, 1933; "New York Gossip, *CE*, May 26, 1935; "De Chambruns Visit in Capital," *Washington Post*, June 1, 14, 1938, X14. Proquest Historical Newspapers (151055237).

4 "Pierre de Chambrun," *Assemblée nationale*, accessed December 21, 2017, http://www.assemblee-nationale.fr/13/evenements/Ceremonie_quatre-vingts/pierre-de-chambrun.asp; Chambrun, *Shadows Like Myself*, 99; JFdeC and JdeC interviews with authors, September 13–15, 2014.

5 Ulrich Von Hassel, *The Ulrich Von Hassel Diaries: The Story of the Forces against Hitler Inside Germany*, trans. Geoffrey Brooks (London: Frontline Books, 2011), Kindle e-book, notes.

6 "Weekend Shakeup Expected as Three Vichy Diplomats Quit," *Washington Post*, August 2, 1941, 3. Proquest Historical Newspapers (151363780).

7 H. R. Kedward, *In Search of the Maquis* (Oxford: Clarence Press, 1993), 210; "Gilbert de Chambrun, Diplomate, homme politique et grande figure de la Résistance dans le Languedoc, Gilbert de Chambrun Est Mort, Disparitions," *Le Monde*, December 22, 2009, accessed November 8, 2016, http://www.lemonde.fr/disparitions/article/2009/12/31/gilbert-de-chambrun_1286320_3382.html#QfRqJP8GyLHiRohT.99; "DÉCÈS. Gilbert de Chambrun," *La Croix Archives, Sommaire*, April 1, 2010, accessed on December 21, 2017, https://www.la-croix.com/Archives/2010-01-04/DECES.-Gilbert-de-Chambrun.-_NP_-2010-01-04-361218.

8 "Pineton de Chambrun, Gilbert, Pierre, Charles, Emmanuel," *Association Maitron Languedoc-Roussillon*, accessed on December 21, 2017, http://www.histoire-contemporaine-languedoc-roussillon.com/Bio%20Chambrun.html; Patrick Cabanel, "Les *Églises*, les Paysans et la Résistance: L'Exemple des Cévennes et de la Lozère," in *La Résistance et les Français*, ed. Jacqueline Sainclivier and Christian Bougeard (Rennes, France: Presses Universitaires de Rennes, 2015), 231, *Open Edition Book*, accessed December 21, 2017, https://translate.google.com/translate?hl=en&sl=fr&u=http://books.openedition.org/pur/16380&prev=search.

9 JFdeC and JdeC interviews with authors, September 13–15, 2014.

10 Ibid.; "Notes of Society," *Washington Post*, May 17, 1941, 10. Proquest Historical Newspapers (151469275).

11 "Works of French Painter to Be Exhibited," *CE*, April 28, 1941; "Opening of Count de Chambrun's Art Exhibit," *CE*, April 29, 1941; *Exhibition of Count Jean*

Pierre de Chambrun (West Palm Beach, FL: Norton Gallery and School of Art, 1942); "Diverse One-Man Shows," *NYT*, May 14, 1944; "Week in Art Circles," *CE*, February 10, 1946.

12 JFdeC and JdeC interviews with authors, September 13–15, 2014; "In Society," *CE*, March 30, 1949.

13 "Pierre de Chambrun," *Assemblée nationale*.

14 JFdeC and JdeC interviews with authors, September 13–15, 2014; "To Aid French Children," *NYT*, July 16, 1946.

15 JFdeC and JdeC interviews with authors, September 13–15, 2014.

16 "L'epervier Divin," *Numerus Free*, accessed December 21, 2017, http://numerus. free.fr/gblectures0003.

17 Ibid., Jean Hodot, review of *L'epervier Divin*, by Marthe de Chambrun Ruspoli, *Archives de sciences sociales des religions* 28 (1969): 186–187, accessed December 22, 2017, http://www.persee.fr/doc/assr_0003-9659_1969_num_28_1_1830_t1_0186_0000_4; Gilles Bounoure, review of *Le retour du Phénix*, by Marthe de Chambrun Ruspoli, *Revue des Études Grecques* 95 (June/December 1982): 497–498, accessed December 22, 2017, http://www.persee.fr/doc/reg_0035-2039_1982_num_95_452_1342_t2_0497_0000_2; Xavier Séguin, "Osiris and Jesus," *Eden Saga*, January 14, 2014, accessed December 22, 2017, http://eden-saga.com/en/mythology-egypt-hebrew-parallel-between-osiris-and-jesus.html. "Col. McCormick Visit Tangiers on Flying Tour," *Chicago Daily Tribune*, March 17, 1952, 2. Proquest Historical Newspapers (178253927); "Tangiers Sends Stone Relics to *Tribune* Rower," *Chicago Daily Tribune*, September 21, 1952, 15. Proquest Historical Newspapers (178377211).

18 "Marquis de Chambrun Dies in France," *Chicago Daily Tribune*, August 25, 1954, b9. Proquest Historical Newspapers (178669780); "Gilbert, Pierre, Charles, Emmanuel Pineton de Chambrun," *Assemblée nationale*, accessed December 22, 2017, http://www2.assemblee-nationale.fr/sycomore/fiche/(num_dept)/1622; "Rally at Warsaw Urges Big Five Talks," *Washington Sun*, November 23, 1950, 12, Proquest Historical Newspapers (541995361).

19 "Gilbert de Chambrun Est Mort, Disparitions."

20 "Lafayette Day to be Celebrated Tuesday," *CE*, May 18, 1975; "Around Town," *CE*, March 6, 1981.

21 JFdeC and JdeC interviews with authors, September 13–15, 2014.

22 JFdeC interview with authors, September 15, 2014; "Historique," *L'Association Lozérienne de Lutte contre les Fléaux Sociaux*.

SELECTED BIBLIOGRAPHY

"2005 Conference Abstracts." *Midwest Art History Society*. Accessed March 8, 2016. https://www.mahsonline.org/display/files/conference_abstracts_32nd.pdf.

"About Cincinnati Children's." *Cincinnati Children's*. Accessed November 4, 2015. http://www.cincinnatichildrens.org/about/history/.

"Activities of the Society Necrology: Mrs. Bellamy Storer." *Bulletin of the American Ceramics Society* 11 (June 1932): 157.

Ahern, Patrick. *The Life of John J. Keane*. Milwaukee: Bruce Publishing, 1954.

Ahlquist, Karen. "Playing for the Big Time: Musicians, Concerts, and Reputation-Building in Cincinnati." *Journal of the Gilded Age and the Progressive Era* 9, no. 2 (April 2010): 145–165.

Allen, Howard, and Robert Slagter. "Congress in Crisis: Changes in Personnel and Legislative Agenda in the U.S. Congress in the 1890s." *Social Science History* 16, no. 3 (Autumn 1992): 401–420. JSTOR (1171389).

Allitt, Patrick. "American Women Converts and Catholic Intellectual Life." *U.S. Catholic Historian* 13, no. 1 (Winter 1995): 577–579. JSTOR (25154049).

———. *Catholic Converts: British and American Intellectuals Turn to Rome*. Ithaca, NY: Cornell University Press, 1997.

"Almost 200 Years Ago, the First Great Wine Was Born." *Paso Wine Barrels*. Accessed November 12, 2014. http://pasowinebarrels. wordpress.com/2013/11/26/almost-200-years-ago-the-first-great-american-wine-was-born/.

Alonso, Harriet. *Women's Peace Union and the Outlawry of War, 1921–1942*. Syracuse, NY: Syracuse University Press, 1997.

"American Art Chronicle." *American Art Review* 1, no. 12 (October 1880): 552. JSTOR (20559738).

Anderson, Isabel. *Presidents and Pies: Life in Washington 1897–1919*. Boston: Houghton Mifflin, 1920.

———. *Spell of Belgium*. Boston: Page, 1915.

Anderson, Larz. *Letters and Journals of a Diplomat*. New York: Fleming Revell, 1940.

"Art in the Cities." *Art Journal* 6 (1880): 126–128. JSTOR (20569508).

Austen, Roger. *Genteel Pagan: The Double Life of Charles Warren Stoddard.* Amherst: University of Massachusetts Press, 1991.

Baldwin, Edward. "Saranac Lake and Saranac Laboratory for the Study of Tuberculosis." *Milbank Memorial Fund Quarterly Bulletin* 10, no.1 (January 1932): 1–16. JSTOR (3347491).

Barber, Edwin. *The Pottery and Porcelain of the United States.* New York: G. P. Putman's Sons, 1893. Accessed April 15, 2014. https://archive.org/details/potteryporcelain00barb.

Barry, Louise. "The New England Emigrant Aid Company Parties of 1855." *Kansas Historical Quarterly* 12, no. 3 (August 1943): 227–268. Accessed May 3, 2015. http://www.kancoll.org/khq/1943/43_3_barry.htm.

"Bellamy Storer." In *The National Cyclopaedia of American Biography*, vol. 11. New York: James T. White, 1901. https://babel.hathitrust.org/cgi/pt?id=uc1.c3545635;view=1up;seq=346.

Benson, Robert Hugh. *Lourdes.* St. Louis: B. Herder, 1914.

A Biographical Cyclopedia and Portrait Gallery with a Historical Sketch of the State of Ohio. Vol. 4. Cincinnati: Western Biographical Publishing, 1887.

Blanchard, Mary. *Oscar Wilde's America: Counterculture in the Gilded Age.* New Haven, CT: Yale University Press, 1998.

Boehle, Rose Angela. *Maria Longworth: A Biography of Maria Longworth.* Dayton, OH: Landfall Press, 1990.

Boram-Hays, Carol. *Bringing Modernism Home: Ohio Decorative Arts, 1890–1960.* Athens: Ohio University Press, 2005.

Boulton, Ann. "The Dealer and Daniel Webster." *Gilcrease Journal* 20, no. 1 (Summer/Fall 2012): 47–63.

Bradstreet, E. Payson, ed. *Golden Jubilee Souvenir Cincinnati Music Hall 1878–1928.* N.p.: n.p., 1928.

Britton, James. "The Catholic Conference, 1906." *The Month, a Catholic Magazine* 108, no. 509 (November 1906): 484–491. Accessed December 4, 2015. https://books.google.com/books?id=fD-Moh2-5SMgC.

Burke, Marie. *Years of Achievement 1917–1958.* N.p.: n.p., n.d.

Cahall, Michael. "Battle for Mount Olympus: The Nichols-Thomas Controversy at the College of Music of Cincinnati." *Queen City Heritage* 53 (Fall 1995): 24–32.

Cannadine, David. *The Decline and Fall of the British Aristocracy.* New York: Vintage Books, 1999.

Carpenter, Frank George, and Frances Carpenter, eds. *Carp's Washington.* New York: McGraw-Hill, 1960.

Carter, Susan Nancy. "Brass and Bronze at the Centennial Exhibition." *Art Journal* 2 (1876): 348. JSTOR (20568986).

"The Case of Mrs. Bellamy Storer." *New Outlook* 84 (December 15, 1906): 901–902. Accessed December 4, 2015. https://play.google.com/books/reader?id=wa9XXoMKwv8C.

Cayton, Andrew. *Ohio: The History of the People.* Columbus: Ohio State University Press, 2002.

Chambrun, Clara de. *Cincinnati: Story of the Queen City.* New York: Charles Scribner's Sons, 1939.

——. *The Making of Nicholas Longworth.* New York: Ray Long and Richard Smith, 1933.

——. *Shadows Like Myself.* New York: Charles Scribner's Sons, 1936.

Chanler, Margaret. *Roman Spring Memoirs.* Boston: Little, Brown, 1934.

"Charles Lindley Wood, Lord Halifax, 1839–1934." *Project Canterbury.* Accessed March 9, 2016. http://anglicanhistory.org/bios/halifax.htm.

Chatfield, Charles. "Peace as a Reform Movement." *OAH Magazine of History* 8, no. 3 (Spring 1994): 10–14. JSTOR (25162959).

Check, Christopher. "Americanism, Then and Now: Our Pet Heresy (Encyclical of Pope Leo XIII)." *Chronicles Magazine*, June 13, 2007. *Free Republic.* Accessed March 10, 2016. http://www.freerepublic.com/focus/f-religion/1849437/posts.

"The Children's Hospital of the Protestant Episcopal Church." *Kitchen Garden* 2, no. 5 (July 1885): 34. https://hdl.handle.net/2027/nyp.33433006783033?urlappend=%3Bseq=9.

Cincinnati Art Museum. *Art Palace of the West.* Cincinnati: Cincinnati Art Museum, 1981.

"Cincinnati Industrial Expositions." *Ohio History Central.* Accessed September 17, 2015. http://www.ohiohistorycentral.org/w/Cincinnati_Industrial_Expositions?rec=489.

Cincinnati Museum Association. *Tenth Report, for the Year Ending December 31, 1890.* In *Annual Reports*, vols. 6–10. Cincinnati: C. F. Bradley, 1891. Accessed December 4, 2015. https://books.google.com/books?id=qHZFAQAAMAAJ.

Cincinnati Music Hall 100th Anniversary Program. N.p: n.p., 1978.

"Cincinnati Pottery at the Bartholdi Exhibition." *Art Amateur* 10, no. 3 (February 1884): 69–70. JSTOR (25628090).

Circular and Fourth Annual Catalogue of the Art Academy of Cincinnati, 1888–1889. Cincinnati: Woodrow, Baldwin, 1889.

Circular and Sixth Annual Catalogue of the Art Academy of Cincinnati, 1890–1891. Cincinnati: C. F. Bradley, 1890.

Clark, Champ. *My Quarter Century of American Politics*. New York: Harper and Brothers, 1920. Accessed December 14, 2014. https://archive. org/details/myquartercenturo1clargoog.

Collier, Mishona. "Shaping American Identity through Music: Nationality, Taste, and Power at the Cincinnati May Festival, 1873–1905." Master's thesis, Carleton University, 2013.

Collier, William. *At the Court of His Catholic Majesty*. London: A. C. McClurg, 1912. Accessed December 14, 2014. https://archive.org/ details/atcourtofhiscathoocollrich.

Conway, Jill. "Women Reformers and American Culture." *Journal of Social History* 5 (Winter 1971–72): 164–177. JSTOR (3786409).

Coolidge, Louis, and James Reynolds. *Show at Washington*. Washington, DC: Washington Publishing, 1894. Accessed December 14, 2014. https://archive.org/details/showatwashingtonoocool.

Cordery, Stacy. *Theodore Roosevelt in the Vanguard of the Modern*. Belmont, CA: Thomson Wadsworth, 2002.

Creed, George. "The Second Message from the United States Government to the American People: A War of Peoples." *Independent* 93, no. 2 (February 16, 1918): 268–269. Accessed April 9, 2017. https:// archive.org/stream/independen93v94newy#page/n271/mode/2up.

Cunningham, Edith Perkins. *Owl's Nest*. Cambridge, MA: Riverside Press, 1907.

"Curculio, Etc." *Western Horticulture Review* 1, no. 1 (October 1850): 30–31. Accessed December 4, 2015. https://play.google.com/ books/reader?id=wxQ4AQAAMAAJ.

Dalton, Kathleen. *Theodore Roosevelt: A Strenuous Life*. New York: Random House, 2007. Kindle e-book.

Davis, Allen. "Welfare, Reform, and World War I." *American Quarterly* 19, no. 3 (Autumn 1967): 516–533. JSTOR (2711070).

Dexter, Julius. "Record on the Death of Joseph Longworth." Cincinnati Museum Association, *Fourth Annual Report*. In *Annual Reports*, vols. 4–11. Cincinnati: Robert Clarke, 1885. Accessed July 26, 2017. https://hdl.handle.net/2027/uc1.aoo11949732?urlappend=%3B-seq=38.

Dock, Lavinia. *History of American Red Cross Nursing*. New York: Macmillan, 1922.

Draper, William. *Recollections of a Varied Career*. Boston: Little, Brown, 1909. Accessed June 1, 2014. https://archive.org/details/recollec-tionsofoodrapiala.

Duff, M. E. Grant. *Notes from a Diary*, Vol. 2, *1896 to January 23, 1901*. London: John Murray, 1904. Accessed June 1, 2014. https://ar-chive.org/details/in.ernet.dli.2015.279102.

Durkin, Mary-Cabrini. *The Story of the Ursulines of Cincinnati*. Cincinnati, OH: Ursulines of Cincinnati, 2009.

Dwight, Eleanor. *Edith Wharton: An Extraordinary Life*. New York: Harry N. Abrams, 1994.

"Editorial Correspondence." *Cultivator* 6, no. 9 (September 1858): 275–277. Accessed December 14, 2014. https://archive.org/stream/cultivator05socigoog#page/n275/mode/2up/search/longworth.

"Editor's Easy Chair." *Harper's New Monthly Magazine* 64, no. 382 (April 1882): 730.

Eidelberg, Martin. "American Ceramics and International Styles." *Record of the Art Museum, Princeton University* 34, no. 2 (1975): 13–19. JSTOR (3774436).

Elliott, Charles Wyllys. *The Book of American Interiors, from Existing Houses*. Boston: James R. Osgood, 1876. Accessed July 10, 2016. https://archive.org/details/bookofamericaninooelli.

——. "Pottery at the Centennial." *Atlantic Monthly* 38, no. 229 (November 1876): 568–578. Accessed July 26, 2017. https://babel.hathitrust.org/cgi/pt?id=mdp.39076000049606;view=1up;seq=588.

——. "Wine-Making in the West." *The Horticulturist and Journal of the Rural Art* 2, no. 7 (January 1848): 313–319. Accessed December 14, 2014. https://archive.org/details/horticulturistjoo2alba.

Ellis, Anita. *The Ceramic Career of M. McLaughlin*. Athens: Ohio University Press, 2003.

——. *Rookwood Pottery: The Glaze Lines/with Value Guide*. Atglen, PA: Schiffer, 1995.

——. *Rookwood Pottery: The Glorious Gamble*. Cincinnati: Cincinnati Art Museum, 1992.

Ellis, Anita, and Susan Meyn. *Rookwood and the American Indian: Masterpieces of American Art Pottery*. Athens: Ohio University Press, 2007.

Emerson, Ralph Waldo, and Thomas Carlyle. *Correspondence of Thomas Carlyle and Ralph Waldo Emerson*. Vol. 2. Boston: James Osgood, 1883. Accessed December 4, 2015. https://play.google.com/books/reader?id=OJMYAAAAYAAJ.

Endy, Christopher. "Travel and World Power: Americans in Europe." *Diplomatic History* 22, no. 4 (Fall 1998): 565–594. JSTOR (24913627).

Erlich, Gloria. *The Sexual Education of Edith Wharton*. Berkeley: University of California Press, 1992.

"Exhibition." *American Art News* 6, no. 24 (March 28, 1908): 2. JSTOR (25590339).

"The Fair." *Kitchen Garden* 1, no. 2 (December 20, 1883): 16. Accessed July 26, 2017. https://hdl.handle.net/2027/nyp.33433006783033?urlappend=%3Bseq=24.

Farrell, John. "Archbishop Ireland and Manifest Destiny." *Catholic Historical Review* 33, no. 3 (October 1947): 269–301. JSTOR (25014801).

Farrelly, Maura Jane. *Anti-Catholicism in America, 1620-1860*. New York: Cambridge University Press, 2018.

———. "Background of the Taft Mission to Rome I." *Catholic Historical Review* 36, no. 1 (April 1950): 1–32. JSTOR (25015111).

———. "Background of the Taft Mission to Rome II." *Catholic Historical Review* 37, no. 1 (April 1951): 1– 22. JSTOR (25015235).

Flora v. Anderson et al., 4770. Open Jurist. Accessed April 2, 1917. http://openjurist.org/75/f1d/217.

Fogarty, Gerald. *The Vatican and the Americanist Crisis: Denis J. O'Connell, American Agent in Rome, 1885-1903*. Rome: Gregorian University, 1974.

———. "Americanism." In *HarperCollins Encyclopedia of Catholicism*, edited by Richard McBrien, 40. San Francisco: HarperSanFrancisco, 1995.

Fohlen, Claude. "Catholicisme américain et catholicisme européen: La convergence de l'américanisme.'" *Revue d'histoire moderne et contemporaine* 34, no. 2 (April 1987): 215–230. JSTOR (20529295).

Foraker, Julia. *I Would Live It Again*. New York: Harper and Brothers, 1932. Kindle e-book.

Forchheimer, Frederick. *In Memoriam Dr. Landon R. Longworth*. N.p.: n.p., n.d.

Ford, Henry, and Kate Ford. *History of Cincinnati, Ohio, with Illustrations and Biographical Sketches*. Cleveland: L. A. Williams, 1881.

Ford, Worthington Chauncey, ed. *The Letters of Henry Adams, 1892–1918*. Boston: Houghton Mifflin, 1938.

"France." *America* 25, no. 621 (August 20, 1921): 411–412. Accessed December 4, 2015. https://play.google.com/books/reader?id=P-Fg_AQAAMAAJ.

"Francis Marion Crawford." *Catholic Encyclopedia*. Accessed December 24, 2015. http://www.newadvent.org/cathen/16030a.htm.

Frey, Juliet, ed. *Theodore Roosevelt and His Sagamore Hill Home*. Oyster Bay, NY: National Park Service, 2007.

Gallos, Philip. *Cure Cottages of Saranac Lake*. Saranac Lake, NY: Historic Saranac Lake, 1985.

Gatewood, Willard. *Theodore Roosevelt and the Art of Controversy*. Baton Rouge: Louisiana State University Press, 1970.

Gavin, Lettie. *American Women in World War I: They Also Served*. Boulder: University Press of Colorado, 1997. Kindle e-book.

"General Hospital of Saranac Lake." *Historic Saranac Lake*. Accessed October 19, 2016. https://localwiki.org/hsl/General_Hospital_ of_Saranac_Lake.

"George Ward Nichols." *Dictionary of American Biography*. New York: Charles Scribner's Sons, 1936. *Biography in Context*. Accessed December 13, 2014. link.galegroup.com/apps/doc/BT2310006698/ BIC1?u=cinc37305&xid=772e7348.

Gillespie, Elizabeth Duane. *A Book of Remembrance*. Philadelphia: J. B. Lippincott, 1901. Accessed December 13, 2014. https://archive. org/details/bookofremembrancoogill.

Glaser, Marion. "Jean Pierre de Chambrun." *Cincinnati Magazine* 7, no. 5 (February 1974): 44–51.

Gleason, Philip. *The Conservative Reformers*. Notre Dame, IN: University of Notre Dame Press, 1968.

Goodwin, Doris Kearns. *The Bully Pulpit: Theodore Roosevelt, William Howard Taft, and the Golden Age of Journalism*. New York: Simon and Schuster, 2013. Kindle e-book.

Goss, Charles. *Cincinnati, the Queen City, 1788–1912*. Vol. 1. Cincinnati: S. J. Clarke, 1912.

Grace, Kevin, and Tom White. *Cincinnati Revealed: A Photographic Heritage of the Queen City*. Charleston, SC: Arcadia, 2002.

Grayson, Janet. *Robert Hugh Benson: Life and Works*. New York: University Press of America, 1998.

Grenville-Moore, George Grenville. *Society Recollections in Paris and Vienna, 1879–1904*. New York: Appleton, 1908. Accessed July 26, 2017. https://archive.org/details/societyrecollectoomoor.

Greve, Charles. *Centennial History of Cincinnati and Representative Citizens*. Vol. 1. N.p.: Bibliography Publishing, 1904.

Griffin, Mike. "Snubbed: Pope Benedict XV and Cardinal James Gibbons." *Catholic Peace Fellowship*. Accessed September 14, 2016. http:// www.catholicpeacefellowship.org/downloads/BenedictXV_Gibbons.pdf.

Grisson, Michael. *Southern by the Grace of God*. Gretna, LA: Pelican Publishing, 1989.

Guelzo, Allen. "Ritual, Romanism, and Rebellion: The Disappearance of the Evangelical Episcopalians, 1853–1873." *Anglican and Episcopal History* 62, no. 4 (December 1993): 551–577. JSTOR (2611573).

Gutman, Joseph. *Moses Jacob Ezekiel: Memoirs from the Baths of Diocletian*. Edited by Stanley F. Chyet. Detroit: Wayne State University Press, 1975.

Hadley, Rollin N. Van, ed. *The Letters of Bernard Berenson and Isabella Stewart Gardner, 1887–1924, with Correspondence by Mary Berenson.* Boston: Northeastern University Press, 1987.

Hall, Henry, ed. *America's Successful Men of Affairs.* Vol. 2. New York: New York Tribune, 1895. Accessed December 14, 2014. https://archive.org/details/cu31924024759460.

Hannickel, Erica. "A Fortune in Fruit: Nicholas Longworth and Grape Speculation in Antebellum Ohio." *American Studies* 51, nos. 1/2 (Spring/Summer 2010): 89–108. JSTOR (41809422).

Hansen, Joan. "Howell and James of London." *Journal of Decorative Arts Society 1850–the Present,* no. 34 (2010): 29. JSTOR (41287812).

Harper, J. Henry. *The House of Harper: A Century of Publishing in Franklin Square.* New York: Harper and Brothers, 1912. Accessed July 26, 2017. https://hdl.handle.net/2027/hvd.32044058247024.

Haverstock, Mary Sayre, Jeannette Mahoney Vance, and Brian Meggitt. *Artists in Ohio: A Biographical Dictionary.* Kent, OH: Kent State University Press, 2000.

Hellman, Caroline. "Chintz Goes to War: Edith Wharton's Revised Designs for Home and Home Front." *Edith Wharton Review* 23, no. 1 (Spring 2007): 8–13. JSTOR (43512999).

Herron, Robert. "Have Lily, Will Travel: Oscar Wilde in Cincinnati." *Bulletin of the Historical and Philosophical Society* 15, no. 3 (July 1957): 215–233.

"Health and Medical History of William Taft." *Doctor Zebra.* Accessed December 15, 2015. http://www.doctorzebra.com/prez/g27.htm.

"Historique." *Association Lozérienne de Lutte contre les Fléaux Sociaux.* Accessed October 26, 2016. http://www.allfs.fr/pages-par-defaut/historique.html.

"History of the Cincinnati Kindergarten Association." *OhioLINK Finding Aid Repository.* Accessed November 13, 2015. http://ead.ohiolink.edu/xtf-ead/view?docId=ead/OhCiUAR0075.xml;chunk.id=bioghist_1;brand=default.

"The History of the Wonderful Thing We Call Insulin." *Stop Diabetes Here.* Accessed October 17, 2016. http://diabetesstopshere.org/2012/08/21/the-history-of-a-wonderful-thing-we-call-insulin/.

Hitchcock, Henry. *Marching with Sherman: Passages from the Letters and Campaign Diaries of Henry Hitchcock, Major and Assistant Adjutant General of Volunteers, November 1864–May 1865.* Lincoln, NE: Bison Books, 1995.

Hobart, Mrs. Garret (Jennie). *Memories.* Paterson, NJ: Carroll Hall, 1930. Accessed July 26, 2017. https://babel.hathitrust.org/cgi/pt?id=uc1.$b727615;view=1up;seq=11.

Hochschild, Adam. *King Leopold's Ghost: A Story of Greed, Terror, and Heroism in Colonial Africa.* Boston: Houghton Mifflin, 1998.

Holliday, Joseph. "The Cincinnati Philharmonic and Hopkins Hall Orchestras, 1856–1869." *Cincinnati Historical Society Bulletin* 26, no. 2 (April 1968): 158–173.

——. "Collector's Choice of the Gilded Age." *Cincinnati Historical Society Bulletin* 28, no. 4 (Winter 1970): 294–315.

——. "The Musical Legacy of Theodore Thomas." *Cincinnati Historical Society Bulletin* 27, no. 3 (Fall 1969): 190–205.

Holmes, J. Derek. "Cardinal Raphael Merry del Val: An Uncompromising Ultramontane: Gleanings from His Correspondence with England." *Catholic Historical Review* 60, no.1 (April 1974): 55–64. JSTOR (25019512).

Houghton, William. *Kings of Fortune; or, The Triumphs and Achievements of Noble, Self-Made Men.* Chicago: A. E. Davis, 1886. Accessed September 22, 2016. https://play.google.com/books/reader?id=3DuI_ c7grwsC.

Howe, Jennifer. "Breaking the Mold: The Metalwork of Maria Longworth Storer." *Studies in Decorative Arts* 8, no. 1 (Fall/Winter 2000/2001): 54–68. JSTOR (40662759).

Howe, Julia Ward, and Maud Howe. "American Drawing Rooms: The Story of My Boston Drawing Room." *Woman's Home Companion* 37, no. 10 (October 1910): 7–8. Accessed July 26, 2017. https://hdl. handle.net/2027/osu.32435056329501?urlappend=%3Bseq=227.

"Humanitarian Intervention and Relief—World War I." *New American Nation.* Accessed September 10, 2016. http://www.americanforeignrelations.com/E-N/Humanitarian-Intervention-and-Relief-World-war-i.html.

Hyndman-Rizk, Nelia, ed. *Pilgrimage in the Age of Globalization: Constructions of the Sacred and Secular in Late Modernity.* Cambridge: Cambridge Scholars Publishing, 2012.

"Importance of *Rerum Novarum* Explored at a Conference." *Catholic University of America.* Accessed December 5, 2015. http://president. cua.edu/inauguration/11RerumNovarumPost.cfm.

Jackson, Mark. *The Age of Stress: Science and Search for Stability.* Oxford: Oxford University Press, 2013.

Janssen, Marian. *Not at All What One Is Used To: The Life and Times of Isabella Gardner.* Columbia: University of Missouri Press, 2010.

Johnson, Niall, and Juergen Mueller. "Updating the Accounts: Global Mortality of the 1918–1920 'Spanish' Influenza Pandemic." *Bulletin History of Medicine* 76, no. 1 (Spring 2002): 105–115.

"Joseph Nichols." *Historic Saranac Lake.* Accessed August 20, 2015. https://localwiki.org/hsl/Joseph_Nichols.

Kane, Paula. *Separatism and Subculture: Boston Catholicism, 1900–1920.* Chapel Hill: University of North Carolina Press, 1994.

Karger, Gustav. "George Barnesdale Cox, Proprietor of Cincinnati." *Leslie's Magazine* 57, no. 3 (January 1904): 273–283. Accessed December 4, 2015. https://books.google.com/books?id=xcvQA-AAAMAAJ.

Kent, Peter. "A Tale of Two Popes: Pius XI and Pius XII and the Rome-Berlin Axis." *Journal of Contemporary History* 23, no. 4 (October 1988): 589–608. JSTOR (260836).

Kern, Kevin, and Gregory Wilson. *Ohio: A History of the Buckeye State.* Hoboken, NJ: Wiley Blackwell, 2013.

King, Margaret Rives. *A Memento of Ancestors and Ancestral Homes.* Cincinnati: Robert Clark, 1890. Accessed April 10, 2017. https://books.google.com/books/reader?id=ePMxAQAAMAAJ.

Kip, Samuel. "Old Notables and Newcomers: The Economic and Political Elite of Greensboro, NC." *Journal of Southern History* 43, no. 3 (August 1977): 373–394. JSTOR (2207647).

Kirkland, Frazer. *Cyclopedia of Commercial and Business Anecdotes.* New York: D. Appleton, 1865.

Kliman, Todd. *The Wine Vine: A Forgotten Grape and the Untold Story of American Wine.* New York: Clarkson Potter, 2010.

"The Late Nicholas Longworth." *Harper's Weekly* 7, no. 323 (March 7, 1863).

Leech, Margaret. *In the Days of McKinley.* New York: Harper and Brothers, 1959.

Levenick, Christopher. "Nicholas Longworth." *Philanthropy Roundtable.* Accessed November 28, 2015. http://www.philanthropyroundtable.org/almanac/hall_of_fame/nicholas_longworth.

Levenson, J. C., Ernest Samuels, Charles Vandersee, and Viola Winner, eds. *The Letters of Henry Adams, 1892–1918.* Vols. 4–6. Cambridge, MA: Harvard University Press, 1988.

Levetus, Amelia Sarah. *Imperial Vienna.* New York: John Lane/Bodley Head, 1905. Accessed December 14, 2014. https://archive.org/details/imperialviennaoolevegoog.

Lindley, Charles. *Viscount Halifax.* London: Catholic Literature Association, 1933.

Linker, Beth. "The Business of Ethics: Gender, Medicine, and the Professional Codification of the American Physiotherapy Association, 1918–1935." *Journal of the History of Medicine and Allied Sciences* 60, no. 3 (July 2005): 320–354. JSTOR (24632198).

Lodge, Henry Cabot, ed. *Selections from the Correspondence of Theodore Roosevelt and Henry Cabot Lodge.* New York: Charles Scribner's Sons, 1925.

Logan, Laura. "Nursing Education in Cincinnati." *University of Cincinnati Medical Bulletin* 1, no. 1 (November 1920): 68–86.

Longfellow, Henry Wadsworth. *Letters of Henry Wadsworth Longfellow*. Vol. 3. Edited by Andrew Halen. Cambridge, MA: Harvard University Press, 1972.

Longworth, Alice Roosevelt. *Crowded Hours: Reminiscences of Alice Roosevelt Longworth*. New York: Charles Scribner's Sons, 1933.

"The Longworth Wine House Grape Premiums." *The Horticulturist, and Journal of Rural Art and Rural Taste* 23, no. 259 (January 1868): 60. Accessed November 10, 2014. http://books.google.com/books?id=w-CgCAAAAYAAJ.

Lorant, Stefan. *The Life and Times of Theodore Roosevelt*. New York: Doubleday, 1959.

"Maline Conversations." *The Episcopal Church*. Accessed October 21, 2016. http://www.episcopalchurch.org/library/glossary/malines-conversations.

Mapleson, J. H. *The Mapleson Memoirs*. Vol. 1. Chicago: Belford, Clarke, 1888. Accessed March 14, 2016. https://archive.org/details/maplesonmemoirs01mapliala.

Martindale, C. C. *The Life of Monsignor Robert Hugh Benson*. Vol. 2. New York: Longman, Green, 1916. Accessed February 1, 2016. https://archive.org/details/lifeofmonsignorro01mart.

"Matters Diplomatic." *The International: An Illustrated Monthly Magazine* 3, no. 1 (July 1897): 82. https://hdl.handle.net/2027/chi.79258330?urlappend=%3Bseq=90.

Maxwell, Sidney. *Suburbs of Cincinnati: Sketches*. Cincinnati: George E. Stevens, 1870.

McCarthy, Kathleen. *Women, Philanthropy, and Civil Society*. Bloomington: Indiana University Press, 2001.

McGuinness, Margaret. *Called to Serve: A History of Nuns in America*. New York: New York University Press, 2013.

McMahon, Joseph H. "Robert Hugh Benson." *Bookman* 41, no. 2 (April 1915): 160–169. Accessed April 9, 2017. https://archive.org/stream/bookmanareviewbo1unkngoog#page/n190/mode/2up/search/benson.

Miklich, ERIC. "1867–1870 Cincinnati Club; AKA 'Red Stockings' Tour." *19C Baseball*. Accessed May 9, 2018. http://www.19cbaseball.com/tours-1867-1870-cincinnati-red-stockings-tour.html.

Miller, Zane. "Boss Cox's Cincinnati: A Study in Urbanization and Politics, 1880–1914." *Journal of American History* 54 (March 1968): 823–838. JSTOR (1918072).

Milligan, Fred. *Ohio's Founding Fathers*. Bloomington, IN: iUniverse, 2003.

Mitty, John. "Deeds Not Words." *Catholic Educational Review* 17 (January 1919): 106–117. Accessed December 14, 2014. https://archive.org/stream/catholiceducatio17cathuoft#page/108/mode/2up.

Monroe, Alden. "Effect to Causes: The Evolution of a Social Agency." *Queen City Heritage* 37, no. 3 (Fall 1979): 191–216.

Moody, Wesley. *Demon of the Lost Cause: Sherman and Civil War History*. Columbia: University of Missouri Press, 1984.

Morris, Edmund. "Introduction." In *The Seven Worlds of Theodore Roosevelt*, by Edward Wagenknecht, vii–x. Guilford, CT: Lyon Press, 2009.

———. *The Rise of Theodore Roosevelt*. New York: Random House, 1979.

Moynihan, James. *Life of Archbishop John Ireland*. New York: Harper and Brothers, 1953.

Mullen, Lincoln. "The Contours of Conversion to Catholicism in the Nineteenth Century." *U.S. Catholic Historian* 32, no. 2 (Spring 2014): 1-27.

Rose, Anne. "Some Private Roads to Rome: The Role of Families in American Victorian Conversions to Catholicism." Catholic Historical Review 85, no. 1 (January 1999): 35-57. JSTOR (25025397).

Murray, Charles. *Life Notes of Charles B. Murray, Journalist and Statistician*. Cincinnati: N.p., 1915. Accessed December 4, 2015. https://play.google.com/books/reader?id=QhkuAAAAYAAJ.

National Cyclopedia of American Biography. New York: James T. White, 1920.

"Necrology Charles Warren Stoddard." *Catholic University Bulletin* 15, no. 6 (June 1909): 599. Accessed December 14, 2014. https://archive.org/details/CatholicUnivBulletinV15.

Newton, Clara Chipman. *A Memorial Tribute*. Cincinnati: N.p., 1938.

Nichols, George Ward. *Art Education Applied to Industry*. New York: Harper and Brothers, 1877.

———. "Down the Mississippi." *Harper's New Monthly Magazine* 41, no. 246 (November 1870): 835–845.

———. "The Indian: What We Should Do with Him." *Harper's New Monthly Magazine* 40, no. 5 (April 1870): 732–739.

———. *Pottery: How It Is Made, Its Shapes and Decoration*. New York: G. P. Putnam's Sons, 1878.

———. *The Sanctuary: A Story of the Civil War*. New York: Harper and Brothers, 1866.

———. "Six Weeks in Florida." *Harper's New Monthly Magazine* 41, no. 245 (October 1870): 655–665.

——. *The Story of the Great March.* New York: Harper and Brothers, 1865.

——. "Preface to the Twenty-Second Edition." In *The Story of the Great March.* New York: Harper and Brothers, 1865.

Nichols, George Ward, ed. *The Cincinnati Organ.* Cincinnati: Robert Clarke, 1878. https://babel.hathitrust.org/cgi/pt?id=pst.000017289535;view=1up;seq=15.

Nichols, Joseph Longworth. "Angeimata in Valves of Heart of a Newly Born Child." *Journal of Experimental Medicine* 10, no. 3 (May 1908): 368–370. *JEM.com.* Accessed April 10, 2017. https://www.ncbi.nlm.nih.gov/pmc/articles/PMC2124526/pdf/368.pdf.

——. "A Study of the Spinal Cord by Nissl's Method in Typhoid Fever and in Experimental Infection with the Typhoid Bacillus." *Journal of Experimental Medicine* 4, no. 2 (March 1899): 189–215. *JEM.com.* Accessed April 10, 2017. https://www.ncbi.nlm.nih.gov/pmc/articles/PMC2118044/pdf/189.pdf.

——. "Studies in Tuberculosis: A Histological Study of Lesions of Immunized Rabbits." *Medical News* 87 (September 30, 1905): 636–638. Accessed April 10, 2017. https://archive.org/stream/medicalnews871philuoft#page/638/mode/2up.

O'Connell, Marvin. *John Ireland and the American Catholic Church.* St. Paul: Minnesota Historical Society, 1988.

O'Connell, William. *Sermons and Addresses of His Eminence William Cardinal O'Connell, Archbishop of Boston,* Vol. 9, *1925-1928.* Cambridge, MA: Riverside Press, 1930. Accessed April 10, 2017. https://archive.org/details/sermonsaddresses09oconuoft.

Offner, John. "McKinley and the Spanish-American War." *Presidential Studies Quarterly* 34, no. 1 (March 2004): 50–61. JSTOR (27552563).

——. "Washington Mission: Archbishop Ireland on the Eve of the Spanish American War." *Catholic Historical Review* 73, no. 4 (October 1987): 562–575. JSTOR (25022638).

O'Toole, James. *Militant and Triumphant: William Henry O'Connell and the Catholic Church of Boston, 1859-1944.* Notre Dame, IN: University of Notre Dame Press, 1994.

——. "'That Fabulous Churchman': Toward a Biography of Cardinal O'Connell." *Catholic Historical Review* 70, no. 1 (January 1984): 28–44. JSTOR (25021735).

——. "'These Stray Letters of Mine': Forgery and Self-Creation in the Letters of Cardinal William O'Connell." *New England Quarterly* 81, no. 3 (September 2008): 489–502. JSTOR (20474657).

O'Toole, Patricia. *Five of Hearts: An Intimate Portrait of Henry Adams.* New York: Simon and Schuster, 1990.

Oulahan, Richard. "William H. Taft as a Judge on the Bench." *American Monthly Review of Reviews* 36, no. 2 (August 1907): 208–211. Accessed August 15, 2016. https://hdl.handle.net/2027/mdp.39015027769697?urlappend=%3Bseq=229.

"Our History." *Church of the Advent.* Accessed December 31, 2014. http://advent-cincinnati.diosohio.org/About%2ous/history.html.

Owen, Nancy. "Marketing Rookwood Pottery: Culture and Consumption, 1883–1913." *Studies in the Decorative Arts* 4, no. 2 (Spring/Summer 1997): 2–21. JSTOR (40662580).

——. "On the Road to Rookwood: Women's Art and Culture in Cincinnati, 1870–1918." *Ohio Valley History* 1 (Winter 2001): 4–18.

Peck, Herbert. *The Book of Rookwood Pottery.* Tucson, AZ: Herbert Peck Books, 1986.

Pennington, Estill Curtis. *Lessons in Likeness: Portrait Painters in Kentucky and the Ohio River Valley, 1802–1920.* Lexington: University Press of Kentucky, 2011.

Perry, Elizabeth. "The Work of Cincinnati Women in Decorated Pottery." In *Art and Handicraft in the Woman's Columbian Building of the World's Columbian Exposition, Chicago, 1893,* ed. Maud Howe Elliott. Chicago: Rand, McNally, 1894. Accessed December 14, 2014. https://archive.org/details/arthandicraftinw93elli.

Peters, Walter. *The Life of Benedict XV.* Milwaukee: Bruce Publishing, 1959.

Peterson, Jeanne. "No Angels: The Victorian Myth and the Paget Women." *American Historical Review* 89, no. 3 (June 1984): 677–708. JSTOR (1856121).

Phelps, Nichole. *Sovereignty, Citizenship, and the New Liberal Order: U.S.-Habsburg Relations and the Transformation of International Politics, 1880–1924.* New York: Cambridge University Press, 2013. Kindle e-book.

Pius XI. *Divini Redemptoris. vatican.va.* Accessed November 6, 2016. https://w2.vatican.va/content/pius-xi/en/encyclicals/documents/hf_p-xi_enc_19370319_divini-redemptoris.html.

Piper, John. "The American Churches in World War I." *Journal of the American Academy of Religion* 38, no. 2 (June 1970): 147–155. JSTOR (1461170).

Pollard, John. *The Unknown Pope and the Pursuit of Peace.* London: Burns and Oates, 2005.

Portier, William. "George Tyrrell in America." *U.S. Catholic Historian* 20, no. 3 (Summer 2002): 69–95. JSTOR (25154819).

Posey, Walter B. "The Protestant Episcopal Church: An American Adaptation." *Journal of Southern History* 25, no. 1 (February 1959): 3–30. JSTOR (2954477).

"Pottery Industry Jobs Index." *the potteries.com.* Accessed July 13, 2015. http://www.thepotteries.org/jobs/index1.htm.

Powers, Hiram. "Letters of Hiram Powers to Nicholas Longworth, Esq., 1856–1858." *Quarterly Publication of the Historical and Philosophical Society of Ohio* 1, no. 2 (April/June 1906): 33–59.

Pringle, Henry. *Theodore Roosevelt.* New York: Harcourt, Brace, 1931.

Quarterly Publication of Report of the Historical and Philosophical Society of Ohio, 1906–1908. Vols. 1–3. Cincinnati: Press of Jennings and Graham, 1907. Accessed December 14, 2014. https://play.google.com/books/reader?id=dGdHAQAAMAAJ.

Remini, Robert. *The House: The History of the House of Representatives.* Washington, DC: Library of Congress, 2007.

"Repertoire by Composer, 1873–Present, Festival History." *May Festival.* Accessed August 29, 2015. http://www.mayfestival.com/pdfs/Repertoire-thru2015.pdf.

Report of the Board of Commissioners of the Ninth Cincinnati Industrial Exposition, Held in Cincinnati, Ohio. Cincinnati: Elm Street Printing, 1881.

Report [of] the Cincinnati Catholic Women's Association. N.p.: n.p., n.d.

Report of the Nineteenth Eucharistic Congress, Held at Westminster from 9–13 September 1908. London: Sands, 1909. Accessed July 10, 2016. https://archive.org/details/reporteucharistoounknuoft.

Reports of the Home for Sick Children, October 1, 1883 to October 1, 1887. N.p.: n.p., n.d.

Reuter, Frank. *Catholic Influence on American Colonial Policies, 1898–1904.* Austin: University of Texas Press, 1967.

———. "William Howard Taft and the Separation of Church and State in the Philippines." *Journal of Church and State* 24, no. 1 (Winter 1982): 105–117.

Rogers, Gregory. *Cincinnati's Hyde Park: A Brief History of a Queen City Gem.* Charleston, SC: History Press, 2011.

Roma, Catherine, Earl Rivers, Frank Pendle, Karin Pendle, and Craig Doolin. *A City That Sings: Cincinnati's Choral Tradition.* Wilmington, OH: Orange Frazer Press, 2012.

Roosevelt, Theodore. *Presidential Addresses and State Papers.* Vol. 5. New York: Review of Reviews Company, 1910.

Sanchez, Nellie Van de Grift. *The Life of Mrs. Robert Lewis Stevenson.* New York: Charles Scribner's Sons, 1920. Accessed December 14, 2014. https://archive.org/details/lifemrsrobertloo2sancgoog.

Schwartz, Abby. "Nicholas Longworth, Art Patron of Cincinnati." *Queen City Heritage* 46, no. 1 (Spring 1988): 17–32.

"Senator's Secretary." *Saturday Evening Post* 179, no. 1 (January 5, 1907): 19.

Shanahan, Mother Christopher. "The Diplomatic Career of Bellamy Storer in Belgium and Spain, 1897–1902." PhD diss., Catholic University, 1960.

Shand-Tucci, Douglass. *The Art of Scandal: The Life and Times of Isabella Stewart Gardner*. New York: HarperCollins, 1997.

Shelley, Thomas. "John Cardinal Farley and Modernism." *Church History* 61, no. 3 (September 1992): 350–361. JSTOR (3168375).

Shippee, Lester. Review of *In Memoriam: Bellamy Storer, with Personal Remembrances of President McKinley, President Roosevelt, and John Ireland, Archbishop of St. Paul* by Maria Longworth Storer. *Minnesota History* 6, no. 3 (September 1925): 286–287.

Singer, Barnett. "Military History: Mon Général: The Case of Joseph Joffre." *American Scholar* 65, no. 4 (Autumn 1996): 593–599. JSTOR (41212565).

Skrabec, Quentin. *William McKinley, Apostle of Protectionism*. New York: Algora Publishing, 2007.

Slawson, Donald. *Ambition and Arrogance: Cardinal William O'Connell of Boston and the American Catholic Church*. Oregon, IL: Quality Books, 2007.

Smith, John Talbot. "Archbishop John Ireland." *Dublin Review* 168, no. 336 (January 1921): 29–30. Accessed July 26, 2017. https://babel.hathitrust.org/cgi/pt?id=coo.31924065586020;view=1up;seq=31.

Smith, Joseph P., ed. *History of the Republican Party in Ohio, and Memoirs of Its Representative Supporters*. Vol. 2. Chicago: Lewis Publishing, 1898.

Sowerwine, Charles. *France since 1870: Culture, Society, and the Making of the Republic*. London: Palgrave Macmillan, 2009.

"Spain." *Cyclopedic Review* 9, no. 2 (2nd Quarter 1899): 458–460. Accessed July 27, 2017. https://hdl.handle.net/2027/inu.30000108664925.

"Special Notice." *The Crayon* 7, no. 1 (January 1860): 32. JSTOR (25528008).

Stern, Madeleine. "Louisa M. Alcott: An Appraisal." *New England Quarterly* 22, no. 4 (December 1949): 475–498. JSTOR (361945).

Steele, Lucy. "Dining at the White House." *Good Housekeeping* 10, no. 9 (March 1890): 197–199. https://babel.hathitrust.org/cgi/pt?id=mdp.39015024013974;view=1up;seq=211.

Storer, Bellamy. "The Church of Brou." *Christian Art* 4, no. 3 (December 1908): 95–106. Accessed December 4, 2015. https://books.google.com/books?id=TxrnAAAAMAAJ.

———. *Letter of Bellamy Storer to the President and the Members of His Cabinet, November 1906*. Cincinnati: N.p., 1906.

———. "The Ocean Is Ours." *Harper's Weekly* 43, no. 2194 (January 7, 1899): 6.

Storer, Maria Longworth. (See Appendix).

Stuart, Graham. *American Diplomatic and Consular Practice.* 2nd ed. New York: Appleton-Century-Crofts, 1952.

Sullivan, Mark. *Our Times, 1900–1925.* Vol. 3. New York: Charles Scribner's Sons, 1930.

Taft, Robert. *The Papers of Robert A. Taft.* Vol. 1. Edited by Clarence Wunderlin. Kent, OH: Kent State University Press, 1997.

Talar, C. J. T. "An Americanist in Paris: The Early Career of the Abbé Félix Klein." In *Weaving the American Catholic Tapestry: Essays in Honor of William L. Portier,* edited by Derek Christopher Hatch, Timothy R. Gabrielli, and William L. Portier, 110-124. Eugene, OR: Pickwick Publications, 2017.

Talliaferro, John. *All the Great Prizes: The Life of John Hay from Lincoln to Roosevelt.* New York: Simon and Schuster, 2013.

Tharp, Louise. *Mrs. Jack.* Boston: Isabella Stewart Gardner Museum, 1965.

Thayer, George. *The First Congregational Church of Cincinnati.* Cincinnati: Ebbert and Richardson, 1917. Accessed July 27, 2017. https://babel.hathitrust.org/cgi/pt?id=hvd.32044086422193;view=1up;seq=52.

Thomas, Louis. "A History of the Cincinnati Symphony Orchestra to 1931." PhD diss., University of Cincinnati, 1972.

Thomas, Rose Fay. *Memoirs of Theodore Thomas.* New York: Moffat, Yard, 1911. Accessed April 11, 2017. https://archive.org/details/memoirstheodoreoothomgoog.

Thomas, Theodore. *Theodore Thomas, A Musical Autobiography: Life Work.* Vol. 1. Chicago: A. C. McClurg, 1905. Accessed April 11, 2017. https://archive.org/details/theodorethomasmo2thomuoft.

Told in the Huts: The YMCA Gift Book. London: Jarrold and Sons, n.d. Accessed April 7, 2017. https://archive.org/details/toldinhutsymcagiooolondiala.

Tolles, Bryant. *Resort Hotels of the Adirondacks.* Lebanon, NH: University Press of New England, 2003.

Trapp, Kenneth. "Rookwood and the Japanese Mania." *Cincinnati Historical Society Bulletin* 39 (Spring 1981): 51–75.

Traynor, W.J.H. "The Aims and Methods of the A.P.A." *North American Review* 159, no. 452 (July 1894): 67–68. JSTOR (25103366).

"Treaty of Peace between the United States and Spain December 10, 1898." *Avalon Project.* Accessed March 13, 2016. http://avalon.law.yale.edu/19th_century/sp1898.asp.

Trustees of the Museum of Fine Arts: 7th Annual Report in Annual Report of the Museum of Fine Arts Boston, Issues 1–15. Boston: Alfred Mudge and Son, 1883.

"Tuberculosis in France." *100 Years: The Rockefeller Foundation*. Accessed October 16, 2016. http://rockefeller100.org/exhibits/show/peace-and-conflict/tb-in-france.

Tucker, Louis. "The Director's Page: Cincinnati and the Civil War." *Bulletin of the Historical and Philosophical Society of Ohio* 19, no. 2 (April 1961): 153–158.

———. "'Old Nick' Longworth: The Paradoxical Maecenas." *Cincinnati Historical Society Bulletin* 25 (October 1967): 244–259.

Twentieth Annual Report of the Rector: The Catholic University September 30, 1909. Baltimore: J. H. Furst, 1909. Accessed December 4, 2015. https://play.google.com/books/reader?id=d2rPAAAAMAAJ.

Twenty-Fourth Annual Report Cincinnati Museum. N.p.: n.p., n.d. https://babel.hathitrust.org/cgi/pt?id=nyp.33433081864310;view=1up;seq=105.

"University Chronicle." *Catholic University Bulletin* 1, no. 4 (October 1895): 565. https://hdl.handle.net/2027/uc1.b2870889?urlappend=%3Bseq=577.

University of Cincinnati Record Announcement of Courses College of Medicine, 1917–1918. Cincinnati: University of Cincinnati, 1917.

U.S. Department of Justice. "About the Office." Accessed December 15, 2015. http://www.justice.gov/osg/about-office-1.

U.S. Department of State. *Foreign Relations of the United States: Diplomatic Papers, 1899*. Washington, DC: Government Printing Office, 1899. Accessed March 24, 2016. http://digital.library.wisc.edu/1711.dl/FRUS.FRUS1899.

U.S. Department of War. *A Compilation of the Official Records of the Union and Confederate Armies*, ser. 1, vol. 12. Washington, DC: Government Printing Office, 1885.

Vandersee, Charles. "Henry Adams' Education of Martha Cameron: Letters 1888–1916." *Texas Studies in Literature and Language* 10, no. 2 (Summer 1968): 233–293. JSTOR (40753989).

Verhelst, D. *Lord Halifax and the Scheut Father Alois Janssens*. Bruges: Desclée de Brouwer, 1967.

Vinzenz, Albert Alexander (General Baron von Margutti). *The Emperor Francis Joseph and His Times*. New York: George Doran, 1921. Accessed December 14, 2014. https://archive.org/details/theemperorfrancioomargiala.

Visitor's Guide to the Centennial and Philadelphia Exhibition. Philadelphia: J. B. Lippincott, 1876. Accessed December 14, 2014. https://archive.org/details/visitorsguidetocoophil.

Vitz, Robert. "Im Wunderschönen Monat Mai: Organizing the Great Cincinnati May Festival of 1878." *American Music* 4, no. 3 (Autumn 1986): 309–327. JSTOR. (3051613).

———. *The Queen and the Arts: Cultural Life in Nineteenth-Century Cincinnati.* Kent, OH: Kent State University Press, 1989.

Voorsanger, Catherine Hoover, and John Howat. *Art and the Empire City: New York, 1825–1861.* New York: Metropolitan Museum of Art, 2000.

Ward, Massie. *Insurrection versus Resurrection.* New York: Sheed and Ward, 1937.

Ward, Wilfrid. "A Visit to America." *Dublin Review* 154, nos. 308/309 (January/April 1914): 209–236. Accessed July 26, 2017. https://hdl.handle.net/2027/coo.31924065585592?urlappend=%3Bseq=219.

"Washington Topics." *The Independent* 60, no. 2990 (March 23, 1906): 645–651. Accessed July 27, 2017. https://hdl.handle.net/2027/msu.31293500313212?urlappend=%3Bseq=669.

Wayman, Dorothy. *Edward Sylvester Morse: A Biography.* Cambridge, MA: Harvard University Press, 1942.

———. ""Some Unpublished Correspondence between the Bellamy Storers and Cardinal O'Connell." *Catholic Historical Review* 40, no. 2 (July 1954): 129–177. JSTOR (25015715).

Weaver, Mary Jo. *Letters from a "Modernist."* London: Sheed and Ward, 1981.

Weber, Mark. "America's Changing View of Mussolini and Italian Fascism." *Institute for Historical Review.* Accessed October 17, 2016. http://www.ihr.org/jhr/v15/v15n3p6_weber.html.

Wharton, Edith. *Fighting France.* New York: Charles Scribner's Sons, 1915.

"What Austria Thinks of Mr. Storer, Foreign Affairs." *Public Opinion* 40, no. 16 (April 21, 1906): 492. Accessed December 4, 2015. https://books.google.com/books?id=Pos3AQAAMAAJ.

Whittredge, Worthington. *The Autobiography of Worthington Whittredge.* Brooklyn, NY: Brooklyn Institute of Arts and Sciences, 1942.

Willets, Gilson. *Inside History of the White House: The Complete History of the Domestic and Official Life in Washington of the Nation's Presidents and Their Families.* New York: Christian Herald, 1908. Accessed December 14, 2014. https://archive.org/details/insidehistoryofwwill.

Williams, Gwydion M. "Why Churchill Admired Mussolini." *Long Revolution: 21st Century Socialism.* Accessed October 17, 2016. https://gwydionwilliams.com/44-fascism-and-world-war-2/why-churchill-admired-mussolini/.

Winner, Viola Hopkins. "The Paris Circle of Edith Wharton and Henry Adams." *Edith Wharton Review*, no. 1 (Spring 1992): 2–4. JSTOR (43512790).

Wood, Charles. *Viscount Halifax: Notes on the Conversations at Malines 1921–1925*. London: Mowbray, 1928.

Wood, Lawrence. *Horace Plunket in America*. Glendale, CA: Arthur H. Clark, 2010.

Worchester, Dean. "Knotty Problems of the Philippines." *Century Magazine* 56 (October 1898): 873–879. Accessed July 27, 2017. http://www.unz.org/Pub/Century-1898oct.

"World War I Veterans." *Historic Saranac Lake*. Accessed September 16, 2016. https://localwiki.org/hsl/World_War_I_Veterans.

INDEX

ABOUT THE AUTHORS

Nancy M. Broermann (left) has always enjoyed studying and researching Cincinnati's history. While working as an archivist for the Ursuline Sisters at St. Ursula Academy (SUA), she discovered that Maria Longworth Storer and her husband Bellamy lived at SUA for nearly four years. **Constance J. Moore** (right), a Theodore Roosevelt researcher from El Paso, Texas, called the archives and asked, "Who is this woman?" That phone call started a seven-year search to learn about this remarkable lady. They found letters in European and American archives, interviewed Maria's great-grandsons in France, and co-authored this book to share Maria's extraordinary story.

Prior to her work in the archives, Nancy researched and wrote articles in several county histories and has authored/co-authored four family history books. She graduated from the University of Cincinnati and taught in elementary schools in Ohio, Illinois and Texas. During Constance's 25-year Army career, she served in various psychiatric nursing positions, in hospital education, and nursing academic roles. Notable assignments included: Army Nursing Corps Historian and Pentagon Crisis Management Team Member after the 9-11 bombings. She has written extensively about nursing history and healthcare topics. She holds degrees from Iowa State University, Seattle University and San Jose State University.